CW01431875

Trip to the Moon

Trip to the Moon

Understanding the True Power of Story

JOHN YORKE

PARTICULAR BOOKS

an imprint of

PENGUIN BOOKS

PARTICULAR BOOKS

UK | USA | Canada | Ireland | Australia
India | New Zealand | South Africa

Particular Books is part of the Penguin Random House group of companies
whose addresses can be found at global.penguinrandomhouse.com.

Penguin Random House UK
One Embassy Gardens, 8 Viaduct Gardens, London SW11 7BW

penguin.co.uk

Penguin
Random House
UK

First published in Great Britain by Particular Books 2026

001

Copyright © John Yorke, 2026

Set in 12/15pt Dante MT Std
Typeset by Six Red Marbles UK, Thetford, Norfolk
Printed and bound in Great Britain by Clays Ltd, Elcograf S.p.A.

The authorized representative in the EEA is Penguin Random House Ireland,
Morrison Chambers, 32 Nassau Street, Dublin D02 YH68

A CIP catalogue record for this book is available from the British Library

ISBN: 978-0-241-63108-9

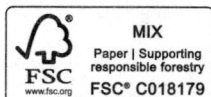

For Auryn, and Dad

Contents

Introduction xi

ACT I – LESSONS FROM THE SCHOOL OF FICTION

1 – A Trip to the Moon (*Three Acts, Midpoints and Fractals*) 3

2 – The Meaning in the Middle (*Five Acts, Ring Structure and Chiasmus*) 37

ACT II – LESSONS FROM THE SCHOOL OF POLITICS

3 – A Face in the Crowd (*The Power of Political Narrative*) 73

4 – A Place Called Hope (*The Rules of Rhetoric and Their Application in Drama*) 120

ACT III – LESSONS FROM THE SCHOOL OF RELIGION

5 – The Promised Land (*The Promise of Transcendence: Ideology, Religion and Story*) 155

6 – The Great White Light (*The Ten Key Questions of Story*) 182

ACT IV – LESSONS FROM THE SCHOOL OF DISSONANCE

7 – Ariadne's Thread (*Non-Archetypal Story and the True Role of Theme*) 211

8 – Into The Labyrinth (*Non-Western Narrative and the Hero's Journey*) 245

ACT V – LESSONS FROM THE SCHOOL OF FICTION, REVISITED

9 – Equilibrium Disrupted / Equilibrium Restored (*What Is a Story?*) 281

10 – A Trip to the Moon, Revisited (*What Gives Stories True Power?*) 309

APPENDICES

I – *Moonlight* through the Prism of Three and Five Acts 335

II – Chiasmus and the Roadmap of Change 340

CONTENTS

III – *Harry Potter* Chiasmus 342

IV – Non-Western Narrative Forms 344

V – Old Knowledge vs. New Knowledge 355

Acknowledgements 357

Bibliography 361

Credits 365

Notes 367

Index 447

The School of Athens (*Scuola di Atene*) by Raphael (1509–11)

Introduction

Stories can make a girl laugh, a boy cry, or send a child to sleep. They can make a man leave his wife, a woman join a cult or a boy wear a bomb. Stories can make a felon a president or an heiress rob a bank. A soldier may rape for a story, a teenager may kill. Stories create religions and cause them to divide; they provoke civil wars, spark genocide too. Stories bring peace, bring love, bring pleasure; they deliver death, destruction, and despair. To command narrative is to control a frightening power. So what, exactly, *are* stories? How do they work, and what gives them that strength?

When Syd Field wrote in 1979 that there were three acts to every story, it was a distillation of his observation of film fiction. That observation led in turn to the explosion of an industry of screen-writing gurus who have expended a great deal of energy on telling us what shape stories should be, but hardly any on *why*. They have had even less to say on what makes some tales hit home with such astonishing *force*.

In my first book on storytelling, *Into the Woods*, I attempted to answer how and why narratives cluster around a similar shape – not just in film, but in all types of storytelling. I steered clear of asking why some were able to transform the world, while many with similar three-act structures simply, well . . . weren't. But after publication I continued to wrestle with this question. What was it that turbo-charged some tales? Might it be possible to understand and harness that terrifying potency? And if one wanted to understand how to do that, where would one *look*?

Nearly all screenwriting books draw on fiction for illustration and example. *Into the Woods* was no exception, and called largely on Western works for reference. This was born partly from a desire

for simplicity, and partly because the target audience were almost exclusively practitioners of Western forms. Ten years on, planning a second book, this felt both an abdication of responsibility and a missed opportunity. If our only forms of reference are fictional, then we can never escape fiction's orbit – we are trapped in its self-referential loop. Narrative, however, doesn't imprison itself within fictional restraints. Surely, to really understand story we need to not only break out of the prison of Western fiction, but also fiction itself. We need to observe the practice of story in the wild.

The most powerful examples of story often lie outside of made-up worlds. On a local, national and global level storytelling dominates our lives. Brexit was won with a story; Donald Trump rose to power – twice – on another. Why did a suicide cluster develop in Palo Alto in 1991? How could some very smart people believe the Princess of Wales was, in early 2024, dead or imprisoned and replaced by a body double? Story is at the heart of these phenomena, just as it links the deaths of 80 million people worldwide to a man hiding out in a cave dictating a tale fifty years before. Stories spread like a virus, invisibly infecting rational belief and reshaping minds, subverting individuals and populations, often with seismic effect. As I write, two dreadful wars are in play, the rivers of blood obscuring their cause: both are conflicts between two competing stories, each slugging it out for supremacy. Is there anything, hideous as it might be, we can understand by looking at real-world narratives, and in doing so learn from them?

On the walls of the Apostolic Palace in Vatican City is a fresco painted by Raphael called *The School of Athens*. Right at the focal point stand Plato and Aristotle, and around them are gathered the great thinkers of the ancient world – Ptolemy, Pythagoras, Heraclitus, Euclid – as well as (perhaps immodestly) Raphael himself. The great minds of classical scholarship, from science, astronomy, philosophy, mathematics and art, are portrayed collectively. The picture is a celebration of the quest for knowledge, and the union of religious and worldly thought.

The work – one of the supreme achievements of Renaissance art – has always fascinated me. Typically perhaps, I was at first more in love with its structure than its content, bewitched by its extraordinary balance and poise. But the more I examined the content, the more I found *that* seductive too. As we so often do with art, I had imposed a narrative upon it: the great minds of antiquity from every conceivable discipline had been called to action by Plato and Aristotle for one purpose – to seek truth. If you want to know something, the picture was telling me, don't just consult the experts in your own field, seek out those beyond.

Rather than using fictional illustrations to understand fiction, then, perhaps we might approach the study of story in a different way. If narrative is present in politics, in rhetoric and in religion, and if non-Western epistemologies can shed light on the narrative arts, what if we gathered the experts in those fields together, alongside philosophers, psychologists and neuroscientists, and utilized their knowledge to bolster our own?

What can the speeches of Roosevelt or Reagan teach us about fiction? Do the narrative structures of the non-Western world like Kishōtenketsu hold useful information? What about the discipline of narratology, the academic study of story? That surely must have something to say too, as must the deliberate distortions inherent in the films of Michael Haneke, Andrei Tarkovsky and David Lynch. True knowledge, as T. S. Eliot suggested, can only really be found from exploring worlds outside our own, our eventual return allowing us to 'know the place for the first time'. If fiction writing is our home, our School of Athens, then these other schools – of politics, of religion, of dissonance (or rule-breaking) – might provide a lens through which we can better understand our art.

Such a study might also unlock an awareness of just how much stories invade our lives, and thus help us guard against their sometimes darker purpose too. So, while my hope is that our school of great thinkers will have much to offer practitioners of fiction, equally there are also lessons the experts gathered here could take from each other. Raphael's fresco suggests that every attendee was enriched by

going to Athens. This book is born from a similar, if more modest, ambition – to create a School of Athens for story.

Look up the definition of the word 'story' and what do we find? According to Merriam-Webster's dictionary, it's:

a) an account of incidents or events
b) a statement regarding the facts pertinent to a situation in question
c) ANECDOTE *especially*: an amusing one.

In *Collins*:

A description of:

a) imaginary people and events, which is written or told in order to entertain
b) an event or something that happened to someone, especially a spoken description of it
c) all the important things that have happened to (something) since it began.

And in *Lexico*:

An account of imaginary or real people and events told for entertainment. *'An adventure story'*.

All of these definitions are technically correct but banal and reductive. They give little sense of story's power or its fundamental role in shaping our understanding of the world. There's nothing about how the very act of narrative formation simplifies and distorts the world, nothing on the joy and terror stories stir up and release.

There are better definitions of the word 'fiction'. The *American Heritage Dictionary*, for example, calls it 'the act of feigning, inventing or imagining'. The word itself is derived from the Latin *fictionem* ('a fashioning or feigning') and in particular from its past participle of the verb *fingere, fictus* – 'to shape, form, devise, feign' – the original meaning of which is even more enlightening: 'to knead, form out of clay'.

Cinema, television, novel, podcast: all embody the process by which we distil, shape and structure the sometimes random, sometimes absurd events of life into a clear, comprehensible whole. Reality *kneaded*. Story is formed from this manipulation, the pressing, shaping and firing of experience's clay. And, of course, that definition takes us beyond fiction – it suggests that all stories are at some level fictional. The kneading makes them so.

That kneading is the subject of this book. In one way, it can be seen as a series of separate essays, each exploring how stories are constructed and weaponized in different forms and contexts, but at a deeper level it's an attempt to answer definitively both what a story is, and what ingredients the most powerful tales require.

Some subjects, such as three- and five-act structure, I am revisiting from my first book, though freighted with a decade's more knowledge and insight. Much else, though, is a new journey into the woods for me, and writing it has caused me to see a subject I thought I knew well with new eyes.

It's allowed me to see how essential storytelling is to politics, history, culture and identity, and how you can extract lessons from those disciplines to construct stronger fictions. It's cast a similar spotlight on religious belief, disclosing instructive parallels between Alcoholics Anonymous and Scientology, and thus illuminating the mechanisms behind not just religion but all life-changing tales. It's unveiled an extraordinary kinship between story and rhetoric, showing how one can influence the other and how world-changing speeches are packed with lessons for storytellers. This in turn has led me to explore social contagion, from suicide epidemics to witch hunts, and extract further lessons from these darker arts. It's divulged a fascinating connection between fiction and learning cycles, addiction counselling and the Kübler-Ross cycle of grief, which has helped unlock the deeper, hidden purpose of structure, and just how it quietly performs its devastating work.

I've deliberately attempted to step outside the Western canon in this book too. The examination of non-Western and non-archetypal structures has thrown up whole new ways of looking at our classic

story shape, showing up both its weaknesses and strengths, and how the former can be countered and the latter employed. This has led to an exploration of narratology, the academic discipline entirely ignored by screenwriting 'gurus', yet whose practitioners discovered most of the secrets of narrative structure long before. All this has allowed me to find not just new definitions of traditional elements of screenwriting such as 'want and need', the 'inciting incident' and 'theme', but the reasons why they exist as well. Perhaps most importantly, it has allowed me to see afresh the midpoint of every tale – the burning sun at the heart of story structure – and this altered perspective, I hope, shines some new light on our craft.

Finally, and because of this, it's caused me to reappraise so much of the screenwriting lore that dominates the world I work in. In particular, it helped me understand how the screenwriting staple of the hero's journey is built on a misunderstanding by Joseph Campbell, which in turn reveals a much wider truth about where narrative structure really comes from. It's shown me, too, that it's not just Campbell who comes up short. It's helped illuminate the numerous shortcomings in so much of screenwriting literature, and brought me to the worrying conclusion that much of it may be closer to conspiracy theory than empirical truth.

Stories are essential for a child's well-being – an adult's and a society's too. Telling them is as instinctive as breathing, but that shouldn't preclude their study. Indeed, they are so essential to our private and public realms, there's an argument they should be the thing healthy societies study most of all. For all its roaming, however, in the end the central concern of this book is to improve the craft of narrative. An astonishingly small number of TV series become hits. Around 60 per cent perform around their time-slot average, while 30 per cent fail outright. Is that really an acceptable figure for an industry that professes such expertise? So many of the shows that aren't hits are the result of poor design or a misunderstanding of what audiences *need* from a story. This book, I hope, offers lessons of how, at the very least, that figure

might be reduced. And so, at its heart, lies the quixotic pursuit of the 'perfect' tale.

There can be no such thing as a perfect story, of course: nirvana is, ultimately, subjective. However, you will have some sense of what a 'perfect' story does to you. You may not be able to describe how or why, but you will know it because you will have felt it, if you're lucky, many times in your life. When that combination of protagonist, antagonist and desire lands correctly, something extraordinary happens. Time stops, the real world disappears, you live for those moments entirely inside a virtual reality. You forget yourself, leave your body, become one with a fictional world and *transcend*, and then, when you shut the book, leave the cinema, or turn off the TV, for the briefest of moments, the world seems fresh, new, ordered – at peace.

The experience will be transient – it will feel outside our normal perception of space and time; it will be ineffable – it cannot be put adequately into words; and it will be noetic – you will feel you've gained knowledge normally hidden from your understanding.* What if we can get closer to understanding that? If this book can be reduced to a simple quest, it's that: the search for the form and content capable of both harnessing and unleashing that terrifying power.

What kind of power? In his book *Sapiens: A Brief History of Humankind*, Yuval Noah Harari illustrates the problems animals have in uniting for collective action. Chimpanzees, he points out, only form groups when members know each other intimately, which limits group size to 'about twenty to fifty individuals'. Any more than that and the tribe becomes prone to dysfunction. When Hitler invaded Russia in 1941, he had 3.8 million troops at his disposal, the combined might of the Axis powers. Not all of them were co-operating freely but even discounting those you are still left with the largest land force in history. Why can't chimpanzees gather in such numbers with a sole purpose like that?

There's one simple answer. Chimps cannot understand abstract concepts and lack the linguistic tools to inspire or terrify. They have

* These categories are taken from *The Varieties of Religious Experience* by psychologist and philosopher William James.

no building blocks with which to erect the powerful fictions of heaven and hell, and therefore cannot mobilize, inspire and lead huge masses against the fear of death towards a single goal. In other words, they do not have at their disposal the terrifying power of the tale.

We do. My hope is that if we can harness those lessons, we can leave behind the conventions that bedevil my profession, from 'how to' to the hero's journey, and tilt the discipline towards the magic, the terror and the awe.

ACT I

Lessons from the
School of Fiction

I

A Trip to the Moon

Three Acts, Midpoints and Fractals

Alan Plater was the son of a Durham coal miner. He came down to London in the early 1960s to make his way as a playwright. After a minor hit at the Royal Court Theatre, he was incubated by the fledgling BBC drama department, his upbringing central to their mission of kicking down old barriers and championing the voice of the Northern working class. This voice came to dominate British television drama for the next twenty years. Gritty urban realism was the stuff of both its popular output (such as *Z Cars*, where Plater started) and its serious plays (like the anthology drama series *Play for Today*, which for many years was pretty much his home). Author of well over a hundred hours of beloved drama, Plater was, in the words of Jimmy McGovern, 'the Godfather' of British TV writing. Even if you don't know his name, you know his voice. It echoes still in the work of James Graham, Peter Bowker, Sally Wainwright, Peter Flannery, Billy Ivory, Debbie Horsfield and McGovern himself: fiercely intelligent, unashamedly popular and always on the side of those the world has scorned or passed by.

Syd Field was a different kind of writer. He was the author of *Screenplay*. Published in 1979, this was the first book to codify the art of modern screenwriting and to show how every Hollywood movie was built using three acts. It transformed the screenwriting industry, providing the first roadmap of movie structure and becoming the foundation stone for writer training, the sprawling suburbs of which surround the city of film and television production today.

What do these two writers have in common? Despite Plater's unprecedented hit rate, his numerous awards, his honorary degrees from Northumbria and Hull Universities, his 2004 OBE for services to drama *and* his BAFTA for Outstanding Writing in Television, he always maintained that the highpoint of his career was the day he tracked down Syd Field and punched him in the face.[1]

Plater's hostility towards Field grew from a natural concern. He was entirely self-taught. He wrote about life. His school was not a paradigm but the hard graft of writing day in, day out, his whole life. Making sense of a world that had dismissed or looked down on the likes of his father. It came from a marriage of anger and a natural sense of justice, and a humour that looked for the good and absurd in everyone. What he saw in Syd Field was the attempt to sideline all that, to replace experience with a formula, hard work with short cuts, and vision with lazy schema.

He wasn't alone. When I started work as a young script editor at the BBC in the early 1990s, Field was widely referred to as 'the enemy'. This was before the publication in 1999 of Robert McKee's *Story* which, building on Field's foundations, drove older writers and producers into even greater paroxysms of fury. Field's work was seeping quietly into the mainstream, often used and consulted in secret. (One member of our team kept a copy of the book in a brown paper bag. 'It's not pornography,' I said to him. He blushed. 'It is,' he replied.) The consensus, however, was Plater's: three-act structure was the enemy. The 'rules' were death.

So, is it the enemy? Where does it come from, and why? Should Alan Plater have punched Syd Field in the face? And if not, why not? Thirty-four years after the publication of *Screenplay*, the war between Plater and Field had been picked up by a new generation of combatants, reaching its apotheosis on 27 March 2013, when an American screenwriting guru posted a new declaration of war on Facebook.

WHY 3 ACTS WILL KILL YOUR WRITING
POSTED ON MARCH 27, 2013 BY JOHN TRUBY

John Truby was a former story editor on *21 Jump Street*, and author of three credited episodes, and he was vehement. 'When they do decide to get a little knowledge,' he wrote,

> most writers go out and buy a couple of books on screenwriting. And what do they learn? Almost invariably, these books tell them about the so-called 3-act structure. These writers have just killed any chance they had of writing a script that will sell.

What followed was a systematic destruction of everything Field and (by implication) a craven industry had stood for for the best part of forty years. In his wide-ranging post, he denounced the received wisdom on the screenwriting craft with apostolic fervour. Three-act structure was, he claimed 'the biggest, most destructive myth ever foisted on writers' and an invention of one story analyst who, having noticed a couple of superficial similarities, constructed a whole edifice of nonsense on top of it. 'Such has been the sad state of screenwriting training and the desperation of screenwriters themselves that no one noticed that the emperor was in fact naked', he railed, comparing the entire industry to cheerleaders in a cult, and himself as the young truth-teller, the only one able, thanks to his acuity, to see through this obvious fraud.

As you're reading you can feel something happen – even the most sceptical reader starts to nod along. I remember thinking, as I read, 'God, you're right.' I'd read Syd Field, and McKee and Christopher Vogler, and while they were all interesting and good, there was something that didn't quite add up. 'It's all very well, these hundreds of books on screenwriting,' I'd thought, 'but where is the *proof*?'

So for many, myself included, Truby's message was immediately attractive. Alongside agreement, another curious feeling begins to build as you read, something like, 'Oh my god – he *knows*.' Not only has he seen through every charlatan and huckster, not only has he gleefully demolished them, but John Truby has also found *the truth*. 'If I keep reading,' you tell yourself, 'I can share in that truth too.' That feeling, teased throughout, is correct. Truby *does* know the truth, and as you venture forth into his teachings that truth is finally

revealed. As he stands over the corpse of three-act structure, bloodied but unbowed, he raises his trusty broadsword to the skies. Three-act structure is dead, he declaims. What must replace it?

The twenty-two stages of story structure.

At which point, if your reaction was anything like mine, you will want to shoot yourself in the head.

What was equally fascinating about the original Facebook post was the debate Truby's tablets of truth engendered in its comment section. For two or three days it felt like every writer and script editor in the world was piling in to share their thoughts on the post – either dissenting half-heartedly, using it to attack TV development or endorsing its gleeful iconoclasm.[2]

It provided a fascinating cross-section of the screenwriting community's thoughts on their art, but in many ways an alarming one too. It might be fine that there is no clear consensus on the 'rules' of narrative structure – if there even are rules – but what was more concerning was the total absence of rationality behind any of the assertions, either pro-Truby or con. It should be simple to assert that there is no evidence whatsoever, let alone proof, that there are twenty-two stages to every story. (Why stop *there*? Why not thirty stages, or 300?) The lack of any rational underpinning to almost every screenwriting tome *should* be a cause of concern – not only because it shouldn't hurt us to articulate and prove the real rules of narrative, but also because without proper academic study we are leaving the world open to snake-oil salesmen. Alan Plater's fears, I think, really stemmed from this. When his world began to be invaded by besuited, confident non-writers with increasingly powerful roles in the industry, what he saw was a sea of susceptible marks falling foul of the universal spiel of the con man: 'Psst . . . Hey, kid, do you want to buy a bridge in Boston?'

The responses to Truby's post are a fascinating illustration of what most writers, producers and editors go through as they enter their first few years in the television industry. You take on board the culture you work in – or you don't tend to work. You know there are some rules and you want to believe in them, but how do you navigate them

when you've read the industry's standard tomes and are left with a nagging feeling of 'Well yes . . . but something doesn't quite make sense.' What you probably don't do is embark on a detailed empirical analysis of the nature of structure.

In that sense, the argument between Syd Field and Alan Plater is central to the whole concept of writing as an art, both inside television and without. Are there rules? Who says so? Why? If you're not asking those questions something would almost certainly be amiss. Central to any debate on 'perfect' story must be the role of structure. Before we take off into the wider, stranger world of story's all-encompassing reach, it might be useful to revisit and re-examine the basics. Not just 'What is three-act structure and where does it come from?' but, before that, 'What is structure, and what's its effect?'

Structure

It's a silent black-and-white film from 1924. 'How much is the beef?' asks the young boy of the butcher, who is busy laying slabs of meat out on an unwashed counter. The babushkas from the village prod, knead and ponder whether to buy some before walking away. But something is odd. They are walking backwards. They reverse down the street and through the doors of the co-operative where slaughtered cows lie on the floor. A title card appears: 'We give the bull back his entrails.' Hands stuff the guts of the animal back into its dead carcass. Then, 'We dress the bull in his skin', as the carcass is wrapped with its coat and sealed by the sawing knife. 'The bull comes back to life' is the final caption as the twitching carcass shudders, spasms and is miraculously resurrected. Backwards it trots, out of the slaughterhouse, reversing through the stockyard, back through the railway cars, the siding, and then by lorry in reverse to the herd from where it began – gambolling happily with its friends in a field.

It's a documentary – *Kino-Eye*. Part propaganda, part insight into a village that had undergone collectivization under communism in

Soviet-era Ukraine. The director is Dziga Vertov, who shortly afterwards would produce the second great documentary film ever, *Man with a Movie Camera*.[3] (The first, Robert Flaherty's *Nanook of the North*, set the template for every traditional biopic that washed up in its wake.) Even early in the medium's history, *Man with a Movie Camera* and *Kino-Eye* before it were attempting to deconstruct and reinvent the form.

Vertov was obsessed with using film to capture 'reality'. His movies had two things in common with Flaherty's. Both told lies to tell the truth – *Nanook* was later discovered to have faked many of its set-pieces – and both craved absolute symmetry. Flaherty found it by inventing the boilerplate structure of documentary film narrative. Vertov found it by reassembling pieces of meat into a living, breathing form. Both however sought the same thing – order. Order is everything in story.

What is order? Order is structure. While *Kino-Eye* might accentuate it to an almost absurd degree, the desire to escape chaos is central to our very existence. The more we lack it in our own lives, the more we must transfuse it from the films we watch and the books and journalism we read. Order is the drug that keeps human beings from going mad. It's a profoundly addictive property, and if you remove its source something else will rush in to take its place.

In 2007, American writers embarked on their first strike of the new millennium. For a hundred days the real, if unrewarded, powerhouses in television exchanged word processors for picket lines, arguing for a slice of the digital revenue they'd helped the big networks to earn. Twelve thousand scribes stopped work, and scripted production effectively came to a standstill across the United States. There were immediate problems for dramas in production (look at Season Two of *Friday Night Lights* if you want to see a show careering off the rails), but there were deeper ramifications too.[4] Ben Silverman, then chairman of NBC and the creative force behind the US version of *The Office*, was one of the more prescient voices:

The basic feeling there and in town was, 'There'll never be a strike.' Then bingo, it happens. The first thing hit were our late-night shows, where we built no contingency. We were super-well-positioned otherwise. I knew *Biggest Loser* could expand, I greenlit *Phenomenon* and *American Gladiators*. Then I came up with the idea of doing *Celebrity Apprentice*. I reached out to Mark Burnett, who said, 'There's no way Donald [Trump] will want to be around other celebrities. He has to be the biggest celebrity.' And I said, 'Actually, he's going to be the biggest celebrity because he's going to be the boss.' I called up Trump and he agreed, and we relaunched to huge ratings.[5]

Silverman understood instinctively that the enormous gaps in his schedule could be filled by bulking out his non-scripted shows. Audiences crave narrative, and almost every great terrestrial network has been defined by the drama it has produced: HBO had *The Wire* and *The Sopranos*, NBC had *Friends*, *ER* and later *The Office*. In the UK, Channel 4 for years wrapped itself in the aura projected by *Queer as Folk*. But, in the US in 2007, narrative suddenly wasn't available. Or rather, as Silverman realized, it was, but *outside* of fiction.

And so reality television began its march towards cultural hegemony. It was cheap, it was quick to make and, whereas long-running dramas gave you massive peaks two or three times a season, *The X-Factor* or *The Apprentice* could knock an audience out every week. It was a TV commissioner's dream. I remember asking my boss at Channel 4 if we could have some more money to reshoot the first episode of *Shameless*. 'I can make twenty episodes of *Wife Swap* for one episode of *Shameless*, and *Wife Swap* gets me three times the viewers.' It was one of the first invaluable lessons in TV I ever received. 'What do you think I'm going to do?' he asked, ushering me out of the room.[6]

The 2007 writers' strike was to have three permanent ramifications: it turbocharged the growth of reality television; it plunged a dagger into soap opera, sending its dying body on a twenty-year stagger round the schedules, every executive convincing themselves,

like Mercutio, that the wound was 'but a scratch'; and it was responsible, indirectly, for *President* Trump.

The latter two need not detain us here, but the first had profound lessons for those who care about narrative. Successful reality television takes all the elements audiences crave in drama and lays them out simply and clearly for our edification. We have enticing and intriguing central characters, whether hosts (Supernanny or Simon Cowell) or guests (Susan Boyle or Nasty Nick); high-stakes emotion, mostly from jeopardy (there are always stakes); big cliffhangers (every week someone loses and someone wins); and not just audience investment but investment *with consequence* (you can vote – you have a say!). While in fiction the repetition of these elements can become implausible and wearing, in factual TV the endlessly disposable guests circumvent similar tedium. The average drama series lasts three seasons. The average hit reality show? Around ten years.

There was one other key ingredient too. The catchphrases and motifs ('You're fired') are just the tip of the iceberg. Below the surface, repetition is hugely important to reality TV. Every episode is the same, not out of laziness, but because mass audiences crave formats. They love familiarity. They love repetition. Too much of the wrong kind may grate, but if you get it right ('Beam me up, Scotty'; 'Goodnight, John Boy') those motifs unlock both the security of familiarity and a childlike glee. It's flattering to pretend that we're above this – 'We're artists,' we tell ourselves – but X-ray any TV hit and you will find the skeleton of a format underneath. It will have an act structure and a group of people who are given a mission, enact that mission, then are judged. That's the format – and it will repeat itself every week. But more than that, within each show is found a deeper, more fundamental engine. What do *Grand Designs*, *How Clean Is Your House?*, *Supernanny*, *The X-Factor*, *The Apprentice*, *Sort Your Life Out* and *Big Brother* all have in common? The replacement of chaos with order. That's the drug.

> Enter a workshop filled with expert craftspeople, bringing loved pieces of family history and the memories they hold back to life.
> A heart-warming antidote to throwaway culture.

The blurb for *Repair Shop*, as I write one of the biggest hits on British TV, hits the nail on the head. The show is literally *restorative* (it's *Kino-Eye*!), making the bad feel good. Ditto *James May: The Reassembler*, another big hit for BBC 4. Here, the former *Top Gear* presenter lovingly rebuilds a variety of household objects – a 1959 Suffolk Colt lawnmower, a 1972 Hornby trainset, a 1957 Bakelite telephone – all carefully tailored to the presenter's demographic. There is nothing that different here from *Vera*, or *Luther*, or *Only Murders in the Building*, nor *The Staircase*, *The Dropout* and *Chernobyl* – they are all appealing to the same innate desire.[7] All successful TV follows one simple archetypal pattern: a problem is found, a problem is solved. The patient is healed, the criminal is captured, chaos becomes order, the cow is reassembled from its constituent parts.

Why do we crave that journey? Because if it *doesn't* happen, chaos remains unordered and the resultant anarchy threatens to overwhelm and drown us all. Without story, all there is is empty, nagging existential dread – a feeling Jean-Paul Sartre termed 'nausea'.

La Nausée is the name of Sartre's first novel. Set in Bouville (the homonym of which translates as 'Mud Town'), it tells the story of Antoine Roquentin, who slowly starts to go mad. Boredom turns to isolation; bare-naked reality starts to impinge on and overwhelm him. Objects slip their verbal moorings, and the true nature of existence bubbles up like lava, causing him to doubt his own existence – to dread it, in fact, inducing the feelings of sickness which give the novel its title.

It's an existentialist treatise birthed on the left bank of the Seine during the gap between the end of the Spanish Civil War and the outbreak of World War II. Today it reads more convincingly as a study of clinical depression, but it's also a brilliant example of a world stripped of story.

The world is too large, too complex, too unfathomable, and we are too small, too simple, too ill-equipped to understand it. The naked world is Kraken, Godzilla, Goliath, and we are David – the vulnerable protagonist standing in awe and terror in its way. The only weapon that can save us is narrative.

In *A Portrait of the Artist as a Young Man*, James Joyce spoke eloquently of the 'nets' flung at a man's soul when it is born 'to hold it back from flight. You talk to me of nationality, language, religion. I shall try to fly by of those nets.'[8] In reality, those nets *are* story. Religion and nationality, mythology – and, yes, language too – are our way of not being overwhelmed. As the Book of Genesis proclaims, the earth was at first 'formless and empty, darkness was over the surface of the deep'. Terror, horror, uncertainty. And then:

> God said, 'Let there be light', and there was light. God saw that the light was good, and he separated the light from the darkness. God called the light 'day', and the darkness he called 'night'. And there was evening, and there was morning – the first day.

It's beautiful. It's the creation story of the Christian and Jewish religions, likely composed during the fifth or sixth centuries BC. The events it purports to describe took place eons earlier – indeed, did not really take place at all. They are mythic, and like all myths, for billions of people they make the world safe. Prometheus steals fire from the gods; Pandora opens the jar that contains death, destruction, hunger, pestilence and war. When we name something, we domesticate it; when we wrap chaos in story, we bring the world to heel. We are pareidolic creatures, wired to impose patterns on any randomness we find. When we see chaos, we panic, but wrap it in narrative and panic gives way to safety; we gasp for breath, breathe deep again, then slowly exhale. We crave order like air. And order is just a synonym for structure.

But if that's what structure *is*, then what's its effect?

When The Beatles gathered in Twickenham Film Studios in January 1969, they did so with cameras watching. There wasn't much of a plan, just a director they trusted (Michael Lindsay-Hogg), who was to film the band rehearse and return, after a three-year hiatus, to live performance. The results, however, were uninspiring, and despite a move to a less cavernous rehearsal space (the basement of

Apple HQ in Savile Row) the resultant film, *Let It Be*, was greeted with little enthusiasm. By the time it was released, the band had split up acrimoniously and it was 1970, a new, grimmer decade of industrial unrest. If the 60s were a technicolour party, the decade that followed was its grey hangover – something the film seemed to encapsulate: a fog-drenched cold turkey with the bitter aftertaste of childish argument, petty narcissism and fashions that had peaked two seasons before. The *Sunday Telegraph* wrote of the film, witheringly, 'Watching an institution such as the Beatles in their film *Let It Be* is rather like watching the Albert Hall being dismantled into a block of national Coal Board offices.' Even while he was making it Lindsay-Hogg sensed the problem. 'There's a lot of good stuff,' he grumbled as he saw his project slip through his fingers, 'but there's no story.'

Fifty years later, on Thanksgiving weekend 2021, *Get Back* was released to almost unanimously positive reviews. Peter Jackson had been given unique access to all of Lindsay-Hogg's footage: fifty-five hours of unseen film, as well as 140 hours of audio that was known to the most avid Beatles bootleggers but not to the wider public. Jackson had restored the film and audio to an almost preternatural degree, but that wasn't the reason the film worked so well, and it didn't account for its extraordinary success. What did? He'd injected the shapeless mass with *narrative*.

Where once there was miasma, now there was compartmentalization. *Day One, Day Two, Day Three* . . . Where once there was torpor, there was now tension and stakes; instead of inertia, there was now a clear, tangible goal. Suddenly we had protagonists we were rooting for, characters we *loved*. In a desperate race against time, the band had less than three weeks to produce an album and a performance before Ringo had to leave to make another movie. They had no idea what form the performance would take, and no finished songs. The original film had been a formless mess.[9] It was now, to all intents and purposes, a heist movie: *Let it Be* as *Asphalt Jungle*. An unlikely gang come together, and plan and execute a daring robbery against impossible odds. We root for them as they encounter malignancy

and incompetence and self-doubt at every turn. Like any good genre picture, it had a ticking clock ('You've got 24 hours, Morse, then I'm taking you off the case') and it had an unlikely, joyous outcome. On the rooftop of Savile Row, playing to an unsuspecting public in a deathless image, The Beatles were, against all the odds, gods again.[10]

It had an inciting incident – 'We've got to make the album'; it had a goal – 'We've got to make the album and perform it live somewhere exciting by Friday 24 January'; it had antagonism – their director, their label, their wives, themselves. It had a crisis – George Harrison leaving the band – and a climax – an unlikely victory snatched from the jaws of defeat. There was even a potent resolution – one in which, as in all the most powerful stories, a myth (the Beatles myth) was recast. Paul McCartney, no longer a control freak, was now the presiding musical genius, while his band were not riddled with hatred but lovingly united by a shared mission.[11] The trilogy even has a perfect midpoint – that moment where everything changes, where things ramp up a gear – when Billy Preston arrives, thumbs up and grinning, exactly halfway through the three films, almost to the second.

What had happened?

When Mount Vesuvius erupted in AD 79 the corpses, covered in volcanic ash, slowly rotted away leaving only the hardened ash behind. Two thousand years later, Giuseppe Fiorelli had an inspired idea. He could resurrect the dead by injecting the volcanic vacuums with plaster of Paris. Not just bodies but faces, intimate gestures – all were brought back to life in perfect facsimile. That's what Peter Jackson did, and that's what structure is. It's injection moulding. Like story, it transforms the intangible into something clear and visible – into magically digestible form. With that injection, vacuum cedes to shape and life.

That's structure. A story simply cannot exist without it. But why three acts?

Three Act Structure

When, in *The Cambridge Introduction to Narrative*, H. Porter Abbott claims that 'conflict is not a necessary component for something to qualify as narrative', he cites the opening scene of Leni Riefenstahl's 1934 documentary on Nazi ascendency, *Triumph of the Will*.[12] Adolf Hitler's plane hovers above the clouds as it heads towards Nuremberg for a triumphant party rally, nineteen months after the Nazis have seized power. To us it is dystopian – a dark god descending to earth to be hailed by brainwashed crowds. At the time it was brutally effective propaganda.

Porter Abbott proffers this as proof of narrative without conflict; however, there *is* conflict in the scene – just not as most of us normally understand it. Antagonism is technically any force that opposes the protagonist's will and desire, so if the plane (or in effect Hitler) is the protagonist, he is opposed by the air he flies through, the force of gravity and, once he lands, the multitudes that flock around his cavalcade as he makes his way to Nuremberg. As conflicts go, it's mild. There's no will to destroy here, just to traverse, and while that's not enough to sustain long-term interest, conflict is still there.

There is another way of looking at the scene, however, which underlines just how integral conflict is to all narrative. You see it with newspaper columnists, Substack writers or Instagram activists: they are the protagonist in their story world, and their antagonist is the subject matter they wish to corral. Narrator-free documentaries are not dissimilar. Here the protagonist is, in essence, *us*, the viewer, and our antagonist is the subject of the documentary. The fact that no one is twirling a moustache doesn't mean there isn't a villain to be vanquished. Conflict is integral. There can be no journey without a path offering resistance; there can be no story without a protagonist battling obstacles, however small, placed in their path.

So Porter Abbott is not only wrong about not needing conflict, but also, by implication, about how narrative is assembled. A single

event is an *incident*, but what makes a story is a chain of cause and effect, and this also underlines the role of antagonism. Without an enemy, a scene is just information. If you cut two scenes of information together, that doesn't make a narrative either – it's just a series of events. What makes them a story is that the second scene is *caused* by the first, and that can only happen if something disrupts the first scene to create a reason for the existence of the next.

This interaction is deeply significant. In fact, it's the very well-spring of three acts.

A protagonist by themselves is nothing. They require the introduction of antagonism to come alive. That crucial moment has one utterly vital effect. It creates *dissonance*, and out of that discord harmony must be sought and found. That's all three acts are: the sense made of a disruption by finding its cure.

Any event, then, will take its narrative form not just from 'hero + villain = story', but from the process of *order, dissolution,* and *re-assembly.* 'I see a plane. Where's it going? It's going to Nuremberg.' Every deed of perception is, at heart, a story in three acts; a planet falls out of orbit and hurls across the universe, seeking another star it may orbit once again. *Existence, disassembly, reassembly. Home, chaos, home.*

An act is a unit of desire, as, in its own way, is every scene. An act ends when a desire is sated or *turned.* A new question has arisen, giving the protagonist a new goal. Existence is challenged (act one), old beliefs are dismantled (act two) and the possibility of a new belief is raised (act three). It's a universal process, working at scene, act and story level. You're doing it now, reading this argument. 'I believe this – I read this – I either put on armour or shed my skin.'

Thesis, antithesis, synthesis; 'I exist, I learn, I change.'

Narrative arises inevitably from the collision between the self and life, the question that collision provokes and the act of answering it. It might be small (someone flying), it might be huge (the Avengers have lost the Infinity Stones) but it will always be there. Story isn't something for which three-act telling might be an option. *Existence, dissolution, reassembly* – story *is* three acts.

So why the antipathy coming not just from Alan Plater, but other greats of the literary world?

A grand old giant of English Literature stares defiantly at the camera: 'There's all this stuff about three-act structure – exactly how you must allow a story to unfold . . . My view is it's all nonsense.'[13]

Salman Rushdie's *Midnight's Children* not only won the Booker Prize in 1981, in 1993 it won The Booker of Bookers, underlining its position as a twentieth-century classic. A magical realist novel, it doffs its cap to the South American titans of that genre, in particular Gabriel García Márquez's *One Hundred Years of Solitude*. Myth, allegory and fable swim side by side as the real events of the novel are often invaded by the extraordinary and the 'magical', to make profound – and hugely entertaining – points. It's an epic, daunting in ambition and execution, charting the history of modern India through the eyes of one troubled protagonist – Saleem Sinai.

Sinai is falling apart under the weight of 'too much history'. Born at the very stroke of midnight on the day India slipped its moorings from Britain and set sail into the stormy waters of independence, he wants to tell his tale, and he knows he doesn't have much time.

And so he begins: how his parents met; how he's born with magical powers; how, as he grows, he journeys through the subcontinent trying to work out who he is and what he stands for. From partition to the Indo-Pakistan War, from the death of his family to desertion from the army, Saleem's story loosely mirrors India's own. When he finally finds happiness as a step-father, India is rocked by civil unrest and he and all the other 'midnight's children' are kidnapped by the state and subjected to Indira Gandhi's forced sterilization programme.

When the emergency ends and the midnight's children are finally released, Saleem seeks out his lost son and heads back to Bombay to work in a pickle factory. Now happy, he plans to start telling his future. Marriage plans are made, but before he can begin, Saleem crumbles into a thousand pieces of dust, his story actually fully told.

Beginning, middle and end; set up, conflict, resolution. If you

shake the foliage from the tree then the trunk of *Midnight's Children* – the journey away from and back to home, the quest to tell the story, the knowledge gained from doing so, the race against time, the regular turning points spinning the story off in new directions and the completion of his tale – it's a perfect three-act form. The content may be new and radical, but the underlying form takes a shape as old as time.

When Salman Rushdie addresses the camera to dismiss the very structure he employs, his statement is at once bold and revealing. Bold, as all sweeping generalizations are, and revealing because it's a structure of which most of us, like him, are unaware.

The fact that Rushdie is dismissive isn't cause for condemnation. Rather, it illustrates the fact that the three-act form isn't something that comes from a screenwriting manual; it's the unconscious process by which humans make sense of information they wish to convey. It might not be formalized – it's not in *Midnight's Children* – but it's still there. Rushdie himself is employing it even as he talks to the camera: *Some people say we should use three-act structure; look at* Midnight's Children; *I don't*. His very argument is in three acts.

Resistance to the acceptance of structure stems from a number of separate beliefs. The first is exemplified by Rushdie: the idea that narrative has a teachable shape, that story is somehow explicable, mitigates against the cult of inspiration.[14] True art, on this view, is born from suffering, pain and personal toil – ideally forged in a garret with Thomas Chatterton as its poster boy.* This is where Alan Plater lives: art cannot be taught, it is a God-given gift. Three acts, to both of them, is a formula, and thus to be rejected for something more personal and unique – though, of course, not entirely without shape. The second belief is that inspiration and structure are antithetical. Most writers argue that their best work is intuitive, emerging from unconscious immersion in their story. Suggesting that writing is, even in part, a conscious process that can be prescribed, therefore, seems to undermine the process that

* A huge influence on the Romantic poets, Chatterton poisoned himself aged seventeen, in despair at his lack of success.

gives their stories life.[15] The third reason for antipathy to structure is, ironically, the teaching of structure. Screenwriting books and courses are often their own worst enemy, compounding the sense that teaching and studying writing invites formulaic, unoriginal work, and it's this more than anything that undermines the idea there is much to be gained from the rigorous study of craft. But is it really that bad?

The study of screenwriting has predominantly concerned itself with prescribing the shape stories take, and then showing how to colour those shapes in. Among the hundreds of books that attempt to make sense of film and television structure, there are four that tower over the landscape. Syd Field's *Screenplay* (1979) laid the foundations that Robert McKee's *Story* (1997) would build on. Christopher Vogler's *The Writer's Journey* added a whole new extension by popularizing the work of Joseph Campbell, and Blake Snyder's *Save the Cat* painted the edifice in brighter colours so it might be more easily seen.[16] All of them have interesting things to say, yet none has any scientific credibility. 'McKee's *Story*,' John Mullan, Professor of English at the University of London, told me, 'wouldn't pass as a dissertation.'[17] 'Why not?' I asked, slightly incredulously. 'There's no proof,' he replied. Mullan wasn't being provocative, merely stating that any rigorous academic thesis must have *proof* – not just a 'what?' but a 'why?'

Story doesn't contain proof, which doesn't make it any the less persuasive, though it should. It sometimes *is* accurate – in some ways groundbreaking – but much of it is purely conjecture. It often makes intuitive sense: it *seems* to fit, and often well. But that's not proof. Analyse the whole corpus of screenwriting literature, and what's striking is that it's almost entirely devoid of *any* academic rigour. We stare at the sun, conclude it's going round the earth and that becomes gospel. But it doesn't, and it isn't, and we deserve more.

McKee's and Field's books are important, but much of what the writing world takes for wisdom is not. It's common to think that screenwriting manuals began with Syd Field's *Screenplay*, possibly because of its seismic impact, but in reality it was just one of a long

line of books going back to the dawn of cinema and before that (as in William Archer's 1912 book *Play-making*) to theatre too.

The explosion of cinema as a popular art form carried with it a huge wave of how-to books. As silent-film historian Kevin Brownlow has noted, by 1920,

> [. . .] studios were overwhelmed by scripts and stories from amateurs all over the world. This was the only side of picture production in which the public could participate. It needed no training, no technical knowledge, and no equipment more complex than a typewriter. Advertisements for photoplay writing schools ousted those for acting.[18]

And so, the craze for screenwriting gurus began . . .

'Keep Your Hero Smiling!' urged 1922's *The Elinor Glyn System of Writing*, 'A laughing, active man full of the spirit of modern life. Understand [. . .] there should be a reason for his smiles. They should radiate cheer and optimism and determination to forge ahead!'[19] In the same year H. H. Van Loan offered more practical advice: 'First, establish a reason for the story, then introduce your characters, and after you have done that, make a dash for your climax.'[20] But, above all, Glyn continued, 'Keep your hero clean.'[21]

The advice Glyn gives to 'find a quiet spot where you will not be disturbed by anyone or anything. Close your eyes and concentrate on your play. See it in your mind. Don't dream. Visualize!' is both trite and true. How do you negotiate that if you're an artist? You may embrace the lessons uncritically, you may reject them wholeheartedly, or you may attempt to navigate between the trite and the true. None of these things feel like the right response. The right response, surely, is: 'OK, three acts might be the best story structure. Show me why.'

Many years ago, in his book *Three Uses of the Knife*, the playwright David Mamet laid out what might be the finest articulation of our need for structure: 'Our survival mechanism orders the world into cause-effect-conclusion.' Three acts is not a patriarchal structure, he said, but 'our way of ordering the universe into a comprehensible form'.[22] I quoted it in *Into the Woods*. But this is a new book, so

we must go further and answer the questions existing screenwriting literature seems to studiously ignore: *why?* And not just *why?* but *how? Where? Who says?* And *where is the proof?*

What can we say with empirical certainty about three-act structure? The simplest answer can be found embedded in a triumphant run of films all made by one studio.

Even now it's hard to grasp just how successful Pixar were in the years surrounding the millennium. In both commercial and artistic terms there is almost no precedent for their imperial phase. Between 1995 and 2010 they produced eleven films without a single failure: *Toy Story, A Bug's Life, Toy Story 2, Monsters Inc., Finding Nemo, The Incredibles, Cars, Ratatouille, WALL-E, Up* and *Toy Story 3*.[23] After that, though less successful artistically and with a greater reliance on sequels, they were still to release gems – *Inside Out 1 & 2, Finding Dory, Incredibles 2* and *Soul* – the first of which (*Inside Out*) is striking in its ability to distil extraordinarily complex ideas into a child-friendly form.

What's even more remarkable is their underlying similarity. In *Toy Story*, Woody is a benevolent dictator whose world is invaded by his direct opposite – Buzz Lightyear. When Buzz falls out of a window after a fight, Woody must learn to collaborate to fetch him home. Marlin of *Finding Nemo* is another benevolent dictator, obsessed with keeping his son safe. When Nemo rebels and is captured by a fisherman, Marlin must learn to let go of his obsessive need for control. *Cars'* Lightning McQueen, too, is dictatorial, at least until he falls off the back of a car transporter, finds himself in the middle of red America and falls in love with a blue Porsche. Winning isn't important, he concludes. In *Inside Out*, Joy, like all the other protagonists, is out to banish the thing (in her case Sadness) she so desperately needs. *Soul* is the most literal of all: Joe literally falls down a manhole, forcing him, through 'death', to finally let go.

The protagonist of each of these films is a martinet. Each of them – Woody, Marlin, Lightning McQueen, Joy and Joe – are punished for their flaws, falling down a rabbit hole into a world the absolute opposite of their own. Big lessons are absorbed there about empathy, love and collaboration, and only when they've learned are

the protagonists allowed to return home. And that's the key thing. Each of them learns the same lesson – that they are not isolated individuals, but part of society that can only survive on empathy and trust. Woody cannot live without Buzz, Joy without Sadness, Marlin and Joe must let go of their obsessive control, Lightning McQueen must reimagine the very concept of what winning means. They are all very different as movies, but underneath they are all identical.

The fact that they all learn lessons isn't the only reason why the films are successful. That's down to an extraordinary combination of artistic and commercial bravery, storytelling talent and profound insight. But the fact that each protagonist learns a clear lesson, the fact that they heal a flaw, is, for our purposes, the most significant thing. Stories and their structure evolve not from something imposed by a book, but from something innate. Stories are built around a lesson.

We exist, we observe, we change. You exist, you read this, you change.* Three-act structure embodies the basic units of perception. A flawed character, tossed down a rabbit hole, emerges with the wisdom to heal their flaw. Woody, Lightning McQueen, Marlin, Joe and Joy, or their dark inversions Michael Corleone, Macbeth and Walter White, all emerge with lessons learned.[24] The Pixar characters embrace the light, the others are enveloped by darkness, but all of them are like Alice in Wonderland: they all fall into a world that embodies everything alien. There, they become a chrysalis, soaking up the energy around them before each emerges as the direct opposite of what they were before. All changed – all changed utterly. Beauty, or a *terrible* beauty, is born. This cannot *not* be three acts.

When I started as a young script editor in TV in the 1990s, any kind of analysis like this risked casting you as Satan. As I mentioned at the beginning, the idea that there was a shape or formula was anathema. Structure was worse: it was *American*. They made *Starsky and Hutch* – we made *art*. Even then it felt to me that people were protesting too much. It wasn't hard to see the same underlying

* This happens even if you don't agree. Indifference or anger are kinds of change, too.

shape, not just in contemporary dramas (*Edge of Darkness*, *Heimat* and *Das Boot* were three that dominated the landscape of the time) but in Jane Austen, Charles Dickens, and further back through Shakespeare and the York Mystery plays of the fourteenth century, speeding back through time to Terence, to *Beowulf*, to *The Epic of Gilgamesh* in the second millennium BC. A character is thrown into a strange new world where lessons are learned; that's not just *Alice in Wonderland*, it's *Gulliver's Travels*, it's England's first novel *Robinson Crusoe*, it's – as we shall see – the Christian foundation story too. A person has a problem, goes in search of a cure to that problem and learns lessons on the way. Just when all hope is lost, they reach inside themselves to overcome their antagonist, apply the lessons learned and save the world, to be rewarded, most often, with sexual union. Its shape or its shadow is everywhere.

We consume that shape in a thousand different ways, through a multiplicity of mediums – and, yes, there are exceptions and bastardizations, to which we will return – but the dominant form for the dissemination of fictional story is through film and television.

There are two things here. The first is that three-act structure is ubiquitous, even if it's divided up into seven acts (*Raiders of the Lost Ark*), two acts (the classic sitcom), or four or five (traditional terrestrial structure for hour-long shows).* The second thing is that arguments against it still circle. Partly they come from those like Alan Plater whose concern was that any reduction to a formula can only 'unweave the rainbow' – an argument both valid and held by many other great writers too.[25] But they also come from those who see any attempt at articulating a universal form as a kind of cultural imperialism and, at its most extreme, an expression of patriarchal hegemony.

This is of course a criticism that should be taken seriously, and it's explored in far more depth in Chapter 9, but that's not the only thing of interest in terms of story here. For the accuser, such a charge immediately confers great power. As the positive response to John

* Much of this, and where it comes from, I discussed in *Into the Woods*. I've tried to avoid recycling those arguments, except where they will provide foundations for what lies ahead.

Truby proved, to stand in opposition to any orthodoxy is empowering. It can be intoxicating to voice your hostility to a construct that dominates the world you work in, particularly if that construct is commercial. It transforms you into Ripley battling Aliens, Moses defying Pharaoh or Bob Dylan going electric, smiting the traditionalist forces of folk with his 'fucking loud' electric guitar.[26]

This is a facet of the power of story we perhaps pay less attention to – the way it makes *us* the hero, drugging us with a power so strong that we forget to check its veracity. It bestows on the teller the power of the priesthood if they are believed, and the cruelty of the inquisitor if they are righteous. And, ironically, it proves three-act structure true.

A hero only exists if they have an enemy, can only prove themselves if they engage their foe in battle, and there can only be a story if that foe is defeated, or if the hero is vanquished in return. Set up, confrontation, resolution. An individual has a belief, they engage an enemy to prove it, then stand triumphant or changed at the resolution. It's deeply seductive, both in fiction and in factual discourse. Those who condemn the idea of the three-act story are using their very enemy to do so. The enemy gives them dissonance, which, as we've seen, gives us story. We all want to think we're Bob Dylan, but often, as custodians of what we believe to be a sacred truth, we're the ones shouting 'Judas!' instead.

The Midpoint

To fully understand the true power, shape and purpose of three-act structure the best place to look is, fittingly, at the point narrative cinema is born.

The workers streaming from the factory gate, the train arriving at the station: flickering pictures in badly scarred black and white. These are iconic images, the foundation stones of cinema. It's 28 December 1895, the first public commercial screening of the Lumière brothers' first ten films.[27] The ability to capture real life and to replay it was a

far more monumental innovation than we give it credit for; it's an extraordinary moment in human evolution. Though it's now a well-worn trope, it is worth pausing to imagine what a breach in the way the world perceived itself this must have been. No wonder audiences shrieked and ran as a train came towards them.

Nothing in life up to that point could have prepared humans for the miracle of film, nor its exponential growth. Within ten years, the novelty of a working-class medicine show had morphed into serious art. Early film was one static camera, one take, soundless and less than a minute long. It was film – an incident or series of incidents – but not story – a chain of cause and effect. The true revolution was to come when, appropriately enough, a fairground huckster with an extraordinary imagination stuck his hands into this primordial soup and fashioned cinema's big bang.

Georges Méliès' *Voyage dans la Lune* (*A Trip to the Moon*) (1902) is extraordinary in almost every way. We have become accustomed to one of its images: the face of the moon in anguish at finding a rocket in its eye. This isn't surprising – it's a marvellous picture – but it doesn't really do justice to the whole movie. *A Trip to the Moon* is only sixteen minutes long but it contains everything film is, would and will be: an explosion of artistry, joy, imagination, craft, effect, design and beauty – and of course flawless structure. Everything that makes film perfect is distilled to its essence here. For the future, just add water and watch it expand and take over the world.

Its story is simple yet profound. A mad-looking scientist, Professor Barbenfouillis, persuades his colleagues that they have the technology and ability to make a voyage to the moon. Once he's won them over, the rocket is built, the astronauts prepare and they are launched in what looks like a giant bullet from a giant gun.

Splat! The bullet hits the unsuspecting anthropomorphized moon in the eye. The astronauts disembark in their top hats, but their ecstasy is short-lived. The locals, Selenites, are anything but friendly. They capture our plucky heroes and take them to their king. What will become of them? In a stroke of luck, they discover a quick prod with their umbrella tips can vanquish each moon creature in a puff

of smoke. Battle commences and the French make a dash for their bullet-shaped ship. Lift off! Back on earth, they fall into the ocean and all hope is lost, until they are rescued by more heroic Frenchmen and are finally honoured for their deeds.

It's fitting that the first-ever narrative fiction on film should employ a flawless three-act form. Everything a story requires is here. A great central character, an inciting incident (the decision to go), the journey (to the moon and back), the crisis (where all hope is lost) and a triumphant resolution to boot. Ignorant characters voyage to a foreign land where great truths are there discovered. Those truths are then brought back, using great fortitude, for our fellow man.

Apart from its very existence, two further things are significant, both of which we will expand on during the course of this book. The first is the absolutely symmetrical nature of the story, and the second is directly related. The story is bisected at the midpoint of the film where our intrepid astronauts actually land on the moon. As such, it lays down the narrative blueprint for this new medium.

The arrival of Billy Preston in *Get Back* and the lunar arrival here may not seem like they have much in common, but essential to any understanding of three-act structure is acknowledgement of the midpoint of a story. Everything changes – for The Beatles, for Professor Barbenfouillis – here.

The midpoint is, in fact, the whole point of the tale, embodying, as we shall see, the central lesson of any narrative. In *Toy Story*, Woody helps save Buzz from the claw; in *Finding Nemo*, Marlin meets the laid-back turtle Crush, who shows him the value of letting your kids play. Lightning McQueen falls in love with a blue Porsche, Joe reconnects with his body and Joy discovers the importance of Sadness. 'Discovery' is the key word here. A story is a shell, wrapped around a discovery the author wishes to pass on, as we shall see in later chapters. For now, though, how fitting that in the very first film, 'discovery' is a rocket landing on the lunar surface. All stories, not just fictional ones, are journeys outside of the self, whether into woods, water, desert or the love of another, thus all stories seek three acts. Fiction just empowers that process through anthropomorphization, giving

abstract arguments rocket fuel by putting them into human shape. All stories are a trip to the moon.

Martin Scorsese paid the ultimate tribute to Méliès' film by making its production a running theme in his own movie *Hugo*. Méliès fell on hard times in later life, and his posthumous reputation had dwindled further still. Perhaps because Méliès never presented himself as an artist, but rather a showman, a trickster, a puppeteer, a magician and a huckster, he unconsciously conspired in the idea that his work was at best a fun little carnival act and at worst an irrelevance. *Hugo* was a welcome corrective.

Our inability to understand the importance of joy when we write about narrative is both telling and significant. How else can we explain *Sight and Sound* magazine, in 2022, anointing Chantal Akerman's *Jeanne Dielman, 23 Quai du Commerce, 1080 Bruxelles*, as the world's greatest film, while Buster Keaton's *The General*, which did more to push the boundaries of cinema than almost any earlier work, languished at number ninety-five?[28] It was incredibly telling that Ackerman's (very good) 1975 film rose from almost nowhere to be named number one in 2022. Its late ascension can partly be laid at the door of its extremely challenging narrative; it had taken a long time for its impact to percolate. But almost completely ignored in the reappraisals that followed was critics' desire, in the wake of #MeToo, to show they admired female directors after all. This suggests only one of two things: either that critics were voting not for the film but what it stood for, or that they *were* sexist before. In other words, its triumph was part deserved and part a perfect illustration of preference falsification.

Publicly praising comedy doesn't confer on us the high status that comes with the admiration of 'difficulty'. One simply derives more kudos in critical circles for praising *Cléo from 5 to 7*, *Persona* or *Meshes in the Afternoon* than *City Lights*, *Wings* or *Safety Last!* This reveals something significant, and sad. Many of us seem loath to be seen as emotional, and thus struggle to understand that the true power of any story lies in its ability to stimulate not intellect, but feeling. *Jeanne Dielman* and *The General* were both made by radical, revolutionary artists at the top of their game, but only one of them was

hacking through a forest that had never been cleared and building the first great cathedral to joy, and that's not the film at number one.[29] Cinema simply cannot exist without triumphing first as a popular art. The arthouse films that grow in the shadows of those cathedrals may be celebrated for their idiosyncratic architecture, but most are built in cul-de-sacs. Too often our critical establishment sit like vicars in English country churches, enjoying their cucumber sandwiches while tutting at the orgiastic horrors of the Southern Baptists an ocean away. Great stories transport you, they corrupt you with sadness or laughter, they surmount reason, and for these very qualities they are often traduced, much as women are shamed as 'sluts' or 'whores' by the very men whose desire they provoke.[30] 'Three acts' used properly – that is, to trigger emotion – is transcendent. It has the power to change worlds.[31]

Dismissed as a cheapjack, Méliès' was, like Keaton, a true magician. He injected narrative structure into the bloodstream of film, and in that marriage of technology, hucksterism and inspiration, marinated in the sheer joy that pours from every frame ('Wow – look what we can do!'), modern cinema was born. That child itself birthed countless children of its own. If we make or consume TV or film then Méliès is both our Adam and Eve. Narrative wasn't new, but this – this *was*. Something as old as time found the perfect accelerant. The big bang. We all live in Méliès' three-act world.

Do we? Finally, we must ask how we relate a sixteen-minute film, over a century old, to the tsunami of serialized product available to us today.

To make something strange seem familiar and something familiar feel strange, to make something old appear new, to make us recast old knowledge by presenting it through a different lens, *and* to become part of the national conversation: at some level, these are the ambitions of any story, and they're as good a metric as any of a narrative's success. In that light, *It's a Sin*, Russell T. Davies's 2021 saga of the AIDS epidemic as it made its way through the gay community in the decade from 1981, does everything a great story is supposed to do. From Seoul to Edinburgh, from Wales to Monte

Carlo, from London to Venice, it won a tranche of best-TV-series awards. More than that, though, it made the British public (and beyond) look at a period they had almost forgotten and completely reassess it. Had we known so little, had we been so cruel? Have we forgotten so much?

It's a multiprotagonist drama of five sixty-minute episodes, and tells the story of a group of (mostly) gay friends as they try to make sense of the catastrophe that slowly engulfs them. It's social realism, it's historically sourced and it could not be further from *A Trip to the Moon*. How do the two possibly relate, and what can their relationship tell us about three-act structure?

EPISODE ONE
A group of eighteen-year-olds from all over the UK come together to share a flat in London. Reports of a new disease targeting gay men begin to circulate.

EPISODE TWO
Led by Ritchie, the central protagonist, the group go into denial, but slowly the virus gets closer to home.

EPISODE THREE
Colin, the virginal Welsh boy, collapses on the floor at work. In hospital he is told he has HIV and he is going to die.

EPISODE FOUR
Ritchie starts to suspect he has the disease, finally admitting it to his friends and taking a stance against the homophobic Section 28 laws advocated by the British Government.

EPISODE FIVE
Ten years after the series begins, HIV / AIDS is a global epidemic. Ritchie's friends gather round to help and comfort him as he comes to terms with the (then) fatal consequences of the disease.

It may not be immediately apparent, but *It's a Sin* and *A Trip to the Moon* share two key things in common. The first is that both are suffused with a sense of absolute joy. Easy to understand in a fantastical trip, but in *It's a Sin* it's counterintuitive. When Davies was initially developing the series with the BBC, he was asked to open it on an AIDS ward in the 1990s before flashing back to tell the events chronologically. Davies refused, calling the idea 'unbelievably crass'.[32] Key to the success of the story was that for the protagonists, faced with almost certain death, the joy of life became incredibly important. We will return to the power of optimism in drama later on. For now, though, let us turn to another aspect of *It's A Sin*, something with a much greater power, working its will unseen.

Channel 4 is a commercial terrestrial broadcaster, so its dramas are divided into five acts separated by four commercial breaks. Look at the third episode of *It's a Sin*, the heart of the series, and how the act structure works there. The spine of the episode is built around Colin's story. There are five acts:

ACT ONE
Colin collapses at work

ACT TWO
Colin is diagnosed with HIV / AIDS

ACT THREE
Colin realizes he is a prisoner – trapped in a guarded room, sat in shock on a commode

ACT FOUR
Colin realizes he's going to die

ACT FIVE
His friends deal with the aftershock as Colin dies

Something incredibly important is happening here. Take a closer look at the third act, bang in the middle of the episode. As Colin sits forlornly, a prisoner in his hospital gown, the programme intercuts

with his mother challenging both medical staff and the police as to why her son has been locked up.

POLICE SERGEANT

Your son is infectious, so we've

been granted a court order for

his detention under the Public Health

Act of 1984. No one is allowed in,

and he's certainly not allowed out.

MUM (Bewildered)

You mean he's under arrest?

POLICE SERGEANT

It's important to say that none

of this is our fault. Aids is

transmitted by sex with men.

If he chose to be part of that

cesspit well – who am I to judge?

But – my judgement is vital when his

disease becomes a public menace.

Because that's what he is now you see.

Your son is dangerous to others.

MUM

Well can I just ask what's to stop me

taking him out of here right now?

POLICE SERGEANT

The law, Mrs Morris-Jones – the law of

the land forbids you.

MUM

You mean he can't get out?

POLICE SERGEANT

That's right.

MUM

He's a prisoner?

It's a Sin by Russell T. Davies

And as her last line begins, we cut to the lonely desolate Colin in his NHS gown, locked in a cold, green-tiled, guarded room, perched on a commode. He's in profound shock – and so are the audience. 'Oh god,' we think, as we're confronted with this utter cruelty towards the character we most love. You want to define what HIV/AIDS was to the gay population in 1986? Well, this, the show is saying, is it. In one image – this is what it is, this is what it *feels* like, this is what it *means*.

It's the midpoint of Episode Three, but it is also, of course, the midpoint of the whole series. This takes on even greater significance when we look at the inciting incident and crisis points of the series as a whole.

The series' inciting incident (the problem the characters must

confront) is when our protagonists first become aware of the virus and an associate of the group is infected; the crisis (the worst possible consequences of the decision they took at the inciting incident) is when Ritchie knows he is going to die. The former is at the end of Episode 1, the latter at the end of Episode 4. So, Episode 3 is, in effect, a microcosm of the series structure as a whole. The show isn't just perfectly symmetrical, it echoes its own structure internally as well. This is what's known as fractal structure – each part is a smaller or larger magnification of the essential underlying shape. Scenes, acts and series are all enlargements of the process we described at the outset of this chapter: *existence, disassembly, reassembly,* the sense made of a disruption by finding its cure. *It's a Sin* is a perfect example of this fractal enlargement. It's intensely ordered. It's intricate, the product of an incredibly clever structural mind. Except . . .

Russell T. Davies is from the school of Salman Rushdie and abhors the study of structure. 'Wherever I looked,' he said, gazing down on the (numerous) gurus who lay beneath him,

> the writing of the script was being reduced to A, B, C, plots, text and subtext. Three Act Structure and blah, blah, blah. And I'd think, that's not what writing is! Writing's inside your head! It's thinking! It's every hour of the day, every day of your life, a constant storm of pictures and voices and sometimes, if you're very lucky, insight.[33]

This isn't to say that Russell is wrong – he's absolutely not. But if Russell writes perfect structure and didn't learn that structure from a book it leads to one inescapable conclusion. The argument for structure being instinctive must be true. Structure is *innate*. It's a product of the human brain as it kneads that complex and random clay, coaxing from it life.

This is not writing to a template, or it shouldn't be. Indeed, even if good writers try to follow a formula, they often find their characters rebel, refusing to do what they want them to do. So, if they have any sense, they follow them, and the unconscious kicks in. And then?

What's so fascinating about writers of Russell's calibre is that a new, clearer form emerges. Structure has happened *despite* you.

If you consider that *It's a Sin* started life as an eight-episode series and went through three broadcasters and numerous drafts on its way to the screen, then that instinct for shaping seems even more remarkable, and it alludes, in the hands of a great practitioner, to how magnificently complex – and beautiful – structure can be.

In both *A Trip to the Moon* and *It's a Sin* individuals are presented with a problem, set out on a journey to discover the truth to that problem, then return, against great odds, bringing news of that problem back to their world. The thing they discover is physical in the moon, more oblique in the true nature of HIV/AIDS, but the underlying shape, *the chassis*, is identical, just scaled to meet the demands of their respective mediums of film and TV.

One other thing: the symmetry we saw in the work of Flaherty and Vertov asserts itself clearly in both *It's a Sin* and *A Trip to the Moon*. Stories seek symmetry as chaos seeks order. Just like water, narrative seeks a level. It's no accident that one of the most successful children's books of all time, Julia Donaldson and Axel Scheffer's *The Gruffalo*, is a completely balanced tale. A mouse needs a nut, so he ventures into the forest, where he's threatened by a fox, an owl and a snake. He tricks them all by inventing a terrible creature, the Gruffalo, who will eat them if they attack him. Halfway through the story, in the heart of the forest, the mouse discovers a real, terrifying Gruffalo. Showing enormous bravery when the Gruffalo threatens to eat him, the mouse persuades the beast that *he* is the scariest animal in the woods. As the Gruffalo follows the mouse back home, they meet the three predators again. As the Gruffalo watches them flee in terror from the mouse, he doesn't realize that they are in fact afraid of *him*. Finally, the mouse threatens to eat the Gruffalo, the Gruffalo flees in terror and the mouse is finally alone, happy to eat his nut in peace.

A character has a problem (they are young, they are scared), they go on a journey to seek a resolution to that problem and deep in the heart of the wood they find the cure (the mouse learns bravery and cunning when he encounters the monster). In the second half

of the story the mouse learns to master that talent until he's finally able to shake the monster off once and for all. It's perfect structurally, in addition to which Julia Donaldson's use of rhyme manages to be economical, funny and propulsive all at the same time. And of course, it's perfectly designed for its audience. Every small child is a mouse, who to prosper must learn the tricks to survive in 'the deep, dark wood'. It's the same experience for the viewer watching *It's a Sin*. 'We're going to live!' shouts the central character exuberantly. Both stories are a trip to the moon.

John Truby declared that anyone writing in three-act structure had 'just killed any chance they had of writing a script that will sell'. 'What should replace three-act structure?' he asked, rightly challenging the status quo. His answer, 'the twenty-two stages of story structure', is laughable. No wonder Alan Plater wanted to punch Syd Field in the face. But Alan wasn't entirely right either.

I was fortunate enough to watch Alan teach in his later years. By then, long after most writers his age had retired (or been abandoned by the industry), he was still going strong, central to the success of one of Britain's biggest TV hits, *Midsomer Murders*. One day, asked by one of my students how he put an episode together, he replied, 'You always put the murder just before the first commercial break, and you always bang them up in the last act.' 'But Alan – that's structure,' I cautiously ventured as I walked him to the station (he didn't suffer fools gladly). He winked, before dashing off to catch his train.

So, what can we conclude of three-act structure and the opposition to it? Apart from anything else, John Truby's Facebook post is a virtuoso storytelling performance. His argument is profoundly seductive; he sucks you in, he takes you on a journey to believe in a new way of thinking. His authoritative, slightly mischievous tone makes him an effective protagonist, and his antagonists – the disciples of rote three-act orthodoxy – are crying out to be smashed on the altars of Syd Field's traditional church. Who wouldn't be against convention, against lazy thinking, against old-fashioned, reactive ways of doing things? His dismissal of the apostles of Field is beautifully done.

To denounce three acts, we may infer, is to denounce the Empire, and who wouldn't want to do that? The endlessly seductive appeal of the maverick – from cops (Columbo, Cracker or Morse) to super-heroes (Iron Man, Spiderman, Antman*) to literary heroes (Camus' *étranger*) – is used by Truby to excellent effect. The defenders of three acts are surly Stormtroopers, guarding the Death Star. Who would you rather be, Han Solo or Darth Vader? It's an argument rooted not in science, but in emotion, thus tapping into a far greater power. It's flattering you into hanging your sense of logic on the coat hook by the door. Truby doesn't say it, because he's not aware of it, but the real subtext of his piece is: 'Together we can bypass common sense.'

A story, by definition, is an ordering. Structure therefore is inherent to any story. The most ubiquitous and most commercial structure is the one that mimics the basic unit of human expression and of human thought. It may not be sought consciously, as Russell T. Davies so strikingly proves. It might be, as in the case of reality TV, a slavish adherence to a model. Either way, even in subverting it, it's always there. There is more to discover about three-act structure, but even if one is disavowing it, it is central to any perfect story, because the truth is it cannot *not* be there.

If that's true, then how can John Truby possibly get around it? He can't.

John Truby says three acts will kill your writing. He explains why. He offers an alternative.

John Truby writes in three acts.

* Indeed, almost every Marvel hero plus all the Guardians of the Galaxy.

2

The Meaning in the Middle

Five Acts, Ring Structure and Chiasmus

Right at the vanishing point of Raphael's *School of Athens* stand two figures, Plato and Aristotle. The former, on our left, is dressed in orange. Barefoot and pointing up to the heavens, he is old and grey; the latter, in sandals, wearing blue and signalling the earth around him, is full of youthful vigour. One represents the divine wisdom of the heavens, the other the value of rational, scientific thought. Opposites.

Pulling back from the oculus, two statues frame Plato and Aristotle. On the left Apollo, the god of light, and on the right Athene, the goddess of wisdom. A further retreat reveals more figures on either side, each symbolic of the different poles of Renaissance thinking. The great philosophers of antiquity have come together to explore the conflict between the scientific and religious ideals of the time, seeking wisdom and hoping to square that wisdom with divine belief.

Most significant, though less apparent, is the framing. A series of vertical and horizontal lines bisect the fresco – the verticals provided by the statues, the columns and the figures themselves, the horizontals by the steps on which the characters sit and the heads of the figures that traverse the top level of the painting.

It's a stage – given greater depth by the architecture it portrays. The building acts as a picture frame for the subject. It echoes the shape of a Greek cross, embodying the fusion of the pagan and Christian, and the design it carries, a meander, is an endlessly repeating motif.

It's deceptively ingenious, the way it focuses the eye of the viewer on its most important themes. Plato and Aristotle, opposites united

LESSONS FROM THE SCHOOL OF FICTION

in pursuit of one goal: *knowledge*. Framed by the blue sky behind them, they leap out, their functions echoed as we track out from the vanishing point to see the School of Athens in all its philosophical glory. My love of Raphael's work grew as I started to fully comprehend the picture as a hymn to balance and symmetry in subject and in craft. The world, it said to me, is made whole by the balance of contrasting figures who come together to find, if not God, then knowledge, and within knowledge *truth*.

In that union of vertical and horizontal planes Raphael creates one of the great masterpieces of the Renaissance; one that's a perfect illustration of the power of composition. The arrangement of subject on the page, the way the eye is drawn to different details to illustrate key themes, to make you feel emotion, to serve repeated viewing and to create an underlying unity in which form and content fuse to create the greater whole.[1] This is the job of structure.

Nowhere does this become clearer than when we pull back from the vanishing point ourselves and look at narrative structure not in three acts, but in five. A tool good enough for Shakespeare is worth taking seriously, and five acts discloses far more detail about the inner workings of narrative than a simple three-act paradigm can provide. It unlocks the extraordinary role of symmetry and the profound meaning that lies deep in the woods, at the dark heart of every story.

Five Acts

> Our baby boy got sick.
> We went to a lot of doctors, trying to find
> out what was wrong with him.
> We found out what it was.
> It was very, very bad.
> It got worse.
> And then he died.
> And now he's dead.[2]

38

At the end of his autobiographical story *A Heart That Works*, Rob Delaney sums up the tale he's told. The bleak, haiku-like lines convey his numbness and provoke our horror at the same time. The whole story of the terrible loss of his four-year-old boy is crystallized in seven lines. Seven lines of perfect structure.

But what is that structure? The best way to understand it is to look at it through the prism of the structure utilized by Shakespeare – the master of the five-act form.

Five-act structure is a refinement of three-act structure. To be strictly accurate, in fact, it's the other way round – five-act structure was the way the world first consumed its stories when it left the oral tradition behind and moved towards a formal shape. 'Let no play,' said Horace in 8 BC, 'be either shorter or longer than five acts, if when once seen it hopes to be called for and brought back to the stage.'[3]

You're a producer. You know your audience has a limited attention span, and you know (if you're running Shakespeare's Globe) that they're standing up and that they're drinking – a lot. You want the audience to watch the work they've paid to see, and you wish to maximize your income from alcohol sales. What's the best way to keep their attention and make money? By structuring the play in a way that makes both possible, building in act breaks so they may refresh and replenish (and empty their bladders) accordingly. Over time these breaks become standardized. Then, an amazing breakthrough, you realize you can create illumination indoors. Act breaks become even more fixed, as each act comes to last the length of the burning candles suspended in chandeliers from above. It's a revolution in the way drama is consumed, created by a technological advance, not dissimilar in effect to the invention of radio, then of television, and latterly of the internet and the introduction of catch-up TV and streaming.

It was the American academic Thomas Baldwin who first noted the extraordinary structural similarity between the works of the Roman playwright Terence, writing around 166 BC, and Shakespeare, despite the 2,000 years that separated them. What is that shape?

ACT ONE

Set up and call to action – *Introduce protagonist and present them with problem*

ACT TWO

Things go well, and initial objectives are achieved – *Pursue course of action that, through adversity, leads protagonist to interim conclusion*

ACT THREE

Things start to go wrong as forces of antagonism gather strength – *Protagonist discovers truth they've been sent to confront*

ACT FOUR

Things go really badly wrong, precipitating crisis – *Nature of that truth becomes overwhelming. Can protagonist possibly accept it?*

ACT FIVE

Crisis and climax: final battle with antagonist; matters resolve for good or ill – *Protagonist accepts that truth.*[4]

You see this in *Macbeth*:

1. Witches' prophecy and decision to murder Duncan
2. Macbeth becomes king
3. Macbeth kills Banquo, Fleance escapes, Macduff defects
4. Lady Macbeth goes mad, Macbeth abandoned; England attacks
5. Final battle; Macbeth killed.

And you see exactly the same pattern in *The Godfather* too:

1. The law-abiding soldier learns his father has been shot
2. Saves his father in hospital, learns he's not scared
3. Kills Sollozzo and McCluskey
4. Gangs plot to kill him; father dies
5. Kills everyone.

Breaking Bad expands the concept fractally from five acts to five seasons, each season a direct parallel to the equivalent act of *Macbeth*.[5] These three stories are not just the same content-wise; their structures, explicitly or fractally (fractals are just magnifications), are identical too.

The longer the duration, the more act breaks there tend to be. Technically, three-act and five-act structure are identical; the latter is just an expansion of the former, with two more pit props inserted to stabilize the expanded work. That expansion, however, is enormously helpful in making the underlying workings of story visible.

Look again at the paradigm above. How does it apply to Rob Delaney's poem?

Our baby boy got sick.
Introduce protagonist and present them with problem.

We went to a lot of doctors, trying to find
out what was wrong with him.
*Pursue course of action that, through adversity,
leads protagonist to interim conclusion.*

We found out what it was.
It was very, very bad.
Protagonist discovers truth they've been sent to confront.

It got worse.
And then he died.
*Nature of that truth becomes overwhelming.
Can protagonist possibly accept it?*

And now he's dead.
Protagonist accepts that truth.

Three stages surround 'It was very, very bad' on either side. Why? Because the story is the journey to discover that key knowledge,

and then explore its consequences. The middle is where everything changes – it's the midpoint of the story.

Midpoints Revisited

Moonlight, Barry Jenkins' 2016 film, is divided into three different sections with the same protagonist featured as a child, a teenager and a man. The story of Little, who becomes Chiron before transforming into Black, revolves around how the protagonist attempts to deny, and later embraces, his sexuality. Gay in a world he feels won't accept him, can he come to terms with the feelings that have been tearing him apart inside, and in doing so find love?

The film is presented in three eponymous acts.* In 'Little' he's unaware of who and what he is; at the film's end, 'Black', he accepts the love of his old friend Kevin. The midpoint of the film – in the heart of the 'Chiron' section – occurs on a beach at night, where he kisses Kevin, who then masturbates him in return.[6] It's a clear illustration of how structure works – the protagonist is driven towards a truth they discover halfway through the story. Unwilling to accept that truth, they spend the second half of the story either testing or denying it, before being given a choice at the crisis point: will they accept the lesson and change?

The same pattern works fractally. In Michaela Coel's groundbreaking *I May Destroy You* (a series of twelve thirty-minute episodes), frustrated author Arabella is propelled by the series-inciting incident at the end of Episode I: *who raped her and how will she take revenge?* At the crisis point (the end of Episode II) she discovers the culprit and then, in the final episode, she imagines the multiple forms her revenge might take. Finally, however, she resolves to move on, using her anger to instead finish the book she abandoned at the beginning of the tale. The remarkably sophisticated midpoint is a full-episode flashback to her schooldays. How does this connect to the end? It's a

* For more on the structure of *Moonlight*, see Appendix I. The film offers a good illustration of how three- and five-act structures overlap.

tangle of stories about schoolyard betrayal and manipulation. Every character is revealed to be far more complex and manipulative about objective and subjective realities than they first seem. It's thus an enormously ambitious thematic midpoint. Like all midpoints, the lesson Arabella learns at the end of the story is a direct echo of the one at the centre – in this case the realization that reality is more complex than it first appears. Revenge, Arabella concludes, may be a Clint Eastwood fantasy rather than a genuine cure.[7]

In every archetypal story, then, a character is sent on a journey to learn a lesson that will finally either 'heal' them, in the heroic version (*Moonlight*), or 'complete' them in the tragic one (*Macbeth* or *Breaking Bad*). They will discover that lesson halfway through, though may not be aware of its implication. The second half is about how they learn to make sense of and master the knowledge they've been given.[8] It's there in fiction, as in *Citizen Kane*, where at height of his power Kane's affair is discovered, just as it is in documentaries like *Fyre*, where everyone turns up halfway through to discover they're not in the paradise they were promised, but at a really shit party.

Though their form may be different, these rules are true of all narrative – even short-form prose. In October 2019 Coleen Rooney, the wife of one of England's most famous footballers, posted a short missive on Instagram that was to monopolize British tabloid conversation for the next three years. Here's what she wrote:

> For a few years now someone who I trusted to follow me on my personal Instagram account has been consistently informing The SUN newspaper of my private posts and stories.
>
> There has been so much information given to them about me, my friends and my family – all without my permission or knowledge.
>
> After a long time of trying to figure out who it could be, for various reasons, I had a suspicion.
>
> To try and prove this, I came up with an idea. I blocked everyone from viewing my Instagram stories except ONE account. (Those

on my private account must have been wondering why I haven't had stories on there for a while.)

Over the last five months I have posted a series of false stories to see if they made their way into the Sun newspaper. And you know what, they did! The story about gender selection in Mexico, the story about returning to TV and then the latest story about the basement flooding in my house.

It's been tough keeping it to myself and not making any comment at all, especially when the stories have been leaked, however I had to. Now I know for certain which account / individual it's come from.

I have saved and screenshotted all the original stories which clearly show just one person has viewed them. It's Rebekah Vardy's account.[9]

It's a small masterpiece of narrative structure. The first two paragraphs provide the exposition and introduce the protagonist (by inference). In the third paragraph the hero engages in pursuit of a cure to their problem; their world has been invaded by chaos, so now they embark on a course of action, seeking for order to be restored. The fourth paragraph is the midpoint – 'I blocked everyone from viewing my Instagram stories except ONE account' – the truth of what Coleen Rooney did to solve her problem. It's the point at which everything changes, and there's no going back. The second half explores the growing consequences of the midpoint decision, escalating jeopardy and danger ('It's been tough . . .'), building to the crisis at the end of the penultimate paragraph – will this plan actually work? What follows, of course, is the climax. Just in the nick of time, with the naming of the culprit in the last line, order is restored.

The structure is classic, but the technique is flawless too. We enter in the middle of an action that creates massive empathy for the narrator: she's the innocent victim of a selfish attack. She sets up a clear, concise dramatic question (*Who is doing this?*) and then embarks on a quest each reader is rooting for. She could have put the main clue as to who the culprit is at the midpoint of the story. That

would have worked, but it's just as effective for Rooney to make it the setting of the trap. Empowerment is the lesson she has learned, now she must watch the consequences of this lesson play out. Then she adds stakes and jeopardy to create greater emotional engagement. The crisis point, where we are poised to see if all is lost or won, is 'I had to' with its note of cost and possible regret; and then, of course, she leads us into the final act. Protagonist confronts antagonist in an epic battle for the character's soul. Empowerment, the opposite state of her initial victimhood, is triumphant. Order is restored. In addition, the whole thing is built around the deferral of gratification – always the main driver of audience engagement – until the end. *Mad Max* director George Miller described storytelling as 'the well-orchestrated withholding of information'.[10] There are few better examples than here.

Gustav Freytag, a professor of German language and literature and a novelist and playwright in his day, outlined the five stages of Shakespearean structure (commonly known as Freytag's Pyramid) in his book *Die Technik des Dramas* in 1863.[11] Those five stages – exposition, rising action, climax, falling action, and denouement – are exactly what we see here.[12] Coleen Rooney may not have any structural training; she just instinctively understood the intrinsic shape of narrative, to which she married a savvy knowledge of language, mischief and social media. The post EXPLODED. The shape of Shakespeare, of *Moonlight*, of *Breaking Bad*, of both book and epitaph written by Rob Delaney – all are channelled by Coleen Rooney here.

Delaney's epitaph in *A Heart That Works* is heartbreakingly potent, and its power is enhanced by its organization. That's what structure does: it amplifies, it expands, it heightens, it boosts; it's the chassis on which all successful narrative is built. You can have the best wheels, gear box and carburettor, but without the frame that holds them together they are nothing. A good chassis maximizes the performance of the elements it underpins. Structure unites, and good structure *empowers*. A nuclear bomb is nothing if it cannot reach its target. If content is a weapon, then structure is its delivery system.

The magnification five acts provide thus reveals more clearly the

essential shape of archetypal narrative: the journey to the centre of a subject, and the return. There is more going on here, however. If we are searching for what gives the greatest stories their power, then five acts has far more to reveal.

Ring Structure and Chiasmus

'The Signora had no business to do it,' said Miss Bartlett, 'no business at all. She promised us south rooms with a view close together, instead of which here are north rooms, looking into a courtyard, and a long way apart. Oh, Lucy!'[13]

Eighteen-year-old Lucy Honeychurch has yet to understand the symbolism that runs through E. M. Forster's 1908 novel, of which she is the protagonist. Three hundred and twenty-one pages later, as she gazes out at the River Arno with the man she loves, she – and we – get it all too clearly: to find fulfilment we must live and experience life outside our own narrow circles. At the beginning of the story, Lucy is trapped with her spinster chaperone in a windowless *pensione*. Here, now, the opposite. Everyone, it transpires, needs a room with a view.

The simple bookends of Forster's novel enclose an elaborate symbolic world – a world of gazing, looking, regarding, seeing and not seeing, and learning to acknowledge that which we *cannot* see. It's an extraordinarily rich novel, one in which every word seems to work as both symbol and signifier, and that's often seen as its governing principle. But beneath this, alluded to by the bookends in Florence, there's another structural force at work.

The bookends are a clue: opposites litter the novel. The world of Florence is licentious, dangerous, reeking of passion and sex, while Surrey, London's soon-to-be Metroland, is where repression and propriety hold sway. In the former she meets George – handsome, sexual and free of the restraints she will later rush to embrace when, in fear, she hastily agrees to marry the deeply repressed Cecil on her return to suburbia.

These opposing forces aren't just evident in character and setting, but in the very design of the novel. They gain even more focus in the 1985 film adaptation. Two scenes directly mirror each other on either side of the movie's midpoint.[14]

The later one takes place outside Lucy's Surrey home. Cecil (who keeps checking to make sure he cannot be observed*) asks Lucy if he may kiss her. She agrees. The book describes this moment as follows: 'As he approached her he found time to wish that he could recoil. As he touched her, his gold pince-nez became dislodged and was flattened between them.'

Neither of them acknowledges that this simple incident is catastrophic – the moment Lucy realizes that the relationship is doomed. The earlier scene, preceding the midpoint, is its opposite. There, in a sun-dappled field on the outskirts of Florence, George – impulsively, passionately, wildly – kisses Lucy, the romantic charge of which changes both their lives for ever.

If you could place a mirror in the centre of the movie, you would notice the two scenes are absolute inversions. One is of unbridled passion, one of damp flaccidity; one is in a wild sea of violets, the other by a muddy puddle. In the former, George sees Lucy and 'the flowers beat against her dress in blue waves'. In the latter, Cecil sees her as 'some brilliant flower that has no leaves of its own'.[15]

In his commentary on Forster's novels, *The Italian Romances*, George H. Thomson points out that Forster continually juxtaposed 'related and contrasting episodes and blocks of material', directly employing an idea as old as the Bible. The bookends of the novel are a clue, but the two kissing scenes in particular point the way to a more intriguing kind of structural design.

Tony Jordan was a market trader from Southport who watched a lot of television. At the beginning of the 1990s, in a collision of bravura and naïvety, he wrote to the BBC, convinced them he was a genuine cockney and in short order found himself working on

* An example of how at every level the book and film utilize the themes of seeing and not being seen.

EastEnders – then one of the biggest shows on British television. He didn't know anything about narrative structure, and he didn't have any understanding of the 'rules' of writing; he just had boundless self-confidence, a love of language and, equally importantly, a deep passion for working-class London – the subject of the show.

EastEnders had a classic format – five stories told over half an hour, normally with an 'A' story forming the spine of the work. Writers were given an outline document of the five stories, each broken down separately – the rest was up to them. Tony didn't know what to do, so he stared at the document for a while before an idea struck him – he would draw a square-shaped grid.[16]

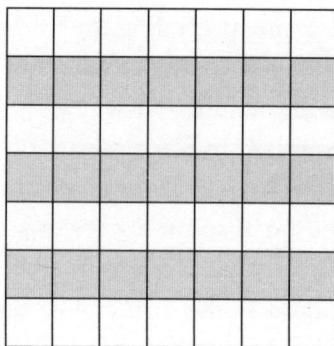

He then looked at the 'A' story he'd been given, noting that the show required the episode to end with the cliffhanger of that story. So, he marked that on the grid first:

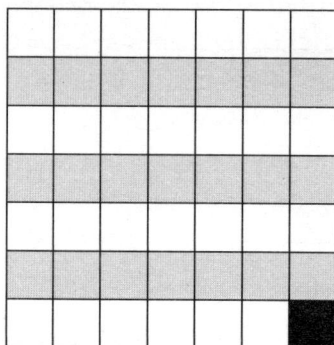

And then, reasoning that the episode should probably begin with the same story, he resolved to begin that story in the opposite corner.

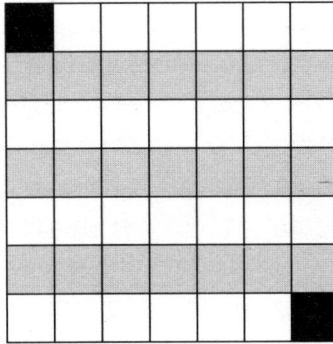

He knew the programme liked to set up the other stories fairly quickly, so he then did the same with the B story:

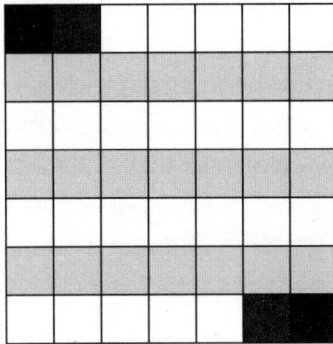

And the C story . . .

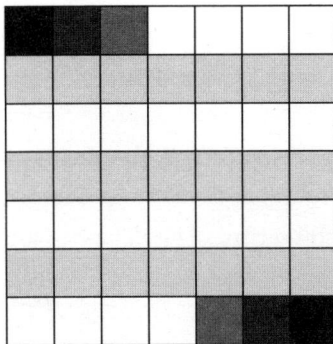

And before he knew it he'd worked his way through the grid, ending bang in the middle of the episode, where, he reasoned, as this was a pivot point, something big should probably occur:

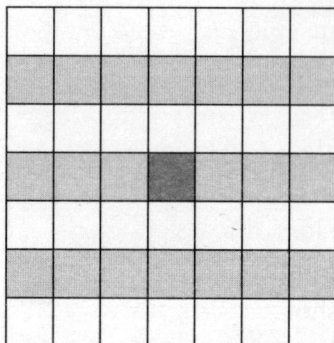

Tony quickly became the most successful writer in *EastEnders'* early history, without ever reading a textbook on writing (there weren't that many then) or attending a screenwriting lecture (there were even fewer of those). His success came partly from his obvious love and passion for the world he was eulogizing, but equally important was his instinctive understanding of how to put a story together. Approaching it with the simplicity of a child, he saw clearly what a more intellectual approach might have missed.* Within half an hour he'd figured out just how archetypal story displayed itself to the world.

What Tony had discovered was an essential prerequisite of the perfect story: what we might call deep symmetry, but more commonly goes by the name of *chiasmus*.

Chiasmus

Tony Jordan's attempt to imprison *EastEnders* within a grid was no different in essence to Raphael's decision to frame his *School of Athens* within his chosen architecture. The desire to trap reality and reduce

* This may sound like an insult, but it's really the absolute opposite.

it to a lattice of perfect order – the impulse to tame chaos, to remove its threat – is both part of human nature and essential (even in its disruption) to the creation of art. There is no greater manifestation of this process than chiasmus.

King Vidor's silent epic *The Crowd* (1928) opens with a (then fantastically original) push-in through a soulless building's window to a Kafkaesque workspace. A million office drones surround our hero, the lonely, isolated John Sims. Ninety-eight minutes later the camera starts tight on John, having survived all that life can throw at him, including the loss of a daughter and attempted suicide. But now he laughs uproariously – and as the camera pulls back, we find him at a vaudeville show accompanied by his wife Mary, and surrounded by what seems like a million happy, smiling people. It's one of the very first filmic examples of a classic bookend – opening and closing images that, in echoing each other, are designed to encapsulate the huge nature of a protagonist's change. Look closely at the film, however, and you notice it's not just the opening and closing scenes that have such a unique relationship, but every other scene too.

We see the same design principle in *A Room with a View*, and over a century later it's there in Todd Phillips's *Joker* too.[17] Look where a bedraggled Arthur Fleck (Joaquin Phoenix) trudges his way laboriously up the iconic stairs in Gotham City, and then, once he's discovered his new persona as the Joker, how he dances back down them again. Indeed, look at the placing of ALL the stair sequences in the film. As he ascends and descends these symbols of heaven and hell, note how symmetrically they are placed – internal bookends, mirror images: chiasmus.

In *Into the Woods*, I looked at how the beginnings and ends of films tend to mirror each other – the tripartite form of first and last acts displaying an uncanny relationship. We listed a number of examples – *ET*, *Strictly Ballroom* and, here, *The Godfather*:

BEGINNING

Wedding – Michael is honest with Kay:
'That's my family, Kay. That's not me.'
Celebration of life
Father is shot.

ENDING

Traitor is revealed
Orgy of death
Funeral – Michael lies to Kay: 'Is it true? Is it?' she asks.* 'No.'

To which we might now add *Thelma & Louise*:

BEGINNING

Submissive to patriarchy and societal norms
They are subjugated and terrorized by a man
They flee scene of crime.

ENDING

Police locate their whereabouts
They subjugate and terrorize a man
Rejection of patriarchy and societal norms.

And, indeed, *Jaws*:

BEGINNING

Shark kills human
Denial of shark's existence
Quint appears to be rejected.

* She is asking him if he was responsible for the death of Carlo, the husband of his sister Connie, and possibly others too.

ENDING
Quint is in charge
Full knowledge of shark's existence
Human kills shark.

The relationship between beginning and end doesn't just end here, however. The mirroring goes much further – it exists at every point of the story. This is much more than a stylistic trick: it gets to the very heart of how humans order information to create narrative. Before we fully understand that, however, we first need to define what chiasmus is.

'Ask not what your country can do for you,' said President Kennedy. 'Ask what you can do for your country.' That's chiasmus, a rhetorical device used more prosaically by Ronald Reagan: 'Government does not get the money it needs; government always finds a need for the money it gets.'

It's a phrase with a turn in the middle, making the second half an echo or mirror image of the first. Remember, of course, that a mirror image isn't identical; it's a reversal of the original shape. At its simplest you can see the pattern here:

A: I was huge.
B: I'd eaten too much food.
C: Something had to change.
B: I ate less food.
A: Now I'm tiny.

The word chiasmus comes from the Greek χιάζω, which literally means 'to shape as the letter "X".'[18]

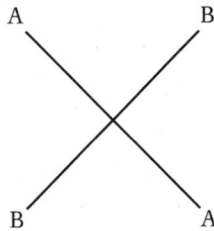

In dramatic terms its power comes from *inversion*. 'Look at that thing you think you know,' the structure seems to say, 'now see how much it has changed.' *Jojo Rabbit* is a film built very consciously around chiastic images – the shoes Jojo's mum wears for dancing in the first half of the story later identify her when she's found hanging from the scaffold in the town square. It is balance and change, and it's far more deeply ingrained in the narratives we consume than perhaps we are aware.[19]

Terminator 2 begins and ends with a voice-over from its heroine, Sarah Connor, the first ominous, the last hopeful. This is far from the film's only parallel. The two great action sequences – one with fire, one with ice (in the form of liquid nitrogen) directly parallel each other, as do breaking out of a mental institution and breaking into the Cyberdyne HQ. In the first half of the film, Sarah shouts at John for coming to save her and he cries, an action mirrored when Sarah later tells him she loves him and breaks down in his arms. The Terminator stitches up Sarah's shoulder wound in the first half of the movie; fold the film over on itself, and she's shooting Miles in the shoulder at the exact mirror position in the second half. In fact, the whole film has a chiastic structure.*

This does not seem accidental, because it not only applies to *A Room with a View* and *The Crowd*, but to Cameron's earlier film *Aliens*.[20] It's true of Julia Donaldson's *The Gruffalo* too. It's far more common than we give it credit for – you'll find it in works as diverse as *Robocop* and Orson Welles' damaged masterpiece *The Magnificent Ambersons*. Indeed, in the latter even Bernard Herrmann's score is built around a chiastic sequence.

Certainly, in *Terminator 2* some of the opposites can feel a bit strained, but at the same time the parallels are too acute and come too often to simply be the product of coincidence. Compared to two of the most successful stories of all time, however, this is nothing. It's only when you pull the camera back as far as it can go that you get a true sense of how all-encompassing chiastic structure is.[21]

* See Appendix II for more detail on the film's chiasmus and how this interacts with the Roadmap of Change.

ACT ⬇ ONE	END
A Sarah Connor tells us the future is bleak.	Sarah tells us there is hope.
B Two Terminators hunt John. He has no idea of the danger he is in.	John hides from the T-100 – fully aware of the danger around him.
C The Terminator rescues John *'My mission is to protect you'*	The Terminator trusts them to keep safe without him, *'Stay here. I'll be back'*
ACT ⬇ TWO	ACT ⬆ FIVE
D The T-1000 kills John's foster parents in hunt for John.	Miles kills himself to save the others from T-1000
E John tells Terminator he (Terminator) must not kill anyone.	John reminds Terminator of his promise not to kill.
F The new family break out of mental institution.	The new family – and Miles – break into Cyberdyne.
ACT ⬇ THREE	ACT ⬆ FOUR
G John cries. Mother refuses to comfort him.	Sarah cries. John comfort her.
H Terminator reveals he has the capacity to learn.	Terminator logically points out it would be best to kill Miles. John replies, *'Haven't you learned anything yet?'*
I Sarah raids the armoury to defend her son – and mankind.	Sarah dies – unable to help anyone in her dream.
MIDPOINT ⬇	⬆ MIDPOINT
The Terminator and John bond like a father and son.	

Series Chiasmus[22]

Star Wars was originally released as a planned trilogy before it was later announced that the original three films formed the second half of a larger story.

In chronological order, the six films tell the tale of how young Anakin Skywalker turns to the dark side and becomes Darth Vader, before finding some kind of redemption. The first three films

(*Episodes IV–VI*) tell the story of Luke Skywalker becoming a Jedi knight by defeating Vader:

*A New Hope**
The Empire Strikes Back
The Return of the Jedi

The prequels (*Episodes I–III*) were shot twenty years later but tell us Darth Vader's origin myth – how Anakin, Luke's father, became his nemesis.

The Phantom Menace
Attack of the Clones
Revenge of the Sith

If story structure is indeed fractal, and there is anything to our theory of symmetry, then it ought to be on display here. Is it? The entire six-film *Star Wars* cycle is built around a chiasm.

A: *The Phantom Menace*
B: *Attack of the Clones*
C: *Revenge of the Sith*
C: *A New Hope*
B: *The Empire Strikes Back*
A: *The Return of the Jedi*

As soon as you start to examine the structure, the parallels become apparent.

Firstly, compare the story of Anakin and the story of Luke, whose tales collectively frame the series. Both are boys from broken families who find themselves on a quest. With the guidance of a mentor, they discover unique and special powers that, at the end of each story, allow them to save their friends by destroying their enemies, actions which grant both of them some kind of spiritual ascension.

Both stories are classic hero's journeys – embodiments of Joseph

* The Original *Star Wars* film, subsequently subtitled *Episode IV*.

Campbell's pattern of mythological quest. In each a hero, faced with a flaw or disturbance, goes on a journey, slays a 'monster' and restores 'boons' to their tribe.* It's the pattern underpinning *A New Hope*, and it's repeated in the other two films of the original trilogy. In addition, you can see a larger (fractal) version of the same pattern in Luke's journey across the three films. Once you add the prequels to the sequence, it's possible to detect the same shape across all six episodes of the saga too. The hero's journey doesn't just frame one film, not just each individual movie, but the whole saga – delivering a perfectly fractal pattern.

There is a fascinating design sensibility at work here. Take the beginning and end sequences in each film:[23]

FILM	BEGINNING	END
A *The Phantom Menace*	Two Jedi embark on a mission to rescue Queen Padmé Amidala from Theed Palace	The primitive Gungans join forces with the Naboo to defeat the evil trade federation
B *Attack of the Clones*	Anakin entraps a stranger using Padmé as a lure. A bounty hunter escapes	The Republic discovers the secret location of the Separatist base
C *Revenge of the Sith*	A battle rages between Republican and Separatist forces	A life-changing encounter takes place between Obi-wan and Luke Skywalker
C *A New Hope*	A lifechanging encounter takes place between Obi-Wan and Luke Skywalker	A space battle rages between the empire and rebel forces
B *The Empire Strikes Back*	The Empire discovers the secret location of the rebel base	Darth Vader entraps his friends as lures. A bounty hunter escapes
A *Return of the Jedi*	Two droids embark on a mission to rescue Han Solo from Jabba the Hutt's palace	The primitive Ewoks join forces with the rebels to defeat the evil Galactic Empire

* For a full description, see *Into the Woods*.

Films B and C are inverse mirrors of each other – there's a direct chiasmus.* What about films A, *The Phantom Menace* and *Return of the Jedi*? We would expect them to be perfect mirrors too, but instead something more intriguing happens. They're not mirrors, they are duplicates.

It's a technique known as *inclusio* (or 'inclusion'), and is effectively a way of 'fencing off' or bookending a particular work or section, thus delivering a very clear sense of beginning and end. You see the same thing in the Book of Genesis – the birth of life bookended by the creation of man and the creation of woman. As Darth Vader himself would put it, with *inclusio*, 'The circle is now complete.'[24]

When the saga was first released on DVD, Lucas spoke of this structural design, comparing it to the refrain in a piece of music. He went on to say that it's central to the shape of *Star Wars*, and something he's been mindful of since his first professional film, *THX-1138*:

> Instead of three acts, there was almost like three different movies, but each movie is telling the same story in a different way . . . It's kind of visual jazz. You go off on a riff on the same idea. You just take a concept and just interpret it differently visually. And there's a lot of that going on in these movies. I like the idea of cyclical motifs that keep occurring over and over and over again.

There is a name for this particular kind of chiasmus – an even more complex way of assembling a story. It's called ring structure.

Ring Structure

In the dark corners of the internet there lurks a small subsection of *Harry Potter* fans obsessed with one simple idea – that J. K. Rowling has fused her arcane knowledge of Greek and Roman literature with her deep, if understated, religious beliefs to resurrect an ancient form of narrative structure. It's one found not just across the ancient

* I have simplified this for ease of comprehension. If you look at the midpoints (see Notes), the pattern is even more uncanny.

literature of Egypt, Russia and China, but also in the structural foundations of The Book of Mormon, the Bible and the Qur'an.[25] It's an observation championed by one man, John Granger, based on the writings of one woman, Professor Mary Douglas, Honorary Research Fellow at University College London.[26] The conclusions Granger reaches carry the musky scent of these dark corners – they are obsessive, vaguely monomaniacal and carry a heavy hint of confirmation bias. They are theories built on fundamental misunderstanding, but they contain something that may shed important light on the nature and meaning of narrative structure.

Ring structure is always spoken of as a separate, mysterious discipline, hard for 'Western minds' to master. So just what is it? And how does it work?

In her book *Thinking in Circles: An Essay on Ring Composition*, Douglas outlines the basic principles: 'It is a construction of parallelisms that must open a theme, develop it and then round it off by bringing the conclusion back to the beginning.'[27] In essence, it's a series of concentric rings or parallels, which echo each other in terms of subject, action and/or imagery, moving inexorably towards the key meaning located at the centre. Imagine the cross-section of a tree – it's that.

The first book of the Old Testament, Genesis, written between the sixth and third centuries BC, contains the story of Noah, which provides a good illustration. Old Testament scholar Gordon Wenham first articulated the underlying structure of the flood narrative:[28]

A: Noah and his sons (Gen. 6:10)
 B: All life on earth (6:13:a)
 C: Curse on earth (6:13:b)
 D: Flood announced (6:7)
 E: Ark (6:14–16)
 F: All living creatures (6:17–20)
 G: Food (6:21)
 H: Animals in man's hands (7:2–3)
 I: Entering the Ark (7:13–16)
 J: Waters increase (7:17–20)

X: **God remembers Noah (8:1)**
J´: Waters decrease (8:13–14)
I´: Exiting the Ark (8:15–19)
H´: Animals (9:2,3)
G´: Food (9:3,4)
F´: All living creatures (9:10:a)
E´: Ark (9:10:b)
D´: No flood in future (9:11)
C´: Blessing on earth (9:12–17)
B´: All life on earth (9:16)
A´: Noah and his sons (9:18,19:a)

And it's not just the events that are ringed – it's the time scheme too.

α: Seven days waiting for flood (7:4)
β: Second mention of seven days waiting for flood (7:10)
γ: Forty days (7:17)
δ: 150 days (7:24)
χ: **God remembers Noah (8:1)**
δ´: One hundred and fifty days (8:3)
γ´: Forty days (8:6)
β´: Seven days waiting for dove (8:10)
α´: Second seven days waiting for dove (8:12)

Perhaps it's no surprise that religious texts feature ring structure so heavily. It does two things extremely well – it creates incredibly memorable turns of phrase, and it emphasizes clearly and simultaneously both order and change. It's easy to see too why that might be attractive in an oral medium. It makes any text easy to memorize for the speaker (a key discipline of traditional rhetoric was delivery without written prompts) and, perhaps more importantly, easy for the audience to remember too: 'Mankind must put an end to war,' said President Kennedy, 'or war will put an end to mankind.'[29]

To back up her case Professor Douglas uses not just key religious texts, but also classics from world literature, showing how ring structure forms the bedrock of the *Iliad*, the *Aeneid*, and much of Zoroastrian literature. She doesn't stop there. *Tristram Shandy* is Laurence Sterne's ingenious and hilarious riff on the impossibility of correctly capturing a life in prose. The narrator's inability to get his own story onto the page, as he's battered by endless facts and digressions, is both subject and form – he simply cannot catch up. It's a novel famous primarily for its perceived *lack* of structure, but Douglas proves it's actually built upon a perfect ring.* In addition, like *Star Wars*, it begins and ends with an inclusio – in her words 'a containing envelope for the whole book'.[30]

Douglas's primary argument is that we have misinterpreted or dismissed many ancient texts by failing to acknowledge their unique style of composition. To read a ring composition in the modern linear fashion, she contends, is to misunderstand it. These works are different – their meaning lies not in understanding the journey towards a goal, but in the way the parallels relate to each other. They must be read in a circular, not a linear, fashion. Only then is true comprehension possible. 'Writings that used to baffle and dismay unprepared readers,' she says, 'when read correctly, turn out to be marvellously controlled and complex compositions.'[31]

We struggle, she believes, to do this. 'Ring Structure,' she argues, 'is extremely difficult for Westerners to recognize.' This belief is seconded by her disciples, the experts in *Star Wars* and *Harry Potter*, who argue that it's somehow a different, magical form. However, as you may have already noticed, this is a failure of critical thinking. Ring structure is, in essence, chiasmus. It shares exactly the same shape. Indeed, chiasmus is not just a technique or style: it is the ultimate refinement of a narrative ideal.

<p style="text-align:center">★</p>

* More on the structure of *Tristram Shandy* in *Into the Woods*.

In *Into the Woods*, we discussed how stories could be boiled down to a journey and its return:[32]

There is a problem	Jack is poor, goes up a beanstalk
The hero goes on a journey	Finds giant and a goose that lays golden egg
FINDS THE SOLUTION	**STEALS GOOSE**
Returns	Heads back with goose, chased by giant
Problem is solved	Defeats giant, no longer poor – living on golden eggs

While the form itself is ancient, its ubiquitous. It's there in the myth of Orpheus and Eurydice, it's there in Buster Keaton's *The General* and it's there in Ian Fleming's *From Russia, with Love*:[33]

James Bond is sent to steal the LEKTOR decoding machine.
Finds location of machine.
STEALS LEKTOR DECODING MACHINE
Heads back with LEKTOR, chased by KGB.
Defeats KGB, LEKTOR (and civilization) saved.

In all of these, the underlying story shape is clear – it's 'journey there/journey back'.

Both Douglas and her disciples note that one of the great strengths of ring structure is that it not only provides a tight, rigid form, but

that form forces the reader or listener to focus on and amplify the most important words and ideas in the text. Nowhere could this be clearer, she points out, than in the centre of any ring composition. Just as an audience cluster round a speaker, concentric circles inevitably force us to pay attention to the very heart of the story. 'The meaning,' Douglas says, 'is in the middle.'

The middle – the lifeblood of the tree – is everything. It is 'the site of an impressive climax that focuses on the major crisis in the narrative' but it's also a uniting force: 'Normally, as in the *Iliad*, the central place in the composition recapitulates the beginning and anticipates the end.' And it's something else too. 'Ring structure condenses the whole burden of its message into the mid-turn,' she writes.[34] It's the message.

Douglas and her disciples have been pursuing what they perceive to be an alternative theory of structure. What they've actually discovered is a brilliant illustration of how traditional narrative works. Journey there/journey back only makes sense if it's a journey *to* something: to meaning. *The meaning is in the middle.* They have uncovered the central facet of narrative: that the lifeblood, the message, the central conflict and the emotional heart – the power source, in other words – are all embodied at the midpoint of a story.

The Cave you Fear to Enter

In the summer of 2022, a B movie, *Fall*, was released, about two friends who decide to climb a decommissioned 2000-foot TV tower in the middle of the Mojave Desert. One of them, Becky, is still profoundly traumatized from a freak accident the year before where her husband fell to his death from a mountain. By climbing the tower to scatter his ashes from the top, she will, of course, confront her biggest fear, and so . . . bang in the middle of the film she reaches the top, dispenses with her husband's remains, and then the ladder breaks. The second half of the movie is the equally tortuous and terrifying story of how the hell she and her friend attempt to get down. It's a lovely – and very scary – little film. It's also a great metaphor for story structure itself.

If you want to define a character quickly you ask one simple question: *what do they most fear?* Then you structure the story around how they confront (at midpoint), deal with the consequences, then finally overcome that fear.

What does Becky fear? Heights. *Fall* is a brilliant paradigm for how any weaponized story should work. You want every character to climb up that tower and reach the top, taking their life in their hands. Then you want the ladder to break so it's almost impossible for them to climb down.[35] 'Mother doesn't like me playing Beethoven. She says I'm always peevish afterwards,' says Lucy Honeychurch, early on in *A Room with a View,* to which the Reverend Mr Beebe replies, 'I can see how one might be . . . stirred up.' The midpoint in *A Room with a View* is uncannily similar to that in *Moonlight,* a story which has far more in common with E. M. Forster's work than might first appear. Both stories are rings, circling the central truth the benighted protagonists must discover – passion. Sex.

In *The Hero with a Thousand Faces,* Joseph Campbell talks of the journey to the 'innermost cave', a metaphor we now know as the midpoint. He makes one incredibly valuable observation about reaching the top of the TV tower in the centre of any story. 'The cave you fear to enter,' he says, 'holds the treasure you seek.'[36]

Let's turn back to *Star Wars.*

Symmetry and repetition are everywhere. *The Phantom Menace, A New Hope* and *Return of the Jedi* are effectively just different versions of the same story: in each, two characters on a rescue mission end up defeating the centre of evil in their respective worlds. In each, too, a central character either learns or is promised the lesson of immortality. Qui-Gon Jinn, Obi-Wan and Anakin all die in their respective films – yet each, we infer, finds a kind of afterlife. This is important, and something we shall return to, but for now let us focus on the midpoint. If *Star Wars* is a ring, then its centre lies at the end of the third film of the complete sextet: *Revenge of the Sith.*

George Lucas has described the entire *Star Wars* saga as 'The Tragedy of Darth Vader' – the story of how Anakin is seduced by the dark side and becomes his evil opposite. Where does this happen? Right

in the middle of the saga, in *Revenge of the Sith*. Having fought Obi-Wan Kenobi (by this time his total opposite) on the volcanic planet of Mustafar, Anakin is badly injured and forced to wear the black mask and suit that will come to define him. But that's not all. As the saga moves to its centre, Luke and Leia are born to Padmé and their fates decreed: Leia will be adopted on Alderaan, while Obi-Wan will deliver Luke to his humble step-parents on Tatooine. The Republic has morphed into the Galactic Empire. As *Revenge of the Sith* ends, at the saga's absolute heart, Palpatine and Vader begin the construction of the Death Star. It's a classic midpoint. As Lucas himself has said, 'The two [trilogies] will beat against each other. One's the fall, one's the redemption.'[37]

It's probably an understatement to say that Lucas is obsessed with intricate detail – only an obsessive could spend so much time and energy consumed by structure.[38] None of this, it's important to point out, makes for a better series of movies, and the *Star Wars* prequels in particular are terrible films. That's not because the structure is wrong, but because in his obsession with perfection – both structurally and through the pursuit of then-revolutionary digital technology – Lucas saps his work of the messy business of *life*.

That fault cannot be levelled at the defining work of twentieth- and twenty-first-century popular culture, a narrative that dwarfs all others with the scale of its success. You can boil down all seven novels or eight films of *Harry Potter* into a simple, clear five-act structure:

1. Voldemort attempts to kill baby Harry but his curse rebounds, banishing his physical form.
 2. Voldemort seeks revenge.
 3. Voldemort emerges, all powerful, in physical form.
 4. Harry seeks to defend himself.
5. Voldemort attempts to kill adult Harry but his curse rebounds, destroying his physical form.

This is given even more salience when you realize that the book that lies at the heart of the series, *Harry Potter and the Goblet of Fire*, is not just the literal midpoint of the saga but the literary midpoint too.

It is here that Voldemort shifts from unseen threat to clear and present danger. The nature of what Harry and his friends are up against – 'the truth' – becomes explicit.* Harry Potter is then driven directly into his first open encounter with Voldemort.† The entire saga pivots around this moment. Like Raphael before her, J. K. Rowling has utilized structure to highlight the importance of the stories' emotional heart. The lifeblood of the seven epic books lies here.

Look at the echoes occurring between the first and final books of the saga:

THE PHILOSOPHER'S STONE	*DEATHLY HALLOWS*
Hagrid arrives on Privet Drive on motorbike with baby Harry	Hagrid departs for Privet Drive on the motorbike with adult Harry
Harry's heart is broken when he sees his parents in the Mirror of Erised	Harry's heart is strengthened when he sees his parents using the Resurrection Stone
Harry locates the Philosopher's Stone	Harry locates the Resurrection Stone
Harry finds out Severus Snape is evil – an ally of Voldemort	Harry finds out Severus Snape is good – an ally of Dumbledore
Harry confronts weak form of Voldemort at Hogwarts	Harry confronts the most powerful form of Voldemort at Hogwarts

This clearly mirrored structure is made more remarkable when

* For a full breakdown of the chiastic structure of the seven novels, see Appendix III.

† The film series, by expanding seven books into eight movies, actually has the benefit of making the midpoint confrontation absolutely central, right at the end of *The Goblet of Fire*. In the books, the midpoint is the Christmas ball and the central characters' sexual awakening. While less overtly dramatic than the movies' midpoint, you can see why, in the journey from childhood to maturity, this point is not just physically but conceptually central. Indeed, the terrors of Voldemort can easily be read as the fear of adulthood and concomitant sexuality.

you realize the same pattern can be found between the second and penultimate books, *The Chamber of Secrets* and *The Half-Blood Prince*, the third and fifth, *The Prisoner of Azkaban* and *The Order of the Phoenix*, and throughout the central novel, *The Goblet of Fire*.

The entire *Harry Potter* saga, written over seventeen years, is, remarkably, almost entirely symmetrical. It's an epic about a young boy who discovers he has great power and a mortal enemy. Exactly halfway through the telling, that threat becomes explicit. Harry battles Voldemort, and the war shifts into the open; the story gets darker and Harry and his friends ready themselves for a repeat battle on a much larger canvas – one for the future of the universe.

Is such a design conscious? It's an important question, and one Mary Douglas grappled with too: 'The case becomes a question of whether the author could have achieved anything so complex unintentionally, or whether he knew very well how to organize a chiastic structure.' Douglas wondered whether Sterne could have written *Tristram Shandy* deliberately, concluding that he certainly would have been aware of its antecedents.[39] Still, she agonized about its origins: 'Presumably, symmetry, balance, matched proportions, and repetition have just as much to do with the way the brain works as the structure of language and grammar.'

That's the answer.

Certainly, it *can* be conscious. George Lucas never mentions ring structure by name but he's vocal about his guiding principles.

> Each episode has to stand on its own and have meaning on its own – except that it's only one chapter in the book. It's not the book. I can't sacrifice one for the other, so I'm constantly balancing between the now and the larger picture. The now has to be engaging, but the larger picture is what's really important.[40]

J. K. Rowling has never talked publicly about her design, though she has said she methodically planned every stage of the saga very early on. Did James Cameron use ring structure with *Terminator 2* or *Aliens*? Again, there's nothing to suggest it, and in a sense the question is academic. It simply happens too often in too many works

from too many cultures to be a conscious construct or mere coincidence. Instead it provides a valuable insight into the human mind.

Our brains, it seems, are intent on creating an extraordinarily elaborate lattice work, one in which the first half of any tale posits a question, which receives its answer from a chiastic echo. As we compose stories, the brain is taking raw data and sifting and shifting it into its most comforting and powerful condition. The bookends we find in *A Room with a View* are repeated at every stage of the story, and we find the same thing in an extraordinary number of the most powerful tales. As we work our way to the heart of any story, observe how intricately opposites occur at every single stage, as the narrative works first towards and then away from that heart. What this structure is telling us is that the truth in the middle – the *meaning* – changes everything. Here, two opposites crash into each other for the first time with equal force: old knowledge and new. That collision, between what we know as 'want and need', is story's big bang, the nuclear explosion that gives the whole thing life. George Lucas's Death Star is a fitting metaphor for a midpoint – a whole universe orbits around it, drawing from it its meaning, its identity and its often astonishing power.

Sometimes chiasmus *can* be a conscious refinement. Even then, I think, it often has an unconscious motive: to distil story to its absolute basics, to strip it of all impurities, to make it *fly*. The purest, most powerful way of achieving this is found in ring structure. Chiasmus enhances meaning and memorability while answering the deep yearning desire for order that permeates the work of Raphael, Forster, Russell T. Davies and Tony Jordan. But not just them. Their desire, once captured, feeds a voracious audience, desperate for the same, quasi-religious function total order brings. Chiasmus, so much more visible in five acts than in three, is the ultimate illustration not just of the ordering brain, but the desire for that order to be disseminated. Audiences demand to see the world like that, for order is God. The more symmetrical the story, the more adherents will be bewitched by its allure.

George Lucas accidentally provides us with a very important

caveat. Such a design, applied consciously, won't necessarily give you great art. There are a million perfectly structured stories that are bad. However, great stories rarely exist without aspiring to the kind of power and memorability chiastic structure provides.

But what is the difference between dead stories like the *Star Wars* prequels and those that turn us inside out and transport us, ecstatically, to other worlds? What ingredients are required to realize the 'perfect' tale? The time has come to step outside of fiction to see what the wider world of narrative can reveal.

ACT II

Lessons from the School of Politics

3

A Face in the Crowd

The Power of Political Narrative

Americans turning on their televisions on the evening of 27 October 1964 were greeted with an exceptional, indeed groundbreaking, piece of storytelling. The protagonist was a vaguely familiar face, but his narrative came not from a drama but a party-political broadcast. He was introduced modestly on this, the last Tuesday prior to election day. Broadcast on CBS, sponsored by the TV for Goldwater-Miller Campaign, the announcer softly intoned: 'Ladies and Gentlemen, we take pride in presenting a thoughtful election address by Ronald Reagan.' A former actor turned spokesman for General Electric, Reagan set out his stall. And then, by co-opting the lessons of narrative fiction, he presented both masterclass and template for how politics was to work in the new television age.

'A Time for Choosing' was its official title, and the speech (such was its power it became known in Republican circles simply as 'The Speech') displayed a mastery of rhetoric – so much so that it has a good claim to be the starting point of a political revolution.[1] The tricks Reagan used weren't new – they were born from the same Hollywood he was – but in the way he used them he showed more clearly than any politician an innate understanding of narrative's power.

What was so special about The Speech and its speaker?

Reagan was a natural, charismatic orator. He was down to earth, he spoke the language of his audience. You instinctively empathized. He didn't make you feel guilty, didn't harangue you for not thinking

73

like him – he didn't *alienate*. But most importantly of all he told a well-structured story.

'I have spent most of my life as a Democrat . . .' he began. He spoke as if he were his audience and they were him, and as they warmed to him, almost imperceptibly, he created an enemy and a goal. The goal was simple and clear, it was *freedom*, but who was the enemy?

There was a trinity: the overpowering state – 'a government bureau is the nearest thing to eternal life we'll ever see on this earth'; a sneering liberal elite 'in a far-distant capitol [who believe they] can plan our lives'; and welfare scroungers like the young mother of six he describes, who filed for divorce when she discovered she could get more from welfare than her husband brought home.

Reagan spun a plethora of anecdotes ('She got the idea from two women in her neighborhood who'd already done that very thing') into a tapestry of institutional venality, idiocy and corruption, all while casting his audience – of hard-working, law-abiding people – as innocent victims of this grift.

The state is stealing your money, Reagan implied. *Welfare claimants are stealing your money. The undeserving are being unfairly prioritized. You work hard. They reap the reward. This is not the frontier spirit. This is not American.* Reagan was – we were – the little man. And we were invited to stand up to a government he portrayed as a Stalinist tyranny.

To modern ears this can sound old-fashioned, but Reagan's ability to encapsulate the perceived ills of society in folksy stories ('a good friend told me . . .') and striking images ('the ant heap of totalitarianism'), and to deliver them with soaring rhetoric that pushed every emotional button, was revolutionary:

> Not too long ago, two friends of mine were talking to a Cuban refugee, a businessman who had escaped from Castro, and in the midst of his story one of my friends turned to the other and said, 'We don't know how lucky we are.' And the Cuban stopped and said, 'How lucky you are? I had someplace to escape to.' And in

that sentence he told us the entire story. If we lose freedom here, there's no place to escape to. This is the last stand on earth.[2]

Co-opting the Hollywood structure he knew so well, Reagan had cast himself as the underdog hero. He, unlike others, was ready to stand firm against this tyranny, and he was so good at explaining why his audience should rise up and join him that even lifelong Democrats found themselves agreeing with him, often passionately. He was, and we were by implication, Gary Cooper in *High Noon*. By dressing himself in the clothing of the Hollywood hero, and Reagan knew those characters better than most, he stumbled on the key to electoral hegemony.

The Speech didn't win Goldwater the election, but enough influential Republicans were watching to know they'd found their future. That October night changed Reagan's life and, eventually, America's.[3]

Reagan had discovered that, in the words of historian Rick Perlstein, 'the best measure of a politician's electoral success was not how successfully he could broker people's desires, but how well he could tap their fears.'[4] Reagan had mastered the importance of a well-chosen enemy. It gave his rhetoric – and his listeners – purpose, direction, shape and drive. Soon, Perlstein notes, there was a 'them' in every speech, and Americans disturbed by the progressive temper of the times found themselves intrigued, if not inspired. Here was someone who understood how they felt. It turned out a lot of people felt the same way. Maybe not at first, but as Vietnam escalated, in turn birthing the Summer of Love, those who opposed the war and the government were engendering their own opposition. That opposition grew, and catalysed a slow-motion avalanche.

The skeleton of every story is very simple. There is a hero – Chief Brody – he has a problem, a shark, and he must kill the shark to save his world. Reagan cast himself as Chief Brody and the Democrats as a giant, predatory killer. With only his common sense and decency to guide him, Reagan would bind together a coalition that would go out to sea in a rickety boat and, through his and his shipmates' integrity and bravery, rid the world of this rapacious predator, save

the tourist industry of Amity, and make the beaches safe for families to swim from and play on once again. Reagan's technique wasn't entirely new: as Perlstein points out in his book *Reaganland*, he'd borrowed it from a previous president, Franklin Delano Roosevelt:

> Reagan had learned from his hero, FDR [. . .] In his 1936 convention acceptance speech, one of Reagan's favorites, Roosevelt attacked a 'them' he labeled 'economic royalists'; a small group (who had concentrated into their own hands almost complete control over other people's property, other people's money, other people's labor – other people's lives [. . .]

What was new was the simplicity and venom with which the technique was utilized – and, of course, the enemy. Reagan studied the playbook, swapped white hat and black hat around, then honed the lesson to perfection.

Reagan's story was told repeatedly with increasing focus and passion, and with each telling new souls were recruited to the cause. He began by harnessing a coalition of evangelical Christians (horrified by what they saw as America's moral decline) and American businessmen (fed up with red tape, the imposition of car safety belts being a particular tipping point). It reached beyond them as the tide of the 1960s swept a detritus of drugs, disrespect and dishonour onto the beaches that, many people imagined, they had known and loved as children.

These people were already known as Nixon's silent majority and, fanned by the oxygen of the Vietnam War, they were becoming increasingly alarmed. Theirs was the America of John Wayne, of Bob Hope, the Eisenhower dream. They had grown up in the shadow of a war (some had even fought in it) to vanquish the evils of Nazism. They were the good guys, their identity inextricably linked to anthem and flag. If they were the goodies, then the Vietnam War could not be wrong, only those who criticized it could. *Those* people – they were the baddies. This was the crack Reagan was to prise open. Just as Satan must be expelled from heaven, he implied, so must America turn on their shark. This is the moment where the apple is eaten,

where the America that had been united by a world war – united by a cold war too – suddenly started to sever, to stagger and slowly split apart. Reagan placed his hands in that wound, pulled it open and tipped containers of salt inside. The more he rubbed that salt in, the more powerful grew the enemy he needed to gain power.

In just over a decade he was president. And afterwards, the deluge. Johnson, Corbyn, Farage, Orban, Modi, Trump, Erdoğan, Bolsonaro, Le Pen, Wilders: the populists of the modern world, all of them pro-pelled by the same binary narrative. It's a ridiculously simple story: we are you, and we have a common enemy, one who is the direct opposite of every value we hold dear. If you join with me, we will destroy them and our beaches will be safe for swimming once again.

Reagan's tale was marinated in Hollywood, and cooked and served by an actor who found he was better at the job when he wasn't consciously acting. The lessons we may discern from his technique are worth reapplying to the fictional stories whence they came, for, as his global dominance proved, they provide us with an uncanny power.

Politics is storytelling red in tooth and claw, and while fiction – *domesticated* story – can expose the make-up of non-fiction narra-tive, political narrative – narrative *in the wild* – contains invaluable lessons for fiction.

In this section we're going to look first at how politicians weap-onize story and, in the next chapter, how rhetoric allows them to do that, for it is in the combination of the two that nations are forged or governments overthrown. Nothing illustrates with more clarity the role of the protagonist and antagonist and the need for tangible enemies and goals than when story is viewed through the bloody lens of politics, and nothing comes quite so close to illustrating story's terrifying power.

In 2008 the British TV writer Peter Moffat gave an interview at the launch of his new BBC 1 series, *The Village*. Loosely based on *Heimat* – the groundbreaking German series that told the history of its country from the end of World War I to the 1960s through

77

the life of one village – Moffat had pitched the show as 'the anti-*Downton Abbey*'. At one level this made sense. If you're up against such a big show (*Downton* was the giant that stalked the land of post-millennium British TV) then it makes sense to differentiate your own show as much as you can. Asked at the BAFTA launch of his show about the threat from *Downton*, Moffat dismissed his rival with a curt, 'It wasn't a golden age if you were poor.'

Critics agreed. A. A. Gill in the *Sunday Times* said that *Downton Abbey* represented 'everything I despise and despair of on British television: National Trust sentimentality, costumed comfort drama that flogs an embarrassing, demeaning, and bogus vision of the place I live in.'

Years later, I asked Julian Fellowes about the criticism *Downton* had received. Fellowes is not just a writer but a Tory peer, and he'd received quite a bit of flak from (mostly) left-wing writers and journalists about what they saw as a revisionist, class-ridden excuse for hierarchy and privilege – worse, one in which the servants welcomed their place in the great scheme of things. He was relaxed about the attacks. 'I just don't see the world like that,' he said. 'I love all the characters. They're not pawns. Most people – certainly all the characters in *Downton* – just spend their lives muddling through.'[5] What can *Downton* and *The Village* tell us, then, about hit TV? And how does that relate to Ronald Reagan's extraordinary power, not just over the American people but far beyond?

At its height *Downton Abbey* towered above its opposition. It won a Golden Globe for Best Miniseries and a Primetime Emmy for Outstanding Series, alongside another twenty-six nominations. It was the most-viewed drama of all time on PBS and listed as the most critically acclaimed English-language television series of 2011 by Guinness World Records. Shown in 220 countries around the world with a global audience of 120 million, it launched the careers of Dan Stevens, Rose Leslie and Michelle Dockery, and, after six big series, it lives on as an increasingly lucrative film franchise. And *The Village*? Its first episode got 6 million viewers and a ton of complaints about a scene where a twelve-year-old boy masturbates

over the sight of his new schoolteacher. By the series end, viewing figures were down to around half of the first episode. It staggered on to a second season, the spine of which was the story of how the British Labour Party achieved power for the very first time. As the series ended with the female lead screaming with delight at their triumph, in real life Jeremy Corbyn was leading the actual Labour Party. Mired in accusations of antisemitism, with his deputy leader forced to apologize for cheering on the 'bombs and bullets' of the IRA, Corbyn led his party to electoral oblivion, just as the brave new socialist dawn was being heralded on BBC 1. *The Village* was quietly decommissioned.

The Village was a very well-written and extremely well-acted show.[6] However, it does contain classic lessons for any writer or commissioner. Put simply, it was the wrong show for the wrong channel at the wrong time. There really should be dramas that tell the story of the British Labour movement, and we absolutely do need a corrective to the mythology of a righteous feudal order undergirding Britain as the bastion of civilized values. But at the same time, if you don't understand the lessons of *Downton Abbey*'s success then you probably shouldn't be involved in politics, or drama.

Downton has its crass and bad moments, of course – that's one of the curses of high-volume TV – but the first act of its pilot is a tour de force of storytelling. A Morse key taps out a message that flies down telegraph wires, past a speeding steam train, to a post office in a rural village where clerks show grave concern as they read. A young man delivers a newspaper to Downton Abbey, and as its contents circle round the house you are intrigued, you are enthralled, you have all the exposition you need to understand and fall in love with the world of the show – all delivered without the audience consciously noticing. Ten minutes in there's the bombshell: residents of Downton are on the *Titanic* and their fate will change everything. At that point millions of viewers threw up their hands in surrender – we are *in*. It's hard to think of another sequence so in command of its purpose and its craft.

It may not be for you (no TV is ever for everyone), but it's

important to watch and acknowledge work aimed at different tribes. I can't think of any writer who wouldn't be proud to have mastered that sequence, nor coined the words of Violet Crawley, Dowager Countess of Grantham, when talking to a new middle-class inter-loper. If the job of dialogue is to distil a character to its essence, capture their world view, give them a distinct voice, establish their status and make you love them, all as economically as possible but with a ton of subtext, then the question she asks of her middle-class guest – 'What is a weekend?' – may just be the perfect example.

So, what are the lessons of *Downton*'s success, what can they tell us about Ronald Reagan and what can both tell us about storytelling?

Both offer an imaginary past, and both celebrate individuals without reducing them to a particular viewpoint or tribe. Both have clear enemies, the threat of a new political world (communism was Reagan's sworn enemy, while the collapse of an age-old system is symbolized in *Downton* by the sinking of the *Titanic*). Where *The Village* serves up dirt, class warfare, underage sex and the brutal slaughter of the town's children (the first series is framed around World War I), *Downton* and Reagan offer clear reasons why their audience's lives could be better. They give you simple villains that may, with cunning, be vanquished if you follow their line. They don't tell their audience their lives are shit and that it's their fault. Instead, they speak to them as friends and the audience respond in turn. This is a world where heroes and villains are simple, that is clear and concise in its premise, and that offers a vision of the world not as it is, but as a substantial part of the population would like it to be. Reagan and the characters of *Downton* are figures of aspira-tion, embodiments of values that they believe important.[7] Purpose and hope are key.

This is not – it's worth repeating – a criticism of *The Village* and its ilk. It's about understanding the nature of the story, the nature of an audience and what they will respond to. Let's look at this further through the prism of politics, the ultimate laboratory for testing which stories work, and in particular the art of the political slogan, which, when done well, distils narrative to its very essence.

The Political Slogan

In 1945 Britain had been at the centre of resistance to Nazi tyranny, and the symbol of that resistance was a statesman, Winston Churchill, a man revered by legions throughout the 'free' world. Against huge opposition he had persuaded the British not to come to an accommodation with Hitler and then had battled fearlessly to bring an isolationist America into the war. He was the ultimate symbol of the defeat of despotism and was standing for sure and certain re-election. Yet the Labour Party beat him in the largest landslide in British electoral history. How?

The poster Labour used for their campaign offers a clue. It is a mini-masterpiece of design – a giant 'V' for victory, implanted on the broad sunlit uplands of Britain's green and pleasant land. The image itself is a quiet appropriation of Churchill's defining V-sign, but the slogan above it is simple, concise and fantastically clear: 'And Now – Win the <u>Peace</u>'. This war was fought for a reason, the slogan says, and those that made the biggest sacrifice – the ordinary working people of this great land – should be rewarded for their blood, toil, tears and sweat. No more class-based injustice, no more of rigid hierarchy. A new, fair deal for everyone.

The message Labour propagated in 1945 was so simple, so impossible to disagree with, so clever in the way it called for change while inciting a patriotic emotion, it has rarely been bettered. Much of its strength comes from inference. The protagonist is the voter, there is a goal everyone can root for without question (a peace worth fighting for) and an enemy everyone wishes defeated (the old unfair pre-war order, and the Tories responsible for it). All of this is good, but becomes great, by coupling it to the cumulative sentiment: this war was fought for a great reason.

Labour won in a landslide, after one term squeaked a narrow majority and a year later lost power. The party was to go through three more leaders and fifteen powerless years before it managed to remember and apply the same lessons again. A grey, corrupt,

inbred Tory government had somehow clung on to power, and it took their leader, Harold Wilson, to distil Labour's promise into a narrative. 'The white heat of the technological revolution' held a clear vision of Labour's recalibrated values – fundamentally, new versus old. Wilson sold it well and, more, it embodied the spirit of the times. The 1960s would sweep all before it and a brave new world of British soft power would wash away the crumbling post-Suez colonial grandeur of old. Twenty-five years later and fifteen years after Labour had fallen prey to the difficulties of government once again, Tony Blair arrived and looked at the lessons of his predecessors. Fighting a Tory government bankrupt of ideas and growing sclerotic on scandal, he found a way to borrow the best of Attlee (justice and equity) with the winning wisdom of Wilson (we can harness technology to build a new utopia). Understanding that the fewer words you need to tell a story the more it will travel, Blair's team distilled their message to its absolute essence. New Labour. New Britain. New. And for the first time since 1945, a landslide was theirs.[8]

After years in the electoral wilderness the Conservative Party finally mastered the importance of using narrative in 2010. It may have been formulaic, but their strategy was simple and efficient: first, give the public an enemy by blaming an off-guard Labour Party for the global financial crash of 2008.* And, through the endless repetition of the phrase 'long-term economic plan', give them a goal to aspire to too.

Every election campaign is really centred round one main battle – which party leader will occupy the role of the shark, and which will embody its slayers. Facts are irrelevant. What mattered in 2015 was painting Labour leader Ed Miliband as a shark and David Cameron as Chief Brody. If the electorate allowed one to defeat the other, we could surmise, we would be rewarded with our freedom. The Conservative Party visualized this story with the first poster they

* Deeply disingenuously. The crash was a global one caused entirely by policies the Tories had advocated at that time. If anything, it was caused by the US sub-prime mortgage market, and particularly toxic financial inventions known as Collateralized Debt Obligations. You can see why you wouldn't put that in a speech.

released for the coming campaign. In the foreground the viewer is placed in the middle of a long road, shaded with a Union Jack, which leads inexorably back to the vanishing point, one surrounded by verdant hills. The message is clear, even without the slogan imposed over the road – 'Let's Stay on the Road to a Stronger Economy'. Protagonist, antagonist, goal – all are easily inferred, and from that, *purpose*. We have a plan, we must not waver, and if we show courage the reward will be great, for we will rediscover our mythical Britain – a land of broad sunlit uplands – once again.[9]

It worked. Labour had no shark, they had no Brody, and they lost badly – for leader Ed Miliband could not tell any story that cut through.* The Tories had utilized the most important lesson in politics. If the protagonist embodies the aspirations of the time and the enemy encapsulates its unconscious fears, then the narrative goes to work and grows like a virus, preying on weakness and insecurity.[10] If the protagonist can vanquish that monster, then the world they symbolize is healed.

At the heart of any successful election campaign is not just a narrative, but one key narrative element. The political slogan is the nucleus around which everything else will spin. A good slogan is narrative distilled to its perfect form. #MakeAmericaGreatAgain made Donald Trump president. It's a masterclass in condensed narrative. Similarly, #DrainTheSwamp. In both you can infer protagonist, antagonist, intention and goal. If you get the slogan right, it underpins your whole campaign. Everything you do will, or should, flow from there.

Contrast Trump with his 2016 rival, Hillary Clinton. Her slogan, #StrongerTogether, is so bereft of inspiration it stands as the ultimate symbol of her failed campaign. 'Drain the Swamp' is a story; 'Make America Great Again', with the 'again' injecting powerful emotion ('it's been betrayed!'), is a *perfect* story. 'Stronger Together' is an observation. It's emotionless, evoking nothing but warm wine at a school staff meeting. Worse, there is no verb. It's a

* To be fair, 'Producers vs Predators' wasn't bad, but it couldn't get past the gatekeepers of a largely right-wing press. Rightly or wrongly, in the UK that's what a good story has to do.

catastrophic political miscalculation. Trump's slogan is strong and muscular, Clinton's weak and floppy. It's not a story, it's an epitaph.*

'Get Brexit Done', 'Let's Take Back Control' – even, despite its lack of sparkle, 'Long-Term Economic Plan' – all elections are won with storytelling. But not just elections. It's long been a commonplace to say that history is written by the winning side, but it's more accurate to say that the winning side in almost any battle is the one with the best story. It's self-evident in fiction that the most successful storytellers are those who master narrative, but it's equally true outside of fiction. As Reagan proved categorically, the best storytellers *win*. Simple binary narratives will always triumph over nuance and complexity. If enough people believe that the candidate is Chief Brody and their opponent a shark, then Brody will always triumph. Trump versus Clinton was Hollywood blockbuster versus arthouse darling: there could only ever be one winner. As American Senator Ted Cruz told Jeffrey Toobin in 2014, 'In both law and politics, I think the essential battle is the meta-battle of framing the narrative.' He continued:

> As Sun Tzu said, every battle is won before it's fought. It's won by choosing the terrain on which it will be fought. So, in litigation I tried to ask, What's this case about? When the judge goes home and speaks to his or her grandchild, who's in kindergarten, and the child says, 'Pawpaw, what did you do today?' And if you own those two sentences that come out of the judge's mouth, you win the case.[11]

If you own those two sentences, you win the audience.

Every successful political slogan has the same things in common. Simple, emotional and impossible to disagree with. Who could possibly object to removing corruption from politics, to draining the swamp?[12] Half a country may object to *who* is saying it, and

* It is worth mentioning that Clinton won the popular vote. However, Trump started from a far lower base – almost no one, at first, thought his candidacy more than a joke. That he won the electoral college is largely down to his unique storytelling skills.

that's certainly an important consideration, but if the slogan is good enough you transcend such an obstacle. 'And Now Win the Peace' – perhaps the epitome of the art.

The greatest political slogans imply an action. 'Make America Great Again', 'Get Brexit Done' or 'Let's Take Back Control': all allow you to infer both a question, the problem if you like, and embody a search for a solution, for that's what in essence a story is. 'Ambitions for Britain', 'For the Common Good', 'Britain Stronger in Europe', 'Defending Wales' – so many get it wrong. And while you can argue that 'Britain Stronger in Europe' does just about imply question and answer, it's missing the emotion of 'Let's Take Back Control' and 'Make America Great Again'. Both are soaked in a sense of betrayal; both imply that a great crime has occurred and promise revenge.[13] So much power in so few words. It sounds reductive, but look at the script or speech or column or essay you're writing now. Can you distil it to those simple core elements – is there a slogan inherent in your own fictional work? It's a great test of both its viability and its efficacy. Can you distil your TV show to one sentence or less? Many writers, lost in the thickets of plotting, talk of simplifying the idea until they can see it clearly: *Master and Commander* is about two friends who are opposites; the *Odyssey* is about a warrior coming home and bringing the war with him. As John Collee, who wrote *Master and Commander*, has said, 'It's amazing how that grain of sand gives you the universe.' It can sound mad, but *Bucolic England fights for survival against Modern Age* has a timeless power, one that may be fraudulent but is no less bewitching for all that.

So, for any story to really land, as the best political slogans attest, it requires three essential elements: protagonist, antagonist and goal. Get those right and everything falls into place. We must turn our attention to these, beginning with the protagonist. If fiction could only learn one thing from politics, it's that so much depends on the teller of the tale.

The Protagonist

Most Germans, so far as I could see, did not seem to mind that their personal freedom had been taken away, that so much of their splendid culture was being destroyed and replaced with a mindless barbarism, or that their life and work were being regimented to a degree never before experienced even by a people accustomed for generations to a great deal of regimentation [. . .] On the whole, people did not seem to feel that they were being cowed and held down by an unscrupulous tyranny. On the contrary, they appeared to support it with genuine enthusiasm.[14]

William L. Shirer lived and worked in Germany from 1934 to 1940, documenting the rise of Adolf Hitler. A foreign correspondent for the *Chicago Tribune*, he saw the evolution of fascism and understood, for the less-than-vigilant, how powerful that pull could be. We may comfort ourselves that the Germans were unlike us but, while they may have been prey to forces particular to time and place, at heart, of course, they were no different at all.

Protagonists nest and grow in a very particular environment, and demagogues in particular derive their power from elements which, at the risk of sounding trite, share something in common with the BBC's *Repair Shop*. That programme is built from emotional damage (a broken artifact), an enemy (the person or forces who broke it) and a goal (restoring the object to peak condition). Into this narrative mulch, a charismatic quasi-deity (the benevolent presenter) descends and implants themselves. They lay out the injustice, point out its cause and then, as they grow and blossom, fix it by vanquishing the enemy (usually time and neglect, but occasionally malevolence too). You, the audience, are enchanted, and before you know it you have been enlisted – part of a growing movement that has taken the programme to heart. Mad? You can find exactly the same narrative pattern in *Supernanny* or *How Clean Is Your House?* The deeper the damage, the greater the force.

Emotional damage is important, and often understated. In his influential study of the psychology of mass movements, *The True Believer*, Eric Hoffer profiled those most susceptible to totalitarian narratives. Those who'd recently lost money or status, religious minorities, misfits, the marginalized – all were magnetically drawn to movements that promised, through united action, to give them the power and strength they were lacking. For these people, an enemy was fundamental ('the ideal devil is a foreigner', Hoffer said), as was a goal: the past and future were glorified, while the present was portrayed as a barren wasteland of missed opportunity. Recruits, Hoffer felt, long for and are promised a glorious future, most commonly by promising a restoration of the past. Of the greatest importance, however, is the person making the promise: 'the man of words', someone who could articulate the inner woes of their disciples and give them shape and form. What Hoffer's argument boils down to is that tyranny thrives when its subjects' wounds are identified and then fed the appropriate story – one they *wish* to be true. For the feeding to be successful, the food must be delivered by a charismatic presence, one either suffering from the same damage or who can articulate it, and who has the power to *persuade* you that falsehoods are true. The lessons in life are identical to those of fiction. You may have the best story in the world, but you need a great protagonist to sell it.

You want a fictional character who transfixes a huge amount of people, lifts them out of ordinary life and transports them to another plane where only their reality exists. A man or woman who will make you not just laugh or cry, but feel like you would lay down your life in devotion. One who recognizes the unjust wound and promises to make it better. Not a leader so much as a *healer*. When silent-star Rudolph Valentino died at thirty-one, his passing occasioned the kind of mass mourning normally witnessed at the deaths of beloved leaders or despots.* During a three-day lying-in-state, his body was viewed by nearly half a million people; hundreds were injured in a riot and two committed suicide. And that was just in New York.

* The two often overlap, Stalin being a prime example.

On the five-day journey west, his train repeatedly stopped to greet mourners lining the route, in scenes reminiscent of Robert Kennedy's funeral train forty-two years later.[15] At Valentino's final ceremony, his coffin was carried by the greatest stars of the day. It's easy to be purist about these things, but you'd be hard-pressed to find a successful producer who wouldn't want a central character that could provoke that level of emotion. Who from real life might help fiction writers understand how to do *that*?

In 2002, the Chief Minister of Gujarat, Narendra Modi, was at best indifferent and at worst complicit in the riots that tore his home state apart. Over a thousand people, mostly Muslims, died, and he was declared *persona non grata* by Western governments. Twelve years later he was Prime Minister of India. How did he achieve such a dramatic rise to power? By harvesting resentment against the post-colonial elites that had ruled India since independence and fanning the flames of hatred by pinning the woes of the country on the minority Muslim population. The two antagonists here are important, and we shall return to them, but for now let us examine the protagonist.

Modi clothes himself, figuratively and often literally, in the saffron robes of the Hindu ascetic. Any politician who renounces family and worldly possessions for a higher cause (in this case the poor of Mother India) is immediately attention-grabbing, if not empathetic, but in India the figure of the ascetic has a deeper meaning. As an image, it has been annexed by right-wingers for decades, not just for its religious meaning but because it invites the derision of the English-speaking urban elite. When Britain walked away from India in 1949 their legacy surprisingly wasn't trashed. For nearly a century, the architecture of the British occupation, such as Lutyens' Delhi and the Victoria Monument in Kolkata, has remained venerated: beautiful, powerful buildings, but unconscious symbols of a prevailing mindset. English, since independence, has been the dominant language of the governing class and its literature. Nothing, it seemed, could flourish in India without a silent blessing from the West. To those secular elites and their anglophone representatives

in power, the figure of the Hindu ascetic was laughable, doing little but inviting derision.

It might seem counterintuitive, but cultivating that derision was key to Modi's success. For years, resentment had festered among large swathes of ordinary Indians towards those above them. Suddenly, here was a man inviting that derision from above, while at the same time stoking the resentment it provoked. Modi was very aware not just of the deranged levels of inequality in wealth and status prevalent in his country, but of the power to be gained by identifying with those who felt most put-upon and offering them an undreamed-of chance of vanquishing those who derided them.

There he was, an enemy of Western governments, a man not afraid to act against a 'traitorous minority' they felt had been indulged and pampered for too long, while they, the hard-working people who built India, were ridiculed. Modi wasn't like any other politician. Journalist Aatish Taseer described him as 'a rare instance of India trusting to herself, throwing up one of her own, one who did not have the blessings of the West at all'.[16] He wasn't just one of them, he *embodied* them. He was their Clark Kent turned Superman, fighting for his very Indian version of Truth, Justice and the American Way. Often boasting of his 56-inch chest, his popularity rose even as his poor economic record and autocratic rule seemed to count against him. *I am you. You are me. And together we can defeat a common enemy.*

It's a lesson fiction should pay more attention to, and one the first stars of cinema knew well. 'I am you. You are me.' No one embodied that idea with greater power than Charlie Chaplin.

It is hard now to even remotely imagine the scale of Chaplin's fame in the early years of the twentieth century. But at the dawn of a new age, in what for so many was a new land, Chaplin carried the spirit of the poor, the downtrodden, the spat upon and gave them a powerful image to latch onto, one marinated in optimism and hope.[17] The spine of Chaplin is resilience, wrapped in an overcoat of dignity – and in a world that could be incredibly cruel he offered his public a roadmap to survive it. What was *The Gold Rush* but an origin myth for the American people, in which their dreams were played out and

rewarded?[18] His greatest success (of many) was 1931's *City Lights*. Two years after America's financial system collapsed, he staged a battle between rich and poor. The poor – in the form of Chaplin – lost and were thrown in jail, but on release found love and redemption. He had suffered, and through suffering found ascendancy. The parallels with Modi (and Gandhi) are stark. The film earned Chaplin alone, in today's money, just shy of $100 million, but its real value lay elsewhere. 'To this day,' wrote film critic David Thomson,

> the film is worth every penny, and it is the amazing mirror of [Chaplin's] very mixed-up ego. You could argue that there isn't another movie that so addresses the appeal of films to poor people in a world where the only other recourse would be violent political action.[19]

Audiences long to see idealized versions of themselves fighting the enemies they believe are agents of their repression, and Chaplin was perfectly cast in that role. It's perhaps no surprise that, in our own time, from *Hetty Wainthropp Investigates* to *Miss Marple*, *Vera* to *Murder She Wrote*, there's a preponderance of characters who embody how their core audience like to see themselves. The largest audience group watching terrestrial television in Britain is female and over fifty-five. No wonder they seek versions of their own selves that give them power.[20]

In recent years, the most successful incarnation of this type in the UK has been Catherine Cawood, the central character of Sally Wainwright's *Happy Valley*. Forty-seven when the show begins, her ability to stand up to injustice, expose idiocy and prove that, contrary to prejudice and expectation, she is not useless, informs every scene.

INT. NEWSAGENTS. DAY 1. 10.00

The NEWSAGENT gives a CUSTOMER change as a police car comes to a halt right outside (flashing lights, no siren). SGT. CATHERINE CAWOOD (48, unassailably pleasant) strides into the shop. She's all tooled up; truncheon and cuffs hanging

off her belt, radio, bullet-proof vest. We see the three stripes.
She looks like she's made of gadgets. Robocop. But there's
something calm and reassuring and feminine about her manner,
despite her striking no-nonsense appearance. She's probably
smiling politely as she asks -

> CATHERINE
> Have you got a fire extinguisher?

> NEWSAGENT (panic)
> A f–?

> CATHERINE
> For putting out fires.
> (No response: shop keeper still stunned)
> I've got one in the car, but I
> may need something bigger.

A robust, breathless 70-YEAR-OLD WOMAN has followed
CATHERINE into the shop.

> 70-YEAR-OLD WOMAN
> There's a fella round t'corner
> reckoning to set fire to himself!

> CATHERINE (charming)
> Yes, thank you, we're on top of that.
> (she pulls some cheap sunglasses off a stand)
> How much can I give you for these?

2 EXT. HOUSING ESTATE. DAY 1. 10.01 2

LIAM HUGHES (23) has doused himself in petrol and he's
standing on a bench opposite some flats. He's drunk so much
his coordination's gone and he's distressed. His face is grubby

and streaked with tears. He's got a can of beer in one hand, a cigarette lighter in the other. His empty petrol cans lie on the ground in front of the bench.

CATHERINE heads inexorably towards LIAM with her fire extinguisher. She's wearing her new cheap sunglasses. P.C. KIRSTEN McASKILL (23 but looks 12) is right behind her.

KIRSTEN
Nice glasses.

CATHERINE
He can send himself to paradise – that's his choice – but he's not taking my eyebrows with him.

Happy Valley by Sally Wainwright

The appeal of her introduction is instant, and the action that follows (in which she talks Liam down) cemented her appeal not just with her own demographic, but a huge cross-section of the British public. Just about everyone watching felt, 'If I was in the Police, then I'd want to be her.' No reaction is more vital to popular success. Cawood is British culture's Narendra Modi. The clothes and the enemy may be different, but the wound and the desire are the same. Both, to their target audience, are intoxicating. She *heals*. At the heart of this is something else of significance, too.

When he wrote and directed *The Way of the Gun*, Chris McQuarrie was in the mood to shake things up. Winning an Oscar for *The Usual Suspects* had made him a much sought-after screen-writer, but he wanted to direct a movie and have complete artistic control. No one would let him do that unless it was a second crime picture. He didn't want to be stereotyped but he agreed, rationalizing that he would just do it very differently. 'The first thing I did,' he said, in an interview around the time of the film's release, 'was to write a list of every taboo, everything I knew a cowardly

executive would refuse to accept from a "sympathetic" leading man.' He decided to include them all. He just wasn't interested in doing another movie where the characters 'go out of their way to ingratiate themselves'.[21] The resulting film is intriguing, but was a critical and commercial flop. Fans would call it 'cult', but to anyone else it's almost unwatchable: 'A lot of uninteresting and unpleasant people torture, abuse, and fire guns at a lot of other uninteresting and unpleasant people, in a repulsive, interminable would-be crime thriller,' said Jonathan Rosenbaum of the *Chicago Reader* – by no means its worst review.[22]

Years later, when McQuarrie (now in his imperial *Mission Impossible* phase) was asked by one acolyte on Twitter 'Where do you start with character development?', he replied, almost instantly, 'Do I give a shit about what they want?'[23] A character will simply not reach a mass audience unless their aspirations are shared. By the time he had co-authored the all-conquering *Top Gun: Maverick* (the film that brought the first big audiences back to cinema after Covid and 'saved Hollywood's ass' according to Steven Spielberg) McQuarrie, his films now odes to cinematic joy, had employed this maxim to perfection.[24]

Almost every commercially successful story is predicated on this point. A protagonist embodies its audience's most widely held desires. Politics displays this with striking clarity: we vote for the politicians that articulate our desires and wish to destroy the same things we do. Writers must write what they want to write (and there are honourable exceptions, which we will come to) but every channel controller, every commissioner, everyone investing in any show needs to understand this.[25] Protagonists, ultimately, are characters our audience want to be. This should be self-evident, but much TV suggests it's not.[26]

On 20 February 2014 a brand-new television series debuted on Britain's Sky One. An hour after its transmission time, it was effectively dead. For years British TV executives had searched for a replacement to ITV's absurdly successful fire-service drama *London's Burning*. Created by Jack Rosenthal, one of the godfathers of TV drama, it had run for fourteen series and at its peak was attracting

19 million viewers. A cheap returning series that personifies the desires of its core audience is one of very few TV holy grails, and whoever could find a new *London's Burning*, observers felt sure, would have riches bestowed upon them.

The Smoke, as it was christened, had a great writer, a great production team and a great cast – future Doctor Who Jodie Whittaker and Taron Egerton (who would go on to lead *Rocket Man*) amongst them. The male lead, Kev, was played by Jamie Bamber – young, good-looking and hot off a big US hit, *Battlestar Galactica*. The omens were good.

In the opening minutes of the drama Kev is terribly injured in a fire, and the episode charts how he, nursed by his loving wife Trish (Jodie Whittaker), comes to terms with the disaster. Though Kev appears to heal, his anger grows until he finally resolves to confront the fire brigade governors who he believes are responsible for what happened to him. The showdown takes place at a big ceremony and, incandescent that he can't get their attention, he drops his trousers in front of them all to reveal that his penis has been completely burned away.

It's a jaw-dropping scene, and you can see why a great, young, creative writer thought of it. You can imagine why commissioners thought it might be special too ('It's different!'; 'It's brave!'; 'It'll get people talking!'). And it did, but not in a good way. If you cut off your protagonist's penis on television, you are effectively castrating your whole production. It wasn't just that the incredibly graphic sight of the injury was enough to traumatize viewers. In an empathetic relationship where Kev is our avatar, its effectively cutting off our penises too. The hard truth is that an injury like this cauterizes something deep in our connection to the character. Appalling as it may be, we run a mile (as the audience did) because we just don't want to *be* that person any more. We don't want to be castrated.

We are driven by sexual desire and aspirational fantasy more than we might like to admit. In *The Smoke*, all of that, in one misguided *coup de théâtre*, was literally cut off. All that remains is sympathy, which can never be a primary driver of story. The scene has almost

been erased from our collective memory (you can't watch *The Smoke* anywhere), but it contains an incredibly valuable lesson about storytelling. At some level protagonists simply must embody our conscious, and ideally unconscious, desires. You follow a story to *be* the central character – that's how and why the star system works. As John Collee puts it, 'You wanted to be them last time, you'll want to be them again.'[27]

In one of the worst commissioning decisions of recent years, Britain's Channel 5 decided to tell the true story of Maxine Carr. Carr had given an alibi to Ian Huntley, her boyfriend, who murdered two young schoolgirls in Soham, Cambridgeshire, in 2002. Whatever the terrible, sad truth of the situation, the idea of making her the central character in a still raw tragedy was a profound misunderstanding of what makes stories work. If you watch the trailer for *Maxine*, you don't want to be her, you want to lock her up – or worse.[28] No one could ever want what Maxine wants, because no one would want to be her. If, at some level, we cannot forge an emotional relationship with the protagonist and demand they vanquish their foe, the audience will always remain niche.

This isn't about making characters 'nice' or 'good'. As *Dexter* proves, it's easy to empathize with a murderer if they're murdering someone you might wish to kill yourself. The emotional connection we feel in fiction is identical in politics. William Hague, Iain Duncan Smith, Michael Howard, Ed Miliband, Walter Mondale, John Kerry, Mitt Romney – none ever transcended their ideologies to capture and hold an audience hostage to their beliefs. John McCain came close, but he was too establishment for a Republican base that had turned rightwards (ironically, defending Barack Obama from racism probably sealed his fate). And, yes, he was up against Obama, who had a cinematic backstory and film-star charisma to boot.

There are exceptions in fiction, of course. *Killers of the Flower Moon* is one.[29] No one is rooting for the protagonist to kill his wife – it's queasy and uncomfortable. A good film? Possibly. A successful film? Its initial publicity ensured people paid attention, but, tellingly, it was entirely abandoned by the award ceremonies of 2024: a film

it was good to say you saw, and bad to acknowledge might be profoundly flawed.[30]

What a majority of viewers will always look for are guides to a better future, custodians of disappearing values, defenders of faith and crusaders for a new way of life that keeps the best bits of the old. That's Catherine Cawood in *Happy Valley*, and it's Luke Skywalker and Harry Potter too. It's Jack Reacher in every new adventure, and in its purest fantasy version, it's Rudolph Valentino. Tony Soprano is an anti-hero, but even he is fighting for his family against (what he sees as) the darker and more malignant forces trying to destroy him. Oh, and it's *Repair Shop* too.

Squid Game's hero Seong Gi-hun, in his quest for survival, his desire to return to his old way of life, his concern for others and his wish to defeat a hideous enemy, illustrates how the traits of the demagogue can be found in far more attractive portrayals.[31] The world of *Squid Game* appears to Gi-hun as the world of India appeared to Modi – a dystopian hellscape that needed to be cleansed. For Modi that evil might lie in any symbol of a colonial hangover – including its tolerance of other religious groups. For Gi-hun it is in the Machiavellian traps of an unseen enemy playing God with people's lives. In purely emotional story terms, however, they are not that far apart. If your protagonist can make you see the world the way Modi or Gi-hun see his, it unlocks a torrent of emotion – a licence to unleash an inner rage. How can a writer best tap into that rage? First, find a hero that embodies that desire. But then create an antagonist that threatens all you hold most dear.

The Antagonist

In brutally simplistic terms there are two kinds of story.* There's the hero's journey:

* There are, of course, many others – a thousand arthouse films immediately come to mind – but they are all bastardizations of this basic structure, as we'll see later.

> I hear there's a book about story structure –
> I hear it's going to be rubbish.
> I buy it and read it intently.
> I conclude it's brilliant.

And the dark, or tragic, inversion:

> I hear there's a book about story structure –
> I hear it's going to be brilliant.
> I buy it and read it intently.
> I conclude it's rubbish.

First drafts are often variations of 'I hear it's going to be brilliant – it is brilliant.' Instinctively, we can sense that's wrong, and by taking a chisel to our block of marble we believe that in our second draft we can carve out the better shape we know lies within. 'I hear it's going to be brilliant – I conclude it's rubbish' is – like the slaves in Michelangelo's *Prisoners*, his four famous half-finished sculptures – screaming to be liberated from its rock. We can ignore those cries, obviously, but that simple binary shape is the most powerful story that can be chiselled from the stone – it *demands* to be liberated.

The success or failure of archetypal story entirely depends on the understanding of this binary. 'It's Mr Chips to Scarface' was how Vince Gilligan famously pitched *Breaking Bad*. Similarly, Rick Jaffa and Amanda Silver described the journey of Caesar from loving chimp to animal revolutionary in *Rise of the Planet of the Apes* as 'Pinocchio to Moses'.[32] The ape who wants to be a boy turns into the ape who will lead his tribe away from humans, eventually becoming their mortal enemy. Even *Pinocchio* itself is puppet to boy. Puppet to puppet – in any three-dimensional story – simply doesn't work. Any story, as we have seen, is built around dissonance. Antagonism is all.

Some years ago, a professor from a British university contacted me to see if I could help him deliver more powerful presentations. He had a great message to get across, but somehow, he said, it was

landing on deaf ears. I asked him to send me an example of what he was doing and the problem soon became clear. He'd made a film outlining a new initiative he'd created. In it, he talked about the enterprise and then spoke to a couple of other people who all agreed it was a good idea. Then he declared to his audience that, yes, it seemed to work.

I've seen that video nearly a thousand times. Even today, if you were to ask me what he was saying I couldn't tell you. I could name the process, but, beyond that, almost everything is instantly forgettable. It's actually almost impossible to watch without zoning out halfway through.

He comes across as kind, dedicated and keen to give his students as good an experience as possible. Empathy clearly isn't the problem. The problem is there's simply no antagonist. He'd designed a great system, but you can't extol the virtues of a great system if you don't show what the system is designed to defeat.

And not just *show*. Any good story must fashion its antagonist in such a way that it creates emotion. You must long for the villain to be defeated. Ideally, the act of dispatch also will give you satisfaction – or, even better, pleasure.

How does one design an antagonist? In the university professor's case, he'd devised a system to combat unnecessary bureaucracy and speed up decision-making. What should have been the antagonist? A dystopian, *Bleak House*-style crush of cobweb-strewn paperwork, piled from floor to ceiling – that would probably do. Who wouldn't wish to defeat that? It doesn't need to be extreme, obviously, but the more extreme it appears the more powerful the argument becomes. If, as discussed in Chapter 1, stories are simply the resolution of dissonance, then the way that dissonance is both created and vanquished should help us understand how, by utilizing the forces of antagonism, stories achieve their world-beating power.

In 2005 the Christian website Ship of Fools declared it had found the funniest religious joke of all time, 'Man on a Bridge':[33]

Once I saw this guy on a bridge about to jump.
I said, 'Don't do it!'
He said, 'Nobody loves me.'
I said, 'God loves you. Do you believe in God?'
He said, 'Yes.'
I said, 'Are you a Christian or a Jew?'
He said, 'A Christian.'
I said, 'Me, too! Protestant or Catholic?'
He said, 'Protestant.'
I said, 'Me, too! What franchise?'
He said, 'Baptist.'
I said, 'Me, too! Northern Baptist or Southern Baptist?'
He said, 'Northern Baptist.'
I said, 'Me, too! Northern Conservative Baptist or Northern
 Liberal Baptist?'
He said, 'Northern Conservative Baptist.'
I said, 'Me, too! Northern Conservative Baptist Great
 Lakes Region, or Northern Conservative Baptist Eastern
 Region?'
He said, 'Northern Conservative Baptist Great Lakes Region.'
I said, 'Me, too! Northern Conservative Baptist Great Lakes
 Region Council of 1879, or Northern Conservative Baptist
 Great Lakes Region Council of 1912?'
He said, 'Northern Conservative Baptist Great Lakes Region
 Council of 1912.'
I said, 'Die, heretic!' And I pushed him off the bridge.

Written by the comedian Emo Philips (though they failed to credit him), the joke is even better when you see him deliver it. It's a perfect distillation of what Freud called 'the narcissism of petty differences', and a good illustration of how we will go to any lengths to define ourselves through opposition. In interacting with others, we seek to be unique, and to be unique we must demonize 'the other'.

Within any period of economic uncertainty can be found a rise in nationalism, the demonization of any enemy and the creation of an

outside caste. As with the Jews in Nazi Germany, so (on a far lesser scale, thankfully) immigrants en masse in the UK. The rise of UKIP, then Reform, and Brexit itself – all are direct results of the rush to blame anyone but *us*.

Nazi and Jew, Hutu and Tutsi, Uzbek and Kyrgyz. From India and Pakistan to Israel and Gaza and divided Cyprus; Shia or Sunni, Tamil or Sinhala, Flemish or Walloon – what do these groups, across the globe, have in common? Neighbours almost always, rivals in dispute, certainly – yet more. Each is protagonist to the other's antagonist; each is the hero in its own story of their battle to vanquish the monster – the embodiment of everything they think they are not. Each, *in extremis*, is Chief Brody to the other's great white shark.

And each of course, is remarkably like the other: the narcissism of petty differences again.

We exist inside the prison of our own heads, forever at one remove from everything and everyone else. The reason we tell stories is to bridge that terrifying gap, but there's a downside too: we *want* to be different; we need our own identity and in order to achieve it we construct reality to oppose, and thus define us. Finding we are not much different to neighbours we therefore *impose* difference. In our own minds we turn those we perceive to be against us into the absolute opposite of ourselves. Such is the power of this process that it can quickly blind us – as President George W. Bush was to discover – to empirical truth.

The Pet Goat by Siegfried 'Zig' Engelmann occupies a unique place in American history. A grade-school reading book, it stands at the fulcrum of not one, but two wars. It was the story President Bush was reading to a class of school children on 11 September 2001, when his chief of staff interrupted him to whisper, 'A second plane hit the second tower; America is under attack.' And it's a symbol in another battle, too.

In January 2001, Bush had launched his 'Reading First' initiative, part of his wider 'No Child Left Behind' programme, the aim of which was to ensure every child could read by the third grade. It was a huge initiative – the largest federal programme in US history.

The Pet Goat was designed to teach children about words ending in 'e'. The goat, the children learned, 'ate cans and he ate canes. He ate pans and he ate panes.'

The initiative was phonics based, and that was a problem. It played directly into a culture war going on at the time between left and right. 'Reading Recovery' was a programme created by New Zealander Marie Clay, its core tenet being the rejection of phonics (the sounding out of letters) in favour of a technique based on Whole Language Learning, in which children learned by deriving meaning from pictures and context.[34] It was a war that had been incubating for many years, but it exploded when Bush adopted phonics as his own. Phonics had to be wrong, screamed the left, because Bush was a right-wing monster, and, from there, first California, then much of the rest of the country embraced its opposite. The results were disastrous. In spite of a significant body of empirical evidence, Whole Language Learning became the new standard. In 2023, the National Literacy Review reported that '21% of adults in the US are illiterate in 2022 [. . .] 54% of adults have a literacy at 6th Grade or below.'[35]

If you were asked to assess the better reading programme, and George Bush were completely absent from the equation, which would you choose? The answer would be the one that works. And if Donald Trump were pro-phonics – how would you feel then?

Our urge for self-definition requires an antagonist, and the search for that can quickly distort our understanding of the world.[36]

The biggest paradox of narrative is that the process that allows us to make sense of the world also traps us within certain endlessly repeating patterns that can also stop us from truly understanding it. Faced with the choice between truth and tribe, the cognitive dissonance, with its attendant fear and trauma, that choice creates keeps us pinned to our tribal tracks. This can make stories impervious to reason, but it's also what gives them most of their strength.

This desire to define oneself leads to a phenomenon which often rears its head in territorial disputes. In 2006 Roger Eatwell, a British political scientist, gave it a name: cumulative extremism.

Cumulative extremism is uncanny in the way it echoes story

structure.[37] Eatwell was inspired by the riots that rocked northern England around the turn of the millennium. In times of deep unease – religious, economic and identitarian – humans become more tribal. The tribe gifts them an identity they have felt lacking before. Then, to bolster its image, the tribe seeks an enemy, and if the ground is fertile a spiral of extremism starts to emerge. If you feel the world is prejudiced against you it's understandable to take solace in the more radical version of your own tribe. Journalist and author Anne Applebaum puts it well:

> [. . .] the mutual anger also acquired its own logic and its own momentum. The perception of anti-Muslim prejudice pushed some Muslims toward radical preachers. The radical preachers provoked an anti-Muslim backlash. Extreme language on one side led to extreme language on the other. Organized violence on one side led to organized violence on the other. Both would blame the other for accelerating the dynamic, but in fact the process of radicalization was mutually reinforcing. Milder, more moderate members of both communities began to choose sides. Being a bystander got harder; remaining neutral became impossible.

These wars are, of course, a live re-enactment of Freud's petty differences. Applebaum notes the parallel with Northern Ireland, where the resurgence of the IRA in the late 1960s was a direct result of the British crackdown on Catholic civil rights marches. As things escalated, the police's inability to control the violence led to a loss of faith in British institutions:

> That loss of faith then led, in turn, to a greater acceptance of violence and eventually to the same phenomenon that Eatwell observed. People who had been only slightly interested in politics were drawn in. The numbers of centrists shrank. In both communities, terrorists found safe harbor among ordinary working people who, in the past, had never considered themselves radical.[38]

This may prolong conflict and escalate violence in the real world, but in attracting people to your story, it's a gift.

At heart it's a law of physics. For each action there is an equal and opposite reaction. You hit someone, they hit you back. But you can't win by just reciprocating the blow. You must hit back harder. Forces of antagonism in any story must increase. Newton is left behind as the snowball rolls down the mountain, getting larger and larger as it careers towards us.

This is how cumulative extremism *and* stories work. They either build or they die. It's why soaps that are forced to drag storylines out for a huge number of weeks so often fail: their stories run out of opposition, or the obstacles become increasingly laughable.[39] If you're reading a book, a script, a newspaper column, make a note of when you look away. It's almost certainly at the point that the boulder that should be going up the mountain rolls back down. Stories *must* build. If they don't, they either explode in bouts of terrible violence or the viewer or listener gets tired of the fact they have nowhere more extreme to go.

Cumulative extremism is, of course, just another name for a purity spiral, the process by which members of a group seek virtue by adopting ever more extreme values to illustrate their fidelity to a cause. This is the most perfect and chilling illustration of story structure at its best, and the history of the French Revolution offers a good example. How did France go from a revolution to overthrow an uncaring monarchy to establishing, with an emperor, a whole new kind of tyranny again? As the scholars Katrin Redfern and Richard Whatmore have observed, it followed a classic spiral.[40] Look at each stage, and mark how it builds into a perfect – chiastic – story.

1. On 14 July 1789 the Bastille was stormed. As the aristocracy abandoned all inherited privilege, wigs were banned and new rights were given to the people. Huge arguments over the nature and direction of France were to follow, but within four years Louis XVI went to the guillotine for treason. A new world was born.

2. Statues were toppled, aristocrats too. Many either fled the country or changed their names to join the mob. People's

blood was up, but with it their *fear*. The only way to show loyalty was to be more revolutionary than those around you. In China, centuries later, Mao would demand the elimination of the 'four olds'– old things, old ideas, old customs and old habits. So it was in revolutionary France. To survive, aristocrats had to prove their fidelity to the new world by pointing out the lack of it in others. Cries of 'traitor' went up, as each proved their worth by naming the 'guilty' men.

3. On 1 April 1793, a new law was passed designed to seek out and kill these traitors – or anyone who was 'an enemy of liberty'. Robespierre assumed total power and imprisoned anyone who seemed remotely suspicious.* He denounced the Catholic Church and declared a new religion, the Cult of the Supreme Being, of which (naturally) he was the divine representative on earth.

4. This was too much for his compatriots, and a coup took place. Robespierre denounced 'internal enemies, conspirators and calumniators' as he was led to the guillotine.

5. Civil war broke out, which led to aristocratic rule, and then another coup placing, finally, a god-like emperor in charge. Napoleon went on to conquer most of Europe, scattering his family members on its various thrones. The king is dead, long live the king.

The French Revolution is Mr Chips to Scarface, Pinocchio to Moses, freedom fighter to tyrant. Every purity spiral follows the same path – they're simply a story amplified to its highest degree. The desire to be different means that every single beat is a war between something and its direct opposite. Absolute opposites smash into each other at every stage, like the robots from *Transformers*, laying chains of cause and effect behind them and catalysing a huge emotional response. They build first to the midpoint (Robespierre assumes power), then on towards the inevitable crisis – the worst possible consequences of the behaviour catalysed at the inciting incident. This,

* The English, or anyone having anything to do with them, were prime targets.

the end of stage four tells us, is how bad things can get, posing the question, as Robespierre is led to the guillotine, 'Do you want to go *this* far?'[41] Lay out the beats of your fiction – do they resemble such a spiral? If not, maybe you're doing something wrong. But more importantly, do those beats stir your blood?

Like a tornado ripping a house from the ground, purity spirals tear arguments away from their empirical foundations. They have only one goal: the antagonist can't just be humiliated, they must be annihilated.[42] Apologizing is pointless – merely the first scent of blood to drive the accuser wilder still. The charge of betrayal gives an electric charge to the indicter. It's addictive, it's powerful, it's invigorating (there's a neurological element to this, to which we will return). Accusation is deeply addictive, combining the ecstasy derived from being the most extreme with the violence that comes from destroying nuance and ambiguity. Purity spirals are the perfect illustrations of perfect structure. Participation is intoxicating. Audiences *crave* these stories.

What marks spirals out for particular attention is that they're always a product of the deepest fear of their particular time. Once it was witches, later communism. In 2021, post the shocking murder by US police of George Floyd, racism became the spark. The nightmare of being denounced as a witch, a communist or a racist became everyone's greatest fear. The modern left holds no greater terror than being denounced for bigotry, just as in the French Revolution being an aristocrat, or even being sympathetic to aristocracy, was a mark of Cain. Such is the terror of exile from the tribe, it can only be cleansed by denunciation. Even then, it's almost never enough. It is this fear that leads people too often from rational thought. What does that tell us? Be deeply wary of any attempts to cancel speech – almost always those calls are part of a spiral, not of common sense. And if you're looking for an antagonist to propel your story, as Netflix's huge 2025 hit *Adolescence* discovered, find the biggest fear of your time.[43]

The Scottish philosopher David Hume was one of the founding fathers of empirical thought. You might imagine he'd be horrified by the puritan purity spiral that emerged out of the English Civil War.

But with classic intellectual detachment he claimed it was absolutely worthwhile, comparing it to a 'wild storm bringing calm'.[44] While his morality may be questionable, that's one great definition of a story.

The novelist Rachel Cusk defined an argument as 'an emergency of self-definition'. That's what a story is too. A great antagonist forces the protagonist to destroy their old self-image, finding it wanting. Then, by defeating that same enemy, the protagonist is able to reinvent themselves.[45] Richard Hofstadter wrote, presciently, in 1963, 'The truth is that the right-winger needs his communists badly, and is pathetically reluctant to give them up.'[46] That was the gift that Hillary Clinton gave Donald Trump.

'Hillary Clinton was the perfect foil for Trump's message,' said Steve Bannon, then the Trump campaign's chief executive officer. 'From her e-mail server to her lavishly paid speeches to Wall Street bankers, to her FBI problems, she represented everything that middle-class Americans had had enough of.' Clinton turned a failed property dealer and TV presenter into a president. Socrates referred to this process thousands of years before as 'definition by negation'. In the first book of his ongoing history of the Republican Party, *Before the Storm*, Rick Perlstein quotes Gene Wyckoff, Nixon's head of advertising in 1960. If you want to win, Wyckoff said, you need 'a first-class villain to make a first-class hero'. The job of any writer of fiction, just like any political operative, is to provide that first-class villain – ideally one that abolishes all common sense, who must be defeated at *any* cost, and can thus dispel Cusk's emergency of self-definition. With this defeat comes the wild storm of the purity spiral, perfect self-definition, the searing pleasure of both indignation and rage. And a perfect story.

The Goal

Screenwriting, said the director Elia Kazan, is the art of turning psychology into behaviour. Making the intangible tangible should be

every writer's, actor's and director's goal. The best filmmakers under-
stand you don't carry a film's meaning in dialogue – you carry it in
action and symbol. It's enough for a character to seek a goal (happi-
ness, wealth, revenge), but how much more powerful if you embed
that goal in a symbolic object. Don't seek power, seek Vibranium
(*Black Panther*). Don't seek love, seek Juliet (*Romeo & Juliet*). Don't
seek heroism, return the ring (*The Lord of the Rings*).

Citizen Kane is remarkable in almost too many ways to mention.
'You see,' it seems to say, 'you thought you understood cinema, but
you don't. *This* is what film can do.'[47] Of all its extraordinary inno-
vations, one of the most radical is often overlooked – the way the
film utilizes the relationship between the protagonist and their goal.

Who is the protagonist? It's not Kane. Instead, Orson Welles,
writer Herman Mankiewicz and cinematographer Gregg Toland con-
spired to do something almost completely revolutionary. The actual
protagonist is called Jerry Thompson, he's played by William Alland
and that you don't remember him is part of a very deliberate design.

Thompson is the journalist charged by the anonymous newsreel
editor with finding out the meaning of Kane's last words. We never
see Thompson's face: most of the time we only hear his voice, occa-
sionally we glimpse his back. The lighting design, a retooling of
German expressionist cinema and its epic chiaroscuro, conspires to
make him completely anonymous. He's supposed to be. He's *you*.[48]

It's a fascinating experiment that might explain why many find
the film a little cold – so much of the action is seen through Thomp-
son's eyes, yet his eyes remain entirely out of view. There's no emo-
tional connection. Instead, a bit like Netflix's *Dahmer*, we hop from
character to character, hoping to find a warm, receptive heart.

What propels the film instead is 'Rosebud'. Kane's last word.
'Find out what "Rosebud" means' is the goal.

The film (though not Thompson) tells us at the end that Rosebud
was the name of Kane's childhood sledge, lost when he left home.
'Dime-book Freud,' Welles called the device, and on one level you
can see his point.[49] Psychologically it's superficial, but in storytelling
terms it's about as good as a tale can get. Rosebud is a symbol of

innocence, of his mother's love, of paradise lost. It's primal, emotive and it tells us, in a simply tragic way, that losing his childhood both motivated Kane to build his empire and yet could never replace what had been taken away. *Citizen Kane* offers a masterclass in every single filmmaking department, but perhaps its most valuable lesson lies in understanding that an ill-defined protagonist won't damage a story if they are pursuing a perfectly chosen goal.

On my first day in TV, I sat, too terrified to speak, in an *EastEnders* writers' room. Bianca, the highly strung and vivacious eighteen-year-old character, was storylined to have a nervous breakdown in an upcoming episode, and the writer was dismissive: 'I'm not going to write that.' 'What are you going to write then?' 'Bianca's lost her hairbrush.' Everyone laughed. The writer played with the numerous rings on his fingers and smiled knowingly (it's as vivid as ever to me, even now).

A week later, the script was returned, and Bianca had indeed lost her brush. The growing angst with which she greeted the news, and how that angst mushroomed into a search of her bedroom, her parent's house, the local community, and led to a massive confrontation in the local pub, the Queen Vic – well, that was Bianca going slowly mad, but without exposition, reflection or interior monologue. To this day, it is the best lesson in television I've ever had.[50] You want to land a story? Find the hairbrush. Embed a quest in a tangible goal. You want to introduce Steve Jobs in a movie? Get him to spend the first act growing increasingly irate when, at the launch of the brand-new Mac, his machine is refusing to turn on and say 'Hello'. Aaron Sorkin's script for *Steve Jobs* is built around a series of simple, tangible aims. Watching a despot getting increasingly violent because he needs his product to be friendly and welcoming is both great drama and a fantastic way to establish a conflicted character.

Goals and antagonists are of course deeply related. The former is often simply the death of the latter. Viewed like that, finding the right giant to slay is central to narrative power. One example from real life may serve, I think, to illustrate just what that combination can do – and what that process may teach us about fiction.

A liberal father – a peace-loving, Dylan-listening hippy – takes a journey to the heart of the American right. His right-wing son takes the opposite road, eventually finding himself, in time, a liberal Democrat. At the fulcrum of the two journeys is a story that changed American political life irrevocably – abortion.

It's tempting to believe that opposition to abortion is one of the foundation stones of the American right, but it was of no real interest to either Republicans or Democrats before the mid-1970s, and it only emerged when one man's passion was co-opted in a fairly cynical alliance.

Francis Schaeffer was an aspiring film director, and his father was midway on his voyage to the Christian right.[51] He asked his son to help make a series of short religious films 'where Dad would take his interest in culture but explain it to an evangelical audience who basically didn't even like art'. The film series was called *What Happened to the Human Race?* and it was Franklin himself who came up with the topic of abortion.

> [I got my] girlfriend pregnant when I was 17 [. . .] and became passionately involved in the issue of abortion [. . .] I had this little girl, and Genie and I were these typical unwed teenage parents. I loved this little child; how on earth can anybody abort a baby? It was just personal and visceral.[52]

The father was sceptical about using abortion: he saw *Roe v. Wade* as nothing more than Democrat overreach, while the evangelical church he belonged to showed almost no interest at all.

> It was a Roman Catholic issue, not a Protestant issue [. . .] Jerry Falwell said: 'It's nothing to do with us. Why would I want to take a stand on that? I'm just a preacher. I want to talk about the Gospel, not social issues.'[53]

What gave the idea currency wasn't just Falwell's change of mind. The thing that lit the fuse on an issue that would go on to tear apart a whole country was, as ever, a very useful antagonist.

Schaeffer's film, even today, is *weird*. White-faced children wander

the earth, ghosts of the unborn dead. A thousand naked toy babies surround Dr Schaeffer, who stands on a rock in the middle of the Dead Sea and intones 'This is the site on which the city of Sodom once stood . . .' before letting loose a Holocaust dog-whistle: 'At least 6 million babies have been aborted,' he claims, 'liberation from biblical absolutes are bearing their bitter fruit.' This, the film is saying, is what abortion *is*. It's kitsch, it's horror, it's ghoulish and grotesque – but it's effective.

The film immediately attracted press attention and, perhaps inevitably, feminist groups started to picket screenings. Counterprotests duly followed against the feminists, and before anyone could blink a revolution had begun. If the women hadn't protested there would have been no purity spiral, and it's highly likely that abortion would be relatively uncontroversial today. But why did it catch fire so quickly?

It's immediately emotional. As soon as you see a foetus in outline it sparks a primal reaction, impervious to rational thought – 'That's a child.' Feminists, the film said, wanted to suck this child out and kill it. If the test of a perfect story is giving a shit what your protagonist wants, then who could be against stopping *that*? Only psychopathic murderers, which is what – to evangelicals – feminists and then all Democrats became.[54]

A goal is good, a tangible goal is better. A tangible goal that reeks of emotion – that you could *fight* for – that's perfect. You could almost see the power coursing through the Republican Party – not just cities, but far-off villages were suddenly *alight*.

> [. . .] all these pastors who feel relegated to the fringe, they're totally irrelevant to American culture, nobody's listening to them [. . .] all of a sudden you take a stand on this issue, you're on the front page of *The Washington Post* [. . .] you've got a club with which to win an election, and you have a senator saying to you, 'Thank you, pastor, for letting me come to your church and talk about my views on abortion . . .'
> [. . .] All of a sudden it was a dream come true. You have blue-collar Democrats voting for Ronald Reagan, and the Roman

Catholics, and people like us just handed them to them on a silver platter.[55]

In all stories, the goal is vital, but, like Rosebud, they're just a Trojan Horse to discuss the things you really care about. Normally those issues are complex, and symbols allow their easy digestion, but in the case of abortion that wasn't so. There was nothing complex about it. It was a proxy for – and a physical manifestation of – fear.

A great symbol is a tiny, bright, shining bauble, packed with fissile material: a foetus, drifting helplessly but for the love and protection of its parents. A child in all but name whom your enemies want to murder – and only you can save it. That feeling – the one Schaeffer set loose within the religious right, the one that evokes traces of blood in the water – is an almost overwhelming narrative power. Just look at the might of the party that embraced it.[56]

Pulling them Together

All stories are built from the holy trinity of protagonist, antagonist and goal. Francis Schaeffer's abortion story was a classic example of how to unite them. The deeply emotive nature of the goal gave the whole thing an unholy power. Why was it so emotive? Partly because of its utter simplicity, and partly because to so many it symbolized an attack on family. We are tribal people – for most of us, family, be it real or proxy, is the thing we hold most dear.

Happy Valley is ostensibly a cop show, but the drama is rooted in something far more primal: Catherine's passionate defence of her family, particularly her grandson, whom she would literally commit murder to save. This is a profound part of our psyche, one that TV fitfully understands. *The Dick Van Dyke Show*, *The Mary Tyler Moore Show* and *The Andy Griffith Show* all got it, as did *Rawhide*, *Gunsmoke* and *Wagon Train*. These are the tent pegs the founding fathers of television hammered into the ground. The marquee they erected would hold *Star Trek*, *M*A*S*H*, *Grey's Anatomy*, *ER*, *The West Wing*,

The Sopranos, Breaking Bad, Z-Cars, Call the Midwife, Death in Paradise, Doctor Who, even *Shameless*: all families fighting for survival of some sort. It's the common denominator of almost all successful television, enacting the attack on and defence of the one thing most of us hold most dear. The antagonist attacks that which is most prized, the protagonist defends it, the audience identify and become utterly consumed by the desire that the witch should be killed.

The same rules are amply visible beyond drama. The Salem witch trials, thanks to Arthur Miller, have become one of the West's most famous cautionary tales, and the perfect illustration of what a story can do when unleashed by malevolent hands. You want to get a message across? Embed it in a clear, specific and ideally emotional target. Kill the witch. From China's Cultural Revolution to Russia's pogroms, from McCarthyite America to Corbynite Labour, the same cry echoes across them all: 'If you join me in this quest to find and kill *this specific target*, you will be saved. Don't, and you will be damned.' If you've ever been on a political demonstration, you will have tasted the intoxicating power of yelling 'Witch!' or 'Traitor!' Such fervour is a direct product of identifying the 'best' story goal. Every powerful story has at its heart a version of 'kill the witch'. Indeed, on one level, every successful story *is* a witch hunt. A goal that rewards the victor and punishes the vanquished is central. How those goals are defined, established and then put to work lies at the heart of every powerful tale. All stories seek the seductive fantasies of Salem.

Andy Griffith was once one of the most famous men in America – and unique in playing both the most seductive fantasy protagonist and one of the great antagonists in American culture. The star of his eponymous show, he played Sheriff Andy Taylor, single father to the ridiculously cute Opie (played by the equally cute six-year-old Ron Howard) in the sleepy town of Mayberry, North Carolina. The blueprint for *The Waltons, Little House on the Prairie, The Wonder Years* and *This is Us, The Andy Griffith Show* was deliberately nostalgic. 'Well, though we never said it,' Griffith remarked years later, 'and though it was shot in the 60s, it had a feeling of the 30s. It was, when we were doing it, of a time gone by.'[57] Griffith, for an enormous amount

of the American population, was the Platonic ideal of what a man should be.

Griffith, like Pop Walton later, personified the values his country aspired to hold. The series lasted for eight years and never dropped below seventh in the Nielsen ratings. Twenty years after its cancellation, 5 million people a day were still watching reruns in syndication. The definitive embodiment of working-class values of the time, it's one of the foundation stones of American television. Griffith and his character, to most, were the same person – it was a classic healthy parasocial relationship. Over half of Americans felt Andy was their dad, their uncle or their best mate. If you want a hit show, you could do worse than look right here – it's a programme with a universally appealing protagonist. But Griffith is significant for creating one of the truly great antagonists too.

The film that first brought him to national attention was directed by Elia Kazan. *A Face in the Crowd* (1957) charted the story of drunken convict Larry Rhodes, a man blessed with fatal charm. Rhodes is spotted by an ambitious young journalist, Marcia, who believes she can monetize his potential. With his down-to-earth folksy humour, his lightning-quick spontaneity, his devil-may-care attitude and (more than a few) old-fashioned values, he is the walking embodiment of an American type. He's the voice of the people, thinks Marcie, who rechristens him 'Lonesome' Rhodes and, in a kind of inverse Pygmalion, sets about making him a star.

With his ability to ad-lib his way out of any situation, his disrespect for contemporary values and his gleeful irreverence, Rhodes seduces the American public and Marcia too. A TV show follows, then, almost inevitably, politics. He is the walking, talking embodiment of populism, and bears an extraordinary resemblance to the protagonist that, more than any other, dictates and dominates our time – Donald Trump. And within the Trump phenomenon lie our most powerful lessons – or warnings – concerning protagonists, antagonists and goals.

Trump's triumph grew out of the seeds planted by Barry Goldwater in 1964. The neo-con politics that peeked out of that soil began

to grow, slowly metastasizing into the Tea Party wing of Republicanism. Tapping into what Richard Hofstadter called 'The Paranoid Style in American Politics', in his essay of the same name, Trump found a well that no responsible commentator believed was quite that deep.

Writing shortly before Hofstadter's essay, Norman Mailer had already noted the same strain. 'Since the First World War Americans have been leading a double life,' he wrote,

> and our history has moved on two rivers, one visible, the other underground; there has been the history of politics which is concrete, factual, practical and unbelievably dull [. . .] and there is a subterranean river of untapped, ferocious, lonely and romantic desires, that concentration of ecstasy and violence which is the dream life of the nation.[58]

Ecstasy and violence.

Jack Reacher. Killing Eve. Wednesday. Succession. Happy Valley. Luther. The Last of Us. I May Destroy You. Fleabag. Baby Reindeer. Squid Game. If you want the most volatile, combative, viral, infectious stories – they are prescribed within the emotion and action here.

Anyone versed in even the most elementary critical thinking cannot fail to notice that Donald Trump is unlike any previous president. A convicted felon and would-be insurrectionist with a trail of broken businesses behind him – he is part P. T. Barnum, part avenging angel. He seems to disdain the constitution, appearing to see it as an obstacle to his goals rather than the totem all presidents are elected to serve. All of these things should count against him, but all, of course, are fuel to his fire.

He 'was vulgar, almost illiterate, a public liar easily detected, and in his "ideas" almost idiotic.' Not Trump, but another great fictional character – Buzz Windrip – the demagogic protagonist of *It Can't Happen Here.* When Sinclair Lewis was writing his dystopian thriller in 1935, it was a response to the rise of Hitler and Mussolini. William L. Shirer pointed out that the liberal world believes it is different from the progenitors of fascism, but Lewis begged to differ:

Something in the intensity with which Windrip looked at his audience, looked at all of them, his glance slowly taking them in from the highest-perched seat to the nearest, convinced them that he was talking to each individual, directly and solely; that he wanted to take each of them into his heart; that he was telling them the truths, the imperious and dangerous facts, that had been hidden from them.[59]

Trump embodies the very same paranoid qualities. A wounded population saw someone who offered to heal them – and, more, offered that service as a cathartic bomb disrupting liberal norms. Every utterance showed the governing class the respect he felt they deserved – none. 'For those voters who feel the game is rigged,' wrote *Guardian* journalist Jonathan Freedland on witnessing Trump in action, 'who feel that the game has turned them into perennial losers – the sight of someone prepared to defy its conventions is exhilarating. It signals the arrival of an outsider, a maverick unbound to the old order and ready to destroy it in favour of something entirely new.'[60]

If you're down already and you see someone contemptuously dismiss you and your community – people who police your speech and appear to indoctrinate your children with their values behind your back – then, as the conservative commentator Mike Cernovich, who came from such a community, put it, there is only one response: 'You don't get to tell me what to say – fuck you!'

Trump rode a howl of primal rage. There is nothing constructive in this kind of politics; when he stood for re-election in 2020, he couldn't even be bothered to write a manifesto. The message was simple, and if federal communication laws hadn't forbidden it, his campaign slogan could just as easily have been 'Fuck you!' And that's a lesson too. If you want a story to percolate, you need to distil it to its absolute basics. ('Strip the barnacles off the boat,' said election guru Lynton Crosby.) The simpler it is, the more basic it is and the more emotional it is, the more powerful it will be. Vote for Donald Trump. Don't like it? Fuck you!

We might feel we should look down on that, but when the *Daily Telegraph* accused others of 'Brexit betrayal' and the *Daily Mail*'s front page called Britain's High Court judges 'Enemies of the People', the emotion was closer to the surface than we might like to think. Even when the subject is milder – a newspaper column on Japanese knotweed, a guide to stamp collecting – the stories that resonate are the ones that liberate us to slam the book shut on our foes knowing they lie bleeding in the dirt. Catherine Cawood, Thomas Cromwell, James Bond, even Jane Eyre, slay their demons (external or internal) and order is restored. Order fuelled by something dark.

Revenge is obviously a key driver of some of the most popular narratives. *Jack Reacher* is one of the most successful franchises – and protagonists – in the world. This modern-day knight-errant who wanders the American hinterland administering his own brand of justice has been the hero of twenty-seven novels, clocking up 100 million sales worldwide. His creator, Lee Child, was a former Granada documentary producer who was sacked from his TV job. Redundant at forty. Revenge.

'The surest way to work up a crusade in favour of some good cause is to promise people they will have a chance of maltreating someone,' said Aldous Huxley. 'To be able to destroy with good conscience, to be able to behave badly and call your bad behaviour "righteous indignation" – this is the height of psychological luxury, the most delicious of moral treats.'[61]

Such traits are all too obvious in *Robocop* or *High Plains Drifter*, but what about the pleasure in listening to Britain's foremost left-of-centre broadcaster James O'Brien, or to right-leaning Joe Rogan, the highest-paid podcast host in the world? To their audiences these men are not just best mates, they are avatars on a moral crusade, fervent in pursuit of their goal.

A goal of course *can* just be a hairbrush, but if you want to supercharge it, you freight the symbol with emotion – and for maximum gain you don't make it a goal you wish to attain, you make it something you want either to possess or destroy by any means necessary. The joy of shouting 'Karen' at entitled white women, or yelling

'Gammon' at middle-aged Blairites, is not that far removed from pointing your finger and whispering 'Traitor', or 'Witch'. As René Girard wrote in his book *I See Satan Fall Like Lightning*, it's intoxicating. So much so we seek victims we can defend: 'the victims most interesting to us are the ones that allow us to condemn our neighbours'.[62] Just like the characters in Emo Phillips' 'Man on a Bridge'.[63] That intoxication is key to understanding story's true power.[64]

When Richard Hofstadter wrote that 'anti-Catholicism has always been the pornography of the Puritan' he was alluding to a universal relationship between the two extremes in every story, and the terrible, brilliant, cathartic, disturbing relationship that can sometimes exist between them.[65] The protagonist is in a pornographic tussle – a dance of death if you like – with its antagonist. The dance between Ahab and Moby Dick cannot fulfil its promise unless it evokes the scent of blood of the white whale. Friedrich Nietzsche once wrote of the 'men of *ressentiment*', characters who carried within them 'a whole tremulous realm of subterranean revenge, inexhaustible and insatiable in outbursts'. *Squid Game*, *Fleabag*, *Succession*, *Killing Eve*, *Luther* and *Happy Valley* are all, at one level, pornographic. It's hard not to escape the fact that ecstasy and violence are the lubricants of so many successful tales.

When William L. Shirer wrote *The Nightmare Years* he was trying to make sense of what he'd witnessed first-hand – the total and complete triumph of a single toxic narrative that unleashed one of the most sustained and brutal catastrophes known to man. Why did Germans become Nazis? The conclusions, for anyone reading, were clear.

Firstly, a wound caused by rampant inflation, a breakdown in established order and a grievance fuelled by two connected ideas. Their country had been betrayed by their own generals in the previous war, then punished beyond reason by the countries that had been victorious.

Secondly, an enemy that perceivably caused it. Those who, the narrative went, now looked down at them, feeling smug and superior. Not, many Germans believed, real Germans at all.

LESSONS FROM THE SCHOOL OF POLITICS

Thirdly, an opportunity to cauterize that wound – to be healed by burning away that poison, both within the country and without.

Finally, a parasocial and empathetic relationship with a father – a Führer – who welcomed you into his family with open arms, offering you the ecstasy of healing, of love, and the opportunity for brutally violent revenge.[66]

Squid Game replicates this exact story architecture. The wound is the brutal nature of laissez-faire capitalism, the enemy an uncaring plutocracy trying to kill you for sport. By tracking down those true culprits, the desire for transcendent revenge will be sated. The show works entirely as a metaphor for how many feel about their way of life: that most of us are participants in an arbitrary game of cruelty rigged by a rich elite, on whom, if we persevere, we can enact revenge. While Gi-hun may not be a father figure, he is in a very real sense *us* (outnumbered, unskilled, naïve to the workings of the world), as well as the us (tenacious, resourceful and determined) we would like to be.

That wound is key. Stories will work whatever a character's fundamental flaw. Selfishness, greed or self-doubt – all will serve just fine. But if you can tap into the reader's or viewer's subconscious damage or grievance – that sense of disquiet with themselves – and from there show a path to healing, then you are mining the most powerful narrative seam of all.

In *The True Believer*, Eric Hoffer outlined the appeal of fascism to the marginalized. What attracts them is a story – a promise – of transformation. *Happy Valley* stars a middle-aged woman whom everyone underestimates, everyone patronizes and everyone thinks is past her prime. That's a wound. Every season ends with her obliterating her doubters, and the final episode of the show's three seasons ends with a perfect example of chiasmus: her antagonist burning to death as, for a few important seconds, she looks calmly on. It's ecstatic. It is almost unbearably violent. And we applaud. The wound is salved for both Catherine and her audience, hand in hand.

The perfect story then won't just offer a sticking plaster to that

wound, but a complete and utter transformation. You – the reader, the viewer – it tells you, can be whole again. That's the line that runs from *Repair Shop*, through Ronald Reagan, all the way to the evangelical preacher and the demagogue. It's what suffuses not just *Happy Valley*, but *Wednesday*, *Erin Brockovich*, *Jack Reacher*, *Yellowstone*, *Bad Sisters*, *Harry Potter*, *Baby Reindeer* and *Mr Bates vs The Post Office*.[67] Look at any modern hit. It's almost disturbing how often you find it there.

All take story and charge it with the transcendental by promising transformation and affirmation. All lubricate that promise with the twin agents of ecstasy and violence. In doing so they can shout like an evangelical preacher, like Elmer Gantry, like Lonesome Rhodes – 'Praise the lord, you have defeated Satan! Praise the lord – you are healed!' Unpalatable as it may sound, the most successful fiction offers us death to our enemies and salvation for ourselves.

4

A Place Called Hope

The Rules of Rhetoric and Their Application in Drama

'Of all the talents bestowed upon men, none is so precious as the gift of oratory. He who enjoys it wields a power more durable than that of a great king. He is an independent force in the world. Abandoned by his party, betrayed by his friends, stripped of his offices, whoever can command this power is still formidable.'

Winston Churchill[1]

In 2002, 120 million people lived under some kind of populist government. Seventeen years later that figure had multiplied exponentially. By 2022, hundreds of millions of people lived under such regimes, with populist leaders holding power in countries like Hungary, India and Brazil.[2] Ripples that began in small countries like Ecuador, Latvia, Paraguay and Croatia swelled into waves that swept across Bolivia, Nicaragua, Mexico and El Salvador. As they churned through much of Europe, powered by the winds of demagoguery, they built into a tsunami that would overwhelm Hungary, Turkey, Mexico, Brazil, India, Tunisia, Russia and of course the US. In some countries the sea drew back, but even there the lingering tidemarks of damage remain.[3] How did that happen? How, in so many places, did unqualified, unscrupulous, unserious or unprincipled people – all claiming to represent 'the people', all with an enemy they would term 'elite' – gain office with promises of simplistic retribution? Chairman Mao said that political power 'grows from the barrel of a gun', and that's

true in some of these cases. However, the most important strategic area in any war is not the disputed territory, it's the battlefield *inside* the combatants' heads. *Cognitive Warfare*, the Chinese military now call it, contradicting Mao.[4] Guns don't matter. In the right order, with the right speaker and the right targets, they understand that the most potent ammunition to win a war is words.[5]

Rhetoric is the art and science of persuasion. If, as Pixar illustrates so well, stories are built around the process of learning, then at some level they must be tools of persuasion too: they must convince you the knowledge they are imparting is correct. It's not a great leap, then, to see that rhetoric and narrative have much in common. Indeed, viewed through the lens of rhetoric, the true power of the perfect story comes into a sharper focus, unlocking a fresh understanding of the power and application of character, emotion and story desire, alongside the importance of purpose and timing, and a whole new way of understanding structure. Having mastered these, the power of which Churchill spoke becomes available.

<p style="text-align:center">★</p>

> I was born in a little town called Hope, Arkansas, three months after my father died . . .

A series of black-and-white photographs glide past as the narrator tells us how he came from rural poverty, shook JFK's hand as a student, and eventually became governor of his great state. 'After I graduated, I really didn't care about making a lot of money,' the kindly southern voice tells us, one stop away from a drawl. 'I just wanted to go home and see if I can make a difference.' And now, he's saying, he wants to continue that journey from poverty all the way to the White House.

The speaker is Bill Clinton and 'A Place Called Hope' was a slogan, a speech and an advert that not only fuelled his re-election bid against the heavily favoured Bob Dole in 1996, but revolutionized the modern political campaign. It's a good place to start, because it contains fundamental elements normally only discussed in the study of rhetoric, but which have a profound bearing on storytelling too. These elements are traditionally known as Aristotle's rhetorical appeals.

The appeals are outlined in the second of the three books that make up Aristotle's study of rhetoric. Like the legs of a stool, they are mutually dependent. They are *ethos*, the character of the speaker; *pathos*, the ability to incite emotion; and *logos*, the apparent logic of the argument. Clinton is declaring he's just like you (ethos), he's tugging at your heart strings by mentioning his father's early death (pathos) and he's creating a seemingly logical argument (logos) – it's an act of altruism, he implies, that qualifies him to be president.

Clinton, despite having lost both the House and the Senate in the midterms, employed 'A Place Called Hope' to win the 1996 Presidential election decisively, taking 379 electoral votes to Dole's 159. The lessons of that strategy are indispensable to rhetoric – but also to drama, and wider narrative too.

Ethos

Two speeches on the Ukraine conflict that dominated politics at the beginning of 2022:

> The fact is that Ukraine, which is a non-NATO country, is going to be vulnerable to military domination by Russia no matter what we do. [. . .] We have to be very clear about what our core interests are and what we are willing to go to war for. And at the end of the day, there's always going to be some ambiguity.

And,

> While the US has many vital national interests – securing our borders, addressing the crisis of readiness with our military, achieving energy security and independence, and checking the economic, cultural and military power of the Chinese Communist Party – becoming further entangled in a territorial dispute between Ukraine and Russia is not one of them.

These are almost identical in outlook.* Yet one was greeted with barely a ripple by the left, the other with outrage. The first quote is Barack Obama reacting to the Russian invasion of Crimea in southern Ukraine.[6] The second is one-time Republican party hopeful Ron DeSantis outlining his position on the conflict after Russia expanded its territorial ambitions to the whole country.[7]

It's basic, but it's important. It's not the message, it's the person saying it. If you're a Republican, then you're more likely to dismiss the argument from the Democrat, and if you're a Democrat you will denounce DeSantis as the heir of Neville Chamberlain, selling out a people for short-term gain. (And that's what happened: 'Appeasement!' many people cried.)

So why would we take one seriously and the other not? Partly of course because we are deeply tribal animals, but also because any protagonist will generate unconscious feelings in their audience which determine their level of engagement. This is their *ethos*.

Much of this is related to the kinds of empathy discussed in the previous chapter, but there's something else here – *deep* empathy, if you like. A great character can turn a good story into a life-changing experience. It's a phenomenon that can be seen most clearly by studying rhetoric, for it is here that you see visceral proof of how the right speaker with the right words can move a mass of people towards whatever they believe to be their promised land.

On 8 December 1941, Franklin D. Roosevelt dictated to his secretary Grace Tully a short speech. The day before Japan had bombed the American fleet at Pearl Harbor, and he knew instinctively the emotional response he needed to create.

> Yesterday, December 7, 1941, a date which will live in world history, the United States of America was simultaneously and deliberately attacked by naval and air forces of the Empire of Japan.

* As political commentator Andrew Sullivan has noted: https://andrewsullivan. substack.com/p/the-biden-desantis-re-balancing-act?utm_source=substack&utm_medium=email.

Reading it back he made two small amendments:

Yesterday, December 7, 1941 – a date which will live in infamy – the United States of America was suddenly and deliberately attacked by the naval and air forces of the Empire of Japan.

The first opening is good, but the final draft – embedded still in the American psyche – heightens the outrage and the deceitful, villainous nature of the enemy. In one clear, short, simple sentence Roosevelt positions himself as not just a moral authority but a righteous avenger, and America – the *United States* of America – *is* him.

Reeling from an unprecedented attack (imagine 9/11 but on a far greater scale), who would you want to channel your fear, your anger, your incomprehension? Nearly a century of American foreign policy stems from Roosevelt's one sentence. It's clear, it's immensely powerful and by the addition of 'infamy' with its short, sharp shock, followed up quickly by the cross punch of 'suddenly and deliberately', the speech provokes an immediate emotional response. You are flooded with outrage, but then, slowly, as he outlines what he is going to do (declare war), another emotion kicks in. Roosevelt has issued an implicit invitation: 'Come and be me, for here true meaning, purpose and excitement will be found.' You may baulk at 'excitement' in such a context, but the promise of being someone else, and in doing so getting what you haven't got, is too tantalizing for most to resist. You are being invited to leave your mundane, perhaps damaged body and become someone else. He is America, yes – and you can be *him*. Together we are righteous, and we will win.

It's this second process that is key to the deepest kind of empathy: you inhabit a person who gifts you the identity you most desperately require. Their identity enchants you, filling every crevasse of your being with desire, and that pull creates a kind of literary osmosis. You flood into them, until your fictional avatar is replete with you.

What you most require, of course, can be deeply subjective, but there are certain key elements that every powerful character can offer. The writer, journalist and war correspondent Sebastian Junger spoke of the qualities any tribe in peril requires if it is to be

saved, and it is striking how readily they apply. The first, he said, is not just any goal, but 'a transcendent cause – I'm fighting for the freedom of my country and the safety of my family'. Any great protagonist offers their audience the chance not only to leave their imperfect body by inhabiting another, but in doing so to find *purpose*. Transcendence – always the most powerful goal. Junger's second quality was equally important. What you need, he said, is a 'leadership that is willing to die. If your leaders are not willing to suffer the same consequences as everyone else your cause is going to fail.'[8] This is Roosevelt, obviously, but it's also Harry Potter and Luke Skywalker. Think, too, of *All Quiet on the Western Front*, *Thelma & Louise* and *Game of Thrones*. In epic sagas of conflict such dynamics are clear and obvious. However, even in chamber pieces like *Priscilla*, *Aftersun* or *The Quiet Girl*, there's a similar pattern playing out. 'War' is whatever represents an existential threat to a protagonist – and if they promise you they can defeat that threat and that they won't give up whatever the cost, then the underlying emotional impact is just as strong.

Although they certainly didn't when my career began in television, most screenwriters now understand that empathy is minimal if a character is just nice. 'Nice' incites sympathy or admiration, qualities which, counterintuitively, remind you you're observing. You are separate, and therefore 'nice' pushes you away. For a true melding of viewer and fictional mind, something else is required, visible in the greatest rhetoricians and rhetoric of any era. The virtuous qualities Junger suggests, leadership and transcendence, may make for strong bonds, but something equally powerful, if not more so, comes from the dark twin of transcendence – transgression.

The opening of the very first episode of *Killing Eve*, written by Phoebe Waller-Bridge, is a striking case in point. Our heroine Villanelle smiles across a café at a little girl eating an ice-cream sundae. It's sweet, it's charming – very old school. We are sympathetic, admiring even. 'What a nice lady!' we think. Then Villanelle looks at her watch and rises. The little girl smiles in anticipation as she approaches – who is this kind stranger? Will she say hello?

As Villanelle reaches the little girl she, too, smiles – then tips the girl's ice cream into her lap. In thirty seconds, the scene has shifted from sympathy to something far more potent. We should hate her, but Villanelle has unveiled a dark, thrilling fantasy world and beckoned us inside. We love her for a monstrous act. Classic definitions of empathy would tell you that shouldn't happen, but in fact the bonding is far more acute. 'Do I give a shit what they want?' is still key, but understanding that we can want things we rarely admit to consciously is even more potent. 'Wow!' we think as Villanelle strolls past, our darker instincts now fully inhabiting hers.

Something very similar happens in Todd Phillips's *Joker*. Here sympathy turns to empathy when the contempt Arthur Fleck endures drives him to murder, and we find ourselves rooting passionately for a psychopath. If you're a liberal, the idea that you could identify with what is, in essence, a deeply right-wing revenge fantasy might seem incomprehensible. The reason so many of us did is because most of us can identify with being ridiculed and hungering for revenge. 'Come in,' says the character, 'the rewards are utterly enticing.' The pleasure of watching Hitler in *Downfall*, or even Mark Zuckerberg in *The Social Network*, is the pleasure of experiencing for two hours what it would be like not to care what anyone thinks of you.[9] There's a reason Brian De Palma's *Scarface* remains revered by so many – particularly in marginalized communities.[10] Al Pacino's Tony Montana, out of his brain on coke, introducing his double-clipped M16A1 grenade launcher with 'Say hello to my little friend' – it's overwhelming.

What we consciously condemn we often unconsciously celebrate. Most of us would be appalled by a bombastic, sex-obsessed, millionaire charlatan who treats women as chattels and whose narcissism borders on pathological. Empathy for Donald Trump, we declare, is impossible. And then we put our feet up for a night's streaming, and find ourselves revelling in Robert Downey Jr's Iron Man, Marvel's most ridiculously successful character. Shut your eyes – they're almost the same person. What all of these characters offer is *thrill*. The gateways to these feelings are fairly universal – sympathy in Joker's case, admiration at the moment we meet

Villanelle. Those prise the gates of empathy open, but what follows next is also vitally important. Standing at those gates, can you spy the promise of a better future or a greater transgressive thrill? Can you hear them whispering quietly, 'Hey, you like me – wouldn't you rather *be* me?' If the answer is yes, the gate slams shut behind you. You are *in*. You have been seduced by the exhilarating drug of not giving a fuck.

Joker, Villanelle and Iron Man all have the qualities of a leader and a mission that promises transcendence – it's just that the transcendence on offer is targeting parts of the psyche we consciously supress. Normal empathy appeals consciously. That can work, of course, but the most powerful stories are those where you want to be the protagonist *beyond* all reason. Does your character offer your audience something thrilling, either legal or illicit? Intoxication? Another life? Do you love them *despite* yourself? As *The Times'* review of Disney Plus's massive hit *Rivals* put it, 'Everyone in *Rivals* is despicable, but I would give anything to be friends with them.'[11] That's it. Look at every Tarantino film, or the TV programmes that bewitch us like Roosevelt did.[12] Most of them are dark and righteous, vengeful against their own Japanese fleet. *Succession, Fleabag, I May Destroy You* – all peopled by proxy leaders with life-or-death causes. Does the journey with your protagonist promise you that?

There's one other thing ethos can teach us. Donald Trump and Tony Stark both tap into a gleeful iconoclasm that lurks within. Stark, however, was able to do something Trump found much harder in 2020 – transcend his base. For the truly successful protagonist (and politician), such a skill is essential. Ronald Reagan had it in spades. You don't win by just motivating your base, you win by persuading others to vote for you.

Look at the following: *Strictly Come Dancing, Doctor Who, The Crown, Bridgerton, The Bodyguard, Line of Duty, Succession, Sex Education, Sherlock, The Last of Us, Stranger Things, Inspector Morse, Cracker, Prime Suspect, Breaking Bad, Star Wars, Squid Game, Game of Thrones, Harry Potter, Top Gun: Maverick, Happy Valley, The Office.* And not just drama: *Porridge, The Likely Lads, Only Fools and Horses, Gavin & Stacey,*

Dad's Army. And not just situation comedy. Comedians: More-combe and Wise, Peter Kay, the Two Ronnies; and then musicians: The Beatles, The Rolling Stones, Stevie Wonder, Elvis Presley, Bob Marley. What do they have in common? Some of them are old.* But more significantly, all of them managed to transcend their initial race-, gender- or class-based tribal appeal.

Observe the film and TV hits recent to the time of writing: *Wednesday, Happy Valley, The Bear, The Last of Us, Chernobyl, Adolescence, Baby Reindeer, Barbie* and *Oppenheimer*.[13] And then the failures: *The First Lady, The Time Traveller's Wife, Truelove, Empire of Light.* The stories that work lie at the heart of the Remain-versus-Leave Venn diagram. Their protagonists are designed, consciously or not, to transcend their tribe. There are many reasons for the current malaise in the American movie industry (Covid, streaming, absurd levels of choice) but one of the most significant is that as the country has become more polarized it's almost forgotten how to talk to anyone beyond its own tribe. Rather than create protagonists those in red states might bond with, a traditionally liberal-leaning industry more often makes those characters antagonists for blue states to despise. As Jeremy Corbyn discovered when his disciples told his critics to 'Fuck off and join the Tories' – they did. No one ever wins an audience by telling them they're shit and should really go away. Steven Spielberg understood this with almost every movie he ever directed or produced. The same with James Cameron's *Avatar*, despite its green agenda. You win landslides, like Roosevelt did, by winning the love of both Republicans and Democrats. That's the breakout ethos of Robert Downey Jr's Iron Man – he captured the *id* of both parties, and half of them despite themselves.

No one since Roosevelt understood this better than Ronald Reagan, and his election in 1980 transformed American and world politics. This great political realignment even gave a name to a class

* Age is important. Many of these TV programmes are products of a three-channel world, where it was easier to transcend tribe. However, even in those days, ITV and BBC viewers were significantly tribal. In a time without remote controls, it wasn't uncommon for families in the UK to rarely, if ever, change channel.

of person – a Reagan Democrat – who abandoned their traditional party loyalty to find a new home. Reagan, 'the great communicator', had an uncommon ability to bridge old divides. His main tool – arguably his only tool, in fact – was rhetoric, of which he was a master.

There are few greater examples of his skill than the speech he gave on 28 January 1986. It was supposed to be the day of his State of the Union address, but a catastrophic event turned everything on its head.

> Ladies and gentlemen, I'd planned to speak to you tonight to report on the state of the Union, but the events of earlier today have led me to change those plans. Today is a day for mourning and remembering.

That morning, at 11.39 am, the Space Shuttle *Challenger* had imploded 73 seconds after lift-off, killing its entire crew. The speech Reagan gave that night is one of the most famous of his presidency, and its last lines narrowly avoided melodrama to lodge themselves in American history:

> The crew of the space shuttle *Challenger* honored us by the manner in which they lived their lives. We will never forget them, nor the last time we saw them, this morning, as they prepared for their journey and waved goodbye and 'slipped the surly bonds of earth' to 'touch the face of God'.[14]

The speech (the full text of which can be found in the Notes) was written very quickly by young staffer Peggy Noonan. The language is plain and simple, and the delivery – a perfect illustration of ethos ('he can heal us') – doubled its power.[15] If a leader's job is to embody the soul of a people, their moral character if you like, then Reagan was, in that moment, untouchable. It is also, for those not too hard of heart, profoundly moving. Pathos, the ability to incite emotion, is, fittingly, the second of Aristotle's rhetorical appeals.

Pathos

Reagan's task that night was to salve a nation's psychic wound. He had to somehow reach a vast cross-section of the public, including the millions of schoolchildren who'd tuned into the *Challenger* launch to watch the first graduate of the Teacher in Space programme – Christa McAuliffe.

Reagan's words turned unspeakable horror into heroic self-sacrifice. The astronauts died not because of NASA's grievous mistakes, but because they had embarked on a special kind of journey, part of a continuum stretching from the very earliest origins of their country. Their death was not grisly, but a sacrifice for a nation that prized exploration and discovery over their con-comitant perils. It's hard not to be roused by that emotion. And if one wonders why so many of us remember Christa McAuliffe most of all, the answer is simple: it's not just that she was undoubtedly brave, not just that she carried the hopes and dreams of a nation's schoolchildren, all of whom were watching. It's that among those millions of transfixed children were not just her own former pupils, but, at Cape Canaveral, her nine-year-old son Scott and six-year-old daughter Caroline, too.

Later investigations were to reveal how negligent NASA had been, but that's not what the generation who witnessed the *Challenger* disaster talk about. We instead remember Christa McAuliffe, who, transmuted by Reagan's narrative, became no longer a school-teacher but a symbol of benign American power in the pursuit of knowledge. We remember because her story is a button that, when pressed, creates a curiously intoxicating emotion. Her story inspires us, while at the same time making us cry. And, in doing that, Reagan spun what was (frankly) a terrible fuck-up into a transcendent tale.

Emotion is utterly vital to the success of any story. Tears are great, but they don't have to be tears. Laughter is equally good – fear and anxiety too. What matters is that feelings arise as the story pro-gresses, and those feelings shift us into a different state. Done well,

we enter a liminal world, far beyond the rational one we inhabited when we sat down to watch or read.

A story that doesn't do that will rarely rise above the status of 'interesting'. The more you can arouse those feelings, the more powerful the story will be. Charlie Chaplin was the first film-maker to really understand this. While Fatty Arbuckle and his contemporaries saw slapstick as an end, Chaplin's comedies exist one step away from tragedy. The underlying desperation of *The Gold Rush*, the anger at exploitation in *Modern Times*, both contain the grit in the oyster that produced a luminous string of pearls. It should have been shocking to learn that the one-bedroom tenement set where Chaplin looked after Jackie Coogan's little boy in *The Kid* was an almost identical replica of the house where Chaplin himself had grown up in indescribable poverty. If we look less at Chaplin than we used to, it could be because we've grown less inclined to look at that horror. Still, his ability to morph damage into both comedy and tragedy, and then alternate between those two poles, made him not just cinema's first truly great artist, but perhaps also its only universal star.

As the fictional Colonel Parker said in Baz Luhrmann's *Elvis*, you want an audience to feel things they're not sure they should be feeling. Chaplin did that better than anyone – he spun his audience into an ecstasy of love and hate, revenge and desire, flooding them with feelings they would normally deeply suppress. He has so much still to teach us: if you manage to achieve what he did, then your audience – tasting that forbidden fruit – will eat your story alive.

What all of these responses have in common, of course, is that they stimulate a hormonal response. If we want to reach the liminal state that the most powerful stories require, we will get there through the application of chemistry. The most successful storytellers, it turns out, are drug dealers.

Allen Carr smoked so many cigarettes they caused his nose to bleed. There were days when so much blood would pour from his nose and over the cigarettes he was smoking it would turn the white stalks red. When he finally gave up aged forty-eight, at a point when he was

consuming up to one hundred cigarettes a day, it was because of one simple insight. Smoking, he realized, was a confidence trick: it fooled you into believing you had to smoke to relieve stress, when all along it was in fact its cause. The insight turned him into a smoke-free multimillionaire, with seventy clinics in over thirty countries. His work, it was claimed, allowed 25 million people to shake themselves free from the drug. How?

His epiphany had arrived via his son John, who had given him a medical textbook as a present. It described the withdrawal from nicotine as 'an empty, insecure feeling'. A bright white light went on: 'Cigarettes are the cause of their stress, and not its remedy.'[16] The only thing, Carr worked out, that makes you want to have the next cigarette is the previous one.

It's a brilliantly simple observation about the nature of addiction, and has profound implications for storytelling too. Each scene is a cigarette.

At the beginning of Asif Kapadia's documentary *Amy*, four teenage girls sit on the stairs in the hallway of a London terraced house. It's 1998 and Juliette is singing happy birthday to her friend Lauren. Then the handheld camera spins round onto fourteen-year-old Amy Winehouse, who takes up the song and, in little more than twenty seconds, seems to reinvent the very idea of what singing can be. We are totally and utterly besotted. She transcends the expectations we have of her, flooding us with emotion. And it's this kind of subversion of expectation that creates the most powerful kind of narrative engagement of all. Kapadia has hit us with a powerful drug. We are momentarily transcendent, but then the hit starts to pall. We need the drug – indeed more of it – again. And so we watch on . . .

Subversion of expectation is often seen as populist, perhaps because action and adventure films use it all the time. In James Cameron and William Wisher's script for *Terminator 2*, young John Connor is on the run from Arnold Schwarzenegger's T-800 Terminator. Or at least he thinks he is. But in this second movie, unlike the first, the baddie is not who it seems – it's the far more deadly and advanced T-1000. Everything in the opening act of the new film, from

the crushing of the roses under Arnie's feet to the cop uniform worn by the T-1000, is designed to make the twist at the end of the act feel as unlikely as possible. When the Terminator shoots the cop and saves John, it's a gigantic subversion of both character and audience expectation. It floods us with relief and love, and, in that moment, triggers an elemental release which rivets the viewer to the story.[17] That release is one of the cornerstones of drama. It's the same as in *Amy*. It's something the Greeks articulated over 2,000 years ago.

Aristotle called it *peripeteia*, which means 'reversal', but if you've grown up in Great Britain, you'll know it as the drums that end every episode of *EastEnders*: the *duff-duffs*, the moment that brings new life to a story. Peripeteia triggers a hormonal release which is hugely powerful in itself, but also has a profound knock-on effect – the same one Allen Carr observed in smokers. It turns you into an addict.

How does it work?

In Act One we examined the primary unit of all dramatic construction:

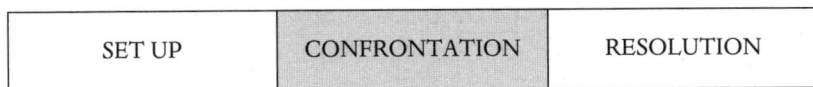

SET UP	CONFRONTATION	RESOLUTION

The diagram shows three acts, but it also represents, because of its fractal nature, both an individual act and an individual scene. As screenwriting embodies the maxim 'less is more', the third, 'resolution' stage is often omitted because its contents can be inferred from what comes after.[18] As a result, the primary unit of all dramatic structure tends to just look like this:

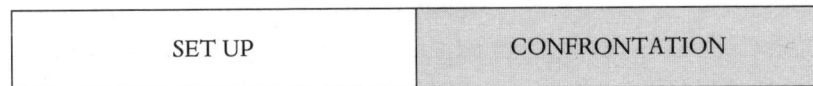

SET UP	CONFRONTATION

In his book *The Science of Storytelling*, Will Storr describes the key moment where every story begins – the moment of change. Once

upon a time, in such and such a place, *something* happens. Stories are individual units of change strung together in a chain of cause and effect, and so this 'something happens' unit is the primordial soup out of which all narrative must emerge. Any sensible story-teller would want such a unit to have maximum impact. To get that, the unit most commonly resolves into these two stages: *something* confronted by its opposite.

It's not hard to see how this unit of structure morphs easily into subversion of expectation. If you want to weaponize your story, why not make the thing that happens not just a new event, not just an opposite, but a complete and shocking surprise? When little Amy unleashes the voice of an angel, when the Terminator saves John, an immediate dissonance occurs. It's fascinating and enthralling – strange, and thus compelling. You want to know more. You can feel the chemicals rush in. You are being drugged.

New information triggers an audience reaction, but subversion of expectation turbocharges that moment. It floods the audience with (in this case) dopamine – normally understood as the 'feelgood' hormone, but in scientific terms now more often described as a trigger of 'motivational salience' – a chemical, released by a neuro-transmitter, that confers a desire or want. In layman's terms, it creates an appetite: it's sugar, it's nicotine, it's heroin. A good story does exactly what a great drug does, it creates a psychological depend-ency, a craving for more.

'Screenwriting,' said comedian and writer David Gross, 'is con-stantly figuring out what no one will see coming that makes perfect sense.'[19] It's a great definition, and helps illustrate how subversion of expectation really works. It's not a gimmick. It's integral – and has the same mechanism as any joke. Les Dawson, a very old-school comedian, gave a ridiculously simple example: 'There is a remote tribe that worships the number zero,' Dawson would proclaim to his audience, before leaving an all-important beat. 'Is nothing sacred?'

That laughter you emit when the joke lands is a product of chem-istry. It's a drug. And, as Allen Carr pointed out, once that drug is

in your system, you want more of it. You don't want the pain of withdrawal – you want to smoke one hundred cigarettes a day.

Story – and drama in particular – is the same. It's a drug delivery system. Scenes exist because they are units of change, they contain a turning point. In a successful scene that turning point will contain a hormonal charge – a hit that will trigger an emotional reaction: love or laughter, hate or fear. Like nicotine, that hit will quickly fade and the audience will demand another, and another, and another, and before you know it a powerful narrative is born. If you don't follow up with the demanded drug, however, the reader or viewer will grow listless and distracted. They'll pick up their phone instead, where better drugs are guaranteed.

You can overstate this – not every scene has got to feel like it's the end of *EastEnders* – but without change in each sentence or each scene, your story will die. Primates in particular are endlessly entranced by the 'new'. Repetition is death – what audiences crave is the *next* cigarette, not the previous one.

Shane Black, the writer and director of *Iron Man 3*, was once asked the secret to good action sequences. He, too, went back to Aristotle.

> Reversals [. . .] It's like a good news/bad news joke. The bad news is you get thrown out of an airplane. The good news is you're wearing your parachute. The bad news is the rip cord breaks. The good news is you have a backup chute. The bad news is you can't reach the cord. Back and forth like that until the character reaches the ground.[20]

It's great advice and it applies to far more than action scenes. You want to create a riveting, addictive, propulsive script? It's scene after scene of good news/bad news jokes; reversals from beginning to end.

In 2019, Matt Wolpert and Ben Nedivi's last episode of Season One of *For All Mankind* was a masterclass in this technique – just one big shock followed relentlessly by another. Or, if you want, go back a century to the beginnings of Hollywood, where Harold Lloyd's

Girl Shy is an equally sublime example.* But it's not just action or comedy. The Irish-language film *An Cailín Ciúin* (*The Quiet Girl*) could not be more superficially different: a slow, lyrical movie based on Claire Keegan's novel about nine-year-old Cáit trying to find her place in a world that doesn't want her. The scene structure, however, is exactly the same as in *Terminator 2*. Scott Frank's peerless adaptation of *The Queen's Gambit* does likewise, each scene swinging the pendulum from solitude to solicitude, then back again.[21] Reversals are narrative's heavy artillery. George Orwell used them in *1984* ('It was a bright cold day in April, and the clocks were striking thirteen'), as did Sylvia Plath in *The Bell Jar* ('It was a queer, sultry summer, the summer they electrocuted the Rosenbergs [. . .]'). Look at *Fleabag*, look at *I May Destroy You*, look at *Squid Game* – all perfect examples of the technique, though no one deployed it more effectively than Truman Capote in *In Cold Blood* when he describes Perry Smith murdering Herb Clutter: 'I thought he was a very nice gentleman. Soft-spoken. I thought so right up to the moment I cut his throat.' Feel the drug coursing through your body. Feel yourself demanding *more*.

Asked to choose between 'cheap, fast or good' when making a movie, *Mission Impossible* director and writer Chris McQuarrie responded with one word – 'emotional'.[22]

So storytelling is drug dealing, but in the best kind of narrative there's something beyond the nature of the hit itself, another vital effect the introduction of true pathos brings. In 2023, J. K. Rowling was talking not about literature, but about the seductive appeal of black-and-white thinking:

> It's the easiest place to be and in many ways it's the safest place to be. If you take an all-or-nothing position on anything, you will definitely find comrades, you will easily find a community [. . .]

* The entire last act of *Girl Shy* is a race against time. Its influence on *The Graduate*, *Notting Hill* and a thousand other 'race to the church' films is all too clear. The way the chase was shot was revolutionary for its day, and Lloyd was consulted for, and some of the shots were copied in, the infamous chariot race in *Ben Hur*. All of the breathtaking stunt work was done by Lloyd himself, who was missing the fore-finger, thumb and part of the palm of his right hand.

What I feel very strongly myself [is]: we should mistrust our-
selves most when we are certain. And we should question our-
selves most when we receive a rush of adrenaline by doing or
saying something.[23]

That adrenaline rush bars you from the road of reason. Rowling
continues: 'Many people mistake that rush of adrenaline for the
voice of conscience [. . .] In my world view, conscience speaks in a
very small and inconvenient voice, and it's normally saying to you:
"Think again, look more deeply, consider this." '

Hormonal stimulation, she's saying, destroys rational thinking.
That's bad when you're trying to make sense of a complex world,
because it inhibits you from any kind of critical thinking. But, in
terms of story, it's not just good – it's vital. Frank Cottrell-Boyce was
one of the writers behind two of the most memorable moments in
recent British public life. He dropped the Queen from an airplane
with James Bond in the 2012 Olympic opening ceremony, and then,
for her Diamond Jubilee, had her host a tea party with Paddington
Bear. In September 2022 he reflected on their emotional effect:

> There was no intention for her to appear in the first one. The
> producer Tracey Seaward went to what she thought would be a
> routine meeting at the palace to ask what the Queen would be
> wearing so that our actress could dress like her. It was the Queen's
> dresser, Angela Kelly, who said: 'Oh, she wants to be in it.'
>
> She put herself up for that moment. It's a moment that was
> meant to amuse people for one night only. If she hadn't been
> in it herself that is all it would have been. But the way director
> Danny Boyle timed that turn of the head – that great reveal,
> 'my God, it's really her' – means that 10 years on, it's one of
> her defining moments.

What he says next however, is most significant:

> Moments like this happen incrementally. Part of their power is
> surprise. When we are surprised, our prejudices and opinions
> evaporate for a moment and we're briefly open hearted. Surprise

is the nemesis of cynicism. One of the most common reactions to that moment was 'I never felt patriotic before'. Maybe. Maybe you felt something like patriotism – some love for the best of this place, but didn't know how to articulate it without condoning the worst. Maybe.[24]

The moment the Queen turned her head that night, the crowd squealed with delight. It's a classic subversion or peripeteia, and the subsequent hormonal release gets under all of our preconceptions. It allows us to see the world afresh and thus reconstitute our sense of reality. Little could be more important in story, because the most powerful stories are the ones that allow the viewer to slip the bonds of their preconceptions and set sail on a new, undiscovered sea.

Rowling rightly condemned this in rational argument but employed it with great skill in her fiction. In the seven *Harry Potter* books, Severus Snape is revealed as first bad (he tries to kill Harry), then good (he saves Harry), then really bad (he kills Dumbledore) and then really good (he didn't murder Dumbledore at all). It's Shane Black's action structure writ large. Each twist is a subversion of expectation, each a needle of adrenaline or dopamine plunged into the reader's heart.

This doesn't negate Rowling's point – it proves it. We like to think that politics is rational. It can be, of course, but mostly it resides in an emotional realm. If you've ever found yourself singing along to the national anthem at a party conference or waving a flag in a room full of others doing the same, then that's because you've been drugged. Ideology is emotional, even as we convince ourselves otherwise. Try writing a subversion of expectation at the end of every scene or paragraph. See what happens. That line, the one that stretches from Ancient Greece, through Shakespeare and *EastEnders*, to *Line of Duty*, *Fleabag* and beyond, is both a continuum and a rising trajectory. What do all the biggest drama hits since the advent of social media have in common? Not subject, not political point of view, but reversals. We are all in a dopamine war now.

There are neurophysiological changes associated with any change in our emotional state. It's a complex field, which for ease of

comprehension I have reduced to a simple metaphor: dopamine and adrenaline. If you swing your story between those two poles then the hormones generated will open the floodgates, raise your reader or viewer from their dry dock, detach them from the rational world and sweep them into fiction's vast, open, turbulent sea.[25]

Terrible in real life, but in stories a gift. Stories aren't rational – they just have the *appearance* of rationality. And it's this point that is at the heart of Aristotle's third appeal.

Logos

The third leg holding up the stool of rhetoric is the *plausibility* of the argument you make. When Martin Luther King declares that 'the arc of the moral universe is long, but it bends toward justice', it feels not just powerful and moving but a logical and persuasive observation. You agree, despite the speech containing no rational evidence to back the assertion up.[26] True observation demands empirical rigour. Stories merely demand the appearance of it. While it is character and emotion that perform the heavy lifting in any story, to give an argument true leverage – King's, Reagan's or anyone else's – it must *seem* logical, even if it isn't. In rhetoric and story, *apparent* logic is king: a story's assertions must *feel* true, according to the rules of the world being described.

The easiest way to understand logic is to look at it through a different frame – that of question and answer.

If the question is 'Why do ships not fall off the edge of the world?' the logical answer is 'Because the earth is round.' This is backed up by all the science we are aware of. But once upon a time, that's not what people believed. Prior to Plato, and more significantly Aristotle, it was assumed by most that the earth was flat, because to the human eye that felt plausible and true.[27] Stories and rhetoric work in the same way we did in the days of pre-Socratic philosophy. It's one of the reasons narratives are so seductive *and* destructive. Emotions unmoor our sense of reality from empirical observation, allowing us to set sail for conspiracy island.

Abraham Lincoln was not even the primary speaker on 19 November 1863, but in just a few minutes and 271 words he would deliver a speech that became a foundation stone of post Civil-War America. As he stood on the ground of what would become the Gettysburg National Cemetery, his speech asked and answered a simple question:

> Four score and seven years ago our fathers brought forth on this continent a new nation, conceived in liberty, and dedicated to the proposition that all men are created equal. Now we are engaged in a great civil war, testing whether that nation, or any nation so conceived and so dedicated, can long endure.

The question, of course, is 'Can it?'

Lincoln's answer is that it can – if, by reminding ourselves of the price paid by these people, we rededicate ourselves to this cause.

> It is rather for us to be here dedicated to the great task remaining before us – that from these honored dead we take increased devotion to that cause for which they gave the last full measure of devotion, that we here highly resolve that these dead shall not have died in vain, that this nation, under God, shall have a new birth of freedom, and that government of the people, by the people, for the people, shall not perish from the earth.

The trick of successful rhetoric and drama is, like Lincoln, to focus the story down to one simple, compelling question, then answer it in a way that appears plausible. One of the oldest myths in the UK is that immigrants are 'coming over here, taking our jobs'. It's rarely true (historically they tend to create more jobs or fill those others don't want), but *apparent* logic will sell the tale.[28] Almost all political discourse is filled with it. Some social justice warriors place all the ills of the world on Western Colonialism. They are keen to point out that every nation suffering from some form of genocide or intense suffering has been a victim of Western capitalism's rapacious desire to steal their natural resources.

This is a suitably attractive proposition for any would-be

revolutionary, allowing them to draw a direct line between colonial conquest and current suffering, but tribal identity conflicts are far more likely to be the cause of genocidal campaigns. Facts quickly become irrelevant when a simple causal relationship (however glib) between cause and effect can be adduced. That's immensely frustrating for fans of critical thinking – but a gift for those in the business of spinning fiction.

Always ask yourself if you can boil down your story, your article or your speech into one simple question. 'What is the cost of lies?' asks *Chernobyl* at its beginning. 'Just because we can, should we?' asks *Jurassic Park*.[29] So many successful stories have a central argument inspired by one simple question. The characters then fight over that central conflict – they *embody* that conflict – before coming to a conclusion. *Chernobyl* tells us, at its end, that 'the cost of lies is death'. 'Maybe we need to be more careful,' concludes *Jurassic Park*. It doesn't matter if that's not logical (it's very easy to argue against both propositions), what matters is that they *seem* to be. Without that veneer of plausibility, the audience won't engage and the emotion cannot get to work.

When Aristotle's rhetorical appeals are discussed, it's normally in terms of a triangle:

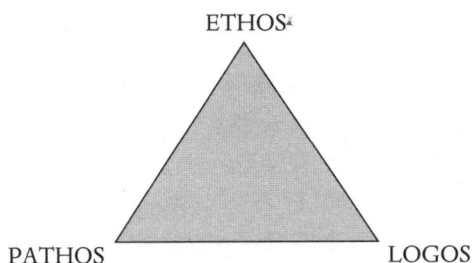

ETHOS

PATHOS LOGOS

While it's true that these elements in perfect balance massively increase the power of a narrative, there are two other rhetorical appeals that are often forgotten. *Kairos* and *telos* both have something to offer the storyteller too.

Kairos

Under a new head of drama, Jane Tranter, and after suffering for years under the commercial might of their rival ITV, the BBC had decided to fight back and re-enter a space that had been largely neglected for years. The show that would launch their bid to steal back the throne of popular drama was *Spooks*.[30] With a largely unknown cast – Matthew Macfadyen, Keeley Hawes and David Oyelowo – it followed a group of MI5 officers as they battled various threats to the British state. When I spoke to her, just after it premiered in May 2002, producer Jane Featherstone was clear about the reason for the programme's huge success. 'It was 9/11,' she told me. Everyone had been nervous – outside twenty-year-old John Le Carré adaptations there had been no great appetite for spy fiction on television. But suddenly, everything happening on *Spooks* felt real. It was huge, and it ran for an almost unheard-of eighty-six episodes – ten seasons over nine years.

Kairos means 'timing'. Every speech, every TV show has a window in which it can strike a chord – and, as you will know from watching in horror the shows your parents once loved, those windows can quickly shut. Jean-Pierre Melville made the greatest of all French Resistance films, *Army of Shadows*, but when it premiered in 1969 it died a death. The Resistance was by then seen as a Gaullist enterprise, and for the students, who the previous year had been barricading the streets of Paris, de Gaulle was the enemy. They wanted to bring him down, not pay tribute. Capturing the zeitgeist is difficult, especially because the lead-times in film and television tend to be very long, but when you do get it right something magical occurs. As Seamus Heaney put it, 'hope and history rhyme'. An audience watches, feeling 'How did they know?'

The big British hits of the late 1970s and early 1980s – *Minder, Only Fools and Horses, Auf Wiedersehen, Pet* – were direct reactions to the massive social upheavals that descended on the UK when Margaret Thatcher came to power. The simple pitch of *Friends* – 'your friends are your family now' – seemed to mark the

exact moment when nuclear families were superseded by proxy ones. *Life on Mars* took eight years and thirty-five drafts of its first episode to develop – it felt like a nightmare at the time, but the delay turned out to be a gift. Not only did the script continually improve, but when it premiered in January 2006 it hit a vital demographic at exactly the right moment. The show was partly a nostalgic wallow through the tropes of 70s Britain, and the children who'd lived then now had kids of their own – kids who were just old enough to appreciate the programme too. A good deal of its success was based on that simple multigenerational appeal. A few years earlier, a few years later, and it would have missed the mark. In 2020, the journalist Helen Lewis wrote of the programme 'I'm not sure you could make *Life on Mars* today without expecting questions about its hankering for a time you could rough up a suspect if you felt he deserved it.'[31]

Has any show captured broken Britain better than *Slow Horses*? Has any myth aged as uncomfortably as Superman? No longer can he, personified by Christopher Reeve, intone without irony that he is fighting for 'Truth, justice, and the American Way'.* In 2021 his mission statement was updated, no doubt fearing a generational backlash at its colonial implications, to the horrifically awful 'Truth, Justice and a Better Tomorrow'.[32] Try watching Eddie Murphy's *Trading Places*, or even *48 Hours,* now.[33] Conversely, have any shows matched *Squid Game*, *Succession* or *Game of Thrones* in catching the insecure, brutal, dog-eat-dog nature of our own time?

In rhetorical terms, the kairos in Reagan's *Challenger* speech is obvious. He had to speak on the day of the disaster. That's what it means in strict Aristotelian terms, but the principle is wider. When you're pitching a show and you're asked, 'Why now?', it's not a stupid question – it's the opposite. A small caveat, however: a drama or novel doesn't have to necessarily *capture* the time – it can also provide an antidote to it. *M*A*S*H* provided a powerful salve (a 'heroic' take) for an America traumatized by Vietnam.[34] *The Waltons* – one of TVs

* The original mantra was 'Truth and Justice'. 'American Way' was added once America entered the war – another illustration of kairos in action.

greatest hits – performed a similar function with the story of a family in Depression-era America. 'We were poor, but we were happy,' the programme said. The ultimate feelgood television, it was made throughout the 1970s, the decade not only of Vietnam but also Watergate and the oil crisis.[35] It was opposite to the moment, just as *Bridgerton*, with its colourblind casting policy, is now. Whether embracing the moment or hiding from it, timing is – almost – everything.

Telos

What's the aim of your composition? For Reagan it was to make sense of the senseless death of seven astronauts, and to transmute the terrible trauma a nation had witnessed into something specifically American and good. Lincoln was doing something similar. The telos of the Gettysburg Address was to inspire his surviving troops to fight on.

Every speech has a purpose. To demand justice, to get elected, to destroy something the speaker hates. And what of drama? What is the point of any narrative? It can of course be to make money, but that's never really enough. If you can define the telos, the objective of any story you tell, then not only are you imbuing it with purpose, you are also giving it shape. This can be political. Jimmy McGovern's *Hillsborough* had one specific aim – to show to Britain that a police force many trusted had lied about the deaths of ninety-six Liverpool fans. *Chernobyl* is less overt, but its purpose – to show how lies destroy everything – is also clear. It's a useful question to apply to any story. Consciously or not, the telos of *Yellowstone* is to illustrate and underline the primal forces that lie behind the concept of 'home'.

Everything that lasts is designed with a purpose, and that purpose in turn gives shape and meaning to the design. The purpose of an ear is to hear things, the purpose of a screwdriver is to screw. When you ask yourself what your story is trying to achieve (as opposed to what your protagonist is trying to achieve) you're not diminishing it,

you're forcing yourself to question every element of its design, so it can hear or screw more effectively. It's one of the least-asked questions by drama commissioners – but it is one of the most important. If you're going to dramatize the story of Jimmy Savile, the notorious paedophile, as the BBC did in *The Reckoning* in 2023, you had better be very clear what your telos is. If you're not, it looks like titillation, whitewashing or worse. What was the point of *The Crown*? Someone should have asked that when they made the final series, because, while for many years its purpose seemed clear, at the end it was hard to tell.

When Bill Clinton told us he came from 'A little town called Hope', he was employing every single one of Aristotle's tools. Ethos – 'I'm a simple, small-town guy'; pathos – 'My father died'; logos – 'I just want to be President, so I can give something back'; kairos – 'Let's return to homespun wisdom after twelve years of Republican plutocracy'; and telos – 'I could bring hope back to the American dream.' Both *Squid Game* and *Friends* embody each of these tenets too. When did Fox News, the scrappy young upstart, overtake the behemoth of CNN? After 9/11, when it started flying the flag and positioned itself as solely on America's side. That tragedy gifted them what rhetoric and story demand: Aristotle could not have wished for a better illustration of the power of his appeals.[36] Get them right and they will provide you with an iron skeleton for your story, as rigid and self-supporting as a three-legged stool. However, that's not the only gift rhetoric can bequeath the dramatist; it has equally powerful lessons to teach us about structure.

The Structure of Rhetoric

Marcus Tullius Cicero was a lawyer, an orator, scholar, politician and philosopher, and his influence is immense. He wrote widely, but the six of his books on rhetoric that have survived are amongst his greatest achievements.

Cicero is credited with providing the structural framework of all

classical oratory, the shape of which is visible in Reagan's *Challenger* speech, and in 'A Time for Choosing' ('The Speech') too.[37]

Cicero divided any piece of rhetoric into six distinct stages. The examples I've added to illustrate these stages are from Simon Lancaster's indispensable *Speechwriting: The Expert Guide*.

1. **Exordium**
 The audience is prepared
 (*Today we're talking about knife crime.*)
2. **Narration**
 The facts of the case are explained
 (*Knife crime has quadrupled since the 1950s.*)
3. **Partition**
 An outline of what is to be disputed or proven is made
 (*We can either tackle it head on or ignore it.*)
4. **Confirmation**
 The case for the idea is made by argument
 (*By tackling it, we can save thousands of lives every year.*)
5. **Refutation**
 The case against the argument is made
 (*If we don't, lives will be lost, communities will be wrecked, society will be harmed.*)
6. **Conclusion**
 Summary, arousing emotion
 (*Join me to save young people from dying and to make Britain a safer place.*)

One of the most memorable speeches of recent years is the address Michelle Obama gave to the Democratic Convention in Philadelphia in 2016. Written by Sarah Hurwitz (though it's said that Michelle Obama had sizeable input), its most notable line is probably 'I wake up every morning in a house that was built by slaves,' though 'When they go low, we go high' runs it close.[38] It is full of striking visual images – from the Obama children climbing into a black SUV surrounded by 'men with guns' at the beginning,

to the chiasmus of them playing happily on the White House lawn by the end.

With its use of tricolon, contrast, metaphor, anaphora and allusion, the whole speech is a masterclass in classical rhetoric. Its telos is to get Hillary Clinton confirmed as Democratic candidate and then elected president. Michelle Obama doesn't say that though – or at least not directly. She doesn't pose the most obvious, simple question, 'Why should we vote for Hillary Clinton?' Instead, she asks a different one – an emotional question, built into the speech's image system. It forms the spine of the work and gives it huge emotional heft. It's a simple, classic illustration of the single-question principle – 'Do you want your children to be safe?'

1. Exordium
 Today I want to talk to you about children.
2. Narration
 Bringing up children is a huge responsibility.
3. Partition
 We can either take on that challenge or ignore it.
4. Confirmation
 We take it on by electing Hillary Clinton.
5. Refutation
 We could expose our children to Donald Trump.
6. Conclusion
 Join me in my quest to elect Hillary Clinton.

Stories are chains of cause and effect lassoed around a truth located at the midpoint.* The first half of *Hamlet* is 'Who Killed My Father?' The second half is 'What do I do about it?' and the midpoint – Act III Scene II – is when Claudius' reaction to the players reveals his own guilt. In *The Godfather Part II*, the first half of the film is 'Who tried to kill my family?', the second half is 'What

* It doesn't have to be a literal truth, just whatever the orator/writer believes their truth to be.

am I going to do about it?' and the midpoint is Michael's realization in Cuba that his own brother was the guilty man ('I know it was you Fredo. You broke my heart'). The midpoint is the truth – the heart of the speaker's argument.

The parallel between dramatic structure and rhetoric couldn't be clearer. The first half of Ronald Reagan's 'A Time for Choosing' is 'There is a problem'; the second half is 'What do I do about it?' The centre – the confirmation – is 'Barry Goldwater thinks we can.'

Confirmation and midpoint – they're the same thing. The first half of Michelle Obama's speech is 'We have to look after our kids'; the second half is 'What if we don't look after our kids?'* The confirmation at its heart is 'Hillary Clinton *can* look after our kids.' That's the midpoint. That's the lesson.

Classic rhetoric follows exactly the same structural pattern as archetypal drama. Both are born from the act of perception, from 'I exist, I observe, I change'. A child discovers fire is hot, Michael realizes Fredo's guilt, Hamlet focuses his ire on Claudio, we learn to vote for Hillary Clinton. A speaker learns something, we empathize with them, they give us a common enemy and their speech allows us to kill that common enemy and learn that lesson too.[39]

The inciting incident – the 'question' in rhetorical terms – comes at the end of the exordium, the crisis at the close of the refutation. If there are any doubts about how closely rhetorical and dramatic structure are intertwined, look for the traces of ring structure or chiasmus. Reagan's *Challenger* speech is a perfect example:

A: We have lost them

 B: They showed great courage and sacrifice

 C: They had a hunger to explore the universe and discover its truths

 D: Pioneers make sacrifices – the future belongs to the brave

 C': Our hunger to explore the universe will continue despite our loss

 B': Courage and sacrifice are essential

A': They have been found by God.

* This is also classic thesis / antithesis.

It's even clearer in the Gettysburg Address:

A: A nation conceived in liberty faces great peril
 B: We are at war
 C: We must consecrate this ground
 B': War has great casualties
A': Liberty must be fought for again; only then can consecration have meaning.[40]

Rhetorical and narrative structure are, to all intents and purposes, identical.

Caitlin Moran was fifteen when she became the *Observer*'s Young Reporter of the Year, and she began to write for the weekly music publication *Melody Maker* a year later. She did a lot of radio and (mostly 'youth') TV, before becoming in 1992 a regular columnist for *The Times* where she has remained, writing two weekly columns, sometimes three. You don't stay a columnist for thirty years unless you're doing something right. Moran is the humorous, irreverent, slightly offbeat, occasionally very angry voice of her generation. She's brilliant, she's a mess, she's a great mum, she's a terrible mum, she struggles to fit in with any feminist ideal yet embodies them all, somehow, perfectly. Sometimes she makes you laugh, sometimes she makes you cry – and to a generation of readers, even though they've never met her, she's their best friend. In April 2017 she wrote a fairly typical column about giving up smoking at the age of forty-two. It began:

> I started smoking because I had to. I literally did. I was the youngest person at an adult-education centre – 16, and home-educated for the past 5 years. Everyone else was a grown-up – in their thirties, forties and fifties – all attracted to this part-time course on film and media because a) it was a pretty cool thing to do, and b) you got a free bus and rail pass for the entire West Midlands, and that was a pretty cool thing to do, too. To get free buses and trains to Dudley and Bilston. To *Birmingham*.

Moran navigates us through her introduction to TV lighting, through its comical intersection with sexism and feminism, to the moment where her new group all went out for a cigarette.

And because I did not smoke, I stayed inside, next to the drinks machine, and heard them all outside, introducing themselves to each other, chatting and borrowing lighters and cigarette papers, while I sat there thinking, 'OK, I just have to start smoking, then. That is clearly part of being a grown-up.'

She buys her first cigarettes – they are disgusting, but she persists.

The next day, at breaktime, everyone went out for a fag, and I joined them.

'Gah, I've been *dying* for this all day,' I said, as I carefully lit up and exhaled, along with everyone else, and started chatting. And I was part of the smoking gang! It worked.

And that was how I learnt how to be around people, and talk, and for people not to notice that I was a virgin child in a large hat, who had never been anywhere or done anything. By smoking. That was my . . . *thing.*

After the course ends, she is even more besotted.

And to a lonely child, cigarettes felt *magic.* A packet of cigarettes was like a combination of a shield and a sword. It both protected you from awkwardness – because someone smoking a cigarette isn't *lonely*; they're just smoking a ciggie – and cut you free from bad situations: 'Just going to pop outside for a fag.' They were useful. They really were.

However, now forty-two, her lungs ache, she smells and the reasons she took up smoking have vanished. Worse, she's terrified her sixteen-year-old daughter might copy her.

What if she picks up these old weapons – like a child finding a rusty grenade on a bomb site – thinking, like I did, that this is just part of being an adult? Some awful thing you must learn?

So, tomorrow, I'm finally giving up smoking. I'm finally going to *allow* myself to be stuck in awkward social situations, and to feel lonely, from time to time. Because, at 16, you *would* rather die than have 5 bad minutes. But, at 42, you think, 'Five bad minutes . . . that is better than no minutes at all.' *,41

It's not the Gettysburg Address – nor should it be. However, if a columnist is there to embody what they want the newspaper to be, then it's doing its job extremely well. And, like any good column, it's perfectly structured. She of course is our empathetic protagonist; the antagonist is tobacco. As for the rest:

Act One (and inciting incident): Left out of the group she must start smoking
Act Two: The desire to smoke
Act Three (and midpoint): 'Part of the smoking gang. It worked!'†
Act Four (and crisis): 'My lungs feel like two socks of wet ash . . . They are not useful at *all*.'
Act Five: I'm giving up.

Like any classic story, she doesn't get what she wants at the end of the tale – she gets what she needs. A newspaper column is where rhetoric meets drama. It's an incredibly demanding form, and in its own way Moran's embodies everything the two disciplines can tell each other. Ethos, pathos and logos are perfectly aligned. Kairos and telos too. It knows exactly who its audience is, and the audience absolutely believes its concerns are personified by the protagonist – whom they love beyond reason – and who will lead them to some ideally transcendent goal.

<div align="center">*</div>

* Note the chiasmus, also, in the last two sentences.
† The midpoint is the lesson, but it's not always overt. Often the second half of a story's job is to decode to the protagonist what the midpoint really means; in this case, it's that she's been totally deceived.

Rhetoric and narrative share the same pattern and the same rules because they are both built around the same process – that of reducing the world to order. In rhetoric that process is then expressed through direct address, while in fiction it is dramatized, but underneath they are identical – the product of our desire to wrestle meaning from a cruel and arbitrary world. As we shall see in the next section, that has enormous implications for the nature of belief.

Donald Trump was re-elected in 2024, and his triumph should give us the last word on political narrative. What his victory proved is that if you want to elect a candidate, just concentrate, with the energy and discipline a great writer brings to their work, on the relentless pursuit of a simple, clear story. Does the candidate embody the deepest desires of the largest number of people? Would their success unleash pleasing emotions? Do they have the simplest, seemingly plausible solution to the problems that affect the largest amount of people? Do they promise to destroy what that mass of people most fear? No, it wasn't the Jews, the Muslims, the blacks, the Latinos, the racists, the antisemites, nor the men or the white women (insert favourite bogeyman here) that caused Kamala Harris to lose – the impact of each of those groups was marginal at best. Rather, it was the story she failed to tell. On every count it should have been worryingly clear to the Democratic campaign managers that with an uncharismatic candidate and the triple enemies of inflation, immigration and a political class that had almost entirely lost touch with its working-class base, they had their work cut out. The story they pursued half-heartedly – 'Turn the Page' – was itself half-hearted and devoid of emotion. No decent political operative should have ever let such a campaign go ahead. So, as I write, Donald Trump takes over the Western world.

Stories are how we make sense of the world and pass it on. If you have reduced the world to a question and answer you almost certainly will want to share that information. Story – by definition – *is* knowledge transferred. Thus, your truths transmute themselves into a shape that will go viral. If your story is the weapon you wish to unleash upon the world, then story structure – cloaked in Aristotle's rhetorical appeals, as Churchill attested – is the delivery system you've been looking for.

ACT III

Lessons from the School of Religion

5

The Promised Land

The Promise of Transcendence:
Ideology, Religion and Story

When Jerry Siegel and Joe Shuster developed the idea for *Superman*, they could have had no idea that it would form the blueprint for a story so big it would almost obliterate every other twentieth-century narrative. Who could? After all, even now it's hard to think of any tale outside the Bible that's had such a seismic effect. The two thought so little of it at the time that they sold the rights for $130.[1] *Superman* would change the world of storytelling forever by making conscious and weaponizing an age-old narrative impulse. That Siegel and Shuster were Jewish was deeply significant; indeed, it gets to the very core of how humans create and fashion their tales, for Superman is an answer to an unquenchable and ancient thirst. What Siegel and Shuster longed to drink in, it transpired, was the story of Exodus again.

The Book of Exodus contains one of the most powerful and consequential tales ever told: a people are led from slavery to freedom, escaping almost impossible cruelty against almost intolerable odds with only their bravery and faith to guide them. It's the foundation myth of the Jewish religion, but its legacy reaches beyond that. For Savonarola, the Dominican friar turned proxy-ruler of Florence, it was the subject of twenty-two sermons. Ascetic purity was his promised land, and through his regular Bonfire of the Vanities he aimed to lead his people away from the corrupting influence of

luxury and the world. Oliver Cromwell claimed that deliverance of the Jewish people was the 'only parallel' to overthrowing the British monarchy and warned repeatedly of the 'return to bondage under regal power'. It became a rallying cry for Boer nationalists, for Rastafari (with help from Bob Marley) and for Americans fighting communism.[2] In the American War of Independence, the Founding Fathers framed their fight as a flight from Egypt. George III, Tom Paine said, was 'the sullen tempered Pharaoh of Britain'. When they reached their promised land, the Founding Fathers discussed heatedly whether the seal of their newfound republic should picture Moses raising his staff to part the Red Sea. That they didn't may perhaps have been because of an uncomfortable matter nearer home. Around 1862, a new song started to circulate across the Southern states of America. 'Go down, Moses,' the lyrics went, 'way down in Egypt's land, tell old Pharaoh, let my people go.' For the enslaved population of America, the perilous journey from South to North via the Underground Railroad, led by their 'Black Moses', Harriet Tubman, was a literal re-enactment of the age-old story.* It was one directly echoed a century later. 'I have been to the mountain top,' Martin Luther King cried in his last speech before he was assassinated, 'And I've looked over. And I've seen the Promised Land. I may not get there with you. But I want you to know tonight, that we, as a people, will get to the Promised Land.'

Exodus is the boilerplate narrative of freedom from oppression, and it is *the* archetypal manifestation of story structure too. A brave protagonist battling against convention, an antagonist who horrifies you with their cruelty and a goal no sensible person could disagree with – one that promises transcendence.[3] 'Let my people go,' says Moses in Exodus 8:1. It's almost the platonic ideal of story.[4] A lost or persecuted tribe hears those words and their arid desert is watered. Take Brexit. Where there was death and despair, its advocates believed, now there will be meaning, purpose – power.

For a story to resonate over time, it must contain images that

* The title 'Black Moses' was also conferred on Marcus Garvey, hero of Rastafari and champion of a pan-African state, and, perhaps less convincingly, the singer/song-writer/producer Isaac Hayes.

reverberate – it must spark up the neural centres in the brain.* Siegel and Shuster were both children of Jewish immigrants, and Shuster's mother had fled Russia after the pogroms. The images of Exodus were so engrained it was as if they were baked into their DNA.[5] The plague of locusts, the tablets of stone descending from the mountain, the parting of the Red Sea (the literal midpoint of the work) are purpose built to inspire awe. One of the most powerful pictures, however, is the core of Moses's own foundation myth – the story of his being found.

Ramesses believes Egypt is threatened by ever-multiplying Israelites (an early indication that the fear of a 'great replacement' is nothing new).[6] He resolves on genocide, and orders the drowning at birth of every Hebrew son. The newborn Moses is placed by his loving parents in an ark of bulrushes and gently left to float down the Nile. He is found, with suitable irony, by the Pharaoh's daughter: 'She saw the child: and, behold, the babe wept.' (Exodus 2:6) She adopts him – his secret identity dormant for now, but waiting to erupt.

The parallels between Moses and *Superman* are manifold. Both are immigrants fleeing destruction for a land of promise, both are adopted by well-meaning people who they must later leave to do greater good. Clark Kent's birth name is Kal-El (-*El* being a Hebrew suffix indicating Godliness).† Moreover, he utterly embodies the American dream narrative: 'Give me your tired, your poor, your huddled masses yearning to breathe free,' proclaims the inscription on the Statue of Liberty. *Superman* almost literally conscripts Exodus into the service of the American foundation myth. So where did this new all-American version of Exodus come from?

Jerry Siegel was a teenager in 1933. One hot summer night, finding it impossible to sleep, he started to wonder what it would be like to fly. One thought triggered a train of impulses – fantasy and desire

* Think of the woodchipper scene in *Fargo*.

† *Kal* resembles the Hebrew word for 'all' and *El* means 'God', so the name roughly translates as 'all, or voice, of God', though some translations render it 'angel of destiny'.

mingled with folk-memory and fear. Together with Joe Shuster, the dots of the story started to connect and bleed into each other. They were the children of immigrants, they loved America, but they struggled to get work. They were geeky, and even in the guise of Clark Kent – a white Protestant – they still felt them-selves the nebbish they really didn't want to be. Such insecurities bred fantasies of power and justice, and Siegel and Shuster were immersed in a culture that was full of them. Jews had, after all, invented the golem – the mythological creature who could wreak justice and vengeance. Why? Because almost everywhere Jews lived they had neither, and thus fantasized about the retributive justice it could mete out. Siegel and Shuster lived in a world feeding them fantasy: *John Carter: Warlord of Mars*, *Tarzan* and *Popeye* stalked their waking dreams, and they devoured the swashbuckling heroes played by America's newest gods, Douglas Fairbanks and Errol Flynn.

But now, also, their newfound land didn't seem quite so safe after all.

'What led me into creating Superman in the early Thirties?' Siegel asked many years later. 'Hearing and reading of the oppres-sion and slaughter of helpless, oppressed Jews in Nazi Germany, I had the great urge to help the downtrodden masses, somehow [. . .] Superman was the answer.'[7]

The golem had been created by the sixteenth-century Rabbi Judah Loew as a response to a rising tide of antisemitism in his native Prague. And now, with the news from Germany and the beginnings of the *Kindertransport*, the same psychic need was forcing Siegel and Shuster to build defences of their own. As Will Eisner – one of that same first generation of comic pioneers – put it, Superman was a direct descendant of the golem. Faced with an existential threat – 'an almost invincible force' – the Jewish people created a direct counter-weight. The invincible hero was born.

Making his debut in June 1938's *Action Comics #1*, Superman EXPLODED. Even Joseph Goebbels was moved to denounce him as an 'inventive Israelite', and though Superman may no longer be

as all-conquering as he once was (a classic problem of kairos), his descendants in DC and Marvel bestride our planet.* Robert Kahn became Bob Kane and created *Batman*, Jacob Kurtzberg morphed into Jack Kirby and came up with *Captain America*, all no doubt merging a commercial opportunity with a desire for preservation, if not a deeper psychic need. The fictional world we subscribe to is dominated by golems now.

Writing in *Philosophy Now* in 2022, Roy Schwartz distilled all of this into one simple but brilliant observation: 'Siegel and Shuster's hero was a personal avatar and a Jewish reaction formation.'[8]

A reaction formation is an ego defence mechanism. When faced with trauma (or unwanted knowledge) we employ coping mechanisms – some healthy, some not – to make that trauma safe. If someone we know and care about dies and we laugh, or a much-loved partner leaves us and we build a skyscraper – these are ego defence mechanisms. A reaction formation occurs when, faced with a threat, we master it by employing and often exaggerating its direct opposite force.†

It's this psychological process that is story's greatest catalyst – indeed, it's the root of individual identity, national identity and all religious belief.

Individual Stories

[My mum] walked me to the bus stop. I just stood there with her, you know – just being quiet and stuff [. . .] I just said bye to her and I got on the bus and I left. And I feel really guilty not giving her a better goodbye – knowing that I would probably never see her again.[9]

* I write before the 2025 release of James Gunn's *Superman* film. It will be fascinating to see if it restores the character's timeliness, making hope and history collide again.

† Much more on these in *Into the Woods*.

Fifteen-year-old Shamima Begum leaves her childhood home in East London. She, together with two schoolfriends, is off to join the Islamic State (IS) in Syria, and eventually the ranks of the exiled and the damned. Some years after her departure, the BBC journalist Josh Baker tracked her down for his podcast, *I'm Not A Monster*. The caliphate had collapsed alongside any dreams of glory, and she was now interred in Camp Roj in Syria. While other nations had begun to take their citizens home, Begum had been banned from returning to Britain by the then Home Secretary, Sajid Javid – a decision she was appealing. The question Javid had ruled on was simple: was she a terrorist or teenage victim of trafficking? On 22 February 2023, the Court of Appeal answered her question. She was, it said, a danger to the British population.

Was she? Early on, evidence had emerged that Begum had been a target of grooming. The police had even been to her school and written to her parents about the danger she was in. Another girl from the school, Sharmeena Begum (no relation), had already gone to Syria the year before, and was, the police said, attempting to find new converts to the cause.

Pressed by Richard Madeley and Susannah Reid on ITV'S *Good Morning Britain*, Javid attempted to defend his decision to bar her return. On the cusp of irritability, Javid, invoking the power and secrecy of British intelligence, retorted with an unanswerable reply: 'If you did know what I knew,' he said, 'you would have made exactly the same decision, of that I have no doubt.'[10]

Begum, we were told, was a member of the Hisbah, the religious police IS employed to stamp on any signs of deviation or defiance. Worse, she'd stitched young children into suicide vests. Of course she was a danger. It was a persuasive argument, and the majority of the British public were convinced. No way was she coming back.

But was there any actual evidence of her involvement in the acts Javid alluded to? At the end of his long investigation, Josh Baker found one witness who had known her during her time in the caliphate. Not just any witness, but Sharmeena, the girl who had

allegedly seduced her admiring younger schoolmate into this pil-
grimage of death.[11] Baker asked her about the allegations. Sharmee-
na's reply, which she sent as a text message, was instructive.

> It's all lies. Lol. That woman never left her house. She didn't even
> attend classes for religion [. . .] She's a *kelbah* [dog] [. . .] They're
> making her seem so jihadi when she was nothing. She didn't even
> have a suicide vest. She couldn't even speak Arabic, so how would
> she be Sharia police? [. . .] The woman could barely speak around
> people who are European, because she was socially awkward.
> Everyone thought she was weird. She always stayed in her house.
> Her husband didn't allow her to go out [. . .] It's such an insult to
> say this woman worked in Hisbah and made suicide belts.
> 😩😩[12]

The groomer dismissed the groomed as an apostate. Shamima
had followed this girl, whom she both admired and adored, halfway
round the world, seeking her approval. What she got instead was,
'She was nothing.' This particular episode of Josh Baker's podcast
was entitled 'The World's Unwanted'. Trapped within her own
tragic chiasmus, Shamima had ended up where she began.

Stories fill a hole.

It's how sex trafficking is said to work. You believe your new pro-
tector loves you. You feel something you've never felt before – and that
feeling washes through like a drug, slaking a thirst that's been there
since a time before you remember. Then they withdraw their love,
and you, desperate for the drug again, will submit to any indignity to
regain it. In his book *The Rules of the Game*, Neil Strauss makes exten-
sive use of the term 'negging', a tactic used by pick-up artists to attract
women, by deliberately trying *not* to impress them, but instead, subtly
or unsubtly, undermining them. It's revolting (it's a revolting book),
but it taps into something important. What fills a lack of self-esteem?
A reaction formation, which the perfect story can provide.

A number of factors in Shamima Begum's life made her vulner-
able to extremist thinking. She was a shy girl who couldn't artic-
ulate her emotional pain. 'I didn't feel British or Bengali'; 'I didn't

feel I was accepted by society either'; 'I didn't want to give them a reason to exclude me' – every word about her old life is fuelled by disappointment and sadness. Trapped by cultural expectations of marriage and tradition, she felt 'oppressed, resentful'. And then, suddenly, a girl she'd idolized – Sharmeena – runs away. An abandonment (a 'neg'), followed by a call to join her in a promised land. It's ridiculous, she thinks. It's almost impossibly scary and thus impossibly exciting. Ninety-eight per cent of people wouldn't go. To go, you need a turning point. You need an enemy.

Years later, when she consigned herself to permanent exile by attempting to justify the Manchester Arena bombing of 2017, you could see how this enemy had wormed its way into Shamima's brain: Britain was evil, Britain was to blame.* The Britain that didn't want me, didn't let me belong, morphs quickly into the Britain carrying out 'equivalent' bombings in Syria. How easily a story is formed when an enemy is found. An enemy is a single-cause justification, and the story you tell about it – the story any terrorist or any country can tell – is one that can justify murder. It's an ego defence mechanism once again. Begum was seduced and brainwashed by a story. A naïve, sheltered fifteen-year-old was offered purpose and meaning – transcendence – by a tale.

In *Lawrence of Arabia* almost every scene between Lawrence and his friend Sherif Ali is about the nature of identity. In one, Lawrence throws his army uniform (his old self) on the desert fire. Ali says to him, 'It seems to me you are free to choose your own name.' Lawrence ponders. 'Yes. I suppose I am.' 'Who are you?' Ali later asks him – a question repeated more than once in the film. It's the most basic and yet the most important question of all.

Each of us seeks definition. Each of us, if we are going to function adequately, must have a story. If we are lucky, we find one that will give us a happy and healthy existence. These stories, since they bring us equanimity with the world, usually exist unnoticed. They only become perceptible *in extremis*, in people experiencing breakdowns,

* Twenty-three people died in the Manchester attack, including many young children. Over 1,000 others were injured.

for example, or mental despair. For these individuals, darker kinds of stories can take hold, more dangerous ones that betray not who the tellers really are, but who they fantasize being. These tales are both progenitor and product of the politics of *ressentiment*. Superhero cosplay dominates the extreme fringes of political discourse. Revenge stories from the looked-down on flourish like bacterial mould, with worrying implications not just for their bearers, but for all.[13]

Stories are fractal, and so is the need for them. It's not just individuals who are defined and held together by the tale they tell, it's any successful group of people – a family, a firm, a football team, even the countries where we live. Revolutionary movements, if they wish to overcome those in power, require them most of all.

Nation Stories

When the two lorries pulled up outside the Banco de Crédito del Peru on 16 July 1992, nobody suspected a thing. They exploded at 9.15 pm, packed with 1,000lb of explosive between them, beginning a week of terror that rattled Lima to its core. Twenty-five people died in and around the bank that evening, and by the end of the week forty more had been killed and a country left paralysed with fear. The perpetrators were the Shining Path guerrilla group, their actions the culmination of a narrative that had seemingly bewitched half the world.

The death toll in Lima was shocking, but, to put it in perspective, it accounts for merely 0.0000499999999999999996 per cent of the total deaths bequeathed by the story that inspired the Shining Path.[14] Estimates suggest that as many as 80 million deaths can be traced back to a meeting between a naïve American journalist and a rebel leader on the run in China, sixty years before the attacks on Lima. The journalist was called Edgar Snow, and he didn't pick up a gun or plant a bomb. He picked up an exercise book and took dictation.

It was the 1930s, and Edgar Snow was newly married and living

in China. He hailed from Kansas but was here, halfway across the world, working for the *Saturday Evening Post*. Feeling restless, he had moved from Shanghai to Beijing, taught at Yenching University and learned Chinese well enough to edit a collection of short stories. He'd hit thirty, though, and was in need of lasting financial security. More than that – he was unfulfilled.

Through a friendship with the widow of Sun Yat-sen, who had been the first leader of the nationalist Kuomintang party, he was given a lead – one that a foreign correspondent with a taste for adventure couldn't possibly resist. It seemed an underground network was offering to smuggle him on a perilous 1,000-mile journey to meet the rebel Communist leader Mao Tse Tung.

Nothing had been heard from Mao's band of communist rebels for years. Mao, Nanking had announced, was dead. But was he? As Snow wrote:

> The fact was that there had been perhaps no greater mystery among nations, no more confused an epic, than the story of Red China. Fighting in the very heart of the most populous nation on earth, the Celestial Reds had for nine years been isolated by a news blockade as effective as a stone fortress.

Snow needed to find out the truth. His journey alone was extraordinary.

> Their territory was more inaccessible than Tibet. No one had voluntarily penetrated that wall and returned to write of his experiences since the first Chinese soviet was established in south-eastern Hunan, in November, 1927 [. . .] We all knew that the only way to learn anything about Red China was to go there. We excused ourselves by saying, 'Mei yu fa-tzu'—'It can't be done.' A few had tried and failed. It was believed impossible. People thought that nobody could enter Red territory and come out alive.[15]

Snow didn't believe that. He was to spend four months with Mao, who was very much alive. He befriended the rebel leaders,

who eagerly embraced him, and to read his account now is to picture the base of the Rebel Alliance in *Star Wars*: plucky freedom fighters warming themselves round the campfires of Yavin before the battle on the Death Star begins.

Masquerading as an objective account, *Red Star* was anything but. In her definitive account of the ideology, *Maoism: A Global History*, Julia Lovell points out:

> Mao and his close lieutenants gave Snow a world exclusive, immersing him in a doctored account of their past and present that photoshopped the violence and purges, and portrayed them as persecuted patriots and democrats. At the end of his stay in the North-west, Snow had 20,000 words of transcribed interviews, all checked and corrected by Mao.[16]

For Mao, Snow was perfect. He had all the right contacts to propagate his story, and harboured both a dislike of the Nationalist government and a strong desire to be accepted and acknowledged. He submitted his text for the rebels' approval and was given clear instructions to omit anything that cast Mao in an unflattering light. The book shows little attempt at interrogation – Snow just appears seduced by the romance of it all.

Snow had cast himself as a prototype Indiana Jones, setting off on a quest to find his own lost Ark. By the time he returned, he'd transformed himself into Moses descending from the mountain holding the words of the prophet in his hands. He, and the book he consequently wrote, acquired an almost impossibly romantic sheen. *Red Star Over China* really *is* the word of Chairman Mao, and the book takes the form of an age-old fairy tale. There are wicked antagonists, virtuous protagonists and a transcendental goal that can only be won through great struggle. It's a Boy's Own adventure, a fantasy of good versus evil. It sold an extraordinary 100,000 copies in the UK alone in the first month after publication, and from there, translated into twenty other languages, it spread like a contagion. Lovell writes:

Since 1937, the book has created rebels and guerrillas: from the jungles of Malaysia to the freezing fields of west Russia, from the alternative lifestyles of West Germany's 1960s counterculture to the training camps of high-caste Nepali Maoists.[17]

What began in the caves of Yan'an ended with the Red Army Faction in Germany, the Shining Path guerrillas in Peru and the Naxalite rebellion in West Bengal. Maoism changed China, and the world, irrevocably. To what end? A bloodstained globe, repression and dictatorship, 80 million dead. All in the name of 'freedom'.

At the heart of the book, Snow recounts Mao's own version of the Exodus myth, and without this section the book would probably have just blown away like autumn leaves. There's no doubt that the Long March – Mao's rag-tag forces escaping certain destruction by the Kuomintang – did happen, but it's Snow's telling of it that propels the story into the realm of myth.

> What were the hopes and aims and dreams that had made of them the incredibly stubborn warriors – incredible compared with the history of compromise that is China! – who had endured hundreds of battles, blockade, salt shortage, famine, disease, epidemic, and finally the historic Long March of 6,000 miles, in which they crossed twelve provinces of China, broke through thousands of Kuomintang troops, and triumphantly emerged at last into a powerful new base in the North-west?[18]

Like Dunkirk, the Long March was a defeat. It was a retreat from a disastrous battle in Jiangxi province to the darklands of China, a thousand miles north. Many died, both Mao's people and those in the villages they went through. Conditions were atrocious, yet somehow this small, underfed, hugely outnumbered army survived. If you find your blood stirring as you read, then that's how this works. The struggle against death is the story, and Snow did his job well. As with Dunkirk, defeat became victory.

Snow commits his crime with great panache, and through the magic of well-chosen words he creates modern China's foundation

myth. Writing in 2006, the journalist Sun Shuyun underlined the book's pivotal importance, particularly its account of the Long March:

'If you find it hard, think of the Long March; if you feel tired, think of our revolutionary forebears.' The message has been drilled into us so that we can accomplish any goal set before us by the Party because nothing compares in difficulty with what they did. Decades after the historical one, we have been spurred on to ever more Long Marches – to industrialize China, to feed the largest population in the world, to catch up with the West, to reform the socialist economy, to send men into space, to engage with the 21st century.[19]

The length of the march had been profoundly exaggerated, wrote Ed Jocelyn and Andrew McEwen in 2006. 'Mao and his followers twisted the tale [. . .] for their own ends. Mao's role was mythologized to the point where [. . .] it seemed he had single-handedly saved the Red Army and defeated Chiang Kai-shek.'[20]

At the beginning of his quest to meet Mao, Edgar Snow wrote one striking sentence. Weighing up whether to face the danger of the journey, 'I concluded that the price was not too high to pay. In this melodramatic mood I set out.'[21] *Red Star* is a melodrama – an almost absurdly literal hero's journey. Luke Skywalker finds his Yoda in the wilderness of Yan'an; the troubled hero meets a guru who heals him in a dark cave. Imagine being a young idealist in the 1930s, the memories of a devastating world war still fresh, deeply disillusioned with the status quo. For that person, one's own Exodus story – like Shamima Begum's IS – would be the best story *ever*.

Why? Because it ensnares a repressed individual's heart, coddles them in the warm embrace of ideology, dressing them in the clothes of purpose and power, before slowly leading them to the white bright light.

How does that journey happen? And what kind of story lies at the root of its power?

Ideology

It was Anton Chekhov who said 'I am not here to judge my characters. I am here to be their best witness.' That ability to remain completely even-handed, to weigh up reality without being partial, is extremely hard to achieve. Under pressure we almost always revert to a binary system of thinking. If you are unable to love the music of John Martyn because you know he was a vicious, misogynistic drunk; feel that Eric Gill's sculpture should be banned because he sexually abused his daughters; if you cannot bear to read J. K. Rowling because of her advocacy of single-sex spaces, then you are falling prey to that binary too. 'The test of a first-rate intelligence,' wrote F. Scott Fitzgerald, 'is the ability to hold two opposed ideas in the mind at the same time, and still retain the ability to function.'[22] It is possible to understand that Winston Churchill could be irredeemably racist while at the same time accepting that his courage gifted future generations the freedom to denounce him: possible, but difficult.[23] Much easier to line up on one side. Once you buy into the binary you are making life much easier for yourself, even as you're surrendering part of your hold on reality. A world of goodies and baddies is one free of cognitive dissonance. And it's the land where ideology is born.[24]

If a test of a good story is whether you can pitch it in a sentence, that's what defines ideology too. Both offer us an instant, simplistic map through a more complex world. Everything can be reduced to something simpler: Marxism is either the enemy or the answer, and all forms of nationalism likewise. It's immensely seductive for two reasons. If you're looking for a sense of purpose, for self-definition, then ideology immediately offers you that – it gives you your story. Secondly, as the ideology creeps into your pores, it places you at the centre of the cosmology. You have the answers; you, with blinding clarity, are suddenly more important. While in most stories you observe a protagonist on their quest and become them via proxy, with ideology you become active yourself. You're no longer just

reading or watching the story, you are an active player in the game.[25] And once you are in the story, of course, you want the story to continue, and as others buy into the story too, the ideology becomes more attractive. You're no longer an individual, you are a gang, and you draw strength from the size of the tribe. The story is gaining power, and you gain power in turn.[26]

But what of inconvenient reality? If the strength of the group rests on everyone agreeing with you and reality appears like barnacles on a boat, what must you do? You are on a mission now, and only ends matter, not means. You can see how tempting it might be to scrape those barnacles away. And it is at this point that something really profound happens. Those who are part of the tribe but have kept one foot on the ground start to experience internal conflict – a deep disquiet as a gap appears between empirical experience and their desire to belong. The choice those people make is extraordinarily important for the success of their tribe's story.

Leon Festinger's *A Theory of Cognitive Dissonance* was published in 1957, and quickly became hugely influential in social psychology. If your tribe is thinking one thing and you find yourself at odds with that, that's cognitive dissonance. And the pressure from the group to supress your concerns can be overwhelming.

During the 2010s, individuals may have privately had doubts about their loyalty to Donald Trump or Jeremy Corbyn, but if you expressed buyer's remorse you stood to be exiled from the tribe. It's easy to laugh at if you're not a member, but for most of us, even if we don't acknowledge it consciously, membership of a tribe is important to our survival. The tribe is our story after all, and our story – that's who we are. 'It is difficult to get a man to understand something, when his salary depends on his not understanding it,' said the writer Upton Sinclair.[27] More pertinent, perhaps, would be to replace 'salary' with 'identity'. The cost of disbelief can be infinitely higher than penury.

As the gap between what you feel and what you ought to feel widens, the mind does its best to find a place of comfort. Cognitive dissonance gives you two options: to resist new knowledge

or to double down on your dissent. If you do the former, you are rewarded with a powerful sense of solidarity. If you do the latter you are expelled by a group that loathe heretics far more than infidels: the apostate must be destroyed for the solidarity of the tribe. How tempting it is, then, to lay your head on the soft duck-down pillow of ideology.[28] Belief, to quote John F. Kennedy, 'provides you with the comfort of opinion, without the discomfort of thought'.[29]

It's a key moment. If you choose tribe over truth, then story detaches from reality; the balloon escapes the child's hands.[30] From the love of Edgar Snow's book, Maoism is born, and those little nagging thoughts of doubt must be sought out and annihilated. Ideology, in effect, is the moment where reality is subverted by story. Stories *kneed* reality, remember – they shape, chisel and lie. They imply causation where often there isn't any and are most powerful when they ascribe to any action a single cause.

There are rarely single causes. Narrative, however, is predisposed to them. In a good story each scene must be caused by the previous scene. *Post hoc, ergo propter hoc* – 'after, therefore because of' – is by definition predisposed to establishing a single cause, and this more than anything is responsible for most narrative fallacy. It's both the method we use to convey reality and the main agent of reality distortion.[31]

In simple terms, story is formed from the interaction between you, the protagonist, and the subject matter – that's your antagonist. The narrative process is derived from you taming that antagonist and thus making sense of the world. *I exist, I observe, I conclude.* But when that subject matter incites emotion, we begin to colour events in. We add depth, of course, but at the same time we begin to morph reality, to distort it in order to pass our observations, now wrapped in emotion, on. Observation is overturned by a simplistic algorithm. In HBO's *Chernobyl*, written by Craig Mazin, the fictional Valery Legasov (Jared Harris) says of the rigged show trial designed to punish the 'guilty': 'We will have our heroes, we will have our villains, we will have our story.' They will have someone – a single cause – to blame. What they won't have is *truth*. As the journalist Andrew O'Hagan put it:

We all want the story we want, for reasons we understand implicitly, but, given the chance, our imagination will take us out of chaos, and replace the randomness of disaster with the heroics of human will.[32]

Ideology, then, is the moment the mechanics of narrative colonize and then alter experience. For most, tribal ideology is a low-level constant, but when identity is threatened, insecurity is heightened or the dissonance grows too great, we enter a different state. We find ourselves standing on the far shores of ideology, where the beaches are lapped by the waters of faith and religious extremism.

Religion

Scientology labels newcomers as 'Preclear', placing them at the lowest level of its hierarchy. By contrast, someone who attains the rank of 'Cleared Theta Clear' is the opposite: they are, in the words of L. Ron Hubbard, a 'person who is able to create his own universe'.[33] In other words, God.

To get from the lowest stage of Scientology to the highest, you need to cross 'The Bridge to Total Freedom' – a series of levels that are proudly displayed on the walls of branches of the 'religion' worldwide. At each stage you will be set a series of tests which, on passing, will allow you to graduate to the next.

In total there are eighteen levels, with a halfway point in the journey where you 'Go Clear'. It is here that you become an 'Operating Thetan', with eight more levels to traverse before you reach Cleared Theta Clear, the point Hubbard, the founder of Scientology, attained before he passed away. True believers discover the secrets of the eight late levels by successfully reaching each one, thus unlocking its hidden codes.

At every stage of the process, an adherent must navigate a specific unit of opposition in pursuit of a precise goal known as an EP ('End Phenomenon'). Each EP you reach confers greater power and status.

All of the eighteen stages are monetized, and it can take you a whole lifetime, driven by curiosity and deferred gratification, to get to the much-prized final level: 'Operating Thetan VIII'.

Eighteen acts. A midpoint. The symmetry of a classic arc. Identical in form to a video game, Scientology mirrors, right down to the midpoint of 'Going Clear', both *Call of Duty* and the precise structure of any archetypal story.[34]

To be accurate, Scientology doesn't mirror a narrative – it *is* the narrative. Meaning and purpose aren't derived from Scientology itself, they're derived from the narrative structure Scientology has colonized. What the cult offers its members, and the source of its disturbingly large appeal, is the holy grail of all writers – a journey via narrative to transcendence.

As such, religion and its two bedfellows, ideology and cultdom, have much to offer any student of story. In this section I want to show how stories are formed from base materials – and then trace their development from simple observations ('there be dragons') to their most powerful quasi-religious forms ('there be dragons – and we must not rest, whatever the cost to ourselves, until the blood of every last one of them waters our fields'). By following that journey – from Preclear to Cleared Theta Clear, if you like – it's possible to see both what human beings crave from narrative, and how we go about manufacturing stories to satiate that desire. The impulse to create Superman is not that different from the one driving Scientology – both imbued weak, self-doubting individuals with god-like powers.*
This fundamentally religious impulse is key both to great fiction and transcendent political causes. They can learn a lot from each other.

On 23 April 1914 one of the most influential books of the twentieth century was published. It described a benighted land, where 'The gloomy shadows [were] enshrouding the streets, concealing for the time their grey and mournful air of poverty and hidden

* Hubbard served in World War II, but was removed from commanding not just one battleship, but two. He was hospitalized for many months after his active service came to an end.

suffering.' The world is diseased and dying. However, there is *one* hope – something is coming to save us . . .

> [. . .] from these ruins was surely growing the glorious fabric of the Co-operative Commonwealth. Mankind, awaking from the long night of bondage and mourning and arising from the dust wherein they had lain prone so long, were at last looking upward to the light that was riving asunder and dissolving the dark clouds which had so long concealed from them the face of heaven. The light that will shine upon the worldwide Fatherland and illumine the gilded domes and glittering pinnacles of the beautiful cities of the future, where men shall dwell together in true brotherhood and goodwill and joy. The Golden Light that will be diffused throughout all the happy world from the rays of the risen sun of God.[35]

I have, for hopefully acceptable reasons, changed one word. It's the very last one – it shouldn't say 'God', but 'Socialism'.

The book is *The Ragged Trousered Philanthropists* by Robert Tressell. An ur-text for any would-be socialist, there was a time when it would have been impossible to find a Labour MP who hadn't read it in their formative years. Whatever your political persuasion it remains an immensely moving work.

That so many have seen socialism as a viable political belief rather than a utopian religion is testament to the story's power. It is easier than we think to mistake what we *want* to believe for the truth. *Enthusiasm: Symphony of the Donbas* was Charlie Chaplin's favourite film of 1931, but that's in no way the most memorable thing about it.* A hymn to Stalin's Five-Year Plan, it was made by Dziga Vertov – the great Russian director behind *Man with A Movie Camera* and *Kino-Eye* – and it opens with revolutionaries marching on Ukrainian churches and violently stripping them of their religious iconography. Where there are crosses, they are smashed to the ground and replaced with red stars or hammers and sickles; all outward signs

* At this point Donbass was part of the Soviet Union; now of course it is a heavily fought-over part of Ukraine.

of the old religion are purged. It's a symbol of Russia's new dialectical materialism: religion is to be frowned on as 'the opium of the people'. But as the crosses are crushed and the symbols of revolution replace them, it is impossible not to see that this revolution is superficial – just one belief system overthrown by another. The religious impulse has not been destroyed; it's just dressed in new clothes that render it harder to see.

The Ragged Trousered Philanthropists, the virgin birth, death and resurrection – all are striving to deliver you transcendence by inciting emotions that will prise you free of the empirical world. And, as we noted with Scientology, this transcendence is the wished-for end state of the perfect story: the total and utter rhapsodic belief in a new reality which has become so by prising it from the devilish clutches of the old.

What, as storytellers, can we learn from this? To understand that, we need to come to an understanding of what we mean by religious belief.

In her book Strange Rites: New Religions for a Godless World, Tara Isabella Burton synthesized the ideas of three foundational scholars – Émile Durkheim, Peter L. Berger and Clifford Geertz – to come up with a good working definition of religion. Durkheim argued it was 'the glue that keeps a society together: a set of rituals and beliefs that people affirm in order to strengthen their identity as a group'.[36] Peter Berger felt that 'it gives us a sense of personal and social meaning', while Geertz 'emphasizes the subjective, personal, emotional experience that religions provide'.[37] Between them, Burton argues, you can distil the role of religion into four tenets: meaning, purpose, community and ritual.

In every archetypal story a flawed character learns a lesson, and that lesson makes them whole. The story they learn bestows meaning and purpose on its audience, certainly, but community and ritual? Those only come when consumption of the story moves from an individual to a collective experience – think of Harry Potter or Star Wars. Every truly successful story acts like the nucleus of a tribe.

Berger himself stated that religion 'allows us to frame our identities within that of a collective cosmic narrative' – that's what the most powerful fiction does too.

Any writer or producer or director *wants* this to happen – it's why writers prize a collective audience above the atomization of television. If you go to theatre and remain rational, you might be watching an overweight star past their prime, in a building with filthy toilets, from a seat that doesn't actually allow you to see the stage. But if the story does its work, then suddenly you are in the Battle of Agincourt, or a cherry orchard or on a Greek island watching as a woman tries to choose which of three men is the right match. Bewitched by emotion, suddenly you are smelling what the characters smell, feeling what they feel. Having slipped orbit, you are flying towards an intoxicating new solar system, one where black is white, and fiction is reality. That's fundamentally religious.

It's easy to forget that denial of rationality is both powerful and addictive. Shouting 'I believe!' in the face of all evidence triggers hormones to flood through your body, and the greater the imaginative leap, the more powerful the reward. It's *faith*, and it's far easier to profess collectively than on your own. When there are two where once there was one, both must agree to the narrative, or cognitive dissonance will occur. But if agreement between two can be brokered, if both buy into the story, then a striking process begins. Others are attracted by the bonding and, as the narrative gets its claws into non-believers, as it starts to take over the building, certain new elements enter to further aid our belief. If they like it, we tell ourselves, then we are right – we can like it, too, and our belief is increased. Rationality dissipates, our logical defences weaken – we are now prey to the collective experience of story.

Suddenly, we are in the arena of communal celebration and the surrender of the self is underway. It is at this point, in this darkened room, that something magical happens – an entire cinema laughs and gasps and weeps at the same time at the same thing. Berger compares religion to sexual masochism – 'intoxication of surrender to another – complete, self-denying, or even self-destroying' – and

that's exactly it. Somehow, in the darkness, we have all united in the protagonist's journey and become one. Their experience is ours, and the object of pursuit – the goal – becomes totemic. As a clan we now seek the sacred goal, for if we grasp it, we now infer, we may experience the divine. We all cry out for the death of Voldemort, for in his death we are promised the return to a prelapsarian world.

For some films, this feeling ebbs away as soon as we leave the cinema. But with others, the desires provoked have drugged us, and we seek them again after the credits roll. We long to recreate that hit, so when the story is over, we create rituals, from catchphrases to cosplay conventions, to venerate and celebrate the vivifying tale, that we might relive it once again. In doing so we attract more followers who will become equally bewitched by the order and meaning the story provides, and the power of the narrative grows. Every trip to the cinema is a tribal experience – and a shared story is more powerful than one watched with all the distractions of home. When an audience is howling and cheering as it *collectively* defeats a common enemy, then the tale is powerful indeed.

For Christians that enemy is sin, for Marxists it's power and oppression, for social justice warriors it's privilege or bigotry, for reactionaries it's 'woke-ism' or the decadent feminization of traditional seats of power. Each religion invites you on an active quest to overcome your darker self, a reaction formation that offers you a shared community and ritual to perfectly order your quest. At their most extreme there will be sacraments to be swallowed, and liturgical call and response. There will be catechisms to underline belief, and exorcisms to forgive those who've strayed. There will be the evisceration of non-believers, an endless hunt for heretics and infidels and a sense that every action you take, from posting a meme to marching on the capital, is blessed with cosmic significance. But victory over others, because of the drug it releases, is prized most of all.

This is enormously powerful, but it is as dangerous a force as it is one for good – a danger that can be seen more clearly in real life.

Durkheim, the French sociologist, called it 'collective effervescence', the moment described above in film or theatre when individual

coughing is usurped by collective laughter, anticipation, fear and joy: the audience is now reacting as one to a story that has colonized every pore. It's a key component of religious celebration – integral, in fact, to religious life. Freed from menial tasks, tribes come together, sharing the same thought and action in pursuit of a goal. As hormones race through your body, as you're feeling feelings you're not sure you should be enjoying, as adrenaline, dopamine and cortisol cause you to leave rational thought behind, well, it's *that* – that's when transcendence occurs. The death of the other – the apostate – confirms your commitment to the cause. It's a reification. A tribe unites to dispel evil from their midst, and bonds of righteousness are forged or hardened anew.

There's an invaluable lesson for storytellers here. Get your audience drunk on righteousness, pump them full of dopamine and adrenaline, then offer them the chance to rip Voldemort apart. Nothing is more intoxicating than the fervour of righteous destruction. Margaret Atwood summarized how quickly and unedifyingly this happens in life:

> In times of extremes, extremists win. Their ideology becomes a religion, anyone who doesn't puppet their views is seen as an apostate, a heretic or a traitor, and moderates in the middle are annihilated. Fiction writers are particularly suspect because they write about human beings, and people are morally ambiguous. The aim of ideology is to eliminate ambiguity.[38]

It is easy to be swept by the riptide of ideology into the darker currents of fundamentalist belief. But while in real life it's profoundly dangerous, in fiction (providing you are happy to rid yourself of Atwood's ambiguity) the ecstasy and violence you find in *Baby Reindeer*, *Fleabag*, *Succession*, *The Last of Us* or *I May Destroy You* can be your closest friend. It's a mistake to see it only in 'right-wing' revenge sagas like *Jack Reacher*, for these effects certainly occur in iconic works of a liberal sensibility. The power of *Mr Bates vs The Post Office* lay in the outrage it invoked at the treatment of the sub-postmasters by a petty and vicious management, and our desire to destroy them in turn. That feeling of outrage, where liberalism

tips into violent desire, is one of the key components of the most popular fiction – it's also there when we root for Offred in Atwood's own *The Handmaid's Tale*. In real life the effects are more damning. It begins with *othering* – the moment you deny humanity to an adversary and give them the characteristics of the devil. That, in turn, promotes you to a member of the elect. It requires a leap of faith, one that causes you to become the characters, buy into the world and accept a premise that lies beyond the rational – but thus, hand in hand with those new compatriots, you escape the gravitational pull of the real.

It may seem harder to make that leap in life than in fiction, but the Hungarian journalist and author Arthur Koestler memorably described just how easy it was. He was to write one of the great anti-communist novels, *Darkness at Noon*, but in his contribution to a later work, *The God That Failed*, Koestler told of that magical moment of finding pure belief:

> [. . .] the new light seems to pour from all directions across the skull; the whole universe falls into pattern like the stray pieces of a jigsaw puzzle assembled by magic at one stroke. There is now an answer to every question, doubts and conflicts are a matter of the tortured past.[39]

Any story that understands your deepest fear and your greatest hope, and which promises you immortal reward; any story that seduces you by articulating your deepest pain and offering the possibility of overcoming it, will bring immense reward. For true power, it must not speak to an individual pain, but a collective one, one held by a family who, as they overcome it, will seem empowered and give off that glow that others too will then seek, knowing that if they do their thirst will be slaked, and they will be bathed in this fresh light – the 'gold light, diffused' as Robert Tressell put it – where new sense seems suddenly found.

Just as Exodus reached far beyond the children of Israel, so Edgar Snow's China myth inspired people around the world to worship

and pay tribute through cleansing violence to Chairman Mao.
Snow's tale maintains its grip nearly a hundred years on, not despite
the fact that it's built on numerous falsehoods, but because of them.
Human beings made a massive evolutionary leap when they evolved
into creatures that could *lie*. As Yuval Noah Harari writes in *Sapiens*:

> Legends, myths, gods, and religions appeared for the first time
> with the Cognitive Revolution. Many animals and human species
> could previously say, 'Careful! A lion!' Thanks to the Cognitive
> Revolution, *Homo sapiens* acquired the ability to say, 'The lion is
> the guardian spirit of our tribe.'

This revolution was, Harari says, the moment human beings
developed a flexible language, one that allowed them to talk freely
about people who weren't present (also known as gossip) and to
create imagined realities. On first glance, these don't seem particu-
larly prepossessing, but they were absolutely central to the evolution
of early man. Without them it would have been impossible for them
to evolve into, well, *us* – a creature that totally dominates our world.

> Any large-scale human cooperation – whether a modern state, a
> medieval church, an ancient city or an archaic tribe – is rooted in
> common myths that exist only in people's collective imagination.
> Churches are rooted in common religious myths. Two Catholics
> who have never met can nevertheless go together on crusade or
> pool funds to build a hospital because they both believe that God
> was incarnated in human flesh and allowed Himself to be cruci-
> fied to redeem our sins.[40]

Harari calls this shared belief 'mythology' or 'fiction'. Wherever
you see a group of people – an organization, a village, a country, an
empire, anything larger than 150 people – they are harnessed to, and
by, the ability to conjure abstract concepts, to believe in devils and
angels, to subscribe to the invisible power of narrative. To fiction.
To say that every tribe has a foundation myth is to look down the
wrong end of the telescope: the foundation myth *is* the tribe. Any
tribe is the physical manifestation of their story.

Such a story should embody a 'truth' that inspires deep wells of emotion. It should also contain some kind of role model of (often sacrificial) behaviour. The more permanent you can make that story feel, the more you can shroud it in the four tenets of religion – meaning, purpose, community and ritual. Thus protected, the more powerful the story will become. It should feel as old as time, yet it's striking how often such stories are relatively new. It's a valuable lesson for fiction.

What writer wouldn't want to tell a story that triggers that level of belief? The tenets of religion aren't separate to fiction writing, they are central to it. 'I believe' is the passport to identity, ideology, religion *and* the most powerful fiction. In each case an extraordinary hormonal rush is triggered by answering the question 'Who am I?' with 'I am the person who believes *this*.' It's that motor that gives us ideology and Scientology. It's a reaction formation: the tale that rushed in to fill a hole, as *Superman* did for Shuster and Siegel; the story that found life-changing purchase in Shamima Begum's heart.

Buster Keaton's 1924 film *Sherlock Jr.* provides perhaps the best of all examples, and is also perhaps one of the greatest of all films. Buster is a loser; he cannot get the girl. Working as a film projectionist, one day he falls asleep on the job and fantasizes about being a detective hero. Striding towards the cinema screen, he literally steps through it to join the world of fiction. Here, once he has mastered the rules of this strange new world, he is reborn – adored, invincible. Now he is equipped to solve the crime and win the girl. *Sherlock Jr.* is not just the very first movie to fully understand the potential of its medium, but the first to understand what movies are *for*. In every transcendent narrative we do what Buster does – we step (it's still dazzling to watch) through the screen. A hundred years on it's a marvel of technical perfection, and still very funny. That's perhaps the main reason we underestimate its greatest strength – it's also deeply profound.

Keaton stepped through the screen to fill a need. A hole. That's fiction's role.

<div align="center">★</div>

Personal belief, we have seen, comes from an internalized narrative, and a successful one fills your veins with rich, pumping, oxygenated blood. The most powerful fictions mimic that process – indeed harden it. They contain the tensile strength that comes from finding perfect form.

How does that happen? Without knowing it, your brain has been churning a series of sense impressions, biases and desires into a binary system of ones and noughts. It's this process that leads some to an unwavering belief in Scientology, some to what they call God and some to write impossibly powerful fiction. How does that happen? By trapping reality within a *grid*.

6

The Great White Light

The Ten Key Questions of Story

Sound-waves are caused by minute particles vibrating in the air. Those particles collide with each other, causing different levels of oscillation, which in turn vibrate our ear drums, triggering a signal that then runs to our brains. Gramophone records, then tape, were the methods by which these waves were traditionally captured, stored and conveyed, but in 1937 an invention called pulse-code modulation would change the whole way we process sound, and much else besides. British telephone engineer Alec Harley Reeves discovered you could sample the waves and store them using simple binaries of ones and zeros. The digital age, and thus the modern world, was born from this miraculous revelation. So much of what we see, hear, feel and experience can be coded as a thing and its opposite. Existence and non-existence. One and zero. It seems miraculous that you can trap immensely complicated phenomena in such a simple form and disseminate them anywhere at lightning speed, but that that's actually what human storytelling has been doing all along.

The analogy isn't perfect, though hopefully it makes its point: if the real world is a sound wave, then story is its digital representation. Using the same ones and zeros, we codify reality by trapping it within a structural grid. Then, using that grid, we disseminate the result in one of the million ways stories can now be passed on. Everything to do with story structure, in the end, leads back to *opposites*.

Obi-Wan told me you killed my father	No, I am your father

The rule of opposites works at every level. You see it at the heart of classic scene structure: something is confronted by its opposite.

And it's visible in overarching structure, where each character falls down a rabbit hole into an opposite world:

STAR WARS	Farm boy vs Jedi
AVATAR	Soldier vs Na'vi
JAMES BOND	James Bond vs Blofeld
THE QUEEN	The Queen vs Tony Blair
THE KING'S SPEECH	King vs Logue
127 HOURS	Free vs Trapped
THE SOCIAL NETWORK	Zuckerberg vs Winklevoss
12 YEARS A SLAVE	Freedom vs Slavery
RUSH	Hunt vs Lauda
GRAVITY	Companionship vs Solitude
BLACK PANTHER	T'Challa vs N'Jadaka
RRR	India vs Britain
MACBETH	England vs Scotland
OTHELLO	Othello vs Iago
PRIDE AND PREJUDICE	Elizabeth vs Darcy
BEOWULF	Danes vs Grunewald

Beginning and end, want and need, protagonist and antagonist, image and reality itself – all reside within a simple binary. They are inherent in story at every level. Look at the internal conflict of Michael Corleone in *The Godfather*. Michael starts his story a war hero and ends up a gangster. Note how during this journey the level of internal conflict shifts in each act, and how important the symmetrical midpoint becomes, as need and want swap sides.[1] Michael's true nature is revealed (light) as the events of the story slowly wash the character's initial appearance (dark) away:

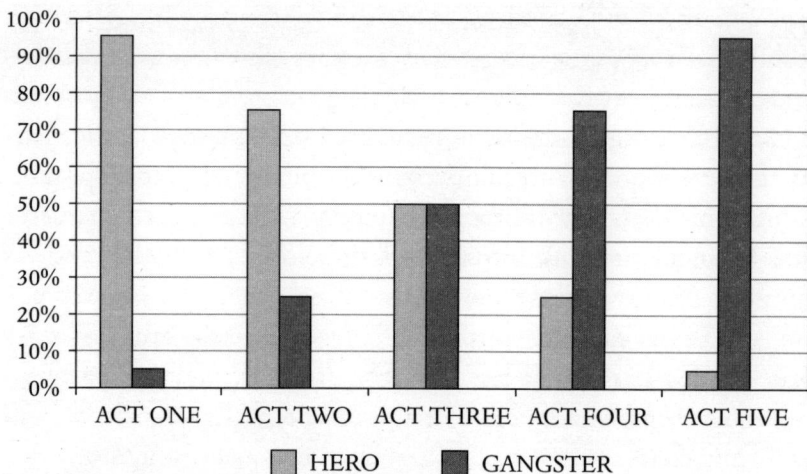

This same conflict is often divided between protagonists and antagonists within individual films and programmes. In Britain's favourite sitcom, *Dad's Army*, the two characters mirror each other exactly:

CAPTAIN MAINWARING	SERGEANT WILSON
APPEARANCE	**APPEARANCE**
A fine soldier	Figure of fun
Model of respectability	Provincial bank manager
A repository of common sense	Ineffectual
REALITY	**REALITY**
Figure of fun	A fine soldier
Provincial Bank Manager	Model of respectability
Ineffectual	A repository of common sense

This pattern can be found in the relationship between every partner and their sidekick: Morse and Lewis, Del Boy and Rodney, Holmes and Watson, Fleabag and Priest, Callan and Lonely, Terry and Bob, Thelma and Louise, Kerry and Kurtan, Sam and Gene, Cagney and Lacey, Starsky and Hutch, Gavin and Stacey, and Buzz

and Woody. It's not a modern construct – it's King Lear and the Fool, Robinson Crusoe and Friday and the struggle between the Pandavas and the Kauravas that forms the heart of *The Mahabharata*. You'll find the same digitization everywhere – from any Shakespeare play to *The Wire*; from the fire and ice of *Game of Thrones* to the Shire and Mordor of *The Lord of the Rings*.

This binary is central to storytelling's power. Instead of endless variation, the world is shrunk down to the simple manipulation of two digits. Instead of unfathomable chaos, there is bright shining order. Once you understand that, the direct relationship between story and religion becomes clear. It is this order that ideologies, religions and cults colonize and then exploit. So how does it work? How do increasingly fundamentalist sects weaponize it? And what can that tell us about writing fiction?

Before we answer those, our first question should be: why do opposites occur at all?

On one level it's just physics – it's Newton's third law: 'When one body exerts a force on a second body, the second body simultaneously exerts a force equal in magnitude and opposite in direction on the first body.' On a more prosaic level, you want your story to be as powerful as possible. How do you do that?

When a character has a desire, drama comes from confronting them with something at odds with that desire. It's that conflict that gives birth to everything. For *exciting* drama to occur, you don't confront your character with something that's just dissimilar, you confront them with the biggest thing you can imagine – which must be, by the laws of physics, their total opposite. It's really as simple as that.

This maximization of dramatic potential works hand in hand with our order-seeking impulse to produce something far beyond any intentional manipulation. As the extraordinary symmetry of Russell T. Davies's *It's a Sin* shows, our unconscious mind is feverishly working to produce the very thing so many of us consciously decry. Structure may not be what we want, but it is, in every sense, what we need. Just like music, just like any sound, reality is reduced to this simple binary for ease of both memory and transmission.

It's an archetypal shape, beautiful in its simplicity, and it can be discerned in any story simply by asking ten basic questions.

THE TEN QUESTIONS

1. WHOSE STORY IS IT?
 Who is the main protagonist? Who is driving their story?
2. WHAT DO THEY NEED?
 What is their flaw? What do they lack?
3. WHAT IS THE INCITING INCIDENT?
 What throws them down the rabbit hole? What problem, as specifically as possible, do they need to confront?
4. WHAT DOES THE CHARACTER WANT?
 What is their (ideally tangible and as simple as possible) goal?
5. WHAT OBSTACLES ARE IN THEIR WAY?
 The forces of antagonism: do they build? And are they big enough?
6. WHAT'S AT STAKE?
 Jeopardy: what will the protagonist lose if they don't reach their goal?
7. WHY SHOULD WE CARE?
 Empathy: why do I want to *be* them for the duration of the story?
8. WHAT DO THEY LEARN?
 Intimately related to question 2. They learn to overcome their flaw.
9. HOW AND WHY?
 Have you brought them face to face with the consequences of *not* changing? This should be crystallized at the crisis point of the story.
10. HOW DOES IT END?
 Does the telling feel completed? Does it excite an emotional response? Does it make you go, 'Oh no! But of course!'?

These questions are, of course, an idealized paradigm. Sometimes there won't be jeopardy. (Though why not? An object of desire

will exponentially increase in value if there is risk attached to attaining it.) Sometimes the ending won't have or need a final twist, and in two-dimensional stories want and need are often conflated. It's fine if a story doesn't entirely fit, but to a surprising degree the model holds true.

Start with a very archetypal action film. James Cameron's *Aliens* is, in many respects, the epitome of genre film-making. But by pushing Ripley right to the front of the story, and by giving her a want *and* a need in a blockbuster world where the more macho and one-dimensional want is king, it was quietly groundbreaking. It was only when the director's cut was released in 1991, four years after the theatrical version, that the death of Ripley's daughter was reinstated near the beginning, thus creating a much clearer flaw for Ripley to overcome: her failure as a mother. It gave the ending – saving Newt, the abandoned child she finds on the planet – a whole new depth and meaning.

Aliens[2]

1. WHOSE STORY IS IT?	Ripley's
2. WHAT DO THEY NEED?	To not be a failure as a mother
3. WHAT IS THE INCITING INCIDENT?	The news that colonists are being killed, and the opportunity for revenge
4. WHAT DOES THE CHARACTER WANT?	To kill the Aliens
5. WHAT OBSTACLES ARE IN THEIR WAY?	Aliens, the military, and the Company
6. WHAT'S AT STAKE?	Her life; civilization
7. WHY SHOULD WE CARE?	She's courageous and purposeful. And loves her cat
8. WHAT DO THEY LEARN?	That she can be a good mother
9. HOW AND WHY?	She rescues Newt from the jaws of the Alien queen
10. HOW DOES IT END?	She destroys the Aliens.

These questions don't just apply to genre film-making, they are equally applicable to more arthouse movies. Barry Jenkins' *Moonlight* is, as we've seen, a coming-of-age story that, over many years, leads Chiron to find love, and self-love, with Kevin.

Moonlight [3]

1. WHOSE STORY IS IT?	Chiron's
2. WHAT DO THEY NEED?	To acknowledge who he is
3. WHAT IS THE INCITING INCIDENT?	Chiron learns that his mentor sells his mother drugs
4. WHAT DOES THE CHARACTER WANT?	To deny who he is
5. WHAT OBSTACLES ARE IN THEIR WAY?	His sexuality; Kevin
6. WHAT'S AT STAKE?	Chiron's mental health and happiness
7. WHY SHOULD WE CARE?	He fights to define who is, against a society that condemns it
8. WHAT DO THEY LEARN?	To be himself
9. HOW AND WHY?	Kevin learns Chiron (now Black) has been dealing, and walks away saying 'This ain't you.'
10. HOW DOES IT END?	Chiron acknowledges who he is.

The ten questions don't limit themselves to fiction; they work with any archetypal non-fiction work, and outside of film as well. *Serial* changed the podcasting game.[4] Debuting in 2014, it opened up the world of literate, scripted speech radio (previously the preserve of a small, mostly highly educated tier of society) to a mass audience. Investigating the incarceration of an extremely loveable 'protagonist', Adnan Syed (the real protagonist is Sarah Koenig, the pretention-free, tough-when-needs-be but nonetheless caring presenter), to date it's been downloaded over 340 million times. Pioneering long-form narrative and

'do-it-yourself-detection', it was the nugget that kickstarted the podcasting goldrush – an army of prospectors would follow in its wake.* You really can divide podcasting into pre- and post-*Serial* worlds.

Serial

1.	WHOSE STORY IS IT?	Sarah Koenig's
2.	WHAT DO THEY NEED?	Knowledge
3.	WHAT IS THE INCITING INCIDENT?	Key witness falls apart
4.	WHAT DOES THE CHARACTER WANT?	Is Adnan innocent or guilty?
5.	WHAT OBSTACLES ARE IN THEIR WAY?	None of the evidence makes sense
6.	WHAT'S AT STAKE?	Adnan's life. American justice
7.	WHY SHOULD WE CARE?	Both are immensely likeable
8.	WHAT DO THEY LEARN?	None of the evidence adds up
9.	HOW AND WHY?	He appeals directly to her
10.	HOW DOES IT END?	Sarah would 'on balance' acquit.

Serial is significant for one other reason, too. The need is 'knowledge' (or, to put it another way, the protagonist's flaw is 'lack of knowledge'). Why is that so important? Because it's emblematic of how human narratives are assembled. We implant our perceived truth within that need or hole.

These questions are both a useful tool to quickly work out any story if you're struggling to find it, and proof that narrative really is reality captured and reframed within a grid. Any archetypal tale will fit into the pattern prescribed by these ten questions. The first episode of HBO's *Chernobyl* is a perfect example.

It's tempting to think that the protagonists here are one of the two leads – either Legasov (Jared Harris) or Khomyuk (Emily

* Charges against Syed were dropped after broadcast, though later reinstated. His name feels universally known. That of his alleged victim, Hae Min Lee, far less so.

Watson) – both of whom are desperate to alert the Soviet authorities to the true horror the explosion at the nuclear reactor has unleashed. Legasov, however, only appears for about five minutes in Episode 1, and Khomyuk not at all. It's a multiprotagonist drama (more on which later), and it breaks down like this:

1. WHOSE STORY IS IT?	The Soviet authorities'
2. WHAT DO THEY NEED?	To accept they are in terrible danger
3. WHAT IS THE INCITING INCIDENT?	Reactor explodes
4. WHAT DOES/DO THE CHARACTER/S WANT?	To deny the truth
5. WHAT OBSTACLES ARE IN THEIR WAY?	The people, and the truth
6. WHAT'S AT STAKE?	Their lives and the future of the country
7. WHY SHOULD WE CARE?	They are clinging to a belief system that defines them
8. WHAT DO THEY LEARN?	Unless they acknowledge the truth, they are all going to die
9. HOW AND WHY?	Irrefutable proof: graphite on the roof
10. HOW DOES IT END?	They call Legasov for help.

Stripped down like this, it's easy to see the narrative engine at work. The story follows the same trajectory as the society it reflects – how a world moves from lies (want, in light) to truth (need, in dark) at huge cost.

The first episode of *Chernobyl*, and indeed the whole series, follows this incredibly simple pattern.* By making the Soviet authorities the protagonist in Episode 1, Legasov becomes a symbol of what the Soviet Union *needs*. In each episode he plays a greater

* The fractal nature of this should be immediately clear. The ten questions illuminate both the story of the first episode and the whole series, one foreshadowing the other.

CHERNOBYL

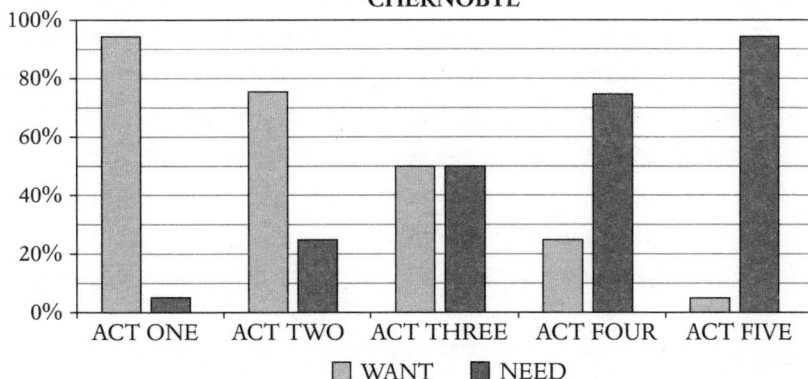

and greater part. Legasov is injected into the infected system like an antibiotic, the need (for truth) fighting over the want to live in denial. He contains the fire. It's a victory of sorts, though a tragic one – for denial and lies will live on.

There's one scene that's vital both for structural reasons and for wider thematic ones. Early in the drama, after the explosion has occurred, the local apparatchiks report to the Communist Party Executive Committee:

INT. BUNKER COMMAND ROOM. 4 AM
Bryukhanov, Fomin and Dyatlov are waiting – then
Bryukhanov rises as: THE PRIPYAT COMMUNIST
PARTY EXECUTIVE COMMITTEE enters. Twelve
men, ages varying from 30 to 60.

BRYUKHANOV
Gentlemen, welcome. Please, find a seat, there's
plenty of room–

The COMMITTEE MEMBERS take their chairs around
the conference table. A guard helps an ELDERLY MAN
WITH A CANE – 85 years old – over to a single, nicer
chair in the corner of the room.

Bryukhanov outlines the facts he wants the committee to know: there's been an explosion, but it's all under control and 'because the efforts of the Soviet nuclear industry are considered key state secrets, it is important that we ensure this incident has no adverse consequences'. The accident is important but keeping it secret more so. Thus, they will declare martial law. There are a few murmurs round the table. One man, Petrov, challenges them. He asks them how serious the problem really is – he's already seen people vomiting in the streets.

BRYUKHANOV

Gentlemen, please! <u>My</u> wife is here. Do
you think I would keep her in Pripyat if it
weren't safe?

PETROV

Bryukhanov – the fucking air is glowing!

Bryukhanov, as the script says, 'has lost control of the room'. Amidst all the mayhem a quiet sound starts to build.[5]

tap tap tap . . . TAP TAP TAP

It's the old man in the corner, he's tapping his cane on the floor:

Everyone quiets down.

The old man is ZHARKOV. He makes a motion to
stand. The guard comes over quickly to help him up, but
Zharkov waves him off. He can do it on his own. He rises
slowly, then:

ZHARKOV

I wonder – how many of you know the name of
this place? We all call it 'Chernobyl' of course,
but what is its proper name?

They look at each other. No clue. Until:

BRYUKHANOV
The Vladimir I. Lenin Nuclear Power
Station.

ZHARKOV
Exactly. Vladimir I. Lenin. And how proud he
would be of you tonight–

(to Petrov)
– especially you, young man . . . and the passion
you have for the people. For is that not the sole
purpose of the apparatus of the State?

Zharkov looks at them, his old eyes twinkling with
memories of great days . . . of great men . . .

ZHARKOV
From the Central Committee all the way down
to each of us in this room – we represent the
perfect expression of the collective will of the
Soviet proletariat.

The Members take this in. Sobered. But proud.

ZHARKOV
Sometimes, we forget. Sometimes, we are all
prey to fear. But our faith in Soviet socialism
will always be rewarded. Always. The State tells
us the situation is not dangerous. Have faith.
The State tells us they do not want a panic.
Listen well.

Zharkov turns to Petrov once again.

ZHARKOV

True, when the people see police, they will be
scared. But it is my experience that when the
people ask questions that are not in their own *best
interest*, they should simply be told to keep their
minds on their labour - and to leave matters of the
State to the State.

Zharkov scans the room. Has them in the palm of his hand.

ZHARKOV

<u>We seal off the city</u>. <u>No one</u> <u>leaves</u>. And
cut the phone lines. Contain the spread of
misinformation. <u>That</u> is how you keep the
people from undermining the fruits of their
own labour. <u>That</u> is how your names become
inscribed in the hallways of the Kremlin.

The men in the room look back at him in reverence.
Dreaming of promotions. Certificates. Maybe even medals.

ZHARKOV

Yes, comrades. We will all be rewarded for what
we do here tonight.
> (beat)

This is our moment to shine.

A beat – then: APPLAUSE. The Committee Members rise
to their feet. Wonderful! Wonderful! Bryukhanov, Fomin
and Dyatlov stand and applaud as well. The system is
working. All will be fine.

Petrov looks across the table at another younger
Committee Member. They both seem to understand that

reason has lost. There's no choice but to clap along with everyone else.

Applause for delusion. Applause for death. Applause for the Vladimir I. Lenin Nuclear Power Station.

Chernobyl by Craig Mazin

The ten questions are fractal – they can be applied to any series, any episode and any archetypal scene. Here's how they pertain to the above. Again, it's multiprotagonist: Zharkov's side versus Petrov's side:

1.	WHOSE STORY IS IT?	Zharkov's side
2.	WHAT DO THEY NEED?	To know they are in terrible danger
3.	WHAT IS THE INCITING INCIDENT?	Reactor exploded
4.	WHAT DOES/DO THE CHARACTER/S WANT?	To insist all is fine
5.	WHAT OBSTACLES ARE IN THEIR WAY?	Petrov's side
6.	WHAT'S AT STAKE?	Their lives and the future of the country
7.	WHY SHOULD WE CARE?	We fear for their safety and are enthralled by the deranged, seductive power of the lie
8.	WHAT DO THEY LEARN?	The falsehood is more comfortable than truth
9.	HOW AND WHY?	The power of a good story
10.	HOW DOES IT END?	The town will be sealed off; the country will lie.[6]

The ten questions underline three key elements about narrative: Firstly, in archetypal story protagonists always learn a lesson,

so questions 2 and 8 are intimately related. The characters we care about always learn what they need, but in this case it's a dark inversion – they learn that security lies in falsehood.

Secondly, the two poles – of need and lesson – are always opposites.

Thirdly, what changes minds are not facts but emotions. Every powerful story has a devil and an angel at its heart. At the beginning of the scene the devil is the reactor explosion, and the angel is saving the population, but by the end both roles have been usurped. The devil is now betrayal, and the angels are the rewards offered by the Soviet system. The ineffable power of story grows from getting those two elements right. Stories resonate when they offer the most emotionally rewarding answers (not necessarily the right ones) to the most intractable, awful problems. Here the story shifts from problem (the explosion), goal (control it) and reward (save the population) to problem (the explosion), goal (seal off the city) and reward (*medals!*). Devils and angels are recast.

The scene is a perfect demonstration of what Yuval Harari identifies as man's ability to use abstract concepts to sway human behaviour. Devils and angels are abstractions, evoked to leverage enormous behavioural change. A complete fiction (*medals!*) is created to trump a terrifying reality. Stories are enormously powerful tools for transmitting the nature of reality ('Eastasia has always been our friend') but equally profound agents of reality denial ('We have always been at war with Eastasia'). In George Orwell's 1984, what changes people's reality is the threat of brute force. However, as *Chernobyl* demonstrates, the most powerful form of reality denial occurs not through threat, but by seduction – often without even knowing we've been seduced. The stories that dominate our lives tend to be the ones that offer us something we *want* to believe, the ones that *feel* true. From there, it's a small step for them to become central to our identity, then for us to defend them despite their divorce from reality, and then finally to defend them with violence. But not only that, the stories that dominate our lives are simple, symmetrical and binary. We are order-seeking creatures, and the more rigid the grid,

the easier the story goes down – life not as it is, but as we desperately want it to be. The journey from observation to ideology to religion to cult is shorter than we might want to believe, and it's one carried totally, utterly and entirely by story.

Most of us exist within fairly invisible stories – the quiet tram-lines within which our lives pursue an orderly path. In Britain those lines might be prescribed by monarchy, political belief or something less overt. Until the financial crash of 2008, we were loosely held together by the post-war myth of a New Jerusalem – all the political parties, escaping the long shadow of a catastrophic war, subscribed to the idea (united against communism by the Cold War) that we could build a more equitable world. It was a kind of unconscious patriotism. Many, particularly on the left, would deny this, and pour scorn on any sense of patriotic feeling. 'England is perhaps the only great country whose intellectuals are ashamed of their own nation-ality,' said Orwell. But even those who denigrate their country – the middle-class liberals, for example, who attacked writer Martin Amis for daring to suggest that the British might be morally better than the Taliban – still wear an England shirt when their football team stride onto the field.[7]

However, once our belief in a story morphs into something self-defining (ideological belief, in other words), we become less tolerant of criticism. We now have an ideological mountain to climb, and no wish to be impeded by dissent. Alternative views become less welcome, for they remind us of the cognitive dissonance at our new ideolo-gy's heart. Critics become enemies, and we embrace 'no debate'. We want to climb higher, so we must crush those voices that threaten to provoke the doubt we are suppressing. We lash out. Where once we saw enemies, now we see heretics. Questions thrown at us we reframe as 'violence'. We double down on our beliefs and pull in fellow believ-ers. We employ guards to escort our narrative up our mountain, attack-dogs beside them, for our story must now be policed. Priests, some would call them, clerical outriders escorting our climbing party of 'truth'. Then, with the peaks in sight and now addicted to the power of routing our infidels, religion transforms into cult-hood, becoming

something absolute. Naysayers become apostates, and apostates find themselves at the bottom of crevices, ice picks embedded in their heads. Finally, surrounded by dead bodies, we stand triumphant on the top of our mountain, affirmed in our purity, not knowing that we, too, are now spiritually dead.

Story, ideology, religion, cult – there is a rigid grid at the centre of them all. What differentiates them is the degree to which reality has receded, and the degree to which we still defend – and indeed enforce – that grid, whatever the objective truth. When the reactor fire was contained at Chernobyl, the Soviets encased it within a sarcophagus to stop its radioactive poison from spreading. An equally rigid narrative binary was constructed to seal off the truth still burning within. They attempted to encase the entire incident in a sarcophagus of lies.

That's what stories at their most extreme can do – they are reality prisons built from ones and zeroes, in which everything must be contained. To a great extent this fidelity is the source of the ideology's (or religion's) power. The greater the cleaving to the story, the greater the denial of reality, the greater the power of the belief. It's faith-based. If you are Zharkov (a fictional but accurate embodiment of Soviet ideology), then the narrative trumps reality. The story is god and king.

The rigid structures that encased Chernobyl, then, are the hallmarks of religion. Their power is derived from how well the binary is believed and protected, and how far cognitive dissonance is crushed. But that process is amplified even further if you look at the far-flung coasts of religion, where the tides of cult pound the shore and reality denial itself becomes central. It is here that story unveils its true frightening power.

Cults

As Scientology demonstrates, the desire for enhanced status, for inner knowledge, for closeness to an inner cadre is highly appealing,

particularly to those who lack it most. Participants are motivated by desire to become supermen or gods, a desire enhanced by suffering and deferred gratification. The best stories build this suffering in. The more you are denied power, the more powerful the desire for inner meaning becomes. Chairman Mao seemed to understand that dynamic – the Cinderella effect – better than anyone. Greater affiliation to his Communist Party was induced by using a classic mixture of affirmation and criticism. Lowering the self-esteem of members was key, so as to move every locus of control outside of the individual. Any power a person might have could only come from total commitment to the story. This must involve pain. Indeed, the pain of commitment is responsible for the purpose.

Shamima Begum joined IS, utterly consumed by their story. Through slavish, painful obedience to an impossible-seeming course, a girl with rock-bottom self-esteem was promised revenge on those who belittled her. Once she made the leap of faith, the story infected her. See how it offered definition. See how it bestowed *life*.

That need to be complete and defined (triumphantly, of course) is insanely seductive. 'I had else been perfect,' says Macbeth when his plan to kill Banquo goes awry:

> Whole as the marble, founded as the rock,
> As broad and general as the casing air.

That's the secret promise of a story, enhanced by religion, turbocharged by cult. Here's a way to be a hero; it will cost you unimaginable pain, but it will be worth it – it will *complete* you. Want a powerful fiction? Make your protagonist like Shamima Begum, and make them suffer. It's the suffering that underpins the value of the goal. If it's not worth dying for, it's not much of a goal at all.

In any story, however, final heroic definition will be shaped by the contours of the antagonist. Again, we can learn a lot from the conspiracy theories common to all cults, and especially from one of the most consequential conspiracy theories of all.

The Protocols of the Elders of Zion were the minutes of a secret meeting in which an elite of Jewish elders (including Dr Theodore

Herzl) outlined, in twenty-four protocols, their plans to take over the world. Hitler cited them in *Mein Kampf* as conclusive proof of the Semitic menace. Except, of course, there was no such menace, and no tribe of elders. The *Protocols* were forgeries. That they were plagiarized from a completely different text, unrelated to Jewish people, tells you all you need to know about the underlying architecture of conspiracies, but even when they were revealed as fakes it didn't matter.[8] Hitler himself wrote, 'the *Frankfurter Zeitung* is forever moaning to the people that they are supposed to be a forgery, which is the surest proof they are genuine'.[9]

His attitude matched that of Henry Ford, who, in addition to being the founder of the behemoth American car company, was publisher of his own newspaper, *The Dearborn Independent*. Every week for ninety-two consecutive weeks the newspaper, which had a circulation of nearly 900,000, carried a section devoted to 'The International Jew: the world's foremost problem'.[10] When the series was finished it was republished in book form, selling another half a million copies.

American antisemitism grew after a wave of Jewish immigration. Fake moon landings weren't proclaimed in 1969, but in 1973 after the Watergate scandal. The US satanic panics of the 1980s coincided with a massive shift in family structures (housewives were now workers, and day-care centres became surrogate parents).[11]

Conspiracy theories bubble up from their zeitgeists, like pus on a psychic wound. One satanic panic case in particular serves to illustrate this. After one child reported painful bowel movements at their California-based day-care centre, hundreds of sexual-abuse charges, including elements of satanic ritual, were made against the owners, the McMartin family. After seven years, however, there were no convictions. The McMartins were innocent, nothing more than a convenient scapegoat for what was, at that moment, America's worst fear. As such, 'civil society' demanded their destruction.[12]

Conspiracy theories, then, are both revealing and useful. They act as bellwethers for any society's biggest fears, and those fears point better than any audience research to the kind of stories audiences

want. If you can find the underlying anxieties of your time, then you can access the strongest tales. But where most stories provoke reaction formations in answer to a need, conspiracy theories are dark inversions: reverse reaction formations. They find something innocent, like a pizza parlour which families enjoy, and transform it into a paedophile's cave.

As ever, these dark stories gain purchase if you can reduce their dastardly effects to one simple symbolic cause. 'What anti-Semitism does is turn the Jews – the Jew – into the symbol of whatever a given civilization defines as its most loathsome qualities,' wrote American journalist and author Yossi Klein Halevi. Examine the fears of any society at any one time – whether crime and child-abduction in Dickensian London, or capitalism to the communists of post war Russia – or indeed their inverse. It's not too hard to find a crime – from the slave trade to the pollution of the German race, that for the conspiracy-minded doesn't have a grotesque Jewish caricature at its heart. It's instructive that the *Protocols*, despite being such an obvious forgery, were endorsed by Presidents Nasser and Sadat of Egypt, alongside other Arab leaders.[13] They were, for many years, treated as foundation texts by the Palestinian nationalist organization Hamas.[14]

A traditional story drives you to what you most fear – a truth – and allows you to understand it. Conspiracy stories drive you towards what you most fear – a lie – and allow you to kill it. Sometimes that fear has its roots in something real: Cold War communism was, at some level, a clear and present threat. Sometimes it's a symbol of a greater destabilization – the biggest theories tend to emerge at times of great social instability. Witchcraft 600 years ago, QAnon now. Often the fear leads you to construct, like Superman, an alter-ego – a classic reaction formation built to hide not just what you're most scared of, but what you most despise about yourself. It's instructive when politicians or demagogues reverse engineer reaction formations. As Christopher Hitchens wrote eloquently:

Whenever I hear some bigmouth in Washington or the Christian heartland banging on about the evils of sodomy or whatever,

I mentally enter his name in my notebook and contentedly set my watch. Sooner rather than later, he will be discovered down on his weary and well-worn old knees in some dreary motel or latrine, with an expired Visa card, having tried to pay well over the odds to be peed upon by some Apache transvestite.[15]

All conspiracy theories are united by the same binary architecture and the same need. They are metaphors for our terror, and by telling a story in which you are the hero, you are re-enacting the exact function of fairy tales – you are taming your biggest fear. Who killed Kennedy? If you're antisemitic it was the Jews, if you're right wing it was the communists, if you're left wing it was the deep state and if you're middle class and law-abiding it was the Mafia. Fear is the key.

When challenged as to the veracity of his outrageous claims, Henry Ford replied, 'They fit with what is going on [. . .] They are sixteen years old and they have fitted the world situation up to this time. They fit it now.'[16] In essence that is the best possible explanation for all conspiracy theories. They *fit*.

How quickly a demagogue can exploit that, for who, viewing their world in such a dystopian manner, would not wish to escape it? How easily a story can convince a reader or viewer they are lost in the desert, and how thoroughly it can offer to quench their thirst. If the former strikes an emotional chord, and the latter taps an equally emotional desire, then very quickly you have adherents to a faith-based belief. When such a story takes off, the need to believe will brook no contradiction as the story tunnels its way into the centre of their being. How passionately they will then construe any lack of evidence as proof of the corruption of naysayers. How forcefully they will use that to prove just how deep the conspiracy of their enemy goes. How hungrily and violently they will then wish to terminate those who haven't seen the true light. A world where there is *nothing* but belief.

A hopefully useful guide:

If every contradiction can be explained away, if every accusation can be dismissed as proof of the accuser's guilt, if you're removing

the right of your questioner to question, if you have a secret language which changes on overexposure, if you have rituals or mantras of which you're unaware, if you are insisting on the primacy of feeling over science, if you're erasing your old self and casting off the shackles of identity to be born anew, if you're pointing a finger at someone and saying 'Do the work!' and if you're shouting 'Betrayal!' at every retreat from a hardcore belief, then you aren't in service of a rational belief – you are in service of a religion.

The hope of sustenance that religion might give you, and the chance to direct anger against those that threaten it, is a difficult bait to refuse. The remorseless power of the simple binary to crush everything it comes across keeps growing. For followers of Marxism, good and evil are class-based; for Critical Race Theorists they are gender- or race-based. For QAnon, it's believers in lizard people and Pizzagate versus, well, anyone who doesn't believe. No wonder people grab at anything that offers them hope, status and belief. Conspiracy theories dangle their fishing lines in the water, and the desperate bite down hard on the hook. Before we know it we are in the grip of an ideology or a religion. Neither left nor right are immune. 'All the "wellness" products Americans love to buy are sold on both Infowars and Goop,' declared a memorable headline on Quartz in 2017.[17] No Goop customer would ever think they were a prey to the same delusions as Alex Jones, even as they pay $66 for the privilege of inserting within them Gwyneth Paltrow's vaginal eggs.[18]

The belief is a vacuum that sucks up everything in its path: even for those who fake belief because it allows them to annihilate those they detest. There is great power in the brute force that comes with repeating 'Oceania has always been at war with Eurasia.' For those people it's not the lie they want people to fear, it's the liar. They are the modern inquisition, who will happily torture you to demonstrate fidelity to their cause. The rigid binary is God-like: a rough beast slouching towards democratic consensus, with violence on its mind.

Ideology, religions and cults are united by the fact they are all narrative-based. Much differentiates them, of course, in particular the degree of perceived pain and the fidelity to that narrative. The

more extreme you become, the more narrative becomes central to your existence. It must be protected, and the degree of protection will reveal what kind of narrative imprisons you.

A story walks freely down the street, an ideology has a body-guard and a religion has an armed escort, outriders and agents, with an ambulance coming up behind. A cult has assassins. The perfect story is a killing machine.

There's one last element the study of conspiracy theory and cult-hood can teach us. We know they activate their adherents, allowing them to destroy, righteously, their biggest fear. That's protagonist and antagonist taken care of. But what about goal? On one level, it's to defeat their enemy, but what comes after is the last essential ingredient: reward.

In his essay in *The God That Failed*, Arthur Koestler described what led him to embrace communism. 'I became converted because I was ripe for it and lived in a disintegrating society,' he wrote. He was 'thirsting for faith', and wrote of the extraordinary peace that descended upon him when, as a true believer in communism, 'you were no longer disturbed by facts'. When Koestler dared challenge the editor of a communist paper about the veracity of a particular story, he was told he was being 'mechanistic'. He needed to master 'dialectics' for true, objective understanding. He did, and his identity was transformed. That is the final goal, and lesson, of story.

In 1957, Bill Wilson, the co-founder of Alcoholics Anonymous, recalled the lowest and then highest point in his life:

> My depression deepened unbearably and finally it seemed to me as though I were at the very bottom of the pit. I still gagged badly on the notion of a Power greater than myself, but finally, just for a moment, the last vestige of my proud obstinacy was crushed. All at once I found myself crying out, 'If there is a God, let Him show Himself! I am ready to do anything, anything!'
>
> Suddenly the room lit up with a great white light. I was caught up into an ecstasy which there are no words to describe. It seemed

to me, in the mind's eye, that I was on a mountain and that a wind not of air but of spirit was blowing. And then it burst upon me that I was a free man. Slowly the ecstasy subsided. I lay on the bed, but now for a time was in another world, a new world of consciousness. All about me and through me there was a wonderful feeling of Presence.[19]

Wilson's words would not have felt out of place describing many of the events of this chapter. Note how similar they are to both Tressell's picture of socialism and Koestler's finding of communism. Meaning, purpose, community and ritual – AA supplies all four to those desperate to change their lives. A great white light shines down and reality is transformed, reconfigured – a somehow brighter, more meaningful and purposeful world.

Alcoholics Anonymous is non-denominational – it denies it's a religion, in fact. But consider the twelve steps that any member must follow:

1. We admitted we were powerless over alcohol – that our lives had become unmanageable.
2. Came to believe that a Power greater than ourselves could restore us to sanity.
3. Made a decision to turn our will and our lives over to the care of God as we understood Him.
4. Made a searching and fearless moral inventory of ourselves.
5. Admitted to God, to ourselves and to another human being the exact nature of our wrongs.
6. Were entirely ready to have God remove all these defects of character.
7. Humbly asked Him to remove our shortcomings.
8. Made a list of all persons we had harmed, and became willing to make amends to them all.
9. Made direct amends to such people wherever possible, except when to do so would injure them or others.
10. Continued to take personal inventory and when we were wrong promptly admitted it.

11. Sought through prayer and meditation to improve our conscious contact with God as we understood Him, praying only for knowledge of His will for us and the power to carry that out.

12. Having had a spiritual awakening as the result of these steps, we tried to carry this message to alcoholics and to practice these principles in all our affairs.

The underlying story structure is unmistakable. A flawed character (Step 1) falls down a rabbit hole (Step 3), changes belief system at Step 6 (literally the midpoint), tests that belief system to destruction against increasingly tougher obstacles (Step 9), before being faced with a crisis – a final choice to acknowledge all flaws (Step 10) – and fully accepting, finally and irrevocably, a new belief (Steps 11 and 12). As the novitiate defeats greater antagonists and works their way up the scale, as each victory gives them an endorphin high, so the story drugs them. They cannot live without another hit. They are host body to a new identity, and that identity becomes both endoskeleton and exoskeleton. The convert finds a strength from within and without, strength that can be stabilizing but can also be a prison. Then, as the drug saturates the body and they are replete, they see no prison at all. It's still there, but it has taken the form of their community – their closest friend.

AA presents an entirely symmetrical structure, but there's more. If you strip away the verbal veneer, you notice the act structure, the Live Action Role Play, the hero's journey. You might notice, finally, the resemblance not just to a purity spiral but also the journey from Repressive Being to Operating Thetan.

The architecture of Alcoholics Anonymous is identical to that of Scientology. In both cases, the body must be cleansed and purified, and the forces of suppression must be identified, fought and defeated. In both – like a video game – there is a hierarchy of escalating difficulty, but with each stage promising a greater reward. Both have a private language, both have a hierarchy (members can become sponsors), both contain priests who define and police the

central story. Both have a proselytizing function and seek to correct anyone with a critical opinion.

All the paraphernalia of religion is there: the serenity prayer in AA, the formal prayer in Scientology. Scientologists believe in an 'Infinity' and 'The Allness of All', Alcoholics Anonymous in a 'Higher Power'. Scientologists hold Sunday services, AA hold meetings; both have ritualistic elements, both have sermons and both have creedal statements. In both, speakers are evangelists and both have their bible – their utterly central story. For AA it's the *Big Book*, for Scientology it's the written and spoken words of L. Ron Hubbard. The architecture of both Scientology and AA, indeed any religion, is directly related to, and utterly dependent on, the architecture of story. It *is* the story. Put that into fiction and you have something very potent – you are holding the power of God in your hands.

There's one final lesson AA holds.

In their 1983 paper, sociologists Arthur Greil and David Rudy describe AA as an 'Identity Transformation Organization' (ITO). According to the paper, 'Organizations which encourage individuals to undergo radical shifts in world view and identity are "Social Cocoons" [. . .] Like cocoons ITOs coat themselves with a protective covering to protect the process of transformation going on within from interference from the outside.'[20] That's a great definition of a cult – a top-secret world in which an overpowering transcendent story can thrive. Think of the power of that reality-denying peace which Koestler finally found. AA promises the same.

Can you translate this into fiction? Look at *Harry Potter*, at *Star Wars*, at *The Chronicles of Narnia*, *The Lord of The Rings*. Look at *Game of Thrones*. Then look at populist demagogues. All of them, at varying levels, are harnessing the very same techniques as Scientology and AA. All are identity transformation machines, all promising you a blinding white light.

Identify your audience's biggest weakness or insecurity – the thing they most fear. Build your grid of opposites around that. Make your angels the most longed-for (Muslim terrorists, the vast majority of which are teenage boys, are offered virgins in the afterlife for obvious

reasons) and make your devils the thing they most despise. Make the need to destroy those devils existential, but make it almost impossibly difficult to do. Promise your heroes it will cost them nothing but blood, toil, tears and sweat, but offer them the chance to rip those devils limb from limb and spray their remains around a blood-drenched floor. And finally remind them that if, against all odds, they manage it, they will stand on broad, sunlit uplands once again.

Run down the bestselling fiction list in any country – it worked for them, just as it worked for the Union thanks to the words of Abraham Lincoln. He spoke to a North unsure of victory, and with words showed them a way they could win. From *need* came lesson. From a speech – from a story – identity became transformed. An identity transformation mechanism: old knowledge, new knowledge; I *want* to keep drinking, I *need* sobriety. There are few better illustrations of archetypal story.

Two insecure Jewish boys created a character to assuage their biggest fear, one that allowed them to transcend their flesh, locate purpose and meaning, and thus become complete. Onto them shone a great big shining light. If you can locate the biggest fear of your time and promise those who fear it an identity transformation by implanting within them the structure usurped by Scientology, then you have commandeered religion as the driving force of your story. For that's what religion is – a grid built around a hole that offers rigid meaning and purpose. One that may offer you the chance to tell, to borrow the title of George Stevens' 1965 biblical epic, the greatest story ever told.

ACT IV

Lessons from the School of Dissonance

7

Ariadne's Thread

Non-Archetypal Story and the True Role of Theme

Out the back door and under the big ash was a picnic table. At the end of summer, 1966, I lay down on it for nearly two weeks, staring up into branches and leaves, fighting fear and panic, because I had no idea where or how to begin a piece of writing for *The New Yorker* [. . .] I had done all the research I was going to do – had interviewed woodlanders, fire watchers, forest rangers, botanists, cranberry growers, blueberry pickers, keepers of a general store. I had read all the books I was going to read, and scientific papers, and a doctoral dissertation. I had assembled enough material to fill a silo, and now I had no idea what to do with it.

When John McPhee began his sixty-year run as a staff writer on the *New Yorker*, he was paralysed by a fear which for many writers is not uncommon.* He had a subject, he had a ton of useful ideas, but he just didn't know how to tell it.

The piece would ultimately consist of some five thousand sentences, but for those two weeks I couldn't write even one. If I was blocked by fear, I was also stymied by inexperience. I had never tried to put so many different components – characters, description, dialogue, narrative, set pieces, humor, history, science, and so forth – into a single package.

* McPhee's *New Yorker* career is still ongoing at the time of writing. He's also written thirty-two magnificent books.

Structure had completely defeated him:

> I was soon sprawled on the floor at home, surrounded by drifts
> of undifferentiated paper, and near tears in a catatonic swivet
> [. . .] I was able to produce only one sentence: 'The citizen has
> certain misgivings.' So did this citizen, and from all the material
> piled around me I could not imagine what scribbled note to take
> up next or – if I figured that out – where in the mess the note
> might be.[1]

His instinct was to seek a shape familiar to many, to tell his story
chronologically, but something in the subject matter resisted.[2] There
was no simple linear arrangement that could do it justice. It needed
something else, but what? The answer, it transpires, lies in some-
thing familiar – and far closer to home than we might imagine.

'The school of dissonance' is an umbrella term for non-archetypal
and non-Western narrative. Embracing everything from multipro-
tagonism to arthouse to Japanese Kishōtenketsu, it appears to open
a portal into a world where stories can be told in a hundred differ-
ent forms. What McPhee was trying to discover was the answer to
the question almost all writers ask at some point in their careers: is
there a better way of telling this? Is there an alternative to the simple
old hero's journey shape that might allow a more honest, truthful,
meaningful tale to be told?

The belief that traditional ways of telling are not adequate to their
task is a common refrain, running hand in hand with the belief that the
hero's journey which dominates most Western narratives serves profit
more than art. The film critic Simran Hans, writing in the *Observer*, felt
that 'With the intellectual property market booming, there is pressure
on those who work in non-fiction – film-makers, long-form journal-
ists, audio producers – to shoehorn the lives of real people into the
tried and tested template of classic storytelling.'[3]

Hans pointed, as evidence, to the highest-grossing non-fiction
films of the preceding fifteen years: *March of the Penguins*, *Amy*, *Won't
You Be My Neighbour*, *Three Identical Strangers* and *Free Solo*. We might
add to that list presenter-led films like *Bowling for Columbine*, *Touching*

the Void and *Searching for Sugar Man*.[4] Then there are voice-over films like *Enron: The Smartest Guys in the Room*, and observational docs too – *Crisis*, *Gimme Shelter* and *Grey Gardens*. All effectively use the three-act template Hans decried. Why should reality be reduced to ones and zeroes within a grid? Surely there has to be a better way of capturing the true complexity of *life*?

Hans believed there was, and in support of her argument she cited documentaries that in the last few years have scorned conventional structure: *Time* by Garrett Bradley, RaMell Ross's *Hale County This Morning, This Evening* and *Cameraperson* by Kirsten Johnson. By rejecting linearity and/or a protagonist, and by the use of 'associative editing, collaging together images from different moments in time', the documentary makers are, she says, able to access a greater truth than retreads of the hero's journey can allow. 'Through their juxtapositions, these film-makers are able to ask questions, convey scale and create emotional resonances that reflect the mundanities, digressions and complexities of real life,' she argued.[5] For her main defence she called on an intriguing argument made by the Canadian director Brett Story. For Hans, Story's films – particularly *The Hottest August* and *The Prison in Twelve Landscapes* – are proof that the default biopic structure, mimicking the progress of Jane Eyre or James Bond, is a limited form.

Story herself was far more damning. In a far-reaching and angry essay she took practitioners of the three-act form to task:

> Documentary filmmakers, including myself, are constantly asked for 'story' at the variety of junctures that enable the production and distribution of their films. And while non-linear, amorphous, and boundary-defiant forms have at many historical moments dominated the landscape of nonfiction cinema, this diversity has gradually been eclipsed by an onslaught of documentaries whose narrative waveforms seem to all track along the same contours.

For Story, these contours are the enemy. 'Main character. Three acts. Heroic journey. Climax. Resolution. Nothing else seems to suffice in today's documentary marketplace. A good story reigns

supreme.' Her own films were different. Of *The Prison in Twelve Landscapes*, she wrote:

> [It] has no plot, no central character or even central community that drives its narrative forward, no dramatic arc propelled by cause and effect, no set of chronological events or decisive moments – and that is, precisely and formally, its point. The film is instead structured through twelve discrete, often oblique vignettes set in a variety of non-prison spaces, like a coal town or a chess park, edited together to portray the vast geographic reach and institutional breadth of the US prison system. An associative essay film, its committedly non-linear narrative structure suggests we consider the prison not through protagonists or dramas at all (as those tend to reify the system as a whole), but through a multitude of ordinary landscapes, each host to pernicious racial and economic violence.

There's an additional problem with traditional structures, Story argues. Most classic documentaries are appropriations – narratives told by privileged film-makers reaping the fruits of underprivileged subjects. The former profit at the expense of the latter. Story (the subject, not the director) has 'become synonymous with "ownership" in the propertied, market capitalist sense.' 'Story [. . .] as a proven narrative formula,' she rails, 'seems to have become the monocrop of the twenty-first century documentary landscape.' Her essay was a plea to stand up, like she was doing, against the tyranny of a single structural form.

These are powerful arguments, made more so by the fact that *The Prison in Twelve Landscapes* is both a commanding and disturbing film. The fault-line Story stands on, between art and the mainstream (which she and many others might frame as a battle between 'truth' and capitalism), is not a new one. The impulse to destroy 'bourgeois narratives' is present in almost every school of art. *Tristram Shandy* mocked the very idea of containing reality within a structure, and that was written when the novel form was barely forty years old.

Every generation has produced its fair share of iconoclasts,

both in film and literature. Faulkner, Eliot, Joyce, Woolf, Toomer, Döblin, Kerouac, Kelman, Patrick O'Brien, Flann O'Brien, Bernadine Evaristo, Pirandello, Pinter, Beckett, Calvino – all attempted to walk the path Brett Story outlines now. Their work implies a belief that, as Story suggests, commodifying reality in a conventional form does no service to the truth. Against these formal rebels, Story tells us, are ranged the dark forces of commercial compromise: 'In my own experience pitching films, "artistic" has only ever been a dirty word, synonymous with commercial irrelevance, vain indulgence, or a sign of fanciful priorities. In the documentary mainstream, "art" and "story" are increasingly positioned as antipodes.'[6]

It is within the school of dissonance, Story argues, that real truth lies. Is she right?

For the 2023 BAFTAs, voters were presented with a shortlist of five candidates for best documentary film. Four were varied in subject matter but fairly traditional in form: *Fire of Love*, *All the Beauty and the Bloodshed*, *All That Breathes* and *Navalny* were all built within a conventional frame. The fifth – Brett Morgen's *Moonage Daydream* – defied that convention, aiming to capture its subject, David Bowie, in a completely different way.

Both it and *Navalny* quickly became favourites. The latter was, in form, utterly conventional. The story of how Alexiei Navalny fought against Vladimir Putin's tyrannous regime – how they tried to kill him and how, with the aid of Bellingcat, he fought back and exposed the would-be murderers – could have been carved out of a classic fictional tale.* Main character, three acts, climax, resolution: this really was a hero's journey. *Moonage Daydream*, a two-hour montage defying linear time and story, was not.

Navalny and *Moonage Daydream*: the twin poles of structure. What can they – and even more complex works – teach us about the nature

* Bellingcat specialize in using open-source intelligence to produce fact-based journalism, and are loathed by dictators everywhere. They began by investigating the use of weapons in the Syrian civil war.

of storytelling, about the validity of Brett Story's argument and the lessons the world of dissonance may have to offer?

Moonage Daydream

Since the moment David Bowie's estate had given him unrestricted access to their archive, Brett Morgen had worried about what structure would best convey the story he would find there. His original plan, to spend four months screening the material and one week writing the screenplay, completely fell apart when it took him two years just to view everything in their vault.

He knew he didn't want to tell a chronological story. In his previous music documentaries (*Crossfire Hurricane* on The Rolling Stones and *Cobain: Montage of Heck* on Nirvana's Kurt Cobain) he'd avoided the clichés of rock biopics (linear time, basic facts and key dates) to look for something deeper. But to portray Bowie he wanted to go even further. He wanted a structure that would capture the fragmentary, chaotic, magpie-like spirit of his subject – a fantasia. However, 'very quickly it was revealed that I [didn't] know how to write an experience. I didn't have a biographical narrative to lock onto.' As months turned into years, '[e]verything was messed up, everything was broken [. . .] It was kind of like walking across hot coals.' Morgen found himself in exactly the same position as John McPhee.

At his office Morgen would write 'long, indulgent essays about themes that David explored – mortality, chaos, fragmentation, Einstein, Joyce, Nietzsche and the reconstruction of our belief system'. He searched for different categories and different themes. 'I employed as many techniques as I could and methodologies that I had learned through my seven years of studying Bowie. That means everything from Oblique Strategies to some deeper sort of philosophical approaches to art.' He pursued every reference he could find: 'Bowie's music was filled with literary references, and it would send us down all sorts of rabbit holes. So, I liked the idea of building that into the film's design.' *Vastly* over budget and time, he still had no real

idea what he was going to do. Taking a leaf from Bowie's own book, he decided to change location. Flying to New Mexico and then taking the longest train trip he could find, he finally cracked it. By the end of his nineteen-hour journey from Albuquerque to LA 'the structure was in place'.[7] What Morgen discovered was – is – absolutely fundamental to how archetype-defying narrative works.

Moonage Daydream is a phantasmagorical evocation of 'the meaning' of David Bowie. It scorns linearity and instead jumps around time periods gleefully, spending almost as much time on his influences – painters, writers, photographers, film-makers and artists – as the subject himself. All exist alongside each other in a kaleidoscopic melange of pictures, words and music that aimed bring to life both how Bowie made sense of the world, and how an audience made sense of Bowie. His films were 'not about presenting facts and information but trying to present the subjects in a uniquely-cinematic manner,' Morgen said. He called it 'an avant-garde jukebox musical [. . .] I aim to create what you can't get from a book.'[8]

Narratively the film appears to make no sense, yet anyone who sits through its two hour fifteen minute run will leave having had a real and sincere experience of story. If it has no narrator, no chronology and follows Bowie and Eno's templates for disorder and chaos – how is that possible?

The answer is both familiar and deceptively simple. It's structured by theme.

Imagine the film was a presenter-led documentary – a current-affairs show perhaps, in which an intrepid reporter confronts the fifty-year failure of the water and sewage industry. The presenter would ask a direct question and then answer it in the best way they could, by ranging across subject, history, political manoeuvring and whatever else they felt apposite. They would not be bound by linear chronology, they would be served only by building the best possible answer to their main question – everything would go back to that one central point.

It's exactly the same here. At the end of the first act, the film has established the protagonist, his world and his relationship to it. But

most importantly, as it reaches the inciting incident – at the end of act one, twenty-five minutes in as the screen goes to black – it has laid out clearly a central question. We are told repeatedly in the first act that Bowie is endlessly seeking, trying different guises, different gurus, different religions, even impersonating messiahs himself. As the act canters towards its end, Bowie himself asks 'What's my central relationship with the universe?' That's the question, and that's the theme: who or what does he need to be or do to find *worth*?

The answer isn't all that surprising. Look at the triangle that defines classic story: the inciting incident, the midpoint and the crisis. The inciting incident is the question, the midpoint is the answer delivered in lesson form and the crisis is whether to accept that lesson or not. In *Moonage Daydream*, Bowie throws everything away at the midpoint: he moves to Berlin and completely reinvents himself and his music. The crisis is actually the spectre of commercial success. Normally, in any movie, the forces of antagonism lead, at the crisis point, to some kind of real or proxy death. You see this very clearly in other music biopics. In *Amy*, Winehouse is close to death; Johnny Cash in *Walk the Line* has succumbed to drink, drugs and despair, while Ray Charles in *Ray* is sent to jail for heroin addiction. Here, though, Bowie has become *too* successful. He's sold out, lost his vision as he pursues fame at the expense of worth. What does he choose to do in the last act? He must embrace the need for permanent change wholeheartedly once again. Art is never permanent. *Transience* is all.[9]

Ironically, for a film that appears to scorn convention, Morgen has talked about the archetypes underlying it. 'I looked at all of these adventures David went on. He was creating his own storms for himself. And so I viewed his journey in mythical terms, the Hero's Journey.'[10] So, at heart, the film is actually built on a classic narrative trope – but unlike most fictions, this hero's journey isn't linear and two dimensional, it carves a path instead through non-linear time and space.

Sometimes a structure is obvious and simple. How do you capture a life? Almost certainly, you will consider the journey from birth to

death. You may start further on in the tale – at a moment of apotheosis or crisis to intrigue us or remind us why the story needs to be heard – before going back to the beginning for the true start of the tale (the documentary equivalent of 'four weeks (or years, hours, minutes . . .) earlier').

Alternatively, you may take a small period of time, as in Asif Kapadia's *Diego Maradona*, where Maradona's shock transfer to Naples works as a synecdoche for his whole career. Theme here plays a greater role, bridging the wider biographical story and the more concentrated central conceit.[11] There is 'always a considerable tension between chronology and theme', felt John McPhee:

> and chronology traditionally wins. The narrative wants to move from point to point through time, while topics that have arisen now and again across someone's life cry out to be collected. They want to draw themselves together in a single body, in the way that salt does underground. But chronology usually dominates. As themes prove inconvenient, you find some way to tuck them in. Through flashbacks and flash-forwards, you can move around in time, of course, but such a structure remains under chronological control and can't do much about items that are scattered thematically. There's nothing wrong with a chronological structure. On tablets in Babylonia, most pieces were written that way, and nearly all pieces are written that way now.[12]

This tension between chronology and theme is absolutely central to any understanding of structure, especially when narratives free themselves from classic linear shape. To fully understand how stories that defy chronology work, we need to come up with an ultimate – final – definition of theme, for it is this that unlocks everything.

Theme

What is theme? The answer begins to reveal itself in the quietest of opening scenes:

INT. AIRPORT CAFETERIA. DAY

A cafeteria in a quiet airport in the provinces. Few passers-by.

A single woman in her mid-40s (JULIETTE) sits at a table. Sips coffee. Gazes around her as if discovering something new – she often has an expression of eager surprise, as if seeing things, people, places for the first time ever.

She seems uncomfortable in the clothes she is wearing. At her feet is an old-fashioned suitcase.

A younger woman (LÉA, early 30s) appears behind Juliette. Less than a meter away.

Juliette hasn't noticed her. Clearly deeply moved, Léa quietly observes her for a few seconds.

Then, sensing a presence, Juliette looks round.

Léa leans forward and hugs her tight before Juliette has time to react. Juliette is slightly taken aback.

She doesn't return the hug at first. Then awkwardly puts her arms round Léa.

There is love between these two women, but something dark and unspoken too. You know straight away a person – people – have been broken. Juliette is played by Kristin Scott Thomas, and very slowly her performance leaches little clues. Over the space of two hours, we learn she's been away, she's been in prison, and we discover (at the midpoint) that she was convicted of murdering her son. At the

crisis point it's revealed just how she killed her little boy, with a twist and a climax that make us love her by explaining why.

Philippe Claudel's *I've Loved You So Long* (*Il y a longtemps que je t'aime*) is a masterclass in film exposition, largely achieved by removing (almost) all of it. We infer more about what happened from the reactions of friends and strangers than from Juliette herself, who refuses to talk about her past. In fact, the film is powered almost entirely by what's left unsaid. It forces us into the role of detective, riveting us to the movie, relying on our own fierce curiosity to complete the puzzle.

Juliette, by quietly forging ahead, learns to reintegrate into a society from which she has long been exiled. That's the main story. Alongside this, runs a second strand.

One of the key agents of her rehabilitation is a probation officer, Captain Fauré, to whom she must report on a regular basis. He has a picture on his office wall of the Orinoco river, which he dreams of visiting. She gets to like him, the relationship becomes less formal and they start to hold their meetings in cafés and bars. One day he tells her he's leaving his job; he's finally going to fulfil his dream. When she turns up to meet her new contact back in the fusty old police station, she asks after Fauré and his trip. The new man tells her bluntly that Fauré did not go to the Orinoco, because he shot himself through the mouth ten days before.

It's a huge shock and a classic reversal, one that immediately transforms our understanding of the character, his loneliness, his isolation and his need to always pretend everything is fine. It's also, in structural terms, the perfect subplot.

A subplot is, in essence, a separate story strand running in tandem to the main plot. It can connect with the main story in a number of different ways – they can share the same precinct (*Hill Street Blues*) or the same characters (*American Graffiti* or *Dunkirk*). They can interact, with one story strand crashing into the other, spinning it off in a new direction (as in *I May Destroy You* or *House*), but the most powerful way disparate story strands can connect is through the use of theme.

The two stories in *I've Loved You So Long* are united by all of these, but most importantly they share the same theme: they both explore the question 'What makes life worth living?'

This shows us what a theme *does* – a good theme binds every strand in a story together. But it doesn't tell us what theme *is*. For that we must delve further.

Since its release in 2003, Pixar's *Finding Nemo* has made its budget of $94 million back more than one hundred times. The script, by Andrew Stanton, is built around one simple, primal moment. Marlin is a clownfish who lives with his family inside an anemone on the Great Barrier Reef. When they are decimated in the opening moments by a malevolent barracuda, Marlin stares down at his one remaining egg – Nemo – and says, 'I will never let ANYTHING happen to you.'

In *Into the Woods*, I argued that it's best to think of subject matter and theme as different entities. Subject matter is a static given, while theme is best expressed as a question. *Finding Nemo*'s 'I will never let ANYTHING happen to you' thus becomes 'Is true love best expressed through fear or trust?' That's the question that runs through the film – a question that, for Marlin, becomes all too clear at the inciting incident, when Nemo swims out by himself and is captured by divers, and Marlin's life is turned upside down.

It is at this point that the actual question the film asks is crystallized dramatically. When Marlin discovers Nemo has gone, he is confronted by the consequences of his own actions. Nemo, he understands, put himself in danger because he (Marlin) was overprotective, judgemental and unfair. Marlin is not ready to admit this, of course, he still claims that true love is expressed through fear. At this very moment, however, doubt courses through him – an antibiotic that will eat away at the bacteria of his belief system. If he had just shown trust, that drug will tell him, then Nemo would be tucked up safe at home. That moment – the inciting incident – is thus when that the antibiotic is injected into the story's veins.

The inciting incident, then, is a question to which the rest of the

story provides the answer. And this is what finally unlocks the true meaning of theme.

Theme *is* that question, the one posed by the inciting incident.

Sometimes this is expressed explicitly. Harry Burns is driving Sally Albright to New York after they've both graduated from the University of Chicago when he tells her, 'Men and women can't be friends, because the sex part always gets in the way.' It's the end of the first act of *When Harry Met Sally . . .* , and though Harry phrases it as a statement, it's really a question: 'Men and women can't just be friends. Discuss.' And that – that's the film. It's effectively three acts:

- 'Men and women can't be friends.'
- A man and a woman try being friends.
- 'Men and women can't be friends – unless they are in love.'

It's thesis, antithesis, synthesis. (Note, too, the last act twist – a mild variation on 'Oh no! But of course!') It's an argument, as all stories really are, over the correct answer to the question posed by the inciting incident. 'Men and women can't be friends' is a very literal example of how this works; the question is rarely so overt, but as such it's a great illustration. That moment, that question, is the inciting incident. And in any archetypal work, that question provides you with the theme – and thus the backbone – of your work.

How are the arguments in *When Harry Met Sally . . .* and *Finding Nemo* resolved? The answer is found in one of the founding tenets of screenwriting lore, one we addressed in our discussions of Pixar earlier in the book: 'What does your protagonist learn?' The protagonists resolve the argument by learning the right answer themselves.

In simple terms, stories work like this:

- First my character believed this . . .
- Then I confront them with this . . .
- And now they believe *this*.

What does your character learn? They learn the answer to the question posed by the theme.

If you want the simplest possible illustration of how all arche-typal story works, it's this.

- First my character believed this:
 I cannot let Nemo play.
- Then I confront them with this:
 Oh.
- And now they believe *this*:
 I can.

The midpoint of the story – 'Then I confront them with this' – is a universal midpoint. That '*Oh*' is the lesson the protagonist must learn to become complete (in *Finding Nemo* it's meeting the laid-back, hippyish Crush, who actively encourages his kids to take risks). It is the answer, in embryo, to the question posed at the end of the first act. It prefigures the ending and is the lesson they must road test to destruction before accepting, in the last act, its indisputable truth.

When you boil everything down, what you discover is that theme *is* dramatic structure. Not just that, but dramatic structure, indeed all narrative, is really just built from a question and an answer.

A question is posed by the inciting incident, then answered by the lesson the character learns. 'Is true love expressed through fear or trust?' the film asks of Marlin. What does Marlin learn? He learns that true love is expressed through trust.

A character, then, goes on a journey to answer the question posed by the theme.

One of the very best examples is found in *Chernobyl*.

RECORDED VOICE (LEGASOV)
What is the cost of lies?

The very first line of the series, delivered in blackout for emphasis, announces the question to be answered by the work. Five hours of television later, there's a very clear answer. Legasov has told the truth to the tribunal, that the entire Soviet System is to blame. He knows that the truth will never be reported. As he climbs into the

back of a limousine to be taken home (or worse – he doesn't know), the voice on tape from the beginning bookends the show:

> **LEGASOV (VO ON TAPE)**
> To be a scientist is to be naive. We
> are so focused on our search for
> truth, we fail to consider how few
> actually want us to find it. But it
> is always there, whether we can see
> it or not, whether we choose to or
> not. The truth doesn't care about
> our needs or wants. It doesn't care
> about our governments, our
> ideologies, our religions. It will
> lie in wait, for all time.

We RISE UP HIGHER - as the car disappears down the road.

> **LEGASOV (VO ON TAPE)**
> And this, at last, is the gift of
> Chernobyl. Where I once would fear
> the cost of truth, now I only ask:

> CUT TO BLACK:

> **LEGASOV (VO ON TAPE)**
> What is the cost of lies?

The very first line in Episode 1, a question, is answered (in a perfect chiasmus) by the very last lines in the final Episode 5. In between them, strung like a tightrope, every single element of the script, design and direction is enlisted in service to that central question. Very often it's visible in the dialogue: 'Every lie incurs a debt to the truth. Sooner or later that debt is paid.'[13] Often it's in the

pictures – we are shown the cost of lies. One way or another, you can see the theme in every single scene. Nothing happens in *Chernobyl* that doesn't, at some level, reflect, discuss, debate and serve the central question. It's the DNA of the drama; it's Zharkov's speech versus reality – what is the cost of each?

As in *Finding Nemo*, the question is stated in the very first lines, but then brought dramatically to life by the series' inciting incident at the end of Episode 1.*

> A line of CHILDREN, 7-years old, in their uniforms and book bags, holding hands and laughing as they walk to school.

> Move in and low to the ground now . . . until we're just looking at the children's shoes as they pass by. A moment or two, and they're out of frame.

> Then a BIRD drops to the ground in front of us, hitting the cement with a sickening sound. It twitches for a moment, then goes utterly still.

It's a chilling moment. What exists already as a verbal idea is now injected into the show's inner core. The question is now embodied by the characters – Legasov versus the Soviet Union – and by the juxtaposed images of macabre death and innocent life. Every single moment from here on will be in reference to how, or if, those characters and those twin images can be reconciled.

This insistence that every single element of a work is prescribed by theme may feel extreme, but it's a key component of so much successful storytelling. Take a look at any episode of *I May Destroy You* or for, an even more intense example, try Benjamin Naishtat's film *Rojo*, set during the time of *los desaparecidos*, when 30,000

* In television, the series-inciting incident is the question posed at the end of any first episode. Here, the explosion has occurred (that's the first act of the episode) and the Soviets are still pretending everything is fine.

Argentinians 'disappeared' during the rise of the junta. Every microsecond from first shot to last is a riff on the theme of disappearance. In both, there is literally nothing that doesn't reflect the central theme.[14] Why would Michaela Coel or Benjamin Naishtat do that?

In Chapter 4 we looked at the relationship between story and rhetoric. One of the principal ways they relate is by theme. Simon Lancaster has been both an author and professional speech-writer at the highest level of government for over twenty years. For him, theme is everything:

> Every great leader's speech is built around a single brilliant theme. It might be a vision ('the caring society'), a conviction ('yes we can') or even just a word ('responsibility'). We expect our leaders to show clarity of thought and the speech should reflect that clarity. It's the theme that will fill the following day's papers and which represents the point of persuasion on the audience: the force of energy that will transport them from A (where they are now) to B (where the leader wishes them to be).[15]

A spine gives definition, it gives purpose and it gives support. Once upright, however, the spine needs muscle and flesh to reciprocate the favour; one without the other cannot stand. Theme is the spine, and the surrounding story the flesh and muscle. They are locked together in an act of mutual support. Plenty of stories concentrate on one or the other, but it's in that reciprocal bond, where every single element is serving the same purpose, that the most powerful narratives are formed. If the theme is utterly clear and the elements it supports reflect it at every point, then something very special can happen. Lancaster rightly calls theme 'the force'. The events of the story are the force multiplier. The strength of the theme is the story, and the strength of the story is theme. The most transcendent stories are an act of fusion between spine and flesh – the nuclear bang that turbocharges the most powerful tales.

How does this help you practically?

If you're in any doubt as to the theme of a story, ask yourself

'What does the character learn?' Reverse engineer the question from there. If the man and the woman learn they can be friends if they are in love, the theme must be 'Can men and women ever be friends?' Likewise, if you're writing a story (or a column or a speech), ask yourself if you can distil it into one simple question. Can you answer it with a logic that appears to be foolproof?

Why did the final season of *The Crown* feel as if it slightly faded away, not unlike the final shot of the Queen herself? Because there was little thematic clarity. It became apparent that the show had forgotten the question it was asking. Such is the fate of too many long-running shows. The minute your favourite programme starts relying on backstory, or long-lost relatives are miraculously introduced with no prior reference, you can tell it's in trouble. Every future episode will be a losing battle against irrelevance, for the narrative question at the heart of these shows has been answered and there is no more story to tell. Watch Season 3 of *The Bear*. The show, about opening a restaurant, reaches magnificent heights but is over by the end of Season 2. There is nothing left but smoke and mirrors, and when the smoke clears the bankruptcy of repetition is revealed. The original question has been answered and the replacement one – 'Can they win a Michelin star?' – (interspersed tellingly with flashback trauma plots, the first sign any show is in trouble) simply isn't a strong enough spine to hold up the body of work.

Is the dramatic question clear? Does every element serve it? Can it be read in every subplot? Then further: is the question relevant? Is it topical? Is it hard to solve? If the answer to any of these is 'no', treat it as if it's a microaggression against audience involvement. Any decent story can tolerate some of these, but there comes a point where the sheer number of flesh wounds becomes life-threatening. Why would any writer want to risk that?

Once the importance of theme is understood, it not only allows you to streamline classic single-protagonist dramas, it opens up a whole new world of narrative possibility: in counter-storylining, in multi-protagonism, in non-linear drama. Indeed, it unlocks every secret

held by the school of dissonance. Theme is not an afterthought. Theme is where everything begins.

Counter-Storylining

Tolstoy's *Anna Karenina* towers over modern narrative literature: the castle at the top of fiction's mountain, dazzling you with its scale, daring you to challenge its worth and power. It's a huge work, but it's built around an incredibly simple structure. Anna is a married woman who falls in love with an army officer – the younger, dashing Count Vronsky. At the same time Konstantin Levin, a wealthy landowner, falls in love with Kitty.

The two stories hardly coincide or connect at all. Kitty is the younger sister of Anna's sister-in-law, and she's infatuated with Vronsky when we first meet her. But this is a book called *Anna Karenina*. Kitty and Levin – *why are they there?*

Partly, of course, it's because they are products of the same time, place and aristocratic milieu. But, while the novel is rich in subject and ideas, at heart the two stories are held together by one simple *thematic* connection, one embedded within the characters of Anna and Levin. They are opposites. She is a product of the bourgeois elite, he of his deep-rooted attachment to the land. Both seek love to find meaning and fulfilment, but she looks outside the boundaries of convention, while Levin attempts to find it within. Anna embodies kneejerk, spontaneous romantic compulsion, while there is not a single second when Levin isn't beset by the demons of prevarication.

In their love for each other, too, Konstantin and Kitty are in almost every way a counterpoint to Anna and Vronsky. Anna falls head over heels and it leads to misery; Kitty initially spurns Levin's advances, only to find, in the end, some kind of happiness there. This is counter-storylining – the character arcs cross like the two strokes in the letter 'X'.

The journey the characters go on both defines the parameters of the argument and creates the structure itself. In *Anna Karenina*

the two story strands cross exactly halfway through the book, as the protagonists travel in different physical and mental directions: Kitty at the wedding heading towards some kind of fulfilment is intercut with Anna in Italy as she waves any possible fulfilment goodbye. Both strands are reinforcing the same point. If the thematic question at the heart of the book is 'What does true love mean?' both strands are very clear: love is *not* born of infatuation, but from an obligation to the other party – a duty. That 'X' structure works like a box-girder bridge. It provides us a shape that's incredibly durable and strong, and if Tolstoy's novel embodies a sense of granite-like purpose, it's in no short order because of this.

I've Loved You So Long does something very similar. While each strand takes the characters in opposite directions, one towards life and the other towards death, both arrive at the same conclusion. If the question at the inciting incident is 'What makes life worth living?' then the conclusion both strands come to is that only by opening your heart can you be happy. Juliette's story proves that true. Captain Fauré's story does the same by showing what happens if you can't.

There is, however, an arguably more interesting version of counter-storylining. Set over twenty-four hours in September 1962, the two central characters of George Lucas's *American Graffiti* swap places. Steve (Ron Howard) and Kurt (Richard Dreyfuss) are planning to head east from California to start college the next day. At the beginning of the film Kurt doesn't want to go and Steve does, and by the end the roles are reversed. It's a classic counter-argument: 'How important is home?' asks the movie. For Steve, it becomes everything, while Kurt finally sees it as a limiting prison. If drama is an argument, then you can see how this thematic approach enriches a work by allowing for greater complexity. Story A proposes a thesis, Story B its counter. Each makes the other stronger. Within that larger argument, blood flushes through the system – it's like injecting colour into a black and white film.[16]

The benefits of this technique become even more apparent once you consider a world which is almost entirely built around this idea – that of multiprotagonism.

230

Multiprotagonism

In Paul Haggis and Bobby Moresco's Oscar-winning *Crash* there are six stories, each exploring the question framed by the opening lines of the film:

> It's the sense of touch. In any real city, you walk, you
> know? You brush past people, people bump into you. In
> L.A., nobody touches you. We're always behind this metal
> and glass. I think we miss that touch so much, that we
> crash into each other, just so we can feel something.

The driving question implied here swims clearly into focus at the inciting incident, a profoundly disquieting stop-and-search between a cop, Sergeant Ryan (Matt Dillon), and the passenger he has pulled over, Christine (Thandie (now Thandiwe) Newton).[17] 'Is isolation an obstacle to empathy?' the film asks, framed here more specifically as 'What causes them to hate each other so much?' Over the next two hours the different storylines will intertwine, bound by subject matter and plot interaction, but most of all by that theme. Each character will explore what happens to them when their insular worlds collide. As the characters discover how isolation has warped everyone's worldview, we do too. Every strand thus answers the question the film poses – 'Is isolation an obstacle to empathy?' – with a resounding and unequivocal 'Yes'.

As with *American Graffiti*, the two strands don't have to come to the same conclusion. In *The West Wing*, perhaps the best example of sustained multiprotagonism in recent times, Aaron Sorkin juggled multiple complex plots each exploring different aspects of whatever the theme might be. He often gave contradictory answers to each specific episode's question, thus allowing even greater nuance and sophistication.[18]

The details of multiprotagonism lie outside the scope of this book, but there is one key element that the most sophisticated type

of multistranded dramas employ, one that can really unlock our understanding of non-linear tales. And it's a direct result of one seismic moment in the history of cinema.

The Host-Seeking Emotion

It's a scene so famous it became the subject of a film. It's three minutes long, opens with a woman getting into a shower and ends with her blood circling round a plughole, her dead-eyed face lying flat on the bathroom floor. It's profoundly sexual, intensely disturbing and the first successful marriage of high-art style and trashy pulp subject matter.

Taking seven days of a six-week shoot, a vast amount of care went into its making. Seventy-eight camera set-ups were used, and there were fifty-two cuts. It was intricately storyboarded by Saul Bass, with a revolutionary score by Bernard Herrmann (the soundtrack of *Jaws* is just this scene's main theme slowed down). It had an advertising campaign that altered the way people went to the cinema ('No one . . . BUT NO ONE . . . will be admitted to the theatre after the start . . .'). The scene opened with a flushing toilet (no one had ever seen *that* in a film before) and in the three minutes that followed it broke, in the words of Guillermo del Toro, 'the covenant between filmmaker and audience'.[19] There is cinema before and after the shower scene in *Psycho*.

The scene contains things that were traditional, but all with a savage modern twist. It has a classic ring structure – the feet getting in the shower mirror the dead body coming out; shower head mirrors shower head; shot mirrors shot – with a midpoint where, if you slow the film down, you can clearly see a knife actually 'in' flesh, just under the woman's belly button, something else audiences had never witnessed before. This moment – this ridiculously Freudian death stroke – is the peak of a manic combination of ecstasy and violence. Scorsese copied it.[20] *Everyone* subsumed it – it's become

part of our cultural shorthand – yet the thing that may well be most important about it rarely gets mentioned.

The moment Norman Bates picks up Marion Crane's dead body and cleans up after her murder, seemingly by his mother, something profound happens, something that unlocks two of the great cornerstones of narrative. Without it, there would be no killing of Ned Stark in *Game of Thrones*, no death of Vincent Vega in *Pulp Fiction*. It lies at the heart of so much arthouse narrative and is embedded right in the heart of one of the great writing challenges, that of the most sophisticated type of multiprotagonism.

At the midpoint of *Psycho*, it's not just Marion Crane that should die, but the film itself. The viewer's avatar has been murdered, and we find ourselves bereft of the vehicle that binds us to the story. Yet fifty-four minutes later we are still watching. What's happened? Empathy, it transpires, is a host-seeking emotion. Deprived of a character they love, an audience will immediately seek a new vessel on which to settle their heart.

The moment Norman Bates finds Marion dead in the shower, we switch. We're with Norman now, as he struggles to save his mother from the police and himself from some kind of death. What Hitchcock had discovered was that you could sustain continued interest not by sticking with one character, but by continually passing the dramatic baton on.

In *Psycho* the result was profoundly shocking, but this discovery has another use in multiprotagonism, never better illustrated than in the first episode of NBC's monster hit of 1994 to 2009: *ER*.

ER lasted fifteen seasons and 331 episodes, during which it won 116 awards and grossed over $3 billion.* By the time it ended, it had experimented with live episodes, backwards episodes and fractured-time episodes, all within the television mainstream. Often it was conventional, but occasionally – and especially in the groundbreaking two-hour pilot – it introduced to television a radical new kind of multiprotagonism.

* As of 2014.

Instead of traditional multiprotagonism (such as in *American Graffiti*) where each character's story appears in every one of the programme's acts, *ER* sought a lighter and more durable construction. It gave each of its six central characters smaller stories, so that in a five-act show, each of the protagonists might only feature in two, three or four acts. Often they'd drop out altogether. So why did it work? Each of the protagonists' stories explored the same theme but, unlike in traditional multiprotagonism, they didn't carry it in every act. Instead, they passed the narrative baton on: each act was carried by a different member of the gang.

This was deeply radical, even though, watching the show, it feels curiously traditional (you see something very similar in *This Is Us*). The traditional single-protagonist structure still exists, but, like a relay team, its race is run by the group. The central gang effectively become one person, forming one character with one theme and one goal: to answer the question posed by the inciting incident. It's a bewitching structure – as light as air, yet absurdly strong.

This baton-passing is deeply significant. Not just for its role in multiprotagonism, but because it gives a much greater understanding of stories with far more dissonant, non-linear structures, too. And it's this that leads us back to the world of the arthouse film.

Andrei Rublev and Arthouse Film

John McPhee understood there was nothing wrong with traditional form, yet at the same time felt instinctively there had to be something more. 'After ten years of it at *Time* and the *New Yorker*, I felt both rutted and frustrated by always knuckling under to the sweep of chronology, and I longed for a thematically dominated structure.'[21] That urge, which would lead him to all kinds of interesting places, is not unique to long-form journalism. Like Brett Story, deep down most of us want to find a structure that serves our material in a unique and different way – that *transcends*. In 1966 the director Andrei Tarkovsky found such a form.

It's three hours long, it's set in medieval Russia and it's in black and white. For some, that's enough to pass it swiftly by. But those who did see *Andrei Rublev*, Tarkovsky's epic portrait of Russia's first great artist, in 1971 (the Soviets suppressed it for many years) were in for a unique and disquieting experience. Anyone expecting a traditional biopic would have felt considerable disappointment.

Andrei Rublev is not *The Agony and the Ecstasy*. Michelangelo (Charlton Heston) and the Pope (Rex Harrison) don't fall out melodramatically over the painting of the Sistine Chapel here. There's little sense of linear time, characters appear and disappear seemingly at random, and the eponymous hero is never even shown to paint. In fact, for long sections of the film he doesn't appear at all, and when he does he hardly does *anything*.

It can feel bewildering. '[T]here always seems to be more going on in the head of the film's director than in the head of the man playing Andrei,' said Vincent Canby in *The New York Times*.[22] For some it's beyond logic, and that's its point: 'We don't necessarily know, or need to know, how Andrei Rublev works or what it's telling us,' wrote Steve Rose in the *Guardian*, declaring it the greatest arthouse film of all time.[23] 'To watch it,' claimed Anthony Lane in the *New Yorker*, 'is to be initiated into sacred mysteries for which no rational explanation will suffice.'[24] But there is one, and it's hiding in plain sight.

The film opens with a man, Yefim, attempting to fly with the aid of a primitive hot-air balloon. An angry mob storm the launching, pushing a branding iron into the face of one of his assistants. Our hero will not leave the ground, they insist. Yet briefly Yefim soars into the bright sky – never to be seen again. Then we cut to the first of eight sections.

Rublev, an idealistic young icon painter, leaves his monastery home with two fellow artists. They are heading to Moscow, and over the eight acts of their journey they will both be educated in life and find the answer to the question posed by the film. What is that question? It's not immediately apparent, but very slowly and quietly, as the journey progresses, it becomes clear.

Andrei and his friends will encounter jesters imprisoned for

speaking truth to power, master painters jaundiced by experience, assistants interested not in subject matter but only in craft, and other artists either ruthlessly ambitious or jealous of their peers' success. They will witness or participate in passion plays and pagan orgies, and at each stage of the journey they will be challenged to examine their core beliefs. It's a story that would work as a linear quest, a kind of artistic *Apocalypse Now*. However, for much of the film, Andrei is either passive or off-screen, and the story is carried completely by colleagues or strangers. Andrei is no Captain Willard. There's something else going on. The prologue, it transpires, is the clue to everything.

In every section of the film there is an echo of this opening scene. A central character experiences some kind of transcendence, while others attempt to bring them crashing back to earth. At the centre of the film this happens to Andrei himself. Inspired by an innocent young girl, he resolves to decorate a church with a hymn to humanity. He *soars*. But then, as he finishes his masterpiece, hordes of Tartars swarm the city. The girl is killed, the church is desecrated and the occupants tortured with hot metal poured into their mouths. Andrei's great work is destroyed. He cuts himself off. He will not speak. Spiritually, he is dead to himself and the world.

Sometime later, somewhere else, a young convict – Boriska – is charged with casting a giant bronze bell. He has convinced the soldiers guarding him that he has inherited his dead father's bell-founding skills. They are sceptical but grudgingly accede.

Molten metal forms rivers of bronze that flow into a vast underground mould, channelled by hundreds of peasants, ruthlessly employed. Andrei passively observes this biblical scene. If the middle of the film is a painting by Bosch or Brueghel, then this is a Salgado photograph. There is misery and degradation, the sheer pain and trauma of medieval Russian life, and then, against all expectation, clods of earth start to tumble. Boriska conjures the bell from the bowels of the earth.

The crowd stand aghast as it's slowly hoisted atop a tower. Like the opening of the film, this is an ascension – a classic inclusio. Here, finally, there will be no last crash to earth. Instead, chimes ring out

across the land, and as they do the film bursts into colour and we are presented with a tableau of the real Rublev's extraordinary art. The medieval icons dazzle, and from that you finally infer the question – the theme – that powers the whole film: 'What does it take to make great art?'

Rublev, his colleagues and complete strangers stumble through each of the eight acts asking exactly that question, sometimes literally, sometimes metaphorically.* They encounter cynicism and pessimism, patronizing attitudes and obsession with technical detail. None of these work for the various protagonists, including Andrei himself. It's only in this final section that he learns the key lesson from Boriska. As the bell rises, Boriska tells Andrei that he lied to the soldiers; he had no idea how to build the bell. We, the audience, suddenly understand it was an act of faith. Like Yefim, who held onto the balloon in the prologue, we see that true transcendence – great art – only comes from that deepest-held belief.

If you look for the classic story triangle in *Andrei Rublev* something really significant becomes apparent. The midpoint is Rublev's artistic celebration of humanity. His icon is close to perfect, but is immediately savagely destroyed. The crisis point, the loss of all hope, is Rublev's silent monastical despair, and the climax, the creation of the bell, is the final triumph of art. Idealism (act one) and brutal experience (act two) are important – they are thesis and antithesis – but they can only be united together through the synthesis of faith (act three). The meaning lies there, inviting us to grasp it, and as we do our faith in this difficult, extraordinary work is rewarded too.

John McPhee spoke of getting bored of chronology, of renouncing it and replacing it with theme. Working on a piece about the celebrated museum director Thomas Hoving, he had an epiphany:

> I remembered a Sunday morning when the museum was 'dark' and I had walked with Hoving through its twilighted spaces, and we had lingered in a small room that contained perhaps two

* It's possible to see *Rublev* more clearly if you think of it like a TV miniseries of eight discrete episodes.

dozen portraits. A piece of writing about a single person could be presented as any number of discrete portraits, each distinct from the others and thematic in character, leaving the chronology of the subject's life to look after itself.[25]

He could be describing *Andrei Rublev*. The film itself is of course structured like a series of tableaux – paintings in which the protagonist often does little or doesn't appear at all. When you look at Jackson Pollock paintings, on one level they're a mess, but they're also beautifully ordered, for their structure is fractal. There's fractal design going on here too: each tableau a mini version of the entire work. But that's not all. We are told at the beginning of the film that Rublev's work is technically brilliant but there is 'no awe . . . no faith that comes from the depths of his soul'. That's a classic first-act flaw, and Rublev overcomes it in the final act when he learns from Boriska the power of belief – and it is that that slakes his soul.

What appears to be a loosely related series of incidents, then, is finally revealed finally as the opposite: a searing quest into the nature and production of great art. The lessons we've picked up from multiprotagonism are visible – the narrative baton passed on in each act – but the cardinal rule of the passive protagonist lies broken on the floor. *Rublev* is a classic hero's journey, but one without any hero at all. It's the hero's journey by *theme*.

It's one of the reasons the film can seem so difficult – there is no one in the story to hold your hand. In archetypal films the protagonist is the viewer's proxy and you experience their world vicariously. Here, the film requires you to actively make sense of the world alone. Art is hard won. Form matches content, structure reinforces theme. For us, as for Boriska, it requires unnatural effort – faith – for great art to erupt from the earth.

What can this teach us about the plethora of films that defy narrative convention? An extreme analogy may help.

Dub music grew out of reggae in the (very) late 1960s. Labels made individual pressings of new tracks for touring sound systems,

so selectors (DJs) could test them for audience reaction. This inevitably led to exclusive 'versions' for different sound systems, which in turn led to even greater manipulations of sound. The base elements of any song – bass, drums, rhythm and vocals – were manipulated, using echo and reverb, compression and omission (and heavily emphasizing the bass), to produce the different versions. There was an economic advantage to this (labels could quickly remix tracks to turn the A side into a B side), but in the hands of a master – a Lee 'Scratch' Perry, Keith Hudson or King Tubby – an extraordinary and hugely influential new sound was born.

Imagine a story is a song, and you are putting that song through a mixing desk: you can remove the vocal, add delay on the guitar, drop any instrument or let it totally take over. Why not lower the protagonist, or raise the theme? Why not prioritize time over event? Why not cut out the main structural signifiers – act, structure or causation? Or lose them before finally recovering them just in time to pick up the beat? *Moonage Daydream* fades down linear time and fades up theme, allowing the latter to drive the story. And *Andrei Rublev*? It's not dissimilar. Linear time beats away quietly (they're on a quest) but they've let Mad Professor loose on the vocal track – the singer has been chopped into little pieces and rearranged in a seemingly nonsensical way. It's still there, but subservient to the now much louder theme, for theme is pushed to the absolute max, taking the place of the protagonist almost entirely. Look carefully: the narrative triangle we find in all archetypal narrative is still there: 1) I want to make great art; 2) I make almost great art, it is destroyed; 3) I finally make great art. That would be a classic structure if carried by a single protagonist, but it isn't – it's carried by a series of baton-changing protagonists and events, linked partly by country but mostly by theme. The 'central' protagonist, Andrei, has been placed far lower, indeed often omitted in the mix.[26]

The true pioneers of dub saw their works not merely as remixes – that just gave them versions with maybe a new vocal on the top. That's *Moonage Daydream*. The best dub was where a track's component parts were stripped to their essence, reordered and then

manipulated electronically to force from them almost impossible change: deconstruction to build something almost unrecognizable. That's what Tarkovsky is doing here.

Amarcord, *A Zed & Two Noughts*, *La Jettée*, *Un Chien Andalou* – all fit readily into this schema. If they're not dialling down the protagonist, the narrative or the exposition, they're dialling up time to take the place of event (the slow cinema of *Jeanne Dielman* or *An Elephant Sitting Still*). They're abandoning or heightening causality (*The Discreet Charm of the Bourgeoisie*), filtering out consistent reality (*Weekend*) or both (*Daughters of the Dust*). But what about films where conventional narrative is almost impossible to discern – films like David Lynch's *Mulholland Dr.*?

'There's no sense in looking for a thorough explanation to *Mulholland Dr.*,' according to the critic David Thomson, 'and only madness would require a reading of it in which every last detail has been made to fit together.' Thomson sifts through the fragments of the movie looking for patterns and shapes, as we do. As we search for connections, we may recognize the film as, at one level, a deconstruction of the fictions Hollywood makes of life (the characters laugh at the absurdity of the lines they rehearse). No single explanation, however, holds up – each hits the buffers that block any path to rational thought. 'If Lynch has a purpose,' Thomson concludes, 'it is surely that we surrender as fully as possible to the helpless fluidity of the arbitrary and ill fitting.'[27]

Thomson is telling us the film's meaning is impossible to pin down. But, of course, by saying that, he *is* pinning it down – identifying that as the film's meaning.

It is this that I think is key. To explain the story – any story – you must convert your own sense expressions into narrative. If three acts is 'I exist, I observe, I conclude', then that's what Thomson is doing here. If asked to describe what any arthouse film is about, we tend to respond in terms that make it clear there's a discernible narrative: *8½* is about an artist struggling to make a film; in *That Obscure Object of Desire* the story is actually in the title – Fernando Rey pursues ideal women. In *Daughters of the Dust* three generations of Gullah

women abandon their spiritual home. *Meshes of the Afternoon* follows a woman as she (and we) increasingly struggle to discern what is real. If you can tell what the story is, you are converting it into three acts in order to understand it, store it and of course disseminate it.

How do you do that? In part, it's just what human beings do: we translate sense impressions into three acts in order to pass them on. But we can only do that if we can detect and make sense of theme, for without theme there is no path and a narrative cannot exist.

In Greek legend Ariadne was in love with Theseus. When the latter is charged with slaying the Minotaur in his labyrinth, Ariadne presents him with a ball of thread, knowing that without it he will never escape the pitch-dark maze. He must tie it to the door and unspool it as he goes, providing him with the perfect path back. That thread is *theme*. Theme is a question and answer, and it is inextricably linked to the three-act form. Act one is the question, act two is the evidence and act three your conclusion. However brutal the *version*, a story cannot exist without a thread to hold onto, even if, as in *Mulholland Dr.*, that thread must at times be inferred. Just as the most extreme dub versions work when the tune is hardly recognizable – when you're lost in the heart of the labyrinth – there must be just enough recognition to create curiosity and anticipation. That's the theme's job in any narrative. It's the thread that allows you to navigate the material, the question that will hold you there until you have received a satisfying answer that lies at the far side of the labyrinth. Theme is everything.

Is that true for Simran Hans and Brett Story?

Story holds up her film *The Prison in Twelve Landscapes* as paradigm-smashing: '[it] has no plot, no central character or even central community that drives its narrative forward, no dramatic arc propelled by cause and effect, no set of chronological events or decisive moments'. And that, she says, is its point – to subvert traditional ways of telling, which are manifestations of economic violence. And yet . . .

Imagine you have been commissioned to write a piece of long-form journalism, possibly entitled 'What are the effects of the US prison

system – not on its prisoners but on the land, the communities, indeed the nation-state that surround the institutions of incarceration?' How would you answer that? Very possibly by finding a series of vignettes: some quirky, some chilling and some asking very awkward questions. Maybe you'd find the state desperate for the work prisons bring. Maybe you'd stumble across the man who had the foresight to set up a store providing for every prisoner's need. Each vignette – like *Andrei Rublev*, like the multiprotagonism of *ER* – drives the story forward, providing narrative momentum, a dramatic arc, and cause and effect. All of these are there because they're rooted in the same thing any coherent narrative is: the desire to answer a clear and simple question. Question and answer are the two essential ingredients that no narrative can survive without, and they cannot but deliver a structure of three acts. Hidden they may be, but they're still there.

The Prison in Twelve Landscapes has no central protagonist, no clear path to emotional identification and a style that demands the audience work. Like Rachel Cusk's bravura novel *Outline*, where we only know the protagonist through the characters around her, the director has chosen to portray something by its absence (or, in dub terms, 'omission'). The subject is visible entirely through its effect on others. It is a strong and powerful idea – and film. But it poses a number of key questions. Who is it for? And what do you achieve by telling it like that?

If you want to raise awareness of the carcinogenic effect of the prison industrial complex – who is your audience? Who needs to see it most? Opinion-makers, sure, but might a much wider cross-section of people benefit too? When *Moonage Daydream* was nominated alongside *Navalny* at the BAFTAs, *Navalny* won – as it went on to do at the Oscars. Was it a greater artistic achievement? Maybe not. Its tale was simple, linear and old-fashioned – all the elements Simran Hans decried. But in its portrait of a phenomenally brave man taking on a tyrant at insane risk to his family and life, might it have been more important? If you are warning of demagoguery, what's the best way of conveying the story you need to tell?

The decision, of course, is the creator's – it's every film-maker's

right to work in any way they choose, while bearing in mind that the more complex the storytelling, the more niche the audience will normally be. Without film-makers like Brett Story pushing at boundaries, any art will ossify – they are essential to the progression of the form. But at the same time, as podcasting attests, if a narrative wants to reach the widest possible audience, it will inevitably gravitate towards one person's emotional journey. Joe Rogan is the most listened-to podcast host in the world for many reasons, but central to his appeal is that single point of emotional identification. Simply put, more people want to be him.[28]

Of course one should try to disrupt that instinct, but the governing question, if you're going to disrupt archetypal storytelling, must always be '*Why?*' If the answer to that doesn't serve the story then you are committing a microaggression against its understanding. RaMell Ross's 2024 movie *Nickel Boys* was lauded as groundbreaking by some critics, partly because, for large swathes of the film, we don't see the protagonists themselves, only what they see – their physical presences replaced with their points of view. *Sight and Sound* swooned: 'Audiences find themselves moving restlessly, lyrically, lovingly, tragically, with a subjectivity that the long lens and partial views ensure.' Kevin Maher in *The Times* hailed it as revolutionary.[29] But is it? As *Peep Show* attests, it's certainly not new.[30] But does it, as critics like Maher claimed, increase the subjective experience, or simply push you *out* of the story experience by reminding you you're watching a film? Does it, in other words, turn an emotional experience into an intellectual one? That is the arguable fault in many an arthouse film. Is enjoyment really such an enemy to intellect that it must be stamped out? Is what we are being offered not story but medicine, and an invitation to preference falsification?

When faced with the experience of narrative dissonance, it seems there is one question any audience should ask: 'Does the structure serve the theme?' Is the artist rendering reality in this way to serve the story, or do they simply like to be seen as contrarian, thus drawing attention to themselves? The former will give you great

art, the latter may just be pretension. As is the case with so much of narrative, motive is all.

There's one last thing – what we might call the 'John Truby trap'. When Brett Story condemns 'Main character. Three acts. Heroic journey. Climax. Resolution,' she poses a question, explores the evidence, then comes to a conclusion.[31] She is using the tools of her enemy to attack the very thing she cannot help but do herself. None of us can. And that is the bigger lesson of all of this. We can alter the carapace, but we can't escape the fundamentals. We are all chained to that particular wheel of fire.

When John McPhee was sprawled on his floor, surrounded by the mess of his potential story and stuck in a catatonic daze, he did what every writer does in the end. He found the question he wanted to ask, then picked his way towards an answer – sometimes chronologically, sometimes thematically, with either himself, a single protagonist or a clutch of them at the heart. McPhee never talked about three-act structure. Instead, he drew diagrams to find his stories, which, when examined carefully, reveal bookends, midpoints and symmetry.[32] Read his articles, every one joyous and profoundly different. They are the work of a master. And the three-act structure is there in each, held together by Ariadne's thread. Dissonant narrative may not be such a labyrinth after all.

8

Into the Labyrinth

Non-Western Narrative and the Hero's Journey

He was angry, and he wanted answers. 'This is just Western. All of it. Protagonists, goals, obstacles. Even dialectics – that's Greek. Greek men. It's all Western. It's all patriarchy.' He spat out the next bit: 'It's not the world, is it?'

I give lectures on narrative a lot. I love doing it, and this particular talk was in front of 150 students who had been both welcoming and combative in the best sense of the word. Talking to people is fine, but being challenged by them – argued *against* – is the best possible way of testing whether your theories are true.

And yet, I shut him down. 'Go on then,' I said. 'Tell me the names of all the films you've seen, the books you've read that completely ignore that structure.' He couldn't. I'd made a point, but I'd also been unfair, and it felt like I'd broken a professional bond. What I should have done is answered more politely, explored the question and worked it out together. Instead, as well as being too aggressive, I'd committed a logical fallacy. Argument for ignorance is a fallacy of informal logic. Absence of evidence doesn't prove a point: it can merely be the result of a lack of research or, more prosaically, an inability of the questioner to recall their facts. I hadn't actually answered his question at all.

I apologized to the student privately, and he was more gracious than he needed to be, but two things lingered after the event. The first was that my aggression was a classic indicator of defensiveness; I couldn't marshal an argument free of *tricks*. The second led directly

from this. In the world of screenwriting, one narrative paradigm recurs repeatedly – one we've referred to throughout. The hero's journey sounds masculine, it sounds Western. To many it sounds pretty colonial, too. It was time to properly confront the question of whether this was, indeed, all 'just Western'. Are we ignoring the rest of the world?

In November 2018, Professor Hartmut Koenitz and four of his colleagues, most from Utrecht University, published what they believed to be a pioneering study: 'The Myth of "Universal" Narrative Models'.[1] Koenitz's professorship was in interactive narrative design, and his team had tasked themselves with looking for new ways to tell stories. Why? Because:

> [. . .] the idea that the Hero's Journey is the paradigmatic, media-agnostic, universal form of narrative structure is problematic in several important ways. On a general level, it blinds us – scholars, writers, designers – to non-Western forms of narrative (as well as 20th century avant-garde forms), which come to be seen as 'more primitive' and/or 'less developed'.

It's a fascinating study, and symbolic of almost all attempts to rope the bolting horse of non-Western narrative and pull it to the ground. It outlines how our Western conception of story is descended from Aristotle's *Poetics* and Campbell's hero's journey, with some of Freytag's Pyramid thrown in, noting how for most people those concepts had become inseparable.* The paper makes a number of now-common observations, including how Campbell's work has become most commonly associated with 'masculine power fantasies' and that 'the forced application of the Hero's Journey structure' has resulted in '[t]he narrative [. . .] and writing found in video games' being 'often of poor quality'.[2]

There has to be another way of forming stories, the paper implies.

* Far more on all of these in *Into the Woods*.

'What is needed, Koenitz and his colleagues assert, 'is a radical shift in the way designers and academics think [. . .] which entails first and foremost doing away with "classical [Western] notions of narrative" [. . .] and dethroning the Hero's Journey as the standard narrative structure'.[3]

They were rigorous in their search, determined to distance themselves from 'a media landscape that is saturated by the Hero's Journey/dramatic arc'. Their methodology, when encountering non-Western paradigms, was to '[focus] on pre-colonial works to preclude Western influence as much as possible'.

What did they find?

There are four significant new forms, they say: *Robleto* from Nicaragua; *Frame Narrative* derived from 'Indo-Arab literary and oral traditions'; *Bengali Widow's Narrative*, and *Kishōtenketsu*, which they describe as 'a conflict-free narrative structure originating in Chinese poetry and widely used in Korean and Japanese writing'.

There were more too:

> [. . .] we studied and analyzed a variety of narratives from Indian, Arab, indigenous North American, and Northern African literary traditions, as well as contemporary (postmodernist) works and Western interactive digital media [. . .] These particular narrative structures clearly demonstrate that viable alternatives exist and thus they already serve to expose the fallacy of assigning universal status to the Monomyth and the dramatic arc.[4]

It's a powerful argument. It is time to look at each of these forms and to understand if we are in fact trapped in a Western, masculine, thrusting prison – or whether there's something more complex going on.

Kishōtenketsu

In the online forums of the screenwriting world, any criticism of the hero's journey is immediately accompanied with encomiums

for *Kishōtenketsu*, a whole new way, we are told, of venturing forth into the story world. It's attractive to many because it seems to offer a technique that's conflict free. The West, this line of thinking suggests, is more conflict-orientated, more masculine, more imperialist than its sensuous rival. 'The standard three- and five-act plot structures – which permeate Western media – have conflict written into their very foundations,' says one acolyte. 'The necessity of conflict is preached as a kind of dogma by contemporary writers' workshops and Internet "guides" to writing. A plot *without* conflict is considered dull; some even go so far as to call it impossible.' Those people are wrong, we are told. Why? 'For countless centuries, Chinese and Japanese writers have used a plot structure that does not have conflict "built in", so to speak. Rather, it relies on exposition and contrast to generate interest. This structure is known as kishōtenketsu.'[5]

What is it? There are four stages:

Introduction (*ki – kiku*[6])
The exposition stage – character and world established.

Development (*shō – shōku*)
New information is introduced to give greater context to the characters' situation. Not unlike a 'colouring in'.

Twist (*ten – tenku*)
A subversion of expectation. Action or information emerging completely out of the blue. It may make no immediate sense, nor even involve characters previously established. It's often a switch between literal and figurative meanings.

Conclusion (*ketsu – kekku*)
This last section unifies the two disparate elements that have gone before, uniting them to create a whole new meaning.

It's a form of narrative used in Japanese manga, and it provides a structure that massively improved the playability of *Super Mario* games (to which we shall return). Fundamentally it's an ancient rhetorical form that was borrowed, then colonized, by longer-form storytelling.[7]

Kishōtenketsu's origins lie in traditional Chinese four-line poetry that was later adopted by Korea and, in turn, Japan. There are many regional variations, but the basic shape is consistent: each line a different stage of a four-stage paradigm, shown here in a poem by the early-nineteenth-century Japanese author San'yō Rai.

Ki き 起: The daughters of the thread merchant in the Motomachi area of Osaka

Shō しょう 承: The eldest daughter is sixteen and the younger one is fourteen.

Ten てん 転: The great lords from all fiefdoms conquer (i.e. kill their enemies) with bows and arrows

Ketsu けつ 結: The daughters of the thread merchant conquer (i.e. kill men) with their eyes.[8]

The third stage – the *ten* section – creates a dissonance. What was logical is suddenly inexplicable, only for that dissonance to be resolved in the *ketsu*, when everything links together again.

You can see how this structure might be useful in horror, a common stable for the form. Take a story like *The Licked Hand*:

Intro (*ki*): A young girl is home alone with only her pet dog for comfort.

Development (*shō*): She hears on the news of an escaped convict and becomes frightened. She is too scared to go to sleep without letting the dog lick her hand from beneath her bed.

Twist (*ten*): When she awakes she discovers that her dog is dead and has been the entire night.

Conclusion (*ketsu*): She finds the words 'HUMANS CAN LICK TOO' written in blood on her floor.

The power of the third-stage twist is key, and was a tool games designer Koichi Hayashida made use of when he was put in charge of the development of *Super Mario 3D Land* – the first ever video game to be dominated by the Kishōtenketsu form.

When you play the game, you *are* Mario, and at every level you must navigate (like Scientology!) a series of escalating obstacles, rising to the next level when you pass the previous test.

What happens at the start of every level? You and your avatar are introduced to the gameplay concept in a safe environment. Here you learn the game skills without losing a life – that's *ki*. Once that's mastered you move on to use the same gameplay but without protection – that's *shō*. The risk factor has been dialled up as jeopardy, the possibility of dying, is introduced. If you reach the end of that section, you're starting to believe you've mastered the game, which is the perfect time to hit you with the twist. This could be a new form of antagonism, perhaps, or a reversal of the rules (what was 'safe' is now dangerous), or a combination of both; it doesn't matter too much, so long as it massively increases your hormone production – dopamine and adrenaline dance side by side. That's *ten*. And then? In the last stage, it's the ultimate test, where the two preceding elements – *shō* and *ten* – are united in a final *ketsu*. This is not the whole game, it's the structure of individual five-minute sections that unite to form a level. It's fractal, like Western story structure, so can build into units of ever greater complexity.

Hayashida had been experimenting with this style on previous games, and realized it answered a lot of their design issues. It was simple, exciting, allowed endless repetition without boring the player, and gave a satisfying symmetry and shape to an otherwise random experience. Paying tribute to the legendary Shigeru Miyamoto, the game director at Nintendo, Hayashida was absolutely clear about its inspiration: 'He drew comics as a kid, and so he would always talk

about how you have to think about, what is that denouement going to be? What is that third step? That *ten*, or twist, that really surprises people. That's something that has always been very close to our philosophy of level design, is trying to think of that surprise.'[9]

But what of movies? How do they utilize the form?

Any discussion of Kishōtenketsu inevitably turns to a number of key films that have found purchase in the West. The pioneering works of Japan's Studio Ghibli are often held up as paradigmatic.[10] *Your Name* (*Kimi no Na wa*) is a good, clear example.

Intro (*ki*): Taki and Mitsuha – two students in different parts of Japan – begin switching bodies when they wake up, and have to learn how to live as the opposite gender.

Development (*shō*): They learn how to communicate with each other, and get closer as they start to understand the rules of the game.

Twist (*ten*): All communication stops. Taki discovers that Mitsuha has actually been dead for three years. The 'switch' involved time-travelling as well. She was killed in a natural disaster.

Conclusion (*ketsu*): Taki finds a way to go back in time and save her. Five years later they bump into each other in Tokyo. They ask each other for their name.

Parasite, Bong Joon Ho's multiple Oscar winner, is also often cited:

Intro (*ki*): The Kim family are trapped in poverty. The son, Ki-woo, gets a job as tutor to the wealthy Park family.

Development (*shō*): Over time, Ki-woo manages to get rid of the old housekeeper and get jobs for all his family, who move into the Park estate.

Twist (*ten*): The old housekeeper returns, unlocking a secret basement door revealing her husband living in the basement.

Conclusion (*ketsu*): The housekeeper's husband escapes, mayhem ensues. The Kims are deposed, with their dad, now guilty of murder, hiding out in the basement. The cycle will begin again.

Parasite was hugely successful, grossing nearly $58 million in the West alone – unheard of for a non-English language film. Why? Some really obvious answers: it has a great script, great story, beautiful direction, first-rate cast. It's also packed with endless subversions of expectation – not just the big *ten* or twist, but about twenty notable other ones too. Before *Parasite*, some had argued that this was a story form that didn't translate. How, then, could *Parasite* have worked?

Since the late 1980s, a series of anime films produced by Studio Ghibli had slowly infiltrated the British independent film circuit. These films – notably *Nausicaa*, *Castle in the Sky*, *Grave of the Fireflies* and *Kiki's Delivery Service* – were like sleeper agents, quietly creating an environment that would first weaken, and eventually fully break down, Western resistance to their methods. When *Spirited Away* was released to universal Western acclaim in 2001, it felt like a huge breakthrough both for the company and the material – the agents had done their work well.[11]

The success of *My Neighbour Totoro* was symbolic of the company's whole journey. It had begun as a little-known curiosity in 1988. Its reputation grew inexorably over the years, partly through word of mouth, and partly through means of distribution. A limited cinema debut, then home release, streaming and most recently a multi award-winning stage adaptation in 2022, have made it, nearly forty years later, a children's national treasure. The occidental world was, perhaps, more ready for a whole different way of framing narrative than we'd thought. For both *Totoro* and *Parasite*. But how different actually were they?[12]

There are many Ghibli films we could reference (the best-known being the highly complex and adult *Spirited Away*, a detailed examination of which can be found in the Notes), but *Kiki's Delivery Service* is at once simple and emblematic of them all.[13]

If every three-act story has an inciting incident, midpoint and crisis, then all are present here. Kiki is a witch – or rather she wants to become one, but in order to do so she has to leave her loving, rural home and travel to the big city. She flies on her broomstick to the port city of Koriko, where she immediately bumps into Tombo, a geeky boy of the same age, who is transfixed by her ability to fly. Kiki ignores him, and finds lodgings with the kind baker, Osono, who inspires her to create her own broomstick-powered delivery service. That's the inciting incident. Her crisis point – what Blake Snyder would call her 'dark night of the soul' and what we at the BBC used to call the 'Oh fuck moment' – is the loss of all her powers and her plunge into despair. And the midpoint? The midpoint is not the classic dark cave of the hero's journey; rather, it's the dilemma she faces when she has to choose between boy and job, between personal pleasure and professional duty – and that's the key to the film.

If the midpoint of any story is the lesson delivered, then *Kiki's* couldn't be clearer. It is a film about growing up. There will always be a conflict between selfish and selfless impulses, the film argues, and the mark of adulthood is learning to choose the latter – in this case, to stay and help the two old ladies whose baking she's been delivering. It's an internal conflict, but it's huge for all that. Kiki doesn't like it – it sends her into a downward spiral. She loses her powers, and returns to her old, slightly narcissistic self (when she leaves home at the beginning, it's against every single parental objection – it's all about *her*). She has to learn that it's about others, too. When she sees that Tombo has jumped onto a free-floating dirigible above the city in an attempt to 'fly' and is in trouble, she finally understands the lesson. 'That's my friend!' she cries, and rushes off to save him. Almost miraculously, she is now able to fly again.

Kiki is a story about squaring the conflict between one's self and the outside world, about showing love to someone else. In the

process a girl becomes a young woman. She thinks she's ugly at the start – 'I'm not very beautiful' – but she's learned confidence and self-esteem by the end, her impetuousness now married to reflection. At the beginning she is focusing on herself; now she's focusing fully on others, and on the children to come. 'What does growing up mean?' asks the theme. 'Caring for others,' the film replies.

In terms of Kishōtenketsu, it's:

Intro (*ki*): Kiki leaves home and meets Tombo.

Development (*shō*): Kiki starts a delivery service.

Twist (*ten*): Kiki loses all her powers – she doesn't (and we don't) know why.

Conclusion (*ketsu*): Kiki rediscovers them by using them to save others.[14]

But . . . it's also strikingly similar to *Jane Eyre*:

Intro (*ki*): Jane leaves Lowood School to work for Mr Rochester of Thornfield Hall.

Development (*shō*): Jane falls in love with Mr Rochester but discovers he has a wife.

Twist (*ten*): Jane runs away and inherits a fortune from a (very) distant relative, while Thornfield burns down in her absence.

Conclusion (*ketsu*): Jane and Mr Rochester are reunited, with both wife and class distinctions removed.[15]

The events may differ, but thematically they're identical. Both are classic *Bildungsromans* – journeys from childhood to adulthood – a form normally perceived as Western (because of its concentration on the self). It's the journey taken by Harry Potter and Luke Skywalker, too.

So it's here that the idea of Kishōtenketsu being a different form becomes more problematic. *Super Mario* designer Hayashida refers to the comics his boss read as a main influence. These comics were a staple part of Japanese culture. Yonkoma manga (or 4 Koma), Japanese four-panel comics, have a naturally funny shape, but look closely. They're really not dissimilar to the classic British 'Knock! Knock!' routine:

> Knock! Knock!
> Who's there?
> Figs.
> Figs who?
> Figs the doorbell, it's broken!

Like any joke, the subversion of expectation – the 'Oh no! But of course!' – is absolutely central.

Kiki, *Totoro* and *Spirited Away* are really versions of exactly the same story. All three are metaphors for growing up, each using different levels of fantasy to dramatize the inner fears of childhood and adolescence. Each film shows how, in accepting and mastering those fears, you grow. So how different actually are they from classic Western stories?

There are a number of things that are immediately striking when you analyse Kishōtenketsu. Firstly, it's packed with conflict: Kiki's journey is riddled with opposition. In addition, conflict isn't always overt. Ghibli's founding father and presiding genius Hayao Miyazaki has the best possible (and most charming) explanation:

> To have a film where there's an evil figure and a good person fights against the evil figure and everything becomes a happy ending, that's one way to make a film. But then that means you have to draw, as an animator, the evil figure. And it's not very pleasant to draw evil figures. So I decided against evil figures in my films.

Removing moustache-twirling villains, however, doesn't preclude conflict. Look back at the Chinese root, using a slightly different translation of the earlier poem:

Ki: The characters are daughters of Itoya in Osaka.

Shō: The eldest daughter is sixteen and the younger one is fourteen.

Ten: Historically in Japan, warriors have killed their enemy with bows and arrows.

Ketsu: However, the daughters of Itoya kill only with their eyes.[16]

There is no conflict here, we are told, but of course that's just not true. Though there's no *external* conflict, nor one carried by the characters, the conflict is transferred to the reader. The third stage, the *ten*, is a massive outbreak of dissonance – it doesn't make any sense, and the telling cannot end until that dissonance is resolved. Without the *ten* it's just a series of incidents, and interest will pale before the end of the page. With it, you have our old friend subversion of expectation. It's an incredibly powerful and not unfamiliar technique. Look at a huge Western hit, *Gone Girl*:

Intro (*ki*): Nick returns home to find his wife missing. Amy's diaries suggest Nick was abusive.

Development (*shō*): Nick is revealed to be having an affair, and Amy to have been murdered.

Twist (*ō*): Amy is alive and well. She faked her diaries to frame him for her murder.

Conclusion (*ketsu*): Nick and Amy reconcile and have a baby.

One final thing. Focus on the four key elements:

1. **Intro (*ki*)**
2. **Development (*shō*)**
3. **Twist (*ten*)**
4. **Conclusion (*ketsu*)**

The stages are symmetrical. The twist almost always coincides with the midpoint of the story. If the midpoint is the lesson, then that's incredibly important. A midpoint at its most dramatic is a subversion of expectation, as it is in *Parasite* and *Gone Girl*, and *Ghostbusters*. These forms are not mutually exclusive – they're the same.[17]

The elevation of this rhetorical model into some kind of antiWestern corrective is deeply misplaced – it simply *isn't*.

The only time Miyazaki ever talked about Kishōtenketsu, he described how he struggled with it in one of his earlier films. Indeed, one of the reasons for his legendary status within the industry is because he begins every film with no script at all; he shapes them as he goes along.[18]

> [T]here is an internal order, the demands of the story itself, which lead me to the conclusion. There are 1415 different shots in 'Spirited Away.' When starting the project, I had envisioned about 1200, but the film told me no, it had to be more than 1200. It's not me who makes the film. The film makes itself and I have no choice but to follow.[19]

Every Ghibli film, despite appearances, adheres to a pattern identical to that found in occidental cinema. *My Neighbour Totoro* is about a monster in the woods, while *Parasite*, *Spirited Away* and *Kiki* are packed with opposites, packed with conflicts and packed with change. These scripts don't come from a book, but from something deeper: from the way we process and order the world. Kishōtenketsu is not, as claimed, a different way of telling stories; it's a cultural riff on a universal form.

Dr Irena Hayter is Associate Professor in Japanese Studies at the University of Leeds. In an interview with me she was very clear about this: 'It's no more a different kind of narrative than any other story telling plan. The sociopsychological meanings might be different dependent on historical and cultural context [. . .] but the structures are the same [. . .] It's a style.'[20] A sonnet, a limerick, a haiku – they are *styles*. Underneath they all communicate in the same way, by wrangling of the world into observation

with beginning, middle and end. Deploying the third-act twist is an immensely powerful tool – as *Ghostbusters*, *Jane Eyre* and *Gone Girl* all discovered – but it's not an Eastern construct. Every culture has a different fingerprint (even culture is tribal) but there is no proof whatsoever that the stories they tell are anything more than a local variation on an ancient, widespread form. There's no argument to suggest it's totally different – the films belie that: *Spirited Away* is the story of a little girl who goes into the woods and emerges a woman.

When I asked Dr Hayter why this belief persisted, she felt that the trope itself was problematic. 'This idea that the Japanese, the East Asian cultural forms are somehow essentially, unchangingly different,' she said, 'is uncomfortable. It feels like the modern version of a very old prejudice. Once, Westerners saw these races as cruel or inscrutable, personified by the likes of Fu Manchu.* This feels like the same kind of exoticism. It's a kind of Orientalism in modern form.'[21]

If the study group at the University of Utrecht were going to create a whole new paradigm for gameplaying, they were going to be disappointed twice. Firstly because Nintendo had already got there with *Super Mario*, but also because there's nothing fundamentally different about the form. What, though, about their other story shapes?

The second narrative structure the university explored is native to Nicaragua. *Robleto*, we are told, consists of five stages, each interspersed with the same repeated line. It's an oral form not dissimilar to gospel call and response, if not to song structure more generally, and is named after a doctor and cattle farmer, Robert Robleto.

* The Chinese supervillain, criminal genius and mad scientist invented by Sax Rohmer, who lent his fictional name to a very stereotypical moustache. When asked how he invented the character, Rohmer said he consulted a Ouija board about what would make his fortune. The board, he said, spelled out 'Chinaman' in individual letters.

Robleto

The Robleto structure consists of five stages: line of repetition, introduction, climax, journey and close. The line of repetition distinguishes this structure from other narrative arcs. The narrative starts with a defining statement that is repeated throughout the story, often marking the end of one stage and the beginning of the next. After a short introduction by the narrator, the narrative quickly moves into the climax, which describes the character's challenge. The journey stage begins by introducing other people, places and events. Unlike other story structures, the Robleto one may tell of several short journeys in one story. At the end of each short journey, the narrator repeats the defining statement, and it is sometimes repeated at the end, after the close, as well. (An example of Robleto 'I am the farmer that became a doctor', by the doctor for whom the form is named, can be found in the Notes.[22])

In addition to the line of repetition, Robleto is usually broken down as having four key elements:

There is an *Introduction*
– both of the narrator (normally first person) and any other exposition

There is a *Climax*
– the turning point where everything changes for good or bad. Traditionally this creates a new goal, rather than complicating the existing one

There is a *Journey*
– we learn of other protagonists, conflicts and settings: a new journey to succeed the old one

There is a *Close*
– reconciliation of conflicts, telling comes to an end. Line of repetition restated at end to underline the central message.

It's an enchanting form, and it works well. But immediately an alarm bell starts to ring. The introduction is a classic first act with inciting incident, the climax (their term) does everything a midpoint is supposed to do. The journey stage, as defined here, is not unusual either; countless Western films change direction halfway through (*Psycho* being an immediate example). And the close is identical to classic resolution. The only difference is the line of repetition: 'I am the farmer who became a doctor.' That too is familiar, both as a religious form and as songwriting technique. Every verse of the spiritual 'Go Down Moses' ends with the same refrain:

> Go down, Moses
> Way down in Egypt's land
> Tell old Pharaoh
> Let my people go[23]

The context may be different, but the underlying effect of imprinting the story into the listener's brain is exactly the same. It's not structure that's different. Once again, it's style.

There are other things about Robleto, however, that should ring alarm bells.

This is a narrative form named after the man telling his story in a YouTube video.[24] That doesn't sound too ancient. Moreover, the Robleto structure is laid out in a Wikipedia article on story structures, in a section on 'Indigenous peoples of North America and Latin America', under the subheading 'Dramatic Structure', but disturbingly the entire section is completely unsourced.[25] Why would an indigenous narrative structure only be discovered post-millennium and named after the man in the video? Why, when you look further, does everyone else who mentions it keep coming back to the same online, unverified source? The short entry tells us it was discovered by Cheryl Diermyer ('an outsider') in 2010. Can this be right? Did a narrative technique remain invisible until a Westerner discovered it? It all has a vaguely implausible, if not colonial, air.[26] Maybe this just doesn't have that much empirical veracity at all.

Something similar occurs with the last two forms identified by the paper's authors at the University of Utrecht.

Bengali Widow's Narrative

Originating in West Bengal, what's noticeable about this form is its total specificity. One kind of form for one kind of story.

The university represents it like this:[27]

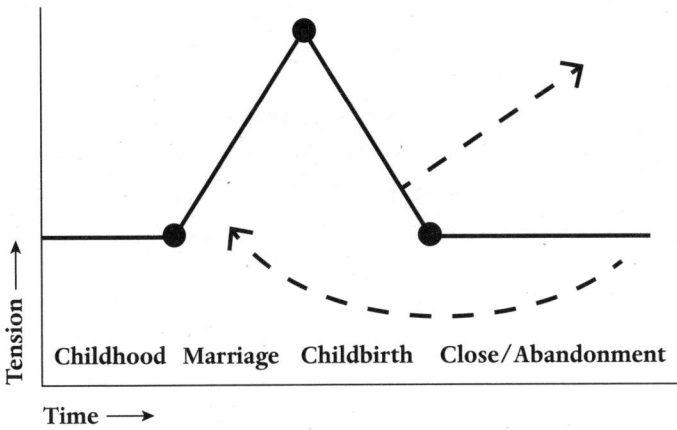

West Bengali Widow Narrative

The authors describe a structure that 'either raises after the climax to a tragic outcome, when the protagonist is abandoned by her family, or folds back to see the protagonist becoming the antagonist'.

How did they codify this form? 'We derived this narrative structure from the comparison of different narratives that circulate among the West Bengal population that focus on the powerlessness of the displaced widowed mother.' In other words, they codified a completely normal story that almost certainly for cultural reasons has taken hold. They argue it's a different form:

At first sight, this narrative structure is reminiscent of the dramatic arc, however there is a crucial variation that is connected to the

'themes' of the narrative. The climax is not followed by a phase of dénouement; rather, the tension keeps growing, either with the narrative looping back on itself if the widowed mother becomes the antagonist (the mother-in-law) for the bride of her son – effectively repeating the cycle from marriage to close – or, by continuing forward to show the abandonment of the mother by her sons after the death of her husband, will end in a climax where her sons and daughters-in-law leave her beggared and alone.[28]

This is specious. There is nothing specifically Bengali about this – it's a classic *La Ronde* structure. It's there in everything from Beckett's *Waiting for Godot* and Genet's *The Maids* to Tom Stoppard's *Rosencrantz and Guildenstern Are Dead* and Bong Joon Ho's *Parasite*. Look at *Macbeth*: at the end of the story Malcolm may be King of Scotland, but Fleance, Banquo's son, is still out there. The Witches, of course, predicted Banquo would bequeath a line of kings, and their predictions have a habit of coming true. The suggestion is clear – death is coming round again.

Frame Narrative

Frame Narrative is the final 'alternative' shape highlighted by the paper. Perhaps the most famous of all frame stories is *One Thousand and One Nights*, which first came to Western attention on the publication of *The Arabian Nights' Entertainment* in 1706.

One Thousand and One Nights is both one of the great stories and one of the great texts *about* stories. It's effectively an anthology. In its narrative sprawl it has similarities with the great Hindu epic *The Mahabharata*. The authors are numerous and the individual tales jump all over the place, but here they are all told by one character – Scheherazade. Her task is to continually entertain a bitter king with new tales. If she fails, she will die.

You can break down each of Scheherazade's stories (and her own) into three acts, and it's possible to detect heroes journeys in most of them – they are really not very different at all. *One Thousand and*

One Nights is the ultimate box-set of narratives, and there is a clear line from Scheherazade all the way through to *Black Mirror*, alongside a very useful universal lesson all writers should take to their heart: 'If my story isn't compelling, I will die.' Further, there's little evidence to suggest that frame narratives originated in the Middle East (though they may have done). What they are is a great example of how narrative continually borrows and bastardizes from different cultures and styles. It's not different – it's a *form*.

Exploring the full range of non-Western storytelling would take another book. Such a tome would elucidate the dominant non-occidental traditions: Indian epic narrative (multiprotagonist and digressive – e.g. *The Mahābhārata*); Japanese *Ma* (間) (relying on audience inference or 'negative space' – *Spirited Away*); African oral (performance-based – the Anansi tales); Chinese Episodic (interconnected vignettes – *Journey to the West*); Native American and Aboriginal (metaphorical and symbolic – 'Raven Steals the Light'); Arabic (frame stories – *One Thousand and One Nights*) and Polynesian (performance-based – the Māori creation narrative of 'Rangi and Papa'). Even the brief descriptions I've given here should indicate that any divergence from the Western hero's journey has less to do with structure than content, purpose and style. At heart, each of these forms springs from a question and an answer, even if sometimes the question may be inferred. Every culture has its own flag, its own dress, its own food, but each is a variation of a universal. It's the same here. Every story contains a three-act theme. That's Ariadne's thread. In the end, that's what a story *is*.*

It's very difficult not to conclude that the University of Utrecht's paper is an exercise in magical thinking – in seeing not what *is*, but what they want it to be. We should perhaps not judge too harshly, for it is easy to misread style for underlying form, nor indeed are they the only culprits. As we've seen, in the wild west of the screenwriting world there is almost a total absence of empirical rigour. Whenever they see 'difference', a cursory inspection reveals similarity instead. *My Neighbour Totoro* resembles *Beowulf*, just as two of the greatest Japanese films, *Ugetsu* and

* For far more detail on non-European story structures, see Appendix IV.

Sansho the Bailiff, are literal journeys into the woods to learn a lesson. Instead, maybe we need to accept that what the study of cultural difference teaches us is that story might just be a universal form.

Absence of evidence isn't evidence of absence, and we would do well to remember that when declaring there is only one storytelling shape. We must be mindful, too, of which stories from other cultures have, over the centuries, reached us in the West. Masterpieces like *Sansho the Bailiff* may be self-selecting – more readily accessible, as they speak a language closer to ours. However, if, as Yuval Noah Harari suggests, storytelling was the primary driver of *Homo sapiens'* triumph over the natural world, then that can only be true if it takes a universally recognizable form.[29] Christianity could never have colonized vast swathes of the world if every culture processed narrative differently.[30] Nor Islam. Protagonist, antagonist and goal are the universal agents of persuasion. No one is immune.

One of the other story forms referenced (albeit in less detail) by the University of Utrecht is Crick Crack, which they cite as an example of Caribbean story structure. Ironically, a detailed study takes us back to the tribal stories we discussed in Act III, and reveals just how storytelling is built around a universal heart.

In 2009 journalist Al Creighton described how a typical Crick Crack performance began in St Lucia:

> The 'leader' or Conteur announces that a story is about to be told by calling out 'Crick!' ('kwik' in patois), to which the audience responds by shouting 'Crack!' ('kwak'), thus the utterance 'crick crack' is completed. The Conteur then tests the audience with riddles to which they may shout the answer, and since many of the riddles are known a whole session of exchanges will follow. After this the story is told.[31]

Performance-based, Crick Crack begins with jokes and riddles that invite the audience's attention, before the facts of the story are established, the conflict played out and matters resolved. Something very similar happens in parts of West Africa, home of the griot, a caste of storytellers who serve as the repositories of the wisdom,

secrets, gossip and purpose of their tribes.[32] This I think is key to understanding its universality, for every culture has them.

The Greeks called these storytellers Rhapsodes. In western Asia they're the Hakawatis (*hekaye* means 'the story' in Arabic and *haki* means 'to talk').[33] We know them best as troubadours or bards. Across the world, wherever oral traditions have existed, from the Norse *skalds* to the Native American *pueblos*; the Turkish or Persian *ashiks* to the *kataribes* of Japan – all have performed, and some still do, the same function. They are the repositories and disseminators of the wisdom of their tribes.

While every culture will tell their stories in a different way, each of those tribes will have a storyteller and a tale. Each will contain moral purpose ('these are the rules of the tribe and will help us survive'), explanation of the universe ('this is how things came to be'), historical retention ('these things forged us') and aspirations ('this is who we are'). The primary colours of tribal identity. Sacred scrolls in oral form.

Electronic communication has distorted this process, but it's still glaringly manifest, as I write, in Donald Trump's appeal. He is the popular storyteller par excellence, and he understands two key things instinctively. Firstly, that the story can change. The best storytellers claim a long line of tradition, while continually seeking the tribe's wound and steering their tale into whatever might salve it. Secondly, that the story is not just for the tribe – it is for all its enemies too. The strength of any in-group is directly related to the fear or awe their story generates without. That can only happen if the language of narrative is as universal as its function – to solidify, protect and give purpose, meaning, community and ritual to the tribe.

These modern griots then are vital, particularly in a world where individuals are more and more isolated, and this gives them an even greater, sometimes more terrible power. The very first character assassinated by the Jewish agents in Spielberg's *Munich* is an Arabic storyteller, plying his trade in exile. There's something symbolic in the act. The storyteller is the beating heart of every tribe. By killing them, you drain the whole clan's lifeblood away.

★

Like any three-dimensional story, in pursuit of a want we discover instead a need. In believing that non-European stories are different, we discover not just that they are the same, but their purpose is too.

The more you dig into the world of alternative structure, the clearer two things become: either the evidence presented is flaky, or it confirms narrative as primarily a three-act form, with question-and-answer theme at its heart.[34] In addition, it reveals one incredibly important thing about the nature of storytelling. What defines the search for non-Western narratives is the need to believe they exist – a need to show *difference*. That suggests that much of what we understand about story structure is rooted in projection – not reality. The world not as it is, but as we'd like it to be.

If there's one thing that's revealed by the numerous forums, blogs and books that I've read while researching this book, it's the fear of Western hegemony: an almost visceral terror that by supporting occidental narrative we are somehow engaged in an act of cultural colonialism. I wouldn't normally consider quoting unsourced and unproven material when building an empirical argument. However, there is value in hearing those arguments when they illustrate how wildly some ignore rational evidence when writing about narrative.

There's one particular example which, though insignificant in reach, can tell us much via its content. In her guide to 'Worldwide Story Structures', blogger Kim Yoonmi continually berates any hints of Western form. She talks of a particularly Western type of structure she calls 'Conflict Narrative':

> It was started by Percy Lubbock in 1921, right after WWI, but took off in the United States through some doubling down through other authors, such as Kenneth Rowe, Lajos Egri and Syd Field. It was mainly supported by Cishet men, who didn't give credit to Lubbock. It's still popular narrative in the US, but is losing favor within the US . . . Ahh . . . Misogyny, racism and homophobia . . . the sweet juice that made the Conflict model because white cishet abled men couldn't stand flashbacks, women, or Gertrude Stein,

a white lesbian Jew talking. (This is why Syd Field ignores her when talking about his story structure and talks about how great the men of the movement were . . . which is subtle misogyny.)

While you can argue that story styles are influenced by cultural conventions (which certainly *can* manifest as prejudice), this isn't a rational argument. These aren't critiques of the form, these are ad hominem attacks. Yoonmi's work, which shares much in common with the story analysis on Wikipedia and acts as a source that many other bloggers then amplify, is largely driven by anger.

Freytag is 'an imperialist' and 'a devout Christian [. . .] pro wiping out the Poland'. Aristotle is 'a sexist ethnocentric classist asshole'. Five-act drama:

> was created by mostly white male critics and writers (Most of them are abled. They are all cis and het (except 1 who was gay, but he was trying to pass as straight for most of his life.)) and one huge a-hole of a pro-genocide imperialist.

It's fun to read, but it's not serious scholarship. It's full of logical fallacies. 'Syd Field [. . .] invented the Inciting Incident.' He didn't – he observed it; it had in fact been discovered and articulated over one hundred years before. Lubbock didn't invent conflict narrative, he observed something he believed to be important and gave it a name. Freytag didn't 'retcon' his Pyramid, he surmised correctly that Shakespeare's tragedies all followed an identical five stage pattern, which is why the editors of the First Folio found it so easy to break his work down into five clear acts. This isn't criticism, it is straw-manning.

On one level it isn't important – it's only a blog. But on another it is, for it is here that you start to understand just how narratives, however far from the truth, take shape. When the hatred or fear of one thing is so great, and identity so contingent on believing its opposite, we warp and shape all evidence, pro or con, to stand as witness in our prosecution. So Kim looks at Chinese history and concludes that because

China endured centuries of brutal famine and war, and as such, conflict was never a good thing; therefore, Chinese stories decentralized conflict. So while stories that followed the Chinese qǐ chéng zhuǎn hé structure (the precursor to Kishōtenketsu) certainly included conflict, conflict often took a definitive back seat to characters' personal development.[35]

I would be nervous of telling anyone who lived in twentieth-century China – through the rise and fall of dynasties, communism, nationalism and the events in Tiananmen Square – that this was a culture that was conflict-averse. If in doubt, just watch any film by Zhang Yimou, or perhaps ask the Uighur population. One blogger, citing the scholar Utako Matsuyama, attributes the supposed lack of conflict in eastern stories to Buddhist values: 'Conflict is replaced with shifting perceptions of the world. Characters aren't driven or called to action – things just happen to them. And there's often no resolution, as we would understand it, but instead just an emphasis of the idea or moral shown in the story.'[36] This is not serious scholarship. As Dr Irena Hayter, making a parallel with Japan, points out:

> Japanese history is ridden with conflict: warring feudal lords devastated the country over five centuries . . . Buddhism added meaning to these conflicts (the mighty man will also fall and all is vanity and evanescence), post factum, to teach the masses, but Christianity has the same streak . . . So the Japanese are EITHER bloodthirsty, primitive, irrational, etc.. (US propaganda during WWII) OR passive, conflict-averse, etc.. Seems like they can't be complex people responding to complex situations . . .

However, it's not just internet flotsam who believe in non-conflict models, it's also giants of literature like Ursula Le Guin. Here she is taking one of the earliest 'story gurus', Percy Lubbock (author of 1921's *The Craft of Fiction*), to task:

> Modernist manuals of writing often conflate story with conflict. This reductionism reflects a culture that inflates aggression and competition while cultivating ignorance of other behavioural

options. No narrative of any complexity can be built on or reduced to a single element. Conflict is one kind of behaviour. There are others, equally important in any human life: relating, finding, losing, bearing, discovering, parting, changing.[37]

It's so tempting to believe her, but of course her definition of conflict is as limited as any other critique of the form. Relating, finding, losing, bearing, discovering, parting and changing mean nothing *without* conflict; they are conflict dependent. Conflict isn't just waving a spear around – it's dissonance, of any size, of any shape, or any form.

The belief that four act structure or 'low-conflict narrative' is different is a faith-based belief, based on a series of category errors. It's a brilliant proof of how narrative propagates – we want to believe it – but it's based on a series of false assumptions that largely fall apart when exposed to air.

Conspiracy theories all begin like this – from the idea that you can dismiss something simply because George Bush said it. Before long, you have your theory: conflict is Western, conflict is bad. It's seductive; it quenches something and, however dishonest, it's an oasis where others who are thirsty for meaning and purpose come to imbibe.

Like any conspiracy theory, the argument against Western narrative has a particular target – a particular goal. As J. K. Rowling became the paradigmatic symbol for TERF, and the elimination of abortion the Republican totem, so the target gets distilled down to one clear, distinct enemy. 'Conflict' is the great straw man of narrative and the hero's journey is the Minotaur that must be destroyed, the repository of all narrative sin.

Western storytelling traditions decree that a linear structure (along with the three-act structure, the Hero's Journey, and a rising self-esteem arc) are mandatory features of any satisfying story. This is Western-centric silliness. In this webinar, author Henry Lien will explore non-linear structures, specifically cyclic and nested structures, using examples from non-Western stories and films.[38]

So says the advertising copy for author Henry Lien's course on 'Non-Linear Story Structures from non-Western Traditions'. Almost every piece on Kishōtenketsu uses the hero's journey as the enemy, which is ironic in that they're using conflict to make their point. In a video essay on YouTube, 'Beyond Hero's Journey: non-Western Story Structures', three young women see the enemy as a product of colonization. 'We have yet to emerge from the narratives of coloniality,' one of the speakers says:

> It destroyed traditional knowledges, ways of thinking etc. [. . .] all of that has been disrupted [. . .] When we think of de-coloniality – we have to first understand our minds our deeply conditioned – connect with 'pre-colonial self' – we need to root ourselves.[39]

Other blogs declare something similar:

> Roland Barthes, master linguist and semiotician once said: 'There are countless forms of narrative in the world.' And yet the majority of western storytellers have been ploughing just one narrative model for over 60 years: Joseph Campbell's Hero's Journey from the <u>Hero with a Thousand Faces</u>.[40]

It's the same argument that began our chapter: 'the idea that the Hero's Journey is the paradigmatic, media-agnostic, universal form of narrative structure is problematic in several important ways.'[41]

This revolt against the hero's journey is understandable. Most of us have rebel fantasies at some level – they're the engine that drives *Star Wars* and *Harry Potter*, after all. If you think of the hero's journey as conflict-centred and largely full of male characters waving their lightsabres, wands or other penis-substitutes around, then your urge to rebel against it (like my student's at the beginning) takes on greater lustre. Who wouldn't, at some stage in their lives, want to challenge that?

But what are we revolting against? What *is* the hero's journey? Where does it originate? Let's finally focus our attention there.

★

It's a map drawn by a former Disney story analyst, showing how to apply Joseph Campbell's monomyth to any narrative work. Inspired by the knowledge that George Lucas had based *Star Wars* on the same monomyth, Christopher Vogler reasoned that it should probably work for every other film fiction, and drew on Campbell's work to create his own popular writing guide *The Writer's Journey*. Vogler's paradigm is dressed in the same mythic garb as Campbell's, and marinated in a cocktail of late-1960s San Francisco hippiedom, marijuana and the music of The Grateful Dead.* His twelve stages of the journey can be summarized as follows:

1. Heroes are introduced in the ordinary world where . . .
2. they receive the call to adventure.
3. They are reluctant at first or refuse the call, but . . .
4. are encouraged by a mentor to . . .
5. cross the threshold and enter the special world where . . .
6. they encounter tests, allies and enemies.
7. They approach the inmost cave, crossing a second threshold . . .
8. where they endure the supreme ordeal.
9. They take possession of their reward and . . .
10. are pursued on the road back to the ordinary world, undergoing a spiritual death before . . .
11. they cross the third threshold, experience a resurrection, and are transformed by the experience.
12. They return with the elixir, a boon or treasure to benefit the ordinary world.

Faced with this paradigm, the first thing we should be asking is 'OK – prove it.'

On any rational basis, it's complete nonsense. There is no empirical evidence to support the hero's journey being a universal form, nor to suggest that following it will make you a great artist. 'But it fits!' we cry. To which one can only reply that so did medieval concepts of God

* For a full, detailed description see *Into the Woods*.

to those who believed them. Vogler offers no proof that the hero's journey resembles story form – he merely observes that if you use the pattern it will work. It's a prescriptive craft book – not an academic study. As such there is little explanation as to 'why?'. When he does go into detail (in the appendix to *The Writer's Journey*) his own examples are deeply unpersuasive.[42] Any undergraduate dissertation that asserted the primacy of the shape as a truth would (well, should) be rejected for posing such an argument without evidence, yet, bizarrely, it sometimes feels as though the paradigm has taken over the world. This, in itself, creates another conflict, because the method appears to work. How could we not succumb? And how could rebels not rail against it?

What *is* the Hero's Journey?

It's a metaphor. The mistake so many disciples make is to believe 'dark caves' and 'thresholds' are a reality rather than mythological embroidery, over which Vogler draped his own cloak. Campbell believed his journey represented underlying Jungian archetypes. But is that true?[43]

In *Into the Woods*, I traced the common pattern by which humans make sense of new information. We find the same shape in purity spirals, in Alcoholics Anonymous, in rhetoric, in column writing, in the underlying structure of Scientology and, as we will discover in the next chapter, in the cycle of grief. That shape is called the Roadmap of Change, and it's a paradigm for how humans acquire and process new information.

The Roadmap of Change

ACT 1
No awareness
Limited awareness
Awareness

ACT 2
Reluctance to change
Overcoming reluctance
Committing to change

ACT 3
Experimenting with change
BIG CHANGE (Mid point)
Experimenting post-change

ACT 4
Consequences of change
Doubt, prevarication, uncertainty
Final choice (crisis)

ACT 5
Re-dedication
Final battle (Climax)
Mastery (Resolution)

Or graphically:

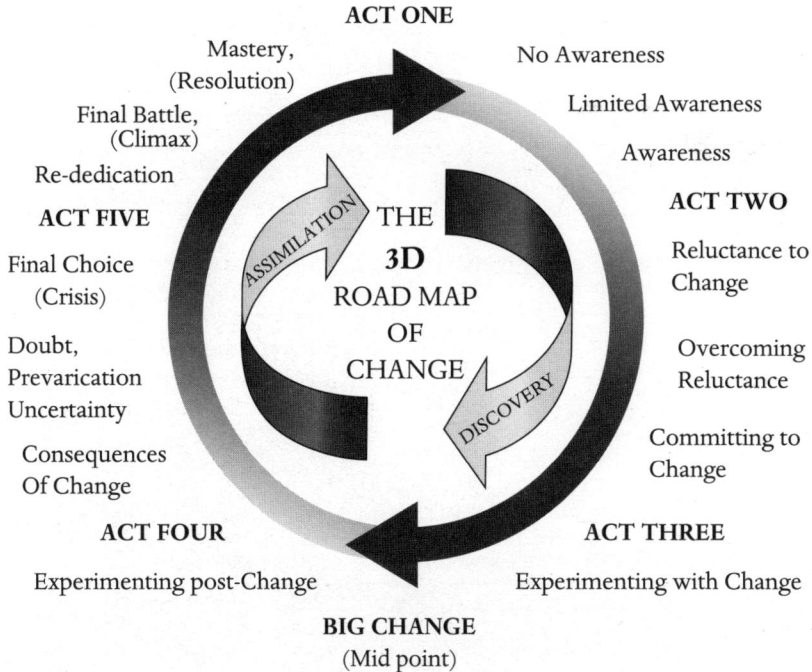

ACT ONE

Mastery,
(Resolution)

No Awareness

Final Battle,
(Climax)

Limited Awareness

Re-dedication

Awareness

ACT FIVE

ACT TWO

THE
3D
ROAD MAP
OF
CHANGE

ASSIMILATION

Final Choice
(Crisis)

Reluctance to
Change

Doubt,
Prevarication
Uncertainty

Overcoming
Reluctance

DISCOVERY

Consequences
Of Change

Committing to
Change

ACT FOUR

ACT THREE

Experimenting post-Change

Experimenting with Change

BIG CHANGE
(Mid point)

If you map the hero's journey against this, it all starts to make sense:

ACT ONE

No awareness	1) Heroes are introduced in the ordinary world
Limited awareness	where . . .
Awareness	2) they receive the call to adventure.

ACT TWO

Reluctance to change	3) They are reluctant at first or refuse the call, but . . .
Overcoming reluctance	4) are encouraged by a mentor to . . .
Committing to change	5) cross the threshold and enter the special world . . .

ACT THREE

Experimenting with change	6) where they encounter tests, allies and enemies. 7) They approach the inmost cave . . .
BIG CHANGE (Mid point)	crossing a second threshold . . . 8) where they endure the supreme ordeal.
Experimenting post-change	9) They take possession of their reward and . . .

ACT FOUR

Consequences of change	10) are pursued on the road back
Doubt, prevarication, uncertainty	to the ordinary world . . .
Final choice (crisis)	undergoing a spiritual death before . . .

ACT FIVE

Re-dedication	11) they cross the third threshold . . .
Final battle (climax)	experience a resurrection and are transformed by the experience.
Mastery (resolution)	12) They return with the elixir, a boon or treasure to benefit the ordinary world

The hero's journey, then, is just a metaphor draped over something far more fundamental – the process by which human knowledge is acquired.

It's the journey there and journey back. It is also a vivid illustration of where chiasmus comes from. The hero's journey and its underlying root are both, in paradigm form, totally symmetrical (something Vogler himself fails to understand). The hero's journey is really not the root of all Western story structure – it's not the Minotaur threatening the free voice of the artistically blessed – it's a disposable skin over a vital human function.

Every single assault I can locate on Western narrative structure starts and ends in the same way. The accuser posits a theory ('Western Structure is wrong, isn't it?'), present all the evidence for and against ('See . . .'), and then concludes ('We told you it was wrong!').[44] That's three acts. The John Truby trap again. That's what I should have said to the student at the beginning of this chapter: 'By asking you are casting yourself as a hero; you will listen to my answer, probing it for inconsistencies, before coming to a conclusion of your own.' Three acts. Narrative is just question and answer (with 'research or evidence' in between, if we're being pedantic). Every question is in itself a narrative act.

From the great multiprotagonist films of South America to the extraordinary (and brave) realism of directors like Kiarostami and Farhadi in Iran, or the African triumphs of Timbuktu, or Russian greats from Eisenstein to Zvyagintsev: all of them are using some bastardization of the hero's journey, whether they like it or not,

simply because all of the authors are human. Culture may be defined by geography – that gives you subject matter and style – but story cannot be so imprisoned. It transcends every obstacle, every border in its path.

No Bears is a film by the Iranian auteur Jafar Panahi. The protagonist is a fictional version of himself, making a film illegally on the Turkish border. It's dangerous work. 'What about the bears?' Panahi asks his companion as they walk to a local village. 'There are no bears,' his friend replies. It's all 'nonsense, stories made up to scare us. Our fears empower others. No bears!'

It's a great film and gets to the heart of conspiracy theory, to which the modern study of story structure is not unrelated – our fears create windmills we call giants. Our fears convince us phantoms are true.

The hero's journey, in the end, is just a Dungeons and Dragons costume on a Barbie. It's fun, it's fine, it's a good look, but it's a costume, not the real thing. When we attack it, we are fighting shadows.

Such is the state of screenwriting analysis, it is absent of almost any empirical rigour at all. Outside the work of narratologists (which I will come to) there is almost no coherent scientific study of perhaps the most important human behaviour of all. You don't build an aeroplane by copying the shape of another aeroplane (just look up the history of Concorde and Concordski). You build it by having a total, rational understanding of every single element and how they work together. If we are in search of the most powerful story, surely we should be in pursuit of that?

If you look at the master texts of narrative that define our world, there is a paucity of rational analysis. Robert McKee's *Story* is important for many reasons, but there's scarcely a mention of the midpoint, his definitions of crisis and climax are deeply flawed and the examples of inciting incidents he gives mostly make no real sense at all.[45] Syd Field is important, like Freud, as a pioneer, but there's little science there – it's no more rational than the pre-Copernican belief that the earth was the centre of the universe. And *The Writer's*

Journey and its offspring? It's a neat observation, but it's a metaphor derived entirely irrationally from something of which the author himself seems unaware.

We should be grateful to all of them, but surely we need to leave their blooded corpses in a heap somewhere and move on, don't we? Isn't it time we found a new explanation for the mysterious power that bewitches us all?

ACT V

Lessons from the School of Fiction, Revisited

9

Equilibrium Disrupted/Equilibrium Restored

What Is a Story?

If the question is 'Why does it go dark at night?' the logical answer is 'Because the earth rotates once every twenty-four hours in relation to the sun.' This is both a rational explanation, and one backed by all the scientific knowledge we have at our disposal. Once upon a time, however, that was not what people believed. Prior to the publication of Copernicus's *On the Revolutions of the Celestial Spheres* in 1543, it was commonly assumed the sun moved around a stationary earth, because to the human eye this felt both plausible and true. It appeared to make sense but, more, it appealed to our need for meaning and comfort. We were, we believed, the centre of everything. In other words, it was nonsense but too good not to believe. It was a bloody good story.

Stories and rhetoric work most powerfully when they unshackle us from empirical observation by drugging us with rage or anger or pleasure. Thus unmoored, we float off on a sea of emotion towards a world where facts are just what we feel. '*Of course* the Democrats are controlling the weather,' says the Republican farmer after sixty days of straight rain. If it feels right and absolves you of responsibility, it *must* be true. The journalist H. L. Mencken said famously, 'There is always a solution to every human problem – neat, plausible and wrong.' The insight gets to the heart of both narrative and rhetorical power – there is *always* a story. So much of our political discourse is the product of narrative thinking: belief stripped of critical

rigour. It is perhaps fitting, then, that so much of what we under-stand about screenwriting falls victim to exactly the same curse. We mistake too easily the flattering and simple for the true. We absent the 'Why?'

In all academic study, that 'why' is almost everything. You cannot say that there needs to be an inciting incident on page 12 unless you a) declare your font size and b) prove it.[1] You may *observe* that it appears to be true, but, without the 'why', the observation is no better than looking out of your window and concluding that the sun circles the earth. We do the same thing with inciting incidents and hero's journeys. They seem to fit, therefore they must be true. But why do we so rarely ask why a tale about a man who seizes a treasure in a dark cave should form the basis for a whole craft system?* Rationally, it's absurd.

Is there anything that can explain not just what a story is but the deeper aspects of that question – where does it come from? What does it do? And most importantly – the one question no screenwrit-ing book has ever successfully answered – *why* does it take the shape it does?

Perhaps.

Try typing into any good search engine the words 'screenwriting diagram'. Immediately you will be assailed by a geometrical blizzard of shapes. There will be a tsunami of circles, a welter of different wave formations. Straight lines will strafe every page, some hori-zontal, some vertical, but many more careering off at unlikely angles as they attempt to chase and prescribe the broader points of story structure. Off-centre triangles will compete with asymmetric oblongs. The simplest diagrams resemble matchstick men, the more complex aspire to some kind of modern art.[2]

With some you can detect the ghost of a three-act structure

* It's hard not to be reminded of *Monty Python and the Holy Grail*: 'Strange women lying in ponds distributing swords is no basis for a system of government. Supreme executive power derives from a mandate from the masses, not from some farcical aquatic ceremony.'

or a midpoint, but there's little underlying logic to most of them. Look too long and they start to resemble the scrawlings of a conspiracy theorist on a blackboard. It's instructive to step back and ask a simple question of storytelling: *why* would any narrative form a shape like that?

Art inevitably prizes mystic inspiration above rational study, perhaps forgetting that Leonardo da Vinci's genius was built on his endless pursuit of scientific understanding. He cut bodies open to find out how they worked.

If we are to discover the 'why' of storytelling, perhaps we can start by taking a scalpel to perhaps the most over-analysed film in the canon. If we cut open *Star Wars: A New Hope* to see how its muscles move, might we reveal the underlying logic no how-to book has ever articulated? An architecture common not just to Lucas's films, but all story?

The internet is riddled with structure breakdowns of innumerable scripts, a problem that will only be compounded by the advent of AI. *A New Hope* – partly because of its popularity and partly because it was directly inspired by the works of Joseph Campbell – features far more than most. Often, they take the form of the hero's journey, and almost every example uses the same points:

1) Heroes are introduced in the ordinary world where . . .	Luke is a farm boy
2) they receive the call to adventure.	Message from Princess Leia
3) They are reluctant at first or refuse the call, but . . .	Turns down invitation to Alderaan from Obi-Wan Kenobi (Ben)
4) are encouraged by a mentor to . . .	Step-parents killed
5) cross the threshold and enter the special world . . .	Luke accepts invitation to go to Alderaan

6) where they encounter tests, allies, and enemies.	Luke meets Han and Chewbacca, who fly them to Alderaan, and he begins to learn the ways of the Force.
7) They approach the inmost cave . . .	As they approach Alderaan the planet is destroyed – they are caught in the Death Star's tractor beam
8) where they endure the supreme ordeal.	They rescue Princess Leia on the Death Star, Kenobi sacrificing himself so they can get away.
9) They take possession of their reward and . . .	They escape from the Death Star with its blueprints – they can search for its weaknesses.
10) are pursued on the road back to the ordinary world, undergoing a spiritual death before . . .	They head to the rebel base pursued by TIE fighters – they realize they have been tracked.
11) they cross the third threshold . . . where they experience a resurrection and are transformed by the experience.	The rebels prepare to take on the Death Star. There is an epic space battle – Luke chooses the Force and wins.
12) They return with the elixir, a boon or treasure to benefit the ordinary world	Our heroes receive medals of valour – there is peace throughout the galaxy – at least for now.

This is a pretty standard interpretation of the film and you'll find myriad variations on it all over the internet. However . . . it's wrong.

What if, as I argued in the last chapter, the hero's journey doesn't exist *except* as a metaphor for dramatic change? It's worth reverse engineering the problem by looking at *A New Hope* as a change paradigm. See what happens when you view each beat as a staging post on the Roadmap of Change:

ACT ONE

No awareness	Luke is a farm boy . . .
Limited awareness	who meets C-3PO and R2-D2 . . .
Awareness	who show him the distress call from Princess Leia.

ACT TWO

Reluctance to change	He is reluctant to follow Ben who wants to help Leia . . .
Overcoming reluctance	until his step-parents are murdered by Darth Vader . . .
Committing to change	and he agrees to accompany Ben, learning the ways of the Jedi along the way.

ACT THREE

Experimenting with change	In Mos Eisley, Luke meets new allies and enemies. Han Solo and Chewbacca agree to ferry Luke and Ben to Alderaan – pursued by Imperial Stormtroopers.
BIG CHANGE (Mid point)	When she refuses to give the location of the rebel base away, Princess Leia watches her home planet of Alderaan destroyed by the Death Star Luke struggles with his light sabre until Ben makes him 'blind'. For the first time, the Force possesses him.
Experimenting post-change	Their destination destroyed our heroes are trapped by a tractor beam which lures them towards the Death Star. They locate Leia . . .

ACT FOUR

Consequences of change	but are trapped in the trash compressor.
Doubt, prevarication, uncertainty	They escape but are chased by Stormtroopers, only just escaping when . . .
Final choice (crisis)	Ben is killed – sacrificing himself so the others can get away. However, their craft contains a tracking device, leading the forces of evil to . . .

ACT FIVE

Re-dedication	the rebel base. Just in time the rebels analyse R2-D2's stolen plans and find the weakness in the Death Star . . .
Final battle (climax)	and attack it. Luke triumphs against all odds, when he abandons his reliance on computers and, instructed by Ben from beyond the grave, learns to 'Choose the Force'
Mastery (resolution)	Order is restored to the galaxy – and our heroes are rewarded for their pains.

While the first halves of each of these interpretations roughly overlap, it's in the second halves that the differences become apparent. Screenwriting analysis is riddled with overtly literal interpretations. For some analysts, every time a character goes through a door they are 'crossing the threshold', every time they pick up a pen they are taking possession of their reward.[3] It's the same here. The 'dark cave' suggests to many the scene where Luke, Leia, Han and Chewbacca are trapped in the trash compactor on the Death Star. This is, they claim, 'the supreme ordeal'. Except of course it's not.

The supreme ordeal is a metaphor for the midpoint – big change.

So what, exactly, happens precisely in the middle of *A New Hope* – can that perhaps shed some light?

Three things occur at this point. Leia's home planet, our heroes' destination, is destroyed and the full power of the Death Star is revealed. At the same time, however, on the *Millennium Falcon*, Ben is teaching Luke the ways of the Jedi. Exactly halfway through the film – literally to the second – Ben is showing Luke how to master the Force by throwing a 'seeker' in the air and asking Luke to hit it with his lightsabre. As if that weren't hard enough, Ben makes Luke wear a visor with a blast shield, so he's blind:

> **BEN (Cont'd)**
> This time, let go your conscious
> self and act on instinct.

> **LUKE (Laughing)**
> With the blast shield down I can't even
> see. How am I supposed to fight?

> **BEN**
> Your eyes can deceive you. Don't
> trust them.

> *Star Wars: A New Hope* by George Lucas

Ben throws the seeker into the air. Luke misses it. Ben tells him to 'stretch out with your feelings' and on the next try Luke makes contact. 'You see,' says Ben, 'you can do it.'[4]

No one ever refers to this scene as the midpoint, and judging by the way its significance is underplayed, perhaps George Lucas didn't realize it either. However, ignoring the fact that it is both badly written and performed (despite the talent of all the participants), it is an extraordinarily valuable moment, one which allows us to understand very clearly the remaining mysteries of story structure.

What are they? Before we can fully understand and answer we

must – like Luke disappearing to Dagobah to meet Yoda – make a series of visits elsewhere. To Joseph Campbell and Tzvetan Todorov – but before them to Vladimir Propp, a Russian Formalist and one of the key forefathers of narratology.

The academic study of story shape and form effectively begins with the German professor and director Gustav Freytag in the mid-nineteenth century. It then became a central preoccupation of the Russian Formalists at the beginning of the twentieth, but it was only in the 1960s that it firmly took hold in (mostly) European universities. The term 'narratology' (literally the study of stories) was adopted universally after it was coined by the Bulgarian scholar Tzvetan Todorov in 1969. An anglicization of the French *narratologie*, it gave name to a deeply intellectual attempt to understand the relationship between story structure and human consciousness, between experience itself and 'what is told'.

The Russian Formalists, while by no means a unified movement, were his precursors, aiming to bring some scientific rationality to the study of literature. 'Poetics, once a sphere of unbridled impressionism, became an object of scientific analysis, a concrete problem of literary scholarship.'[5] For them, structure was as important as content – even their name is derived from the belief that it is impossible to separate form and content in any artistic work. Just as I argue with *Andrei Rublev*, the form *is* content.

As a school they arose organically at the beginning of the twentieth century before being swept away under the suspicious gaze of Stalin, though they were to be a major influence on the Prague School of the 1920s and the (much) later French Structuralists. Removing the emphasis on philosophy and psychology, stories were instead viewed as artifacts that could be better understood by being broken into constituent parts.

Vladimir Propp's seminal *Morphology of the Folk Tale* grew out of this idea. Published in 1928, though it didn't reach the West until its translation thirty years later, the book proved hugely influential in academic circles and beyond. Propp studied a hundred Russian

folk tales and decreed there were thirty-one canonical stages – 'functions' or 'narratemes' – that they all had in common.[6] 'Each function,' wrote Propp, 'derives from the other through a logical and artistic necessity. We see that no function excludes another. They all belong to the same pivot, and not to several pivots.'[7] In other words, they are story beats: linked together chains of cause and effect.

Propp's full list of stages (see Notes) appears complex, but if you break it down into its key elements you find something far more recognisable:

VILLAINY or LACK
Something causes harm to a family member,
or something is missing in family or community
that becomes desirable

DEPARTURE
Hero leaves home to find or seek

STRUGGLE
Hero finds villain and they engage

VICTORY
Hero beats them

LIQUIDATION
The 'lack' is eliminated

RETURN
Hero returns

PURSUIT
Hero is chased

UNRECOGNIZED ARRIVAL
Hero loses identity

DIFFICULT TASK
Final trial

MARRIAGE
Identity revealed and final union.

We can clearly see, here, the universal journey in which the protagonist, suffering from a flaw or 'lack', goes on a journey into the heart of the forest to find the thing missing within themselves, before returning with that thing to their home.

This same journey is even more explicit in Joseph Campbell's monomyth (his universal pattern of mythology), articulated twenty-one years later, and the birthplace of the hero's journey itself:

> A hero ventures forth from the world of common day into a region of supernatural wonder: fabulous forces are there encountered, and a decisive victory is won: the hero comes back from this mysterious adventure with the power to bestow boons on his fellow man.[8]

Both academics, Campbell and Propp, are staring intently at their own subject matter, trying to find a common underlying pattern, which they then express in terms of their own discipline. Unknowingly, however, both have discovered something common not just to their own area of expertise, but to *all* story. Both are referring to the same underlying shape.*

It's this universal shape that Tzvetan Todorov tried to make sense of when he drew the chair of narratology up to their table. Attempting, like the Formalists, to dissect story into its constituent parts, he developed the 'narrative theory of equilibrium', outlined in a 1971 paper called 'The 2 Principles of Narrative'.[9] A story, he said, was 'equilibrium disrupted, then restored'.

* More on this in *Into the Woods*.

To illustrate his theory, he turned to the same source Vladimir Propp had used when writing *Morphology of the Folk Tale* forty-three years before. From the vast collection of Russian folk tales compiled by Alexander Afanasyev, Todorov chose (as Propp had before him) story 113, 'The Swan-Geese'.

A little girl forgets to look after her brother who is then kidnapped by the swan-geese – creatures who give the story its name.

1. A young couple go out, leaving their two children to play. The daughter is told to keep an eye on her younger brother.
2. Preoccupied, she loses sight of him and the magical, villainous swan-geese steal the little boy away.
3. The girl is out playing; when she returns, she realizes her brother has gone missing.
4. The girl attempts to rescue her brother from the monstrous spirit who ordered his capture. The challenges get harder.
5. The spirit is defeated, the girl rescues her brother and the siblings return home.

In an explicit criticism of Propp, Todorov strips his thirty-one key stages down to 'five indispensable elements' which, he says, can apply to all stories:

1. The situation of equilibrium at the beginning
2. The breakdown of the situation by the kidnapping of the boy
3. The girl's recognition of the loss of equilibrium
4. The successful search for the boy
5. The re-establishment of the initial equilibrium, the return to the father's house.

To which he adds: 'None of these five actions could have been omitted without causing the tale to lose its identity.'[10]

Todorov named these stages equilibrium, disruption, recognition, resolution and new equilibrium, and envisioned them as part of a continuous circle:[11]

Equilibrium /
New Equilibrium

Attempt to resolve
the disruption

**TODOROV'S THEORY
OF NARRATIVE
EQUILIBRIUM (1971)**

Disruption of
the equilibrium

Recognition of
the disruption

The purpose of the circle is to stress the importance of transformation, as opposed to chronology, in narrative. In basic terms, the pattern of every story, Todorov suggests, is this:

1. A state of equilibrium
2. A disruption of that order by an event
3. A recognition that the disorder has occurred
4. An attempt to repair the damage of the disruption
5. A return or restoration of a new equilibrium.

How closely this fits the idea of the journey into the woods. Indeed, 'recognition of the disruption' is a rather brilliant definition of a midpoint. At the heart of the story, the protagonist makes the first real sense of the problem that has destabilized their life. The second half of the story is how they then deal with that now-conscious knowledge.

It's not hard, I hope, to see how helpful this can be. A character lives a relatively simple life, until their world is blown out of shape (disruption of the equilibrium) by something they are not equipped to understand (the inciting incident). Halfway through the story they manage to identify the source of their problem (recognition of the disruption) and set about repairing it, though at great cost to themselves.

It's exactly what a midpoint is – a recognition of the disruption. Look at *Moonlight*, *Thelma & Louise* or *Star Wars: A New Hope:* all fine examples from different genres of 'order disrupted; disruption recognized; order restored'. Halfway through each film a disruption is recognized – Chiron has his first gay experience, Thelma has her first orgasm and Luke is brought face to face with the Force.

Todorov makes one further important observation, this one about symmetry:

> It is obvious that the first element repeats the fifth (the state of equilibrium); and that the third is the inversion of one and five. In addition, the second and the fourth are symmetrical and inverse: the little boy is taken away from his house or taken back. Thus it is not true that the only relationship between the units is one of succession; we can say that the relationship of the units must also be one of transformation. Here we have the two principles of narrative.[12]

He's describing chiasmus. Syd Field wrote *Screenplay* in 1979, Robert McKee wrote *Story* in 1997, yet here, in a short academic paper published in 1971, Todorov had beaten them both to it – had outdone them, in fact, for Field and McKee's models, lacking any midpoint identification, are fatally flawed. The fundamental shape of all stories, including a perfect exposition of chiasmus, is all there in Todorov's five lines.

What does this tell us? Firstly, that narratologists and screenwriting gurus are effectively saying the same thing. Whether personified by Joseph Campbell or Tzvetan Todorov, each has, within the language of their own specialism, found their metaphors for one underlying, universal story shape: an order-making mechanism that wraps a steel sarcophagus around messy, gelatinous reality.

Secondly, that shape is not just for its own sake – it has a function. It turns reality into a lesson.

In February 2021, a documentary premiered on HBO. Directed by Kirby Dick and Amy Ziering, *Allen v. Farrow* explored the allegations

of sexual abuse made against Woody Allen by his and Mia Farrow's co-adopted daughter Dylan – abuse she claimed happened when she was seven years old. The key to understanding story structure lies not in the actual programme, but in examining its trailer. It's 2 minutes and 14 seconds long, and it follows a very recognizable arc. To borrow the language of Freytag, it first lays out the essential exposition:

> This is the story of two of the biggest stars in the world. The father is Woody Allen, the mother is Mia Farrow, his co-star, and mother of his three children . . .

At 20 seconds, the inciting incident kicks in, as a friend comments, 'No matter what you think you know, it's only the tip of the iceberg.' Then we're into the rising action:

> Woody gave her everything she could possibly want . . .

Woody Allen, we are told, is perfect. But then, slowly, doubts creep in. '. . . That's the great regret of my life,' says Mia Farrow, 'I wish I'd never met him.' Farrow, we learn, reportedly has a video of Dylan describing how her adoptive father molested her. Allen denies the incident, but 'freely admits he's in love with another of Farrow's daughters, twenty-one-year-old Soon-Yi'.* Farrow explains how she discovered illicit Polaroid photographs of Soon-Yi (the adopted child of Farrow and André Previn), before adding, clearly distressed, 'I remember struggling to breathe.' This moment comes at 1 minute 7 seconds, exactly halfway through the trailer – the point Freytag would call the climax. It's the recognition of the disruption, and both the literal and structural midpoint of this mini archetypal tale.

As if to underline that fact, the music changes. Suddenly it's dramatic, urgent. The falling action kicks in, the case against Farrow is laid out:

* These are the words of the trailer. It doesn't explicitly say that Allen was not related to Soon-Yi except by his marriage to Farrow, a detail which is legally important, even if the relationship clearly raises questions around guardianship.

The report says Farrow may have coached the child to tell the story.

And then – the crisis point, or what Freytag would call the moment where falling action smashes into resolution. A key witness cries out:

I read the court documents – my reaction was 'holy shit'.

'It doesn't matter what's true,' says Farrow, making her final thrust, 'what matters is what is believed.'[13]

It's a mini masterpiece of narrative structure and an extremely good example of the primacy of emotion over reason. It's also incredibly effective: the programme became one of the most watched multipart documentaries in HBO's history. Like almost all narrative-based adverts it has a classic fractal structure (it's a movie in miniature), but it also underlines two things that are incredibly important.

The first is the role of the midpoint. *Allen v. Farrow* was accused by Woody Allen of being wildly misleading: 'These documentarians had no interest in the truth.'[14] And, sure enough, the programme was widely perceived to be vindicating Farrow's allegations. Watching the trailer, you can see this at work. A classic midpoint prefigures the ending of a story.* The lesson delivered prefigures the lesson being learned.[15]

The holy trinity of storytelling, a structure echoed very clearly by Freytag's Pyramid, is the relationship between three elements – the inciting incident (*the question asked*), the midpoint (*the truth delivered*) and the crisis point (*are you going to accept the answer – the truth to the question you've been asked?*).

If you work in storytelling, this is an incredibly valuable thing to know. Just as you can work out the length of one side of a right-angled triangle by knowing the lengths of the other two sides, so it

* There are exceptions to this, 'The Swan-Geese' being one, but it's a sound rule of thumb. Even in 'The Swan-Geese' the lesson is there. On recognizing her brother's absence, the girl knows what she's got to do. His absence drives her search on.

is with story – the three elements have an algorithmic relationship. Take, for example, *The Godfather*, which we might think of as *thesis* (Michael is a law-abiding soldier), *antithesis* (he murders Sollozzo and McClusky in revenge for the attempt on his father's life) and *synthesis* (he's the new, utterly ruthless, Godfather). Thesis and synthesis are clearly absolute opposites, but now look at the midpoint, the assassination of the crooked cop and gangster. Michael is the direct opposite of the war hero at this point too, but by becoming a criminal he's also prefiguring the person he will, at the end, become.

This reveals a great 'trick', if you like, but I think a better word is 'rule'. If you know the beginning and the middle of a story, the ending isn't that hard to work out.* In *The Shawshank Redemption* Andy Dufresne (Tim Robbins) is an incredibly conventional, law-abiding banker, unjustly imprisoned for murdering his wife and her lover. Exactly halfway through, Dufresne has changed substantially – he locks himself in the governor's office and incurs the wrath of the warden by playing Mozart's *Marriage of Figaro* across the PA system to the entire prison. 'I don't know what those two ladies were singing about,' says the narrator, Ellis (Morgan Freeman):

> I tell you, those voices soared higher and farther than anybody in a grey place dares to dream. It was as if some beautiful bird had flapped into our drab little cage and made those walls dissolve away, and for the briefest of moments, every last man in Shawshank felt free.[16]

It's incredibly on the nose. The midpoint of the film is *freedom*, and at that moment, if you understand story structure, you can see how it foreshadows the ending – you already know that Andy *must* escape. Not all midpoints are this obvious – sometimes the lesson needs decoding – but most archetypal ones are.

* Additionally, the change in Michael's character is clearly reflected in his costume. Army uniform at the beginning, civilian with suit and tie in the middle, shirt sleeves at the end. Structure gives you not just story, but tells you how to design, shoot, play and dress your film as well.

Now look again at the midpoint of *Allen v. Farrow*. The trailer, without saying it, is telling you 'Allen is guilty'. The midpoint, Farrow's 'I remember struggling to breathe', is deeply significant. It's the midpoint prefiguring the end of the story once more. They may not have done it consciously, but it's what the directors believe is the truth.[17]

This is also key to the second big lesson the trailer can teach us. As we've seen, it's clearly divided into two halves – the first half largely takes Farrow's side, but after the midpoint it switches and the argument favours Allen. Freytag called this 'rising action and falling action' but there are clearer and more helpful terms. We might think of the first half of a story as 'argument for', while the second half is 'argument against'.

Argument for, Argument against

Again, a trailer is most instructive. In 2022 a commercial dropped for a new documentary about the life of tennis legend John McEnroe. The advert is 2 minutes and 2 seconds long, and the first half is laudatory. He's a god. 'I go around the world. I meet girls. I'm number one in the world, I'm the greatest player that's ever played,' McEnroe intones. Then, suddenly, at the 1 minute 1 second mark: 'Why does it not feel that amazing?' The second half concerns McEnroe's spiral into depression, his thirty-seven psychiatrists, his issues with his father and with being a father, his desperation to find self-worth. 'Is it all worth it?' he ends, which is of course the question that forms the skeleton of the entire film.

The rules of dramatic structure are followed very clearly here, but in a way that reveals something more, something the trailer shares with all rhetoric and all archetypal narrative. We've seen that the first half of any story is the journey there and the second the journey back, but there's another way of looking at this. We could say the first half of any story is the argument *for* and the second the argument *against*.

Look at Reagan's *Challenger* speech:

> Exploring is American
> We must explore
> Exploring is dangerous
> Should we not explore?
> Explore.

Argument for; argument against. It's an incredibly useful way of understanding story (and speech) structure.

> Premise
> Argument for
> Midpoint
> Argument against
> Conclusion.

If stories are about learning a lesson, then structure moves toward that lesson in argument form. It naturally states the case for both sides. The first half of any story stresses the positives of whatever is at issue, the second the negative consequences.

You can see such a pattern in David Fincher's Facebook saga *The Social Network*. Halfway through the film Sean Parker arrives to buy his way into the company and Mark Zuckerberg's best friend Wardo is pushed to one side. In a film about a friendship network, the first half is the argument *for* friendship, the second the argument *against*. And the end? Mark is all-powerful, and all alone. It's not just films, or modern fiction either. In *A Room with a View*, Lucy argues for passion, then against, before coming down on the side of the former. She cannot live without a room with a view.[18]

Here are the positives, here are the negatives – here is the answer. Look for that pattern. Archetypally, a character lives a relatively simple life before their world is blown out of shape by something they are not equipped to understand (disruption of the equilibrium). They grasp for a new understanding, and halfway through the story

manage to identify the source of their problem (recognition of the disruption). Now they must set about testing that recognition, at much greater cost to themselves. No change is easy. The temptation to revert to the old self is strong. And that choice, between old knowledge and new, is exactly what a crisis point is – a fork in the road. It's where 'the whiff of death' you so often find at this point comes from too, because in archetypal narrative the old self is left bleeding in the road. Farrow abandons her love, Mark Zuckerberg waves goodbye to friendship and John McEnroe abandons the relentless pursuit of perfection to seek happiness elsewhere.

John Stuart Mill once said, 'The beliefs that we have most warrant for, have no safeguard to rest on, but a standing invitation to the whole world to prove them unfounded.' That's what a good story should rest on too – opposition defines you.

It is this that brings us back to *Star Wars*, and what Luke's lightsabre lesson finally reveals about the true design of story structure.

An inciting incident is made up of two elements: the explosion that throws a character's life out of balance and the decision to rectify that balance. It's a question, and the search it provokes for the answer. In *A New Hope*, the question (*What does it take to be a hero?*) comes when Luke intercepts the message from Princess Leia to Ben, the answer when he makes the decision to join Ben on the journey to Alderaan. (*This.*)*

The true consequences of Luke's decision don't become clear to him until the middle of the script. The moment when he strikes the seeker with his lightsabre while wearing a visor *should* be huge – it's the moment everything starts to make sense for Luke. 'Oh my god,' he should be thinking, 'Maybe I *am* a Jedi?' – but the whole scene is spectacularly underplayed. None of the actors seem to recognize that this is the nuclear reactor at the heart of the film.

* Events don't focus until the end of the second act, the point of commitment in the Roadmap of Change. It's quite a common pattern – *Erin Brockovich* and *Thelma & Louise* are good examples: in both, the protagonist's decision to give an issue sole focus doesn't arrive until around the forty-minute mark.

To be fair, *A New Hope* isn't big on psychological realism. Leia never looks more than slightly upset when her entire planet's inhabitants are killed.* Han Solo saves the day at the end without any plausible turning point and, within two minutes of their murder, Luke's step-parents are completely forgotten. The midpoint however, the moment Luke suspects his destiny, that's the perfect definition of Todorov's 'recognition of the disruption'. If the theme is 'What does it take to be a hero?' then the answer is 'Faith.' Being a Jedi – choosing the Force – is utterly central to the whole story. That's what Luke is told at the midpoint and then forced to discover whether true.†

There is no dark cave in *A New Hope*, and the way the midpoint is staged suggests neither cast nor director/writer was aware of its significance.[19] Does that matter? It would be churlish to argue with a film that revolutionized cinema for good or bad, but it does help explain why the hero's journey can be so misleading. Everyone, it seems, is searching for a literal 'innermost cave' rather than grappling with what the story really means. It also underlines that this process isn't a construct. It's not derived from a book, but from the unconscious. That's where the initial story-shaping process happens.

The *Star Wars: A New Hope* example is ridiculously literal. Ben teaches Luke a lesson at the centre of the film – 'choose the Force' – which he will finally understand at the end of the film. In addition, it literally coincides with an example of the forces of evil (the Death Star destroying Alderaan) that he must defeat. It's almost too on the nose. As such, however, it's a brilliant illustration of why stories are the shape they are.

* Alec Guinness memorably did his best with the dialogue: 'I felt a great disturbance in the Force, as if millions of voices suddenly cried out in terror and were suddenly silenced. I fear something terrible has happened.'

† The destruction of Alderaan is another part of the 'lesson delivered'. Luke ignores Ben's wailings – only later will he fully begin to grasp what they mean.

Why?

Human beings tend to ingest new knowledge according to a pattern, as the Roadmap of Change attests. But there's something more to this process that is significant, something made strikingly clear by a comedy that brutally scorned convention, only to find itself accidently embracing it entirely.

Groundhog Day belongs to a small stable of films that retain their cultural cachet long after release. Partly that's because its subject matter touches on the near-universal dream of reinventing ourselves and thus finding the love we've always longed for. The film is well cast and well made, but it's perfectly structured too, and not just in an archetypal sense. It is built on a single, brilliant insight that transmutes its premise from what could have been a forgettable *Saturday Night Live* sketch into something both hugely influential (its descendants include *Edge of Tomorrow*, *Source Code*, *Russian Doll*, *Palm Springs* and *Before I Fall*, as well as notable episodes of *The X Files* and *Buffy the Vampire Slayer*, among others) and a shorthand for existential ennui.

Bill Murray's Phil Connors is an irascible and self-centred weatherman who finds himself trapped in the town of Punxsutawney – reporting on the belief, fuelled by an old Pennsylvania–Dutch superstition, that a groundhog emerging from its burrow can predict the coming of spring. Phil's cynicism and superiority are flaws he must overcome when he finds himself trapped in a time loop, forced to relive the same day endlessly until he can learn the power of love. So far, so archetypal, but that's not what gives the film its real bite.

In the commentary accompanying its DVD release, the film's director and co-writer, Harold Ramis, touches on the idea that Phil's growth of character was modelled by co-writer Danny Rubin on Elisabeth Kübler-Ross's famous articulation of the differing stages of grief. 'We actually took Elisabeth Kübler-Ross as a model – her five stages of death and dying – and we used that as a template for Bill Murray's progress.'[20]

In her 1969 book *On Death and Dying*, based on her work with

terminally ill adults and children, Kübler-Ross outlined the pattern that those facing death tended to follow: denial, anger, bargaining, depression and acceptance. It wasn't a fixed pattern, she said: 'they are not stops on some linear timeline of grief. Not everyone goes through them or goes in a prescribed order.'

Acceptance Denial

KÜBLER-ROSS STAGES OF GRIEF (1969)

Depression Anger

Bargaining

It's easy to see how the Kübler-Ross paradigm maps onto both archetypal five-act structure and the Roadmap of Change.

1) **Set up and call to action (DENIAL)**
 After being miserable and cynical throughout *Groundhog Day*, Phil wakes to find himself trapped in Punxsutawney.

2) **Initial objectives achieved (ANGER)**
 Phil becomes increasingly angry about his predicament, confiding in Rita, his colleague, who suggests he reach out for help.

3) **Things start to go wrong as forces of antagonism gather strength (BARGAINING)**
 Phil starts to experiment and enjoy the freedom this new world gives him, including using his newfound knowledge to try and seduce Rita. However, after a stranger dies in front of him – 'sometimes people just die' – he starts to feel how oppressive and empty this world is.

4) **Things go really badly wrong, precipitating crisis (DEPRESSION)**

Phil tries many ways to kill himself, all of which prove futile. He admits to Rita that he cannot escape. He's desperate. She tells him to see it as a blessing not a curse.

5) **Final battle with antagonist; matters resolve for good or ill (ACCEPTANCE)**

Phil resolves to become a better person. He consummates his relationship with Rita and is released from the curse. He even suggests to Rita they should buy a house in the town.

Each act in Phil's story is built around a different stage of the cycle. He's in denial about his flaws, then angry with his metaphorical imprisonment, then he decides to explore all its possibilities, finds himself suicidal, before redemption finally comes.

Danny Rubin, and indeed Harold Ramis, were notoriously averse to any kind of screenplay formula. In an interview with *Vulture*, Rubin described how he would often meet with Hollywood execs who would pitch him ideas:

> 'It would be like, Goldie Hawn has a dysfunctional family, none of them get along, so they go camping and in the end they all learn to love each other,' Rubin recalls. 'Typically, I would say, "Okay, I am going to tell you your movie."' He'd lay out a perfectly respectable studio picture, with a three-act structure and a conventional conclusion. 'And then I'd say, "Under no circumstances am I going to write that movie."'[21]

As if to defy them, Rubin based his screenplay not on any clear act structure, but on Kübler-Ross's paradigm instead. What's both striking and ironic, however, is that he ended up producing a beautifully modulated and deeply archetypal script. The reason that happened is incredibly important.

Stories, we have argued, are units of learning – of knowledge. Archetypally, a character learns something and overcomes a

flaw to achieve their goal. Whether told in fiction (selfish Rick in *Casablanca* – 'I stick my neck out for no man' – becomes the most selfless man in the world: 'This could be the start of a beautiful friendship') or hewn from life (Michelle Obama's kids move from looking scared behind men with guns to playing freely on the White House lawn), the lesson is always there.[22]

When a story works best, it's because the lesson the characters learn is a hard one, difficult for the protagonist to comprehend, let alone achieve. What is trauma but unwanted knowledge? What is the story process? It's unwanted knowledge becoming belief.[23] In trauma, in learning, in story, the brain makes sense of the world using exactly the same pattern – and when it does, identity is transformed.

Denial, anger, bargaining, depression, acceptance. That's grief recovery, but it's also the pattern of every archetypal story. Look at *Macbeth*, look at *Richard II* – both are journeys utterly enhanced by their protagonists' near refusal to want to take them. *Breaking Bad* as well: each season is effectively a stage of the trauma cycle. Mr Chips becomes Scarface *reluctantly*.

And it is this that leads us to the final 'why?'.

How do we learn *anything*?

We are confronted with new information. We can either reject that information out of hand or recognize its validity and test it to destruction. If it passes that test, we accept it as truth.

To borrow the language of Todorov, we exist in a state of equilibrium; new knowledge disrupts this equilibrium. We explore any new knowledge until we recognize a coherent shape, then ask ourselves, 'Will this knowledge help or damage me? What's the worst thing that can happen if I accept this new information?' If we are willing to accept those consequences, we can repair this disruption – a new equilibrium is achieved.

See how elegantly this maps onto the graphical representation of character change we discussed in Chapter 6: at one level the graph shows how character want is replaced by character need. What it also reveals is how *old* knowledge is replaced by

new knowledge. That, in fact, is one of the best possible defini-
tions of those two pieces of classic screenwriting terminology,
want and *need*.*

Note how they cross over at the midpoint. Old knowledge
is confronted by an equal weight of new knowledge at a story's
centre, splitting the protagonist in two. You see this very clearly
with Michael Corleone in *The Godfather* and Chiron in *Moonlight*,
but look too at Rick (Humphrey Bogart) in *Casablanca*.† Halfway
through the film, almost to the second, he demands Ilsa (Ingrid
Bergman) leave his life for ever. She goes, and Rick crumples – the
only time he shows vulnerability in the film. He hates her and
wants her in equal measure. That completely balanced conflict –
between old and new – is, in essence, the midpoint of every arche-
typal story.[24] Soon Michael will become a monster, Chiron will
embrace his sexuality and Rick will discover a newer definition of
love. Their old prejudices will be washed away. Our want is for old
knowledge, for things to stay as they were. Our need is the opposite
(they should always be opposites). It's for new knowledge, that will
let us overcome our flaws and be born anew.

The story process, then, is instigated by an external force we
don't yet understand. That's our inciting incident. Incrementally
we work towards forming a working hypothesis; we articulate the
possible nature of the problem and expose it to the world. That's
our midpoint. We stress-test that hypothesis, increasing the pressure
on it to see if it breaks, ramping it up until we've thrown up every
single argument against it. Does it break? There's our crisis point. If
it does, we dispose of it, but if it doesn't – if it survives the full force
of the arguments against it and the worst possible consequences for
accepting it – then we embrace the hypothesis as a fact and a brand-
new truth is forged.

The use of the term 'hypothesis' is not accidental. The story-
making shape is identical to one we are taught at school: the scientific

* Every successful Pixar movie illustrates this perfectly.

† For additional discussion of *Casablanca* see *Into the Woods*.

method – the process from which fact-based empirical thought is born.

In essence, the scientific method is the logical creation of hypotheses followed by the exposing of them to sceptical thinking, counterargument and rational thought. The model that led to the explosion of science in the seventeenth century and the birth of the age of reason is often represented like this:

Observation/
question

Report
conclusions

Research
topic area

**SCIENTIFIC
METHOD**

Analyse
data

Hypothesis

Test with
experiment

If this looks familiar that's not an accident. It's identical in design to our own story cycle, because, of course, they are fundamentally the same – they are cycles of knowledge accretion. We exist, we ask a question that leads to research (that's the inciting incident), then, through a chain of cause and effect, we produce a hypothesis (which coincides with the end of a story's second act), which we put to the test (that's the midpoint in the third act). The second half of the cycle is the analysis of that test – how does it stand up? What might we need to adjust to make it objectively true? Was the initial conjecture correct, or should we abandon, accept or modify it? Does it stand up to full-frontal logical assault (the fourth-act crisis)? If so, we take it on board and change our belief system (the climax and resolution).

Story shape mirrors the scientific method because it's effectively the same thing. It seems we enact that process millions of times a minute, and it's that sense-perception that builds fractally into a story. It seems incredible that one single unit of structure – something followed by its opposite – can apply both to a joke and to 300 episodes of *ER*, but that simple digital binary fuels everything. Each scene, each act, each episode and each series – every story is built from that simple question and answer.

You cannot fail to undergo this process now – not just with this book, but with any new stimulus. And that's why stories are the shape they are. That's why Russell T. Davies can write perfect structure while hating structure, because it's innate. Story shape is just the symmetrical, ordered consolidation of a question and answer, a product of the way the brain works when confronted with the unknown. And that, too, is one key reason Russell is such a strong writer: in every one of his works the clarity of, and emotion derived from, his question and answer form a rock-hard spine on which his fantastical elaborations are built.

The five stages of grief – denial, anger, bargaining, depression and acceptance – entwine themselves around this spine, adding immeasurably to its power. The characters who don't want to hear the answer, who don't want to learn (the Lightning McQueens of this world), give us the greatest conflict, the critical mass that unleashes the true power of the story, because their journey is harder. They don't want to but they must confront their biggest fear. It's from that tussle that the story shape charted throughout this book will emerge – not from a three-act diagram.

Equilibrium, disruption, recognition of the disruption, repair of the disruption, new equilibrium. Or in its most heartbreaking, tragic form:

> Our baby boy got sick.
> We went to a lot of doctors, trying to find out
> what was wrong with him.
> We found out what it was.

It was very, very bad.
It got worse.
And then he died.
And now he's dead.[25]

Transformation – change – is derived from acquiring knowledge, from learning. We distil that learning to its essence and then structure it so the tribe will pass it on. The dictionaries in our introduction all struggled to define a story. So what *is* a story?

In *Into the Woods*, I outlined the different explanations given for story's function. There's the societal reason (stories contain a genetic pattern), the information-retrieval reason (we store memories as narrative for ease of recall), the rehearsal reason (we can practise in fiction responses for the real world), the healing reason (it's possible to feed any flaw into the archetype and resolve it), the procreation reason (the sheer volume of stories that end in sexual union) and the psychological reason (stories show us how to achieve psychological balance in a brutal world). All of these have some truth, but there's a better definition – one that encompasses them all.

Stories are a unit of knowledge, weaponized for maximum viral transmission.

But a perfect story? The most powerful story? What is *that*?

A Trip to the Moon, Revisited

What Gives Stories True Power?

She's stuck on a stationary train. Its destination is King's Cross, where her parents first met. It's 1990, and her forty-five-year-old mother is now desperately ill. At the end of the year she will pass away. What is it about this moment that causes Joanne Rowling to create an idea that would transform the very notion of what a story could achieve?

Harry Potter and *Superman* are in essence the same story, and the parallels in their creation are striking too. When they created *Superman*, Joe Seigal and Jerry Shuster needed someone to safeguard them from the insidious antisemitism metastasizing around Europe. And *Harry Potter*? What was the enemy there?

Rowling had a difficult relationship with her father, who once told her he would have preferred a son. She was in a long-distance relationship that would soon fall apart, and facing up to the hideous reality of losing, from a deeply distressing illness, the person she most loved. It's not hard to imagine how a surely terrified twenty-five-year-old, faced with the worst crisis any child can go through, might create a hero that could vanquish the thing she most feared. Harry Potter will battle Voldemort: 'Death, thou shalt die.'[1]

Over the five years she took to write *Harry Potter and the Philosopher's Stone*, Rowling's own life changed dramatically. She had a child, fled her violent husband and found shelter with her sister in Scotland. Her own story contains uncanny parallels with *Harry Potter* – a beleaguered protagonist finds strength against impossible

odds and, propelled only by faith, quietly builds a complex and elaborate universe for their own protection.

And then, publication. It is impossible, really, to grasp the scale of the success of *Harry Potter*. Six hundred million copies have been bought in eighty-five languages, earning $7.7 billion in revenue, with the eight films earning $7.7 billion as well. This makes it the best-selling book series in history – a remarkable achievement for a commercial series that has been on sale for less than thirty years, competing in an open market without the institutional backing enjoyed by the Bible or the Qur'an, or politically-mandated volumes like the Quotations from Mao Tse-Tung.* Most new books sell less than 3,000 copies on average, and the median wage of a UK author is £7,000 per annum.[2] Even giant hits like *The Godfather* novels, films and assorted spin-offs have, at around $1 billion, earned barely a fifteenth of *Harry Potter*'s worth.[3] Stories don't do this. The success of *Harry Potter* is utterly abnormal.

If sales and reach are a metric, *Harry Potter* comes close to a perfect story. So, what is the secret of its phenomenal power?

This book has, in its brief tours of politics, religion and dissonance, outlined many of them. The most powerful stories will seek symmetry, if not chiasmus. The protagonist will represent their core audience, the antagonist their biggest anxiety. They will resonate with their time, and ideally beyond it too. They will embody a simple question, one that will catalyse an argument, and demonstrate a clear but utter transformation for the protagonists, who will achieve that state by confronting and embracing their biggest fears. They will incite as much emotion in their audiences as possible, the continual reversals effectively drugging them to a point where addiction is vastly preferable to the withdrawal that might come from abandoning their tales. They will tap into the author's deepest fantasies, the protagonist an alter ego representing what they most deeply (and, ideally, improbably) desire to be. The audience's love for the central characters will trigger a kind of ecstasy in their company, alongside an abiding complicity in the righteous violence

* As of 2025, and increasing exponentially as I write.

that they – we – exact on their foes. And the stories will, within their own worlds, be plausible – they will appear to be logical, even if on close analysis that logic is revealed to be false.

Such stories may be boiled down to one simple, clear idea, which will assume a binary form. The good will be good, the bad will be evil, the two will be opposites and the protagonists will achieve their tangible goals (symbolic of something greater) by defeating their antagonists and taking their power for themselves. Underlying this will be a simple journey there/journey back structure, centred around a midpoint. This element will embody a truth or hypothesis – a provisional answer to the question posed by the inciting incident – which overtly or subtextually will give birth to the theme. It will also be an incarnation of that which is lacking in the protagonist's life, ideally the thing they most fear.

The stories will have sufficient critical mass to sustain their duration and an irrepressible forward momentum, steering well clear of characters arguing about their pasts or introducing long-lost relatives not present in the initial exposition, and they will end when the initial dramatic questions are resolved. Whatever their time scheme, they will be propelled either thematically or narratively by causal logic – each scene happening because of the previous one, or else providing a deliberate obstacle to that causal flow. There will be no repetition without purpose. And the form, however complex, will serve not to show off the author's intelligence, but solely to weaponize and reflect the underlying theme. All this will occur fractally: in individual chapters or episodes, as well as across the whole work.

Character change will be provoked by new knowledge, which will arrive unwanted and then be processed as a trauma that must be healed. The protagonists will grapple with denial, anger, bargaining, depression and acceptance, either overtly or quietly, as they inch their way towards the lessons they learn. The first half of the stories will argue towards and for those lessons, the second half virulently against, with the protagonist having to choose between the two binaries of the central argument around two-thirds of the way through. Do they revert to their old self? That might be safer, but the

journey has told them their original identity is built on a falsehood. They will instead choose a new self, one that embodies the opposite of what they once were. In doing so the old self will die, and a rebirth – transcendent, for character, reader or ideally both – will occur. They – we – will be born again and live to pass on the tale.

The finished article will transport you across a flood of emotion to a place initially unrecognizable, having had a kind of euphoric experience outside time. *Mad Max* director George Miller articulated what should happen when you combine all the elements above:

> What you are trying to accomplish is to have the audience lean into the film [. . .] The moment you get a repetition or redundancy – that is a signal to the audience that, O.K, you can back off. I call it falling off the wave. I used to surf, living in Sydney, so I know that if you stay on the wave it will take you all the way to the beach. You say, 'I got from here to there and I don't know how it happened.'[4]

For Miller, one of the most technically accomplished directors of our time, every great story is a surf ride. The viewer, mounted by empathy on a surfboard, is carried from sea to shore on waves generated by the manipulation of emotion.* Such seas will be tempestuous – a storm formed from the battle between old knowledge and new. The ride will be one long dreamscape that for a brief moment in time – 'I don't know how it happened' – will allow the viewer to ride those waves, survive against all odds and thus transcend.

But following the above lessons will not, by itself, produce another *Harry Potter* or any story of equivalent power. If it did, we would be drowning in billion-selling sagas. That hasn't stopped people trying to codify recipes for success, however, and to a very real extent we now live and work in a world happy to provide us with formulas to follow. Every Hallmark movie has a template, many Netflix documentaries too. The argument this engenders, between formula and originality (between Syd Field and Alan Plater), lies at the heart of why I first

* Miller takes the rule of no repetition right down to single shots. All are micro-aggressions against attention – invitations to pick up your phone.

became obsessed with the study of narrative. This book, like *Into the Woods*, grew out of the question that inevitably arises here: does following prescribed templates diminish the power of any work?

In a world where money is everything, where failure leads to job loss, it's understandable to talk of format and convention, and for writers and broadcasters to attempt to replicate past successes. And now of course there are newer temptations – how appealing it is to reach out and grasp the friendly, welcoming hand of AI. That may be a route to short-term economic well-being, but it's not where art comes from. All this knowledge of story should fascinate, but it should also make us wary. If you're just filling up a grid, nothing more, there's no spirit, no *life*.

When, in 1968, Picasso said, 'Computers are useless – they can only give you answers,' he was arguing that the only important thing in the creation of art is the question and the active battle to resolve it. A true artist must begin by lying down, as W. B. Yeats put it, 'where all the ladders start / In the foul rag and bone shop of the heart.'[5] 'ChatGPT rejects any notions of creative struggle,' wrote the singer Nick Cave, explaining why formulas and artificial intelligence can never produce work of real value. Cave points out how, in the Bible's creation myth, God created the world in six days and rested on the seventh.

> The day of rest is significant because it suggests that the creation required a certain effort on God's part, that some form of artistic struggle had taken place. This struggle is the validating impulse that gives God's world its intrinsic meaning. The world becomes more than just an object full of other objects, rather it is imbued with the vital spirit, the pneuma, of its creator.[6]

That tussle seems essential to all great art. True power doesn't come from imitation; it comes from struggling, honestly, clearly and brutally, with not just your character's dilemma, but their soul. And yours. Out of that struggle the story (and a shape remarkably similar to that prescribed above) will emerge. That shape isn't a formula, it's a tool with which to perfect craft. And, as long as you remember first

principles – the 'why' and that the struggle must come first – that tool can be your friend.[7] Knowledge should not be feared but sifted, to parse truth from imitation.

So what of the struggle? What of its final product? What is it that can transform works that are perfectly structured but dead into lethal weapons – stories that bewitch the world's heart?

In one of the very few long-form profiles she's submitted too, J. K. Rowling traced the relationship between *Harry Potter* and her first book for adults, *The Casual Vacancy*. 'I think there *is* a through-line . . . Mortality, morality, the two things that I obsess about.' In the same interview she clarified the latter book's meaning:

> [. . .] it's death! The casual vacancy, the casualness with which death comes down. You expect a fanfare, you expect some sort of pathos or grandeur to it. And, you know, the first big death I ever suffered was my mother's, and it was *that* that was so shocking: just gone.[8]

Rowling's mother was diagnosed with multiple sclerosis when she was thirty-five, and Rowling was just fifteen. Ten years later, Rowling conceived *Harry Potter* just as her mother entered the terminal stage of her illness, and Harry was born the same year, 1990, as she passed away. A moment that comes to us all came to Rowling far too early; an overwhelming trauma triggered a profound response, one that holds the key to the work's success.

Despite the diversity of their systems, rituals and structures of belief, all five major religions have one core creed at their heart – immortality. They all make one solemn promise: that death is not the end. To believe is to make peace with death, to remove its crippling power. From the earliest archaeological discoveries of ancient tombs to the magnificent spectacle of the pyramids, the burial of the dead, equipped for a life beyond, tells us so much about our greatest terror. As sociology professors John B. Williams and Calvin Moore wrote in 'The Universal Fear of Death and the Cultural Response':

The Greeks used reason and philosophy to deal with the fear of death. Early Jews incorporated a variety of practices into their religious beliefs surrounding cleanliness and purity to stave off unwanted death. Christians of the Middle Ages gave themselves over to the reality of death by associating the death of the body with the freeing of the spirit to spend eternal life with God. Religious systems of the Eastern world evolved ideas of continual rebirth and the attainment of freedom from the cycle of rebirth through enlightenment or nirvana. In each case, the symbolic system accords death a place in society that offers meaning to the individual and prevents the society from lapsing into complete nihilism in the face of death.[9]

Every society seeks some kind of belief system that portrays 'death not as an end, but as a transition to another world that is still very much connected to the earthly one'.[10] Without that we are exposed to Jean-Paul Sartre's nausea, the sickness that comes from glimpsing the universe in all its terror. To annul that feeling, Sartre implies, we lash the world with story.[11] Religion becomes the narrative that tames that far greater nausea, that makes it safe. So it is with *Harry Potter*.

In the cemetery at Godric's Hollow, Harry inspects the inscriptions on both his parents' gravestones and on Dumbledore's family tomb. It is the last book in the series, *The Deathly Hallows*, and Harry is coming to terms with his final destiny. 'Where your treasure is, your heart will be also,' from Matthew 6:21, is written on the Dumbledore tomb, while his parents' gravestone quotes from 1 Corinthians: 'And the last enemy that shall be destroyed is death.' 'I think those two particular quotations he finds on the tombstones at Godric's Hollow,' Rowling has said, 'they sum up – they almost epitomize the whole series.'[12]

A young, neglected child receives a prophecy and must come face to face with his destiny – that he is the only hope for humankind. He must flee his birthplace and build a community of disciples to battle against the forces of apostasy. Part boy, part god – Harry will

realize that he can only set his people free by sacrificing his life for others. Even on a superficial level, the echoes with the story of Jesus are uncannily clear. He is sent to save his world from darkness and, though reluctant, finds the strength within to do that, to die, then come back and finish his task.

It's not just the bare bones of the narrative, it is its very substance. There is an omniscient God, Dumbledore, a Devil, Voldemort, and every character must navigate the pull between the two. It is shrouded in religious imagery from start to finish. Potter's mother is called Lily, a symbol of the Virgin in medieval lore. Stags symbolize the Potter family as they once stood for Christ. There are descents into hell and the crushing of serpents' heads. Harry walks along a road and stumbles, not unlike Christ on the Via Dolorosa, on the way to his death. Even the name of King's Cross – the station where the portal for entry requires *belief* – is a synonym for Calvary and cru-cifixion. Harry asks Hermione if there is anything that can heal an evil-damaged soul, to which she replies 'Remorse.' And, at the book's end, Harry learns the lessons which his dead mother passes on: that selfless love will triumph over vanity, and good will prevail.

Rowling has never spelled out the religious nature of the work but came close to admitting its huge biblical influence in an inter-view with the *Vancouver Sun* in 2000. Asked if she herself was a believer she said:

> Yes, I am. Which seems to offend the religious right far worse than if I said I thought there was no God. Every time I've been asked if I believe in God, I've said yes, because I do, but no one ever really has gone any more deeply into it than that, and I have to say that does suit me, because if I talk too freely about that I think the intel-ligent reader, whether 10 or 60, will be able to guess what's coming in the books.[13]

In other words, it's the same story. If you knew the Christian gospels, you knew exactly how *Harry Potter* would end. It is a pro-foundly religious work. As, indeed, is the other world-straddling narrative behemoth that towers over the storytelling world.

'There was no father. I carried him, I gave birth, I raised him. I can't explain what happened,' says Anakin Skywalker's mother in *The Phantom Menace*. Like Jesus, he is the product of a virgin birth. Like Harry Potter, he is also the 'chosen one', who it is prophesied will bring balance back to the Force.

And the Force?

The Force, according to Obi-Wan, is 'what gives a Jedi his power . . . an energy field created by all living things, it surrounds us and penetrates us. It binds the galaxy together.'[14] 'I don't see *Star Wars* as profoundly religious,' George Lucas has said, but if the Force is what gives us meaning, purpose and power, if the Force is what binds the galaxy together, then, whether intentional or otherwise, he's talking about God.

Star Wars is framed by the battle between the Jedi and the Sith, a religious war in which good and evil battle for supremacy, and in which the combatants must decide which side they are on. The capacity for good and evil exists within each individual – which will they choose? That's the story that binds every single character in the films together, all of whom are soaking in a profoundly religious marninade. It's a concoction part Daoist (the Force is balancing yin and yang), part Christian (the farm boy who brought down Goliath), part Islamic (Alderaan appears to be derived from Alderamin – the name of a real star (Alpha Cephei) in the Cepheus constellation), part Jewish (the opening scroll of the first film is pretty much a synopsis of the battle which Hanukkah commemorates).[15] Lucas's first draft didn't begin with 'A long time ago in a galaxy far, far away . . .' It got straight to the heart of the matter:

> . . . And in the time of greatest despair there shall come a saviour, and he shall be known as: THE SON OF THE SUNS.
> – Journal of the Whills, 3:127[16]

If you shaded the Venn diagram where all religions intersect – salvation, resurrection, the afterlife and triumph over death – you'd find the world of *Star Wars* embedded there.[17] The religiosity is all

held together by one key concept. In the midpoint of the first trilogy, deep in the swamp-like woods of Dagobah, Luke and Yoda meet so that the secrets of the Force can be passed on. When Luke tells him, 'I don't believe it,' Yoda replies: 'That is why you fail.'

Lucas, in his quest for simplicity, distils the tenets of the five major religions into one. J. K. Rowling does something less explicit but similar with *Harry Potter*. Just as Ben tells Luke, as he blinds his eyes with a visor, all that's required is *faith*.

Both of these sagas found audiences on a scale previously unknown. Among them, people who were not so much fans as believers.

'I think I had not such a great childhood, and I think a kid with not such a great childhood actually escaped to something else in a book.'

'Harry Potter has been a kind of like beacon of hope in a lot of times in my life.'[18]

'For me, Harry Potter is more than just a book. It is my way of life.'

'It means love. It means friendship. It means triumph of good over evil. It means the world to me. Harry Potter is my life.'

'That one story changed millions of lives like mine. That one story inspired millions of people in various fields. That one story, will always remain in our hearts.'

'I thought I was useless, and I wanted to kill myself until I read Harry Potter. When I read the books, I was taken away into a magical world with new adventures at every corner. Harry, Ron, and Hermione became my friends. Since I was ten I have read each book 15 times and I am only 15. Harry Potter just means so much to me, it is part of my life and part of my heart.'[19]

From fan conventions to fan forums, it's not hard to be taken aback by this extraordinary level of devotion. They speak not of a

book but of an *experience* that has reached down, touched their very core and healed or reshaped their lives. Experience is the key word – these readers *become* the protagonist, they fight the fight, they feel and talk like they have transcended their old selves, then afterwards create rituals to celebrate, honour and reconstruct that feeling. It's the same with *Star Wars*.[20] In fact, if you list the epic sagas that have dominated the Western canon – *The Lord of the Rings* and *The Hobbit*, *The Chronicles of Narnia*, *His Dark Materials*, *Superman*, *The Avengers* – all of them have in their time provoked a similar response.[21] They are fundamentally religious epics, each with legions of disciples for whom the art provides a lodestar.[22]

So many works that inspire such devotion, from *Thelma & Louise* to *Jack Reacher*, have a religious underbelly.[23] They may not spell it out – like the best art, they invite you to *feel* it. Purpose, meaning, place; comfort, reassurance and a balm against one's biggest fears – all are derived from the pages of these works.

It would be easy to assume from this that any kind of 'perfect' story is one derived from or colonizing the universal elements of the five great religions. There's some truth in that, but it's a category error. Instead look at this description again:

> *Star Wars* is framed by the battle between the Jedi and the Sith, a religious war in which good and evil battle for supremacy, and in which the combatants must decide which side they are on. The capacity for good and evil exists within each individual – which will they choose?

This isn't just *Star Wars* – it's *all* stories.

Protagonist and antagonist. Hero and Villain. Both derived from the root *agon*, meaning 'conflict'. Story, by definition, is protagonist and antagonist in conflict. Religion, with its devils and angels, is identical. And it's this that's key: it's not so much that successful stories seek a religious architecture, but that *all* stories have a religious architecture. Or, to put it another way, religious architecture *is* story architecture.

In every story a protagonist ventures forth into a world where, to

reach their goal, they must navigate treacherous terrain and separate whatever is 'good' from whatever is 'bad'. In doing so, after a road of trials, they reach either a state of transcendence (the hero's journey) or damnation (its dark inversion). That, in a nutshell, is the story offered us by religion too.

This doesn't mean all stories attain the power of the overtly religious, but the ones that most blatantly offer meaning, purpose, community and ritual do – perhaps because their authors (particularly those interestingly charged with trauma) are able to burnish these structures to transcendent ends. They write as if seeking a world – as *Harry Potter* does, as *Star Wars* does, as all world-conquering franchises do – where death is not the end. Why are these tales the most successful? Because they tap into the one need shared by all humanity. The more the 'bad' in any story is equated with death, the more powerful any story tends to be, because what unites humanity is the need to overcome death. The most powerful stories, novels and speeches are those negating mortality. What are Roosevelt's Pearl Harbor and Reagan's *Challenger* speeches but paeans to triumph over death? Religion is the uber-story: find the story with the need that affects the largest amount of people, and you'll find true potency.

It needn't be death, of course; there are other fears particular to time and place that large groups of humans share. As Eric Hoffer suggested, those most susceptible to totalitarian narratives tend to be the most damaged. What wound unites your target audience? That is the place that should be prised open to have the narrative planted within. The power of any story begins there.

It is wounds, real or imagined, that bequeath us Donald Trump. Returning to him tells us something else about story power.

Narratologists argue that there is a division between actual events (*fabula*), and the way they are described (*syuzhet*). It's tempting to think a story's existence is dependent on the latter, on its recorded form. But stories take shape before and independently of being transcribed. We organize our random thoughts into an ever-shifting narrative that places us at its centre and makes sense of our world every

second of every day. Only a few of us put a small fraction of these stories down in words or forward them for publication – in fact, we're rarely conscious of the process at all. This is fundamental to understanding story's true power. Narratives may be provoked by events (*fabula*), but narratologists miss a stage in their analysis: stories take shape unconsciously long before the *syuzhet*, the writing down, occurs. These stories, because they remain invisible yet completely prescribe our lives, can offer us the same certainty as religious belief. They can also offer an equivalent power.

In 2011 Arlie Russell Hochschild went to Southern Louisiana and immersed herself in the world of Lake Charles. Predominantly poor, predominantly white and, by common standards, badly educated – it was a Tea Party stronghold. A sociologist by training (she was Professor Emeritus at the University of California, Berkeley), Hochschild wanted to understand why so many working-class Americans were seduced by a political movement that seemed not just in their worst interests but counter to so many of the values they held dear. She was welcomed affectionately (mostly) and spent five years trying to understand why Donald Trump – an eastern son of enormous wealth and privilege, a serial adulterer who had declared bankruptcy six times – held such appeal. The resulting tome, *Strangers in Their Own Land: Anger and Mourning on the American Right*, was a finalist in the National Book Awards of 2016 and one of 'Six Books to Understand Trump's Win', according to the *New York Times* the day after the election victory that was to turn politics upside down.

Hochschild liked the people she lived with, and admired their sense of community and loyalty to both family and church. Everywhere she went she found a deep respect for the corporations who had brought work to the area, and for the work itself – harsh, difficult and often dangerous labour. For many, physical effort brought them closer to God. They resented government handouts that reduced self-sufficiency and pride, finding them demeaning, and they all felt that government – liberals – were sneering at them, holding them in contempt for the values they felt had built America. They also felt that that contempt had pushed them to the bottom of the pile.

· Hochschild discerned that everyone she spoke to, whatever the specifics of the predicament, had evolved collectively a defining narrative.

'You are patiently standing in a long line leading up a hill, as in a pilgrimage. You are situated in the middle of this line, along with others who are also white, older, Christian, and predominantly male, some with college degrees, some not,' the narrative begins. These people are queuing to access the American Dream, which lies just on the other side of the mountain. 'You've waited a long time,' the story continues, 'you've worked hard, and the line is barely moving.' They are patient, they've suffered from deindistrialization, poor health, lay-offs, reduced pensions, but 'the American Dream of prosperity and security is a reward for all of this'. And then suddenly:

> ... Look! You see people *cutting in line ahead of you*! You're fol-
> lowing the rules. They aren't. As they cut in, it feels like you
> are being moved back. How can they just do that? . . . Through
> affirmative action plans, pushed by the federal government, they
> are being given preference for places in colleges and universi-
> ties, apprenticeships, jobs, welfare payments, and free lunches . . .
> Women, immigrants, refugees, public sector workers – where
> will it end?[24]

Towards the end of her travels, Hochschild reads this story to the people she'd met on her journey, and every single one of them replied with a variant of 'Oh my god, that's me.'

Hochschild's narrative isn't an endorsement. She doesn't skirt over the racism, the projection and the hypocrisy at work here (most of the people she talked to were in receipt of some kind of govern-ment aid). It's a sociological exploration of how a group converts experience into feeling, and that feeling into a narrative that 'feels right' – one independent of critical thinking, of *fact*. She called this 'deep story' and it's a vital observation.

We all have them, we're just normally not conscious they are there. Stories aren't written; they emerge from unarticulated thinking, providing an invisible framework that 'feels right'. When

journalists talk of 'vibe shifts', they're really talking about these early-stage narratives, those moments when you sense an inexplicable change in the personal or political wind.[25] It's not dissimilar to social contagion. Any geographically localized outbreaks of behaviour (suicide or anorexia clusters being classic recurring examples) are really just symptoms of a narrative infection taking hold.[26] The most attractive deep stories are those that proffer the opportunity for a centring of the self, either as tragic victim or heroic dispenser of 'truth'. These are most likely to spread, fuelled by the opportunity they offer to allow the most insecure or self-loathing to become beloved. The story Hochschild identified has proved to be particularly potent, becoming a global rallying cry for the right. A direct mirror of the Exodus myth, 'Let my people go' has morphed into 'Don't let them come here.' The more you look, the more you see deep story at work. Why did vaccine denial achieve such agency in the Covid pandemic of 2020–21? Because receiving the vaccine was a passive act. Rejecting, though, was *active* – it made you the hero of the tale. Again, the story heals a wound.

It's these stories – the ones that tell us our successes are products of our own ingenuity and our failings the fault of foreign agency – that tend to percolate, washing away the sands of logic with far more attractive emotion. If these narratives coalesce with others, tribes are formed around them, and Hochschild's 'deep story' is born.

If the sense of self and opposition catalysed by this process is great enough, fidelity to such a story becomes an integral part of the believer's identity, taking on a semi-religious form. Other adherents to these beliefs are sought, and if found this new tribe will seek a leader, a priest to focus energy on embedding the narrative. They will then reward those who support it and punish the heretics who don't. Such a leader – a king, in effect – can be enough, but as the group grows and becomes more dependent on the tale, other figures of worship may be required. At this point, Émile Durkheim argued, such forces need to be represented by external objects – totems.[27] A story must be objectified, made visible. Like any good story, at its heart will be the object of desire. Once the object is

tangible, it can be worshipped and thus made sacred – a cause for which the tribe will die.

Sounds far-fetched? Individual shame begets the Tea Party, the Tea Party begets a priest – Donald Trump. Trump raises the twin issues of gun rights and abortion to totemic status, and there you have it – a deep story has created a religious force from which total identity can be derived. Trump promises healing, he promises triumph over a meaningless existence. In place of spiritual death he offers life. The story cannot now be abandoned or every individual's sense of self, their foundations, would be opened up to the sea. Instead, identity becomes a mortal struggle: the enemy again is death (the antagonist who will kill you), and death must die so the tribe might live. That's what deep story does – it buries itself inside a host body, like Ridley Scott's Alien, before slowly taking it over.

'But it's not rational!' we might cry. That's true. But no one is immune from its effects. If you interrogate the formation of your own political beliefs, was every one of them formed by empirical reasoning and careful weighing of the facts? The answer, except in a few cases, is probably not. How many of us vote the way our parents do? Or, if not, in a visceral reaction against them? The cultural commentator Ian Leslie puts it so well: 'Maybe your opinion is just a feeling about a story.'[28] Was your judgement about Woody Allen's guilt or the royal family's racism towards Meghan Markle really fact-based? Again, probably not. So why do we so quickly rush to take a position on one side or the other with such utter certainty? What can explain that?

In her book on the psychology of the fraudster, *The Confidence Game*, Maria Konnikova lays out the basic stages (or 'plays') that define the art of the con. If you want to sell someone the Eiffel Tower, an undiscovered trove of Abstract Expressionist paintings or shares in the long-lost fortune of Sir Francis Drake, then you (the con man) will move on your victim (the mark) in a very particular way. It begins with the careful selection of the victim:

1. You identify the mark. You seduce them with empathy and create a rapport: 'an emotional foundation must be laid before any scheme is proposed'. Then you hit them with 'the play', the inciting incident where you inform the mark of your problem. ('I am heir to Sir Francis Drake and I have a proposition.')

2. Next are 'the rope', 'the scheme' and 'the convincer'. You explain how with the mark's help you can gain indescribable riches. ('The riches are in this secret location – I just need your help to reach them.') At end of this stage the riches are normally revealed. The mark commits their investment.

3. Halfway through comes 'the breakdown': the midpoint test of the mark's commitment. Just as you have their full commitment, you double-cross them. ('Drake's money is gone! And ours!')

4. The mark is panicking. ('Oh god, I've lost everything.')* So now you hit them with 'the send'. ('It's all ok! I've found the money – and there's more!') Here, awash with relief, the mark recommits their fortune, and more. Now they will give up anything for the tale; unknowingly, this is their worst point.

5. You fleece them with 'the touch', the final act. ('We've both lost everything, and the police are onto us – run!') The mark is knocked for six. Sometimes this is followed by 'the blow-off' and 'the fix', in which you convince the mark to stay quiet. The best cons don't need these, however, as the mark remains utterly convinced of the validity of the con man and, however implausible, the events of the con.[29]

A con is literally classic story structure brought to life, with the mark invited to experience a hero's journey. They are captured within a narrative prison so clever that, even as it traps them, it convinces them they are free. A great con follows story structure exactly, because

* The breakdown is not dissimilar to 'the neg' in this respect.

that's what stories are. That's what deep story is, certainly: fiction so brilliant, so invisible, so flooded with emotion it destroys our intellectual capacity and convinces us it's real.

Every powerful story works in exactly this way – some more obvious than others. Why, in 1980, did the *Washington Post* publish a completely fabricated story about an eight-year-old heroin addict? Why did *Rolling Stone* accuse University of Virginia students of a made-up rape?[30] Why did canny investors give Bernie Madoff $65 billion to run a Ponzi scheme? Why did millions follow when Trump said he'd lead his people to the promised land? Because, in the rueful words of *Washington Post* editor Ben Bradlee, who swallowed whole the tale Janet Cook brought him, it was 'too good to be true'.[31]

We are *surrounded* by conspiracy theories, indeed we propagate them ourselves. When the left-wing journalist George Monbiot tweeted, in February 2023, that 'All successful but groundless conspiracy theories either originate with or land with the far right. They are fascism's rocket fuel', Monbiot was technically disseminating a conspiracy theory.[32] Such theories know no party allegiance, they bind themselves like knotweed equally around left and right.[33] Why? Because they are attempts to bring order to a chaotic world, carried out by the disempowered or aggrieved who inhabit the extreme wings of any political persuasion. Most of our beliefs, from social justice to ethno-nationalism, stem less from rational analysis than how we feel about the teller and the tale. Fuelled by good intention, it's all too easy to confuse what is true with what we *wish*.

Maria Konnikova makes this very point, and attaches a warning, echoing Ben Bradlee. Everyone has heard the saying 'If it seems too good to be true, it probably is.'[34]

Two further lessons from the con artist are worth mentioning, because they allow us to see more clearly the profound nature of belief. Every con begins with 'the put-up': the choice of victim (or audience). Ideal marks are always damaged (there's the wound again): 'Con artists love funerals and obituaries, divorces and

scandals, company layoffs and general loneliness.'[35] It's here that the great con artist goes to work:

> [. . .] learning what makes someone who she is, what she holds dear, what moves her, and what leaves her cold. After the mark is chosen, it is time to set the actual con in motion: the play, the moment when you first hook a victim and begin to gain her trust. And that is accomplished, first and foremost, through emotion.

Like any great story, a con begins by creating an emotional bond between subject and story:

> As any good confidence man will tell you, someone who is emotional is someone who is vulnerable. And so, before a single element of the actual con is laid out, before a single persuasive appeal is made, before a mark knows that someone will want something, anything at all, from him, the emotional channels are opened. And as in that first rush of romantic infatuation, we abandon our reason to follow our feeling.

The conman – the story – is drugging you. The story is telling you it loves you, that you have value, that you are important, and it is carrying something that beyond all reason you *need*.

Many confidence artists, Konnikova says, 'have it easy. We've done most of the work for them; we want to believe in what they're telling us. Their genius lies in figuring out what, precisely, it is we want, and how they can present themselves as the perfect vehicle for delivering on that desire.'[36]

Everything the con promises – transformation, knowledge, enrichment, purpose, meaning, identity and understanding – is delivered through the medium of narrative. It's no accident cons thrive (think Trump or Boris Johnson) in times of great uncertainty and chaos.[37] 'Take this chaos,' says the story or the would-be demagogue, 'and I promise to transform it into perfect order.' You work in Iraq and need an instant bomb-disposal machine?[38] Here's one I made earlier.[39]

What's common to every mark is how they are transported. How, flooded with hormones, they now *live* the story. They are not *told*, they are immersed in a parable that feels more real, more charged, than the real life that surrounds them. They are riding George Miller's wave. As logic is washed away by emotion, they may appear the same on the outside, but inside they are being transformed. It's religious. The alien has taken them over.

People like Shamima Begum may not realize it, but they are the perfect marks. Police in the UK arrested 166 people for counterterrorism offences in 2022. Thirty-two were under seventeen years old, an 11 per cent increase over the previous year.[40] Just how many were injecting their own twisted version of Superman into their veins to rid themselves of a self they despised? In times of turmoil, however fatally misguided, these are people grasping for the perfect story – red-blooded *life*. The con, ideology, and religious belief are, in their construction and effect, the same thing. They're just stories, that unseen and unbidden, envelop us at every turn. How do we protect ourselves? Critical thinking. And never trusting journalism that isn't double-sourced, or a book without a bibliography, an index and detailed notes – screenwriting books included.

Many of these stories are dangerous then, but, in the spirit of 'argument against', others provide us with an architecture that offers enormous emotional and political stability.[41]

When, in the sixth century, King Ethelbert of Kent fell under the spell of the papal envoy, Augustine of Canterbury, it began Britain's journey from a region wracked by endless tribal war, not just to a country with a shared financial and administrative system but to a kingdom united by faith. The bloodstream of England was oxygenated with a story; that story turned those streams into rivers, which flooded across tribal boundaries to form one big, holy sea. The power of God had transformed the land from a tribal backwater into a nation.

Similar stories were doing the same work elsewhere. Tribal Arabia fell to the spell of Islam, Hinduism united much of the Indian

subcontinent and the words of Zoroaster bewitched Persia with his talk of Ahura Mazda, the Lord of Wisdom. As Clark Kent becomes Superman, warring tribes become kingdoms united by a narrative. That gives a stability and power the animal kingdom can only dream about. What happens to countries, to individuals – to us – when that narrative loses its hegemony? When the people it created turn their backs on it?[42]

When the singer Nick Cave, for many years a poster-boy for rebellious chic, announced he was attending the King's coronation, he incited a storm of protest from fans who had, until then, held him dear. He was unwavering in his response. He told of how he found himself weeping when the Queen died, as her coffin was 'stripped of the crown, orb and sceptre and lowered through the floor of St. George's Chapel'. Cave was smart enough to know that it was just a box containing an inert carbon unit being lowered into a hole, yet he could also articulate how, for far more people, there was 'an inexplicable emotional attachment to the Royals', answering a need for something deeper within.

Unpalatable rationally, constitutional monarchies are significantly more stable than almost every other form of government. Removing kings and queens will end monarchy, but won't end the impulse to create it. Cave understood our need for 'the bizarre, the uncanny, the stupefyingly spectacular, the awe-inspiring'.[43] Anyone wishing to dismantle that needs to understand not the financial cost of monarchies (which can often seem disgraceful) but the cost of their absence, and what that vacuum might suck in in its wake.[44]

Absenting an old belief system doesn't destroy the need for belief. As the Soviets in the Donbass found when they replaced the crosses on their churches with red stars, they weren't ridding themselves of medieval superstition but unleashing a far more efficient tyranny in its name and in its wake.[45] They were giving new skin to an old ceremony.[46] The global explosion of gurus, preachers and teachers, of cult leaders, of 'wellness', of demagogic populists, speaks of the collapse of traditional religion but not the demise of its impulse.[47] As social media and self-serving politicians undermine any attempt

to retain a shared epistemology, darker forces rush in to sate our endless desire for peace of mind.[48]

We are all, like Arthur Koestler, 'thirsting for faith'.[49] For many, of course, the source can be anthem and flag. 'The soul of America is defined by the sacred proposition that all are created equal in the image of God,' said Joe Biden, encapsulating the idea of American Civil Religion.[50] But those more cynical about fading nation-states, who have turned their backs on traditional faith, are still looking somewhere. If the feeling we are searching for is a combination of order and awe, accompanied by an all-encompassing deeply emotional world, then you can get that from *Harry Potter* and *Star Wars*, effectively modern retellings of the Bible. And if you are a liberal humanist, then *Star Trek* offers you a version of that faith too.[51] Jediism, as Tara Isabella Burton has pointed out, is bigger than Scientology and one of the largest alternative religions in the world.[52] 'God' is a fiction. That's one way to look at this, but perhaps a better way is to invert it: fiction is God.

Look again at *My Neighbour Totoro*. At the beginning a father and his two daughters move to the country to be near their sick mother's hospital. Bang at the heart of the movie, the youngest girl goes into the woods where she finds a giant, teddy-bear-like 'monster' – Totoro – a benevolent force that calms her anxiety and lets her sleep. She goes home happy as he watches over her, hovering above the trees. But anxiety returns, the mother gets worse, and all hope is lost. The girls get separated before Totoro reappears at the crisis point of the film to help them find each other once again. And, of course, the mother gets better. Under the benevolent gaze of their spirit-family, the real family are reunited.

If a story is about characters searching for what they need, there are few better examples. Only the girls can see Totoro, and he only appears when the girls feel anxious. He appears at the midpoint to deliver the lesson, the characters lose faith before they choose to believe in him, and together, because of their faith, the world is still again.

That's not just a ridiculously archetypal (Western) story structure,

it's a profoundly religious one too. The girls call him Totoro but others might call him God, for he arrives at a time of great need and through his benevolence he vanquishes death.

The most powerful stories – they're doing God's work.

In 1670, Blaise Pascal published *Pensées*, his defence of Christianity. 'There is a God-shaped vacuum in the heart of each man,' he thundered, 'which cannot be satisfied by any created thing but only by God the Creator, made known through Jesus Christ.'

Pascal unwittingly articulated the idea that belief exists to fill a gaping chasm in the self. He called it God, but it is not literally a god – it is a story. The virgin mother and the all-powerful father – what is that but a child's projection of their idealized parents? God is simply the story we create to fill the hole inside us. It's a metaphor for what we *need*.

This vacuum it fills is essential to both the priest/guru/shaman and the con man, and the gap between those figures isn't nearly as big as the first of them might like to pretend. Most stories live in a rather drab Protestant world, inciting nods of the heads in intellectual appreciation. Fully exploited, however, somewhere between religion and the con, lies the perfect tale, ringing with a far more Catholic awe.

There is no greater example of this than the work of perhaps the greatest con man of all: Carl Thomas Patten, who, together with his wife Bebe, made a fortune from their ministry as it evolved from humble beginnings to become 'The Patten Academy for Religious Education'.

C. Thomas Patten (the 'C', he joked, stood for 'cash') boasted proudly, 'I am the only man in the world who ever made a million dollars three times over from religion.'[53] These millions were made illegally, and Patten (though not his wife) was jailed for three years on counts of fraud, embezzlement, grand theft and obtaining money under false pretences. What did he do?

In *The Confidence Game*, Maria Konnikova calls his con 'the scam of all scams':

the one that gets to the heart of why confidence games not only work but thrive the world over, no matter how many expert debunkers and vocal victims there may be. It was a scam of belief, the most profound yet simple belief we have: about the way the world works, why life is the way it is. We want to believe.[54]

He offered them God, and his followers believed.[55] Faith is the most powerful drug of all, for it is, by definition, belief in the impossible. Rationalists decry this, not realizing that the absurdity is the root of its power. Our earlier analysis of midpoints reveals that the nuclear reaction in any story occurs when opposites collide. There can be no greater opposites than truth and faith. Saying something isn't true is immensely powerful. It's perhaps no accident that Hitler and Goebbels popularized 'the big lie', for it gifts you the greatest possible form of fictional fusion.[56]

Konnikova makes the explicit link between confidence games, religions and cults, and with the aid of two cult deprogrammers, David Sullivan and Jennifer Stalvey, demonstrates how 'the techniques and basic psychology [between them all] remain the same'. At the heart of it all of course is story – a story so wonderful that you cannot help but believe.

> Every confidence artist you've met is in the exact same business, using our deep-rooted need for belief, in all its guises, to advance an agenda all their own. The screaming evangelist or the grandstanding religious leader or the cult spiritual guru is simply the most extreme incarnation: he doesn't just go after small beliefs; he attacks the core of existence. 'We're really adamant we have free will,' Stalvey said. 'But so often, that's simply not true. Everyone has a weakness. We want to connect to someone or something greater. I'm spiritually bent, and here is someone offering me a way to be a better person. The cult stuff just goes to a different level from your regular con.'[57]

'Religions,' writes Tara Isabella Burton, 'provide a framework to link the existential decisions we make in our own lives with the

overarching structure of reality.'[58] Like the rocket that ferries the curious scientists in Georges Méliès' *A Trip to the Moon*, that's what a story does. It's a vehicle that carries us to another world, allows us to hypothesize ('There be dragons!') and then return. A flawed character is fed into a mechanism that fuses inner and outer worlds together and makes them whole. Stories, very briefly, make us one with the universe. You may resist it, and many great works do, but the most powerful stories gift us what religion provides. Not only do they share the same architecture, but in one sense a story *is* God – it brings us together with the universe and makes it clear and safe and whole.[59]

Picasso once told Françoise Gilot (his fellow artist and lover) that he saw art 'as a form of magic, designed as mediator between this strange hostile world and us'. Dominic Dromgoole writes of one such instance, which took place in Philadelphia in February 1949:

> Before the evening premiere of *Death of a Salesman* in the Locust Theatre there was a matinee performance of Beethoven's Symphony No 7 across the street. The director Elia Kazan and the author, Arthur Miller, decided to take their star Lee J. Cobb to see the afternoon concert. They wanted the heroic surge and emotional swell of the music to inspire his performance that evening. As Miller puts it: 'Lee was showing signs of wearying. We sat on either side of him in a box, inviting him, as it were, to drink of the heroism of that music, to fling himself into his role without holding back.' It worked. At the end of the first performance of Miller's poetic tragedy of a man's collapse, there was a profound silence. Nobody spoke. Some people got up and put their coats on, then stood still. Some stumbled in silent circles. Then after three minutes of dazed incomprehension, someone started to clap. Then the house fell in. The applause, once detonated, carried on and on, as all wept, and newly understood their country and moment.[60]

It's David Hume's 'wild storm bringing calm'. The perfect story whips up a hurricane, then stills a need.[61]

Human beings are like becalmed boats, waiting for the wind of story to whip them into any concerted plan of action. With the right angel ahead of them, the right devil behind them, it's all too easy to create a hurricane-scale force. The blinding light, the rhapsody experienced by the new converts to communism, to Scientology and to Alcoholics Anonymous, is the end goal of the perfect story. Given the right devils and angels, however fleetingly, we can see that light – and create it too.[62]

Red Sparrow (2018) is not a great film. Jennifer Lawrence plays a Russian agent, a 'Sparrow', trained by the security services to elicit secrets using sex.* Her brutal instructor, played by Charlotte Rampling, offers her one powerful bit of advice: 'Every human being is a puzzle of *need*. You must become the missing piece, and they will tell you anything.'

You structure your story in order to answer a need. It doesn't need to be God, of course, it can be any kind of need. Alan Plater had one. Syd Field had one too, they just filled it in different ways. Religion or its substitutes contain the most powerful kind of need, however, because fear of death is the one universal trait all humans share.

In 1968, discussing with the BBC why *The Lord of the Rings* had become so insanely popular J. R. R. Tolkien said, 'If you really come down to any large story that interests people, that can hold their attention for a considerable time . . . they're always about one thing, aren't they? Death. The inevitability of death.'[63]

The perfect story? It's forged inside that god-shaped hole within us. You want to transform the world? That hole is your foundry. Cast your tale there.

* A technique literally called 'sexpionage'.

APPENDIX I

Moonlight through the Prism of Three and Five Acts

Barry Jenkins' Oscar-winning *Moonlight* presents itself in classic three-act shape. Three actors play the protagonist, Chiron (who has three different names), at three different stages in his life. The film poster is a portmanteau assembly of Chiron's face made up of the three different cast members.

However, a closer analysis reveals that under the 'flesh' of the three acts, lies a more intriguing five-act structure, one that helps reveals our classic archetypal shape. By showing the two together, I hope it serves to illustrate both the relationship between the ostensibly different structures, and how the paradigm can help understand classic story shape.

Here is the traditional three-act shape:

Act One: Little
Chiron, a shy and withdrawn child who goes by the nickname Little, is rescued from a gang of bullies by Juan, an Afro-Cuban drug dealer.

Putting Little up for the night, he and Juan bond, and even after he returns Little to his mother Paula, they continue to hang out. This new father figure teaches Little how to swim and instils within him an important lesson: he is responsible for his own destiny.

The drug-addicted Paula continues to punish Little for her own shortcomings, while the boy struggles with his identity. Accused of being a 'faggot' by the gang that terrorise him, he asks his mentor what it means. Juan tells him there is nothing wrong with being gay.

Little then discovers Juan's source of income is through dealing drugs - his mentor is part of the problem destroying his mother. Everything he knew and trusted is broken. He has no sanctuary any more.

Act Two: Chiron

Chiron is now a teenager and his Chiron is now a teenager and his mother is working as a prostitute to support her drug habit, becoming almost impossible to live with. Chiron seeks solace with his friend Kevin, but finds himself confused by his feelings towards him. Things reach a head when they find themselves on a beach together at night. They kiss, which confuses them both. Kevin is manipulated to start bullying Chiron, who fights back, leading to his arrest.

Act Three: Black

Chiron, now an adult, bulked up and almost unrecognizable, is going by the name of Black. He is dealing drugs, both to make a living and cut himself off from others emotionally. His mother reaches out to him; she is very sick and in rehab, and eventually he finds himself able to reconnect with her. She tells him she loves him, but he cannot find the words to say it in return.

This, in turn, leads him back to Kevin, whom he seeks out in Miami. Their reunion is difficult and uncomfortable. Chiron learns that Kevin has had a child with an ex-girlfriend and has found peace of mind by becoming a father. Chiron forces himself to be honest and talks of his drug dealing. Kevin walks away, saying, 'That's ain't you.'

So who is Chiron?

Kevin cooks him dinner, and Chiron tells him that he's never been intimate with anyone since the night on the beach. Kevin hugs him, and Chiron is finally able to surmount the trauma of his past. Both men overcome their defence mechanisms to – in the end – find true love.

It's a simple, clear and powerful story, which the structure amplifies and drives home. However, if you apply the five-act paradigm to the film, it reveals a deeper, perhaps more helpful underlying sense of how classic story structure really works. The paradigm is this:

1. Set up and call to action
2. Things go well, initial objective achieved
3. Things start to go wrong as forces of antagonism increase
4. Things go really badly wrong, precipitating crisis
5. Matters resolved for good or ill.

Using this paradigm, the story breaks down like this:

Act One

Chiron, a shy and withdrawn child who goes by the nickname Little, is rescued from a gang of bullies by Juan, an Afro-Cuban drug dealer. Putting Little up for the night, Juan and he form a bond, and so when Juan returns Little to his mother, Paula, they continue to hang out. This new father figure teaches Little how to swim and instills within him an important lesson: he is responsible for his own destiny.

The first act is around 21 minutes long, and states the theme that his destiny is his own.

Act Two

The drug-addicted Paula continues to punish Little for her own shortcomings, while the boy struggles with his identity. Accused

of being a 'faggot' by the gang that terrorise him, he asks his mentor what it means. Juan tells him there is nothing wrong with being gay.

Little then discovers Juan's source of income is through dealing drugs – his mentor is part of the problem destroying his mother. Everything he knew and trusted is broken. He has no sanctuary any more.

The second act is around 15 minutes.

Act Three

Chiron is now a teenager, and his mother is working as a prostitute to support her drug habit, becoming almost impossible to live with. Chiron seeks solace with his friend Kevin but finds himself confused by his feelings towards him. Things reach a head when they find themselves on a beach together at night. They kiss, which confuses them both.

The kiss, which comes exactly 55 minutes into a 110-minute movie, is the midpoint – the lesson Chiron needs to learn about his identity.

Kevin is manipulated to start bullying Chiron, who fights back, leading to his arrest.

The third act is 30 minutes in total.

Act Four

Chiron, now Black, reconnects with his mother. She tells him she loves him, but he cannot find the words to say it in return. This, in turn, leads him back to Kevin, whom he seeks out in Miami. Their reunion is difficult and uncomfortable. Chiron learns that Kevin has had a child with an ex-girlfriend and has found peace of mind by becoming a father. Chiron forces himself to be honest and talks of his drug dealing. Kevin walks away, saying, 'That's ain't you.' So who is Chiron?

The fourth act is around 24 minutes. Note the classic 'worst point'. This crisis is of course the core dilemma of the work.

Act Five

Kevin cooks him dinner, and Chiron tells him that he's never been intimate with anyone since the night on the beach. Kevin hugs him, and Chiron is finally able to surmount the trauma of his past. Both men overcome their defence mechanisms to – in the end – find true love.

The final act is around 20 minutes. The ending of course was foreshadowed at the midpoint. Chiron was told then who he was – he just wasn't ready to accept it.

APPENDIX II

Chiasmus and the Roadmap of Change

The direct relationship between chiasmus and the Roadmap of Change can be clearly seen by looking at *Terminator 2* by James Cameron and William Wisher.

Note that this Roadmap of Change is showing John's character path, but you could easily replace it with Sarah's or the Terminator's. Every character learns and changes.

CHIASMUS	ROAD MAP OF CHANGE
ACT ONE	
A. The two Terminators seek John.	NO AWARENESS
B. The Terminator rescues John from the T1000.	LIMITED AWARENESS
C. The Terminator tells John he is there to protect him. (Inciting Incident)	AWARENESS
ACT TWO	
D. John learns the T-1000 has murdered his foster parents.	RELUCTANCE TO CHANGE
E. John sees Terminator save Sarah from the T-1000 – a clear and present danger.	OVERCOMING RELUCTANCE TO CHANGE
F. Together they escape from the mental institution.	COMMITMENT TO CHANGE
ACT THREE	
G. John cries – Sarah doesn't comfort him.	EXPERIMENTING WITH CHANGE
H. MIDPOINT – JOHN AND THE TERMINATOR FORM POWERFUL BOND	BIG CHANGE
G. Sarah cries – John comforts her.	EXPERIMENTING POST CHANGE
ACT FOUR	
F. Sarah, John and the Terminator break into Cyberdyne with Miles Dyson.	CONSEQUENCES OF CHANGE
E. The T-1000 returns – a clear and present danger.	GROWING UNCERTAINTY ABOUT CHANGE
D. Miles sacrifices himself to save them from the T-1000. (Crisis Point)	FINAL CHOICE
ACT FIVE	
C. The Terminator tells John and Sarah, 'Stay here. I'll be back'.	REDEDICATION TO CHANGE
B. John hides from the T-1000.	FINAL ATTEMPT TO CHANGE (CLIMAX)
A. John understands why the Terminator must die.	MASTERY (RESOLUTION)

APPENDIX III

Harry Potter Chiasmus

THE PHILOSOPHER'S STONE	DEATHLY HALLOWS
Hagrid arrives on Privet Drive on motorbike with baby Harry	Hagrid departs for Privet Drive on motorbike with adult Harry
Harry's heart is broken when he sees his parents in the Mirror of Erised	Harry's heart is strengthened when he sees his parents using the Resurrection Stone
Harry locates the Philosopher's Stone	Harry locates the Resurrection Stone
Harry finds out Severus Snape is evil – an ally of Voldemort	Harry finds out Severus Snape is good – an ally of Dumbledore
Harry confronts weak form of Voldemort at Hogwarts	Harry confronts the most powerful form of Voldemort at Hogwarts

CHAMBER OF SECRETS	HALF-BLOOD PRINCE
Horcruxes first introduced	Horcruxes fully explained
First glimpse of Tom Riddle's past	Tom Riddle's complete backstory explained
Shy, scared Ginny becomes victim of Tom's diary	Confident, direct Ginny becomes Harry's girlfriend
Malfoy is innocent of opening the chamber – jeopardizing our heroes	Malfoy is guilty of plotting to kill Dumbledore – jeopardizing our heroes
Basilisk is killed by Harry, atop the statue of Salazar Slytherin	Dumbledore is killed by Snape atop the Astronomy Tower

PRISONER OF AZKABAN	ORDER OF THE PHOENIX
Sirius Black is introduced – a threat	Sirius Black dies – a mentor
Dementors guard Hogwarts	Dementors join Voldemort
Harry learns Patronus Charm	Harry teaches Patronus Charm to Dumbledore's army
Harry flies on a Hippogriff to save Sirius Black	Harry flies on a Thestral to save Sirius Black
Sirius Black saved with Time-Turner	Sirius dies in the Department of Mysteries

THE GOBLET OF FIRE	
Harry's life at Dursleys/Introduction of Triwizard Tournament	Return to Dursleys/Aftermath of Tournament
First Triwizard task – Battle with Dragons – (Upbeat) Intimations of return	Final task – Battle with Voldemort – (Scary) Ministry in denial of return
VOLDEMORT'S RETURN	

This is a highly simplified version of the narrative, and there are far more detailed parallels if you care to look. Interestingly, when Harry and Voldemort battle at the midpoint of the saga, their clash of wands causes a *priori incantatem* spell, releasing imprints of Voldemort's previous murders into the world. Past magic is thus repeated in reverse order – the saga double backs on itself. It's hard to imagine Rowling wasn't aware of this very clever conceit, which mirrors the structure exactly.

APPENDIX IV

Non-Western Narrative Forms

The assumption that different cultures employ completely different narrative structures is itself the product of narrative thinking. It's easy to believe that, because we in the West watch Marvel movies that foreground a hero's journey, all Western tales must be plot-driven, linear, conflict dependent, masculine, thrusting, phallic and with a built-in sense of domination. One piece of incorrect deduction leads to the next in a chain of cause and effect that quickly leaves any actual evidence behind.

If the hero's journey is a lazy stereotype of Western structure, those that surround non-Western narratives are often equally simplistic, occasionally tipping into exoticism. Other cultures, we are told, prioritize theme, communal experience and philosophical exploration. They are meditative, conflict-free and (the worst stereotype) 'Zen'. How true is this? By examining many of the narrative forms from countries that appear unimpressed with the hero's journey, it's possible to get a clear idea.

It would take a whole book to explore in detail the different kinds of narrative that diverse cultures bring to the table. In what follows I've tried to provide a reasonably global overview. Its brevity will mean that in many respects it's wanting, but I hope it's possible to see from this that all these story forms have far more in common than might first appear.

Japanese Ma (間)

Outside Kishōtenketsu, the most commonly referenced type of Japanese narrative is *Ma*, or storytelling using negative space. What does that mean? Hayao Miyazaki, founder of Studio Ghibli, explains:

> We have a word for that in Japanese. It's called *ma*. Emptiness. It's there intentionally. [claps his hands] The time in between my clapping is *ma*. If you just have non-stop action with no breathing space at all, it's just busyness, but if you take a moment, then the tension building in the film can grow into a wider dimension. If you just have constant tension at 80 degrees all the time you just get numb.[1]

It's an often misunderstood quote. Absence isn't nothing happening, it's *something else* happening. If it adds, it's narrative; it's just not, figurately and literally, *Fast and Furious*. It's fairly common to see this technique used in the West and Charlotte Wells' *Aftersun* (2022) is a good example. In essence, it's no different from subtext: *Ma* allows audiences to infer. The films of Studio Ghibli are at heart structurally utterly conventional (see Chapter 9), proving it's not the shape but how the shape is raised and realized from the material that counts.

Chinese Epic Narrative

When I was on the cusp of adolescence there was one programme that transfixed everyone in my school. It was called *Monkey (Saiyūki)*, and it ran from 1978 to 1980. A Japanese TV series that became particularly famous in English-speaking countries through its BBC English-language version, it was an adaptation of perhaps the most famous example of Chinese epic narrative: *Journey to the West* (西游记).

The popularity of *Monkey* reveals, perhaps, how close it is in form to much of modern TV today. Each episode followed the eponymous

hero and his friends as they faced a challenge, test or monster of the week, with each episode forming a stage on the journey to collect Buddhist scriptures (their goal). It's a very early example of series hybrid form, and a pattern instantly recognizable to viewers of *Game of Thrones* or Ron Moore's epic remake of *Battlestar Galactica*. There's a fractal structure, with each episode following a common pattern:

1. The group encounters a new location or situation
2. A supernatural threat emerges (often a demon wanting to eat Xuanzang)
3. Initial attempts to solve the problem fail
4. Our heroes must identify the true nature of the threat
5. Resolution often requires help from Buddhist or Taoist deities, and when achieved our gang continue their journey, often with moral lesson learned

Water Margin (水浒传) is another classic of Chinese epic form. Developed orally then codified as text in the fourteenth century, in content and form it's not dissimilar to *The Mahābhārata*. Like that work, there are multiple versions, varying in length from 100 to 120 chapters. This was another example of a cult BBC hit in the 1970s, showing how readily these stories were welcomed and assimilated by the West (and how universal they are).

Journey to the West and *Water Margin* are two of what are commonly referred to as China's Four Great Classical Novels (四大名著), alongside *Romance of the Three Kingdoms* and *Dream of the Red Chamber*. All of them would make fabulous epic adaptations.

Other East Asian Narratives

Two narrative forms are often cited as alternatives to Western structure. Chinese Wuxia narratives, which explore the nature of heroism through individual moral development, and Japanese Zen stories.

Wuxia narratives have a number of key elements in common: Setting is key. The stories normally take place in the *jianghu* (江湖) or

'rivers and lakes', a parallel world. Martial-arts schools, secret societies and wandering heroes populate this space, operating with their own system of justice and honour, distinct from imperial law. Here, martial arts are treated as paths to both physical and spiritual perfection.

Several plots recur regularly – training arcs, revenge over generations, duels, political intrigue – and a very strong sense of honour and morality permeates the work. (You can see this influence at play in *Kung Fu Panda*).

Romance often plays a key part. A classic example is *The Legend of the Condor Heroes*, written for the *Hong Kong Commercial Daily* in 1959 and adapted five times for television or film.

> A son of the Song Dynasty, Guo Jing, is born after his father's murder by Jin forces. Raised among the Mongols under Genghis Khan's protection and trained by the 'Seven Freaks of Jiangnan', he grows from a seemingly slow-witted but honest youth into a formidable martial artist. His journey becomes intertwined with Huang Rong, the brilliant daughter of a martial-arts master, as they face rivalry with Yang Kang (the son of his father's best friend who chose a darker path), complex martial-arts sect politics and, ultimately, Guo Jing's conflicting loyalties between the Mongols who raised him and his native Song Dynasty.

The hero's journey structure is clearly visible – it's more Western than a Western. The classic spine this and almost all Wuxia tales follow is incredibly familiar too:

1. Initial training or revelation of martial talent
2. Entering the jianghu and facing early challenges
3. Discovering deeper mysteries or conflicts
4. Personal growth through trials and setbacks
5. Final confrontation that tests both martial skill and character

The most familiar examples to Western audiences are probably Ang Lee's *Crouching Tiger, Hidden Dragon*, the breakthrough hit that

brought Wuxia to Western audiences, and Zhang Yimou's *Hero* and *House of Flying Daggers*. All are masterful examples of the art.

Japanese Zen stories, also known as *koans* (公案), are superficially less conventional, being incredibly brief. Found in Zen Buddhism, they take the form of classic fables.

In *Empty Your Cup* a proud scholar visits his Zen master. As they sit, the master pours tea into the scholar's cup until it overflows. When he protests, the master explains that the scholar's mind is too full of preconceptions to receive new teachings – like the cup.

In *Not Far from Buddhahood* a monk proudly tells his master he can perform miraculous feats like writing characters from across a river. The master asks, 'Can you do these things in your sleep?' When the monk says no, the master tells him that his practice is not yet complete.

The three-act structure in each should be readily apparent. It's worth noting that Japanese Zen stories feature masters and students. The question-and-answer format that births three acts could not be clearer. They are another good illustration of how a universal shape adapts to a specific task – in this case, religious instruction.

African Oral Storytelling

African oral storytelling beautifully reveals story's primary function – preserving and transmitting history, knowledge, values and cultural identity from generation to generation for a tribe.

Central to this tradition are West-African griots, whom we mentioned in Chapter 8. They occupy a prestigious position in their communities and are highly skilled, able to recite thousands of stories, genealogies and historical accounts from memory. Creation myths – of the world, the people and of natural phenomena – are central, as are morality tales (much like Japanese Zen). The griot's role is not just to provide entertainment, but to preserve – by carrying and disseminating their cultural knowledge – the identity of their tribe.

Oral storytelling is ritualistic and participatory, involving music, call and response, physical performance and the kinds of chorus work we saw in Robleto. The direct relationship with the African American spiritual is also clear. In Chapter 8 we discussed Crick Crack, a St Lucian example of the form, that in content is not too dissimilar to the Anansi (or Ananse) tales of Ghanian origin. Anansi is a trickster hero, normally a spider, and the Anansi tales are an essential part of West African, African-American and Caribbean culture.[2] '[T]he same stories are known in many different territories, often with variants and versions,' wrote journalist Al Creighton, who did a much deeper exploration of African storytelling in the Caribbean in 2009.[3]

Is this a different way of telling stories? At heart, there's little to distinguish African oral tales from any other kind of narrative structure, apart from the ritualized elements and content – but of course those are different in every culture. What often goes unremarked on is how many African stories have bled into cultures far beyond their own. Kipling's *Just So Stories* owe them a huge debt, and the Br'er Rabbit stories many of us know from Enid Blyton have a clear line of connection to them too, back through the Uncle Remus stories of Joel Chandler Harris.[4] Br'er Rabbit stories are adored by children partly because they personify persistence against adversity, the protagonist loved for his ability to outsmart his captors. Cherokee Tar Baby stories are remarkably similar.

Many argue that these stories came from first-hand experience of slavery, and there's certainly a clear thematic connection. Control, empowerment, reaction formations – all these stories are not just similar in form, but in function too. Also key is the way the stories move and change over the years while maintaining their core messages. Like Donald Trump, they show an uncanny ability to find and match the *kairos* and *telos* of their time.

Indian Epic Narrative

The monumental Hindu epic *The Mahābhārata* is a poem consist-ing of huge events. It tells of battles, gods, demons and the lives of millions of men. It has been told and retold, rewritten, reworked and reimagined countless times since it emerged in northern India around 2,000 years ago.

To describe the work as a story is almost too simple. Yes, there's a thrilling tale at its heart, and if you love *Game of Thrones* or *The Sopranos*, *Wolf Hall* or even *Succession*, it's one you'll relish. But it's also a magnificent, sprawling collection of plots and sub-plots, myths, fables, allegories, moral instructions and religious sermons. Its cast of characters is vast; some are human, some are gods and some are both at the same time. It's almost overwhelming in its ambition, which seems to be to capture all human life and thought, and it's astonishingly entertaining to boot.

An ancient sage called Vyasa is credited as the first narrator of *The Mahābhārata*, who passed on the stories to his students, who in turn passed them on to others, until, around campfire after campfire, the tales began to solidify. Bits that didn't catch on disappeared; bits that hit home got amplified. Then parts of it got written down, and those bits were read aloud, and it moved again – like a story cloud. At its heart is a simple spine – the battle between two families: the five Pandava brothers, led by their eldest, Yudhishthira, and the hundred cousins, led by their eldest, Duryodhana. The saga charts the build-up to their war, the war itself and the long aftermath. There are numerous echoes of *The Mahābhārata* within Western stories, from *The Sword in the Stone* to *The Lady of the Lake*, and even Luke Skywalker choosing the Force. The work is like some giant centrifuge, spinning its magic outwards, informing other cultures, which affect it in turn.

APPENDIX IV

Arabic Narrative Traditions

As griots serve their tribes in Africa, so the Hakawati tradition, mentioned in Chapter 8, is the repository of history, culture and morality in many Arab cultures. Performing in coffeehouses and public spaces, Hakawati employ classic narrative techniques to maintain audience engagement, including cliffhangers and dramatic timing, thus allowing them to tell episodic tales over many nights. Similarities with Western television, in structure at least, abound.

Arabic narrative traditions are incredibly rich and diverse, with two especially notable examples:

1. Maqama emerged in the tenth century as a unique genre combining prose and poetry, typically featuring (like African Anansi tales) a clever trickster character. Known for elaborate wordplay written in rhymed prose (saj'), the most famous authors are probably al-Hariri and al-Hamadhani. The former is perhaps best known for his 'The Maqama of Baghdad' (Al-Maqama al-Baghdadiyya), the story of a chance meeting in a Baghdad market:

 > Al-Harith encounters a shabby but eloquent stranger, who claims to be a fallen nobleman and convinces a group of scholars to give him money. Al-Harith confronts the stranger, but he defends himself, using his wit and wordplay to survive. The narrator is left to ponder the moral: the relationship between artistry, deception and survival.

 Striking how the story anticipates Maria Konnikova's work on the storytelling behind any great con.

2. The most famous of all Arabic literary traditions is the frame narrative, explored in Chapter 8, and its most well known iteration is almost certainly One Thousand and One Nights (Alf Layla wa Layla) which dates to the ninth century.

It's tempting to see frame narrative as a relatively modern form, as they're so common nowadays. *The Handmaid's Tale, Life of Pi, The Princess Bride* and *Cloud Atlas* are all recent examples. However, European writers were borrowing and adapting this Arabic tradition as early as the medieval and early Renaissance periods. Chaucer's *The Canterbury Tales*, written in the fourteenth century is a wonderful example (a group of pilgrims travelling to Canterbury hold a storytelling contest), as is Boccaccio's *The Decameron* (1353) (ten young noblemen and women flee plague-ridden Florence and find themselves in a ten-day quarantine, each telling one story per day).

Single stories within frames became increasingly popular with the growth of the novel, allowing opportunities for thematic resonance, dramatic irony, unreliable narration, subjective experience and moral tuition. Mary Shelley's *Frankenstein* uses a number of nested frames, while Henry James' *The Turn of the Screw* is built around a frame – of ghost stories told round a fire. Joseph Conrad's *Heart of Darkness* and *Wuthering Heights* by Emily Brontë are similar in form. British TV, meanwhile, had Jimmy McGovern's *The Street*, a very modern version of *The Canterbury Tales*, while Margaret Atwood's *The Blind Assassin* employed a novel-within-a-novel structure.

The influence of Arabic narrative traditions on the West is unheralded and profound. Frame narratives, when coupled (like *One Thousand and One Nights*) into one overarching story and underlined with jeopardy, are a key inspiration both for the modern novel and the development of techniques to increase audience engagement. Their universal adoption is a wonderful rebuke to the idea that narrative cultures are unique and insular.

Indigenous Storytelling

By the very nature of their conception and dissemination (tribal and oral) it's hard to pin down precise versions of the stories told

by indigenous peoples, including Native Americans and Aboriginal people of Australia. There are countless regional and spiritual variations, another example of a story morphing to meet the needs of any particular tribe.

One of the best-known Native American stories is *Raven Steals the Light* from the Pacific Northwest:

> The world is dark, for an old man keeps the sun, the moon and the stars in a box. The Raven turns himself into a pine needle and drops himself into the water the man's daughter is drinking. She becomes pregnant and gives birth to The Raven in new form. As this new child grows, he persuades his 'grandfather' to let him play with the boxes, finally liberating the sun, moon and stars, turning back into a raven, and thus bringing light to the world.

It's a classic three-act creation myth (problem, confrontation, solution) and an example of a common form among indigenous stories, which tend to be metaphorical and symbolic, thus useful for collective knowledge transmission.

Polynesian Storytelling

Polynesian storytelling culture is also rooted in performance, and is similar in many ways to African and Arabic traditions. Cultural and historical knowledge, creation myths and moral instruction are passed on by a griot-equivalent, with various names across different islands (*Tusitalā* in Samoa, for example). Again, the role of tribal storyteller is highly skilled.

Polynesian creation myths share common themes, but with distinct regional variations. The Hawaiians talk (chant, in fact) of life emerging from darkness in the *Kumulipo*. From Tahiti, we have the tale of Ta'aroa, who emerged from a cosmic egg and used its fragments to create the world.

One of the most widely travelled tales is the Māori creation narrative of Rangi (the sky father) and Papa (the earth mother):

Rangi and Papa were locked in an embrace, while their children lived in darkness between them. One of their sons, Tāne Mahuta, pushed them apart, and this separation created the world of light and space where humans could live. Though separated, the parent's love lives on – Rangi's tears fall as rain, and Papa's sighs rise as mist.

As befitting island people, there are many creation tales with navigation at their heart, showing how, like all stories, the forms and needs are universal but the content specific to the region. Equally, the emphasis on genealogical narratives of ancestral connection tells us much about how stories emerge to quell our biggest fears. Three acts: fear, search for cure and solution. I don't know who I am; I trace my lineage back to creation; now I do.

It is all too easy in our polarized world to believe in cultural essentialism, that every culture is unique, and for that to blind us to what makes us similar. We're human. We all breathe in the same way. While every culture will emphasize different aspects of narrative or use different vehicles for delivery, the underlying structures are fundamentally the same.

While acknowledging the genuine cultural specificities that make each tradition unique, we must avoid the patronizing, if well intentioned, 'othering' of non-Western narratives which, as Dr Irena Hayter points out in Chapter 8, contains the seeds of racism in disguise. It is possible to hold two ideas in the mind at the same time: that there is an extraordinarily rich diversity of storytelling across different cultures, and that their essential shape and purpose are universal. As they should be – storytelling is an integral part of what makes us human, after all.

APPENDIX V

Old Knowledge vs. New Knowledge

It is instructive, I hope, to compare the separate paradigms I have used within this book.

In Chapter 9, we showed how our own Roadmap of Change was uncannily close to the hero's journey. In addition to that we can now add the Kübler-Ross cycle of grief – which illustrates how we process trauma – and the scientific method, which is how we make rational sense of the world. The elements they have in common are striking. Perhaps, however, we shouldn't be surprised, for in effect they're all showing how humans replace old ways of viewing the world with new ones.

Storytelling is all about reducing complex issues to their absolute essence, so in that spirit only one real paradigm might be required to sum up the contents of *Trip to the Moon* – Old Knowledge vs New Knowledge – or, to borrow a piece of screenwriting terminology, 'Want vs Need.'

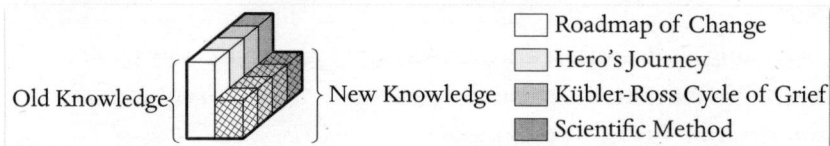

Acknowledgements

I never intended to write a second book. That I did so is due to a niggling feeling there was more to say, and to the persistence of two people – my agent Gordon Wise, and Penguin's Stefan McGrath. Both continued to blow on reluctant embers until the project finally caught fire.

While it exists because of their enthusiasm, the bricks from which the book is built were baked in the heat generated by the many brilliant students and staff of the BBC Writers' Academy. I will always be grateful to all of them, and in particular to Caroline Young (née Ormerod), Ceri Meyrick and Jenny Robins, alongside some very benevolent people in BBC management – Jane Tranter, Ben Stephenson, Mark Linsey and Tim Davie – all of whom either offered enormous support or chose to turn a blind eye to my increasingly feverish endeavours to make sense of the stuff with which we were plying our trade.

I began planning *Trip to the Moon* ten years ago, which perhaps indicates how ignorant I was of the subject's scale and how hard it was going to be to find a shape and form to give it life. That the book itself is about this process is both fitting and ironic. I found the shape, in the end, through trial and error, and then used that process to inform the content. All of this was helped enormously by some extraordinary colleagues and friends. Simon Ashdown, Katerina Watson and Susannah Marriott all read early drafts and offered invaluable advice. Suzy Cripps and Mia Pinto went out of their way to offer detailed critiques, bringing the incredibly useful cynicism of youth to the table. Russell T. Davies offered the best of correctives ('It's all bullshit, John!'), alongside many writers I've worked with over the years who weren't even aware they were helping. Jimmy McGovern, Peter Bowker, Peter Straughan, Sarah Phelps, Neil Cross, Steve Thompson, Ashley Pharoah, Emma Frost, Matthew Graham, Peter Moffat, Jed Mercurio, Paul Abbott, Abi Morgan, Simon Burke, Billy Ivory and Debbie Horsfield – their

ACKNOWLEDGEMENTS

peerless mastery of craft lit up the winding road I was trying to
follow, as did the writing of those like Craig Mazin, Philippe Clau-
del, Sally Wainwright, Paul Haggis and Bobby Moresco, and Cait-
lin Moran, who've graciously allowed me to reproduce their work.
Tony Jordan must stand at the front of that list – the first writer I
ever edited, and whose grid of squares was where all of this began.
I must mention David Edgar, whose kindness matched his per-
spicacity, John Collee, whose enthusiasm and experience proved
deeply inspiring, editor Eddie Hamilton (who got me an interview
with Chris McQuarrie that I failed to turn up to – I'm still mortally
embarrassed) and Tony Grounds, who has rightly never forgiven
me for failing to thank him for his help on *Into the Woods*. I hope he
will take this mention as some kind of reparation.

I am indebted to master speechwriter Simon Lancaster for his
thoughts on rhetoric, and to Dr Irena Hayter, Associate Professor
of Japanese Studies at Leeds University, for her wisdom and insight,
and her translation in the Kishōtenketsu section. Colette Colfer,
Lecturer in Religious Studies at SETU, Waterford, was important
in getting to grips with the theories of religious belief, and Luke
Knowles from *The Custard* blog led me by hand through the broken
landscape of TV failure. Professor Sophie Scott, CBE, Director
of the Institute of Cognitive Neuroscience at University College
London, was an invaluable guide to a subject I have no natural gift
for understanding. Julian Payne, CEO of Edelman UK and former
Director of Communications to THR the Prince of Wales and
the Duchess of Cornwall (now our king and queen), provided an
extraordinary amount of background information on shaping real-
life narratives – almost all of which I am unable to print. (Julian,
in a former existence, was our Press Officer at *EastEnders*, an apex
guerrilla fighter disguised as Cary Grant. He saved my life, and what
little reputation I had, on many occasions.) Will Storr was incred-
ibly supportive when I needed it most, and it was a personal thrill
to enlist Vivien Goldman, a heroine of mine since adolescence,
to cast a beady eye over my brief ramblings on reggae. Sarah Pick-
stone, Paul Walker and David James Smith made valuable contri-
butions to individual sections too.

Much of the content grew from incredibly valuable interactions
with minds far wiser than mine. Over the last few years, conversa-
tions with Professor Linda Anderson, journalist Helen Lewis, BBC
Radio Factual Commissioner Dan Clarke, and the great American

showrunner Jeff Melvoin lit up whole areas of narrative of which I was previously unaware, and all of them were kind enough to offer detailed notes on early drafts. *Casualty* creator Paul Unwin did, too, and he, Jeff and Helen all showed me how to impart brutally important notes wrapped in a patina of kindness. Not all of them were received with the same gracious spirit – they should have been. To all three I am hugely grateful.

My editor Josephine Greywoode has shown the patience of a saint, the fortitude of a political prisoner and the wisdom of a Nuremberg judge. It wasn't always easy – but the lesson I have chosen to take from that is that easy isn't all it's cracked up to be.

On a personal note, I must thank Wendy, who rolled her eyes at all the right moments, and my son Auryn, who learned to read as I was writing this. Watching a child get tangled up in the web story was weaving around him was the most wondrous illustration of the process I was trying to capture, and if I've managed that in any small way, it's down to him.

Finally – Rob Williams. Rob lit the fuse on my whole writing journey, and has stood beside me with support, guidance, the first-hand knowledge of a craftsman and artist, and the most valuable of friendships. My co-pilot on this trip to the moon.

Bibliography

Aaronovitch, David, *Voodoo Histories* (Jonathan Cape, 2009)

Archer, William, *Play-Making: A Manual of Craftsmanship* (Chapman & Hall, 1912)

Baker, Joshua, *'I'm Not a Monster': The Shamima Begum Story* podcast (BBC Radio 5/BBC Sounds 2023)

Baldwin, Thomas, *Shakespeare's Five-Act Structure* (University of Illinois Press, 1947)

Baudrillard, Jean, *Fragments* (Routledge, 2003)

Belton, Catherine, *Putin's People: How the KGB Took Back Russia and Then Took on the West* (2021)

Berger, Peter L., *The Sacred Canopy: Elements of a Sociological Theory of Religion* (Doubleday & Co., 1967)

Bradlee, Ben, *A Good Life: Newspapering and Other Adventures* (Simon & Schuster, 1996)

Branigan, Tania, *Red Memory: The Afterlives of China's Cultural Revolution* (Faber, 2024)

Brecht, Bertolt, *Mother Courage and Her Children*, trans. John Willett (Methuen Drama, 1983)

Brownlow, Kevin, *The Parade's Gone By* (Alfred A. Knopf, 1968)

Burton, Tara Isabella, *Strange Rites: New Religions for a Godless World* (Public-Affairs, 2020)

Campbell, Joseph, *The Hero with a Thousand Faces* (Bollingen Foundation/Pantheon Book, 1949)

Carr, Allen, *Packing It In the Easy Way* (Penguin, 2005)

Chaplin, Charles, *My Autobiography* (Simon & Schuster, 1964)

Churchill, Winston, 'The Scaffolding of Rhetoric' speech (1897)

Collins, Philip, *The Art of Speeches and Presentations* (Wiley & Sons, 2012)

Corbett, Edward P. J. and Robert J. Connors, *Classical Rhetoric for the Modern Student* (OUP, 1999)

Courtois, Stéphane *The Black Book of Communism* (Harvard University Press, 1999)

Davies, Russell T. with Benjamin Cook, *Doctor Who: The Writer's Tale* (BBC Books, 2008)

Delaney, Rob, *A Heart That Works* (Coronet, 2023)

Dikötter, Frank, *Mao's Great Famine* (Walker & Company, 2010)

Douglas, Mary, *Thinking in Circles: An Essay on Ring Composition*, Terry Lecture Series (Yale University Press, 2007)

Dromgoole, Dominic, *Astonish Me! First Nights That Changed the World* (Profile Books, 2022)

Durkheim, Émile, *The Elementary Forms of Religious Life* (Alcan, Paris, 1912)

Field, Syd, *Screenplay* (Dell Publishing Company, 1979)

Fusco, Paul, *RFK Funeral Train: Expanded Edition* (Aperture, 2019)

Geertz, Clifford, *The Interpretation of Cultures* (Basic Books, 1977)

Gerbaudo, Paolo, *The Digital Party: Political Organisation and Online Democracy* (Pluto Press, 2019)

Girard, René, *I See Satan Fall Like Lightning* (Orbis Books, 2001)

Glyn, Elinor, *The Elinor Glyn System of Writing* (The Authors' Press, 1922)

Granger, John, *Harry Potter as Ring Composition and Ring Cycle: The Magical Structure and Transcendent Meaning of the Hogwarts Saga* (Unlocking Press, 2010)

Han, Suyin, *A Many-Splendored Thing* (Little, Brown & Co., 1952)

Harari, Yuval Noah, *Sapiens: A Brief History of Humankind* (Harvill Secker, 2014, first published in Hebrew, 2011)

Herman, David, Manfred Jahn and Marie-Laure Ryan (eds), *Routledge Encyclopedia of Narrative Theory* (Routledge, 2005)

Hitchens, Christopher, *Hitch-22: A Memoir* (Atlantic Books, 2010)

Hitler, Adolf, *Mein Kampf*, translated by Ralph Manheim (Mariner Books, 1999)

Hochschild, Arlie Russell, *Strangers in Their Own Land: Anger and Mourning on the American Right* (The New Press, 2017)

Hoffer, Eric, *The True Believer* (Harper & Brothers 1951)

Hofstadter, Richard, *Anti-Intellectualism in American Life* (Alfred A. Knopf, 1963)

Hofstadter, Richard, *The Paranoid Style in American Politics and Other Essays* (Alfred A. Knopf, 1965)

Horace, *Ars Poetica* (Loeb Classical Library, OUP 1999)

Hubbard, L. Ron, *Scientology 8-8008* (1st edition, originally typed and duplicated, 1952; 3rd edition published by Foundry Press, 1956)

Hume, David, 'Of Superstition and Enthusiasm' in his *Essays, Moral, Political, and Literary* (1742–1754), Essay XIII

Huxley, Aldous, *Crome Yellow* (Chatto & Windus, 1921)

James, William, *The Varieties of Religious Experience* (Longmans, Green & Co., 1902)

Jocelyn, Ed and Andrew McEwen, *The Long March* (Constable, 2006)

Joyce, James, *A Portrait of The Artist as a Young Man* (B. W. Huebsch, 1916)

Kapic, Kelly M., *The Devoted Life: An Invitation to the Puritan Classics* (InterVarsity Press, 2004)

Kiernan, Ben, *The Pol Pot Regime: Race, Power and Genocide in Cambodia under the Khmer Rouge* (Yale University Press, 1996)

Koestler, Arthur, Louis Fischer, Andre Gide, Ignazio Silone, Stephen Spender and Richard Wright, *The God That Failed*, compiled by Richard Crossman (Harper & Brothers, 1949)

Konnikova, Maria, *The Confidence Game: The Psychology of the Con and Why We Fall for It Every Time* (Canongate Books, 2016)

Le Guin, Ursula K., *Steering the Craft: A Twenty-first Century Guide to Sailing the Sea of Story* (Mariner Books, 2015)

Lewis, C. S., *Present Concerns* (Harcourt Brace Jovanovich, 1987)

Lewis, Helen, *The New Gurus* podcast (BBC Sounds, 2023)

Lewis, Sinclair, *It Can't Happen Here* (Doubleday, Doran and Company, 1935)

Lovell, Julia, *Maoism: A Global History* (The Bodley Head, 2019)

Lubbock, Percy, *The Craft of Fiction* (Jonathan Cape, 1921)

Mailer, Norman, *The Presidential Papers* (Penguin, 1964)

Mamet, David, *Three Uses of the Knife: On the Nature and Purpose of Drama* (Columbia University Press, 1998)

McGinniss, Joe, *The Selling of the President* (Trident Press, 1969)

McKee, Robert, *Story* (Methuen, 1998)

Orwell, George, 'Politics and the English Language' (First published in *Horizon* magazine, 1946, then in *Shooting an Elephant and Other Essays*, Secker & Warburg, 1950)

Osbon, Diane K. (ed.), *Reflections on the Art of Living: A Joseph Campbell Companion* (HarperCollins, 1991)

Perlstein, Rick, *Before the Storm: Barry Goldwater and the Unmaking of the American Consensus* (Hill & Wang, 2001)

Perlstein, Rick, *Nixonland: The Rise of a President and the Fracturing of America* (Scribner, 2008)

Perlstein, Rick, *The Invisible Bridge: The Fall of Nixon and the Rise of Reagan* (Simon & Schuster, 2014)

Perlstein, Rick, *Reaganland: America's Right Turn* (Simon & Schuster, 2020)

Porter Abbott, H., *The Cambridge Introduction to Narrative*, 2nd edition (Cambridge University Press, 2008)

Phelps-Roper, Megan, *The Witch Trials of J.K. Rowling* podcast (Free Press, 2024)

Propp, Vladimir, *Morphology of the Folk Tale* (University of Texas Press, 1928, first published in Russian as *Морфология сказки* (*Morfologiia skazki*), 1928)

Reagan, Ronald, *An American Life* (Simon & Schuster, 1990)

Rimmon-Kenan, Shlomith, *Narrative Fiction: Contemporary Poetics* (Metheun, 1983)

Rinzler, J. W., *The Making of 'Star Wars: Revenge of the Sith'* (Del Rey Books, 2005)

Sagan, Carl, *The Demon-Haunted World* (Random House, 1995)

Schwartz, Roy, *Is Superman Circumcised? The Complete Jewish History of the World's Greatest Hero* (McFarland, 2021)

Shirer, William L., *Hitler: The Nightmare Years (1930–1940)* (Little, Brown & Co., 1984)

Sun, Shuyun, *The Long March: The True History of Communist China's Founding Myth* (Anchor Books, 2008)

Sinclair, Upton, *I, Candidate for Governor: And How I Got Licked* (Farrar & Rinehart, 1935)

Snow, Edgar, *Red Star Over China* (Victor Gollancz, 1937)

Snyder, Blake, *Save the Cat! The Last Book on Screenwriting That You'll Ever Need* (Michael Wiese Productions, 2005)

Thomson, David, *Have You Seen . . .? A Personal Introduction to 1,000 Films* (Allen Lane, 2008)

Todorov, Tzvetan, *Grammaire du 'Décaméron'* (Mouton, 1969)

Tressell, Robert, *The Ragged-Trousered Philanthropists* (Grant Richards Ltd, 1914)

Trottier, David, *The Screenwriter's Bible*, 3rd edition (Silman-James Press, 1998)

Truby, John, *The Anatomy of Story* (North Point Press, 2007)

Van Loan, H. H., *'How I Did It'* (Whittingham Press, 1922)

Vogler, Christopher, *The Writer's Journey* (Michael Wiese, 2007)

Wilson, Bill, *Alcoholics Anonymous Comes of Age* (Harper & Brothers, 1957)

Credits

pp. 30–32 – extract from *It's a Sin*, Episode 3, by Russell T. Davies. Red Productions, 2021. Reproduced by kind permission of the author.

pp. 90–94 – extract from *Happy Valley*, Series 1, Episode 1, by Sally Wainwright. Red Productions, 2014. Reproduced by kind permission of the author.

pp. 191, 192–5, 224, 225, 226 – extracts from *Chernobyl* by Craig Mazin. HBO, Sky UK and Sister Pictures, 2019. Reproduced by kind permission of the author.

p. 220 – extract from *I've Loved You So Long (Il y a longtemps que je t'aime)* by Philippe Claudel, 2008. Reproduced by kind permission of the author.

p. 231 – extract from *Crash* by Paul Haggis and Bobby Moresco, 2005. Reproduced by kind permission of the authors.

pp. 218, 317, 433 – extracts from *Star Wars: A New Hope* by George Lucas, 1976.

p. 296 – extract from *The Shawshank Redemption* by Frank Darabont, based on the 1982 novella *Rita Hayworth and Shawshank Redemption* by Stephen King

p. 317 – extract from *Star Wars: The Phantom Menace* by George Lucas, 1999.

p. 318 – extract from *Star Wars: The Empire Strikes Back* by Leigh Brackett and Lawrence Kasdan, from a story by George Lucas, 1980.

p. 403 – 'I'm Kicking Butts' by Caitlin Moran, published in *The Times*, 1 April 2017. Reproduced by kind permission of the author.

Notes

CHAPTER I

1. Conversation with author, 2007.
2. Observations in the comment section included the following:

 'Like any form, over-use and over-familiarity can reduce the impact of a particular structure.'

 'Script readers expect a great story. That's it. Enough with "rules" and formulas and all that crap.'

 'A bad workman blames his tools and all that jazz.'

 'I have found that most people who use three-act structure can't tell me what an act is.'

 'The point behind all this is that formalism is the death of creativity. No-one here is going to argue that . . .

 . . . BUT it's an extreme luxury to allow oneself the authority to dismiss formal craft in screenwriting . . . or painting . . . or ballet . . .'

 'A major reason for the three-act structure being adopted as gospel was not as an aid to writers but as a way of helping the more hopeless brand of development executive.'

 This last was by far the most 'liked' post on the thread, followed by a slightly weak-hearted plea to stop worrying and head to the cinema to watch the big art house hit of the day: 'Oh sod it . . . just go watch Blue Valentine.'
3. Vertov's real name was Denis Abramovich Kaufman. One of his brothers, Boris, was director of photography of *On the Waterfront*.
4. All sense of narrative control seems to go out of the window in the second season of *Friday Night Lights*. Much-loved characters (including Landry

Clarke, played by a young Jesse Plemons) suddenly become murderers. It's as if the show has been hijacked by satirists. Future series wrestled back control, however, and the crimes quickly became forgotten.

5. Rebecca Ford and Lacey Rose, '100 Days That Changed Hollywood: The Writers Strike, 10 Years Later', *Hollywood Reporter*, 17 May 2018.

6. The executive was Mark Thompson, who went on to be Director General of the BBC, CEO of *The New York Times* and, in 2023, CEO of CNN. To his credit, he did bail out *Shameless* and effectively saved it from extinction. It became as important to the channel as *Queer as Folk* had been before it, and ran in the UK for eleven series and 139 episodes. The US adaptation ran only five episodes short of that and became the longest-running scripted series in its broadcaster Showtime's history.

7. As the screenwriter John Collee has pointed out, if you look under the hood of *Life on Mars*, you find *Z-Cars* and *Starsky and Hutch*. Do the same with Christopher and Jonathan Nolan's *Memento* and you'll find a classic police procedural: a detective follows the evidence backwards, over five acts, to finally arrive at the crime.

8. James Joyce, *A Portrait of the Artist As a Young Man* (B. W. Huebsch, 1916).

9. Somewhat reminiscent of Godard's *Sympathy For The Devil*, a largely unwatchable film of The Rolling Stones recording the eponymous track.

10. Admittedly this wasn't enough for some people, like *Guardian* music critic Alexis Petridis, who found the eight-plus hours profoundly boring: '[. . .] the moments of inspiration and interest are marooned amid acres of desultory chit-chat ("aimless rambling", as Lennon rightly puts it) and repetition.' ('The Beatles: *Get Back* review', *Guardian*, 25 November 2021, https://www.theguardian.com/tv-and-radio/2021/nov/25/the-beatles-get-back-review-peter-jackson-eight-hours-of-tv-so-aimless-it-threatens-your-sanity.) Perhaps, but its release and reception felt like a major cultural event, and that doesn't happen unless the weapon is hitting its target. For a more sympathetic and perceptive take on its value, try Ian Leslie's piece here: https://www.ian-leslie.com/p/the-banality-of-genius-notes-on-peter.

11. In Philip Norman's enormously influential Beatles biography *Shout*, McCartney is depicted as both controlling and second-rate, in almost every aspect, compared to the god-like genius of John Lennon. It's a shameful book.

12. H. Porter Abbott, *The Cambridge Introduction to Narrative*, 2nd edition (Cambridge University Press, 2008).

13. Online MasterClass advert, 2022, https://www.youtube.com/watch?v=RPDOioWeByo.
14. David Hare and Charlie Kaufman also share this view. For more, see *Into the Woods*.
15. As John Collee has pointed out, 'I think writers are consciously or unconsciously flipping between these left- and right-brain activities. Pixar allocated separate rooms to the two processes. Salman Rushdie and, I assume, J. K. Rowling do a lot of it in their heads, but every painter, every writer, every architect will routinely take that step back to objectively assess their subjective creation.' (Conversation with author.)
16. There are others of note: Alexander Mckendrick's *On Film-Making* and Lajos Egri's *The Art of Dramatic Writing* (which concentrates on plays) are more than worthy of attention, as is David Mamet's *Three Uses of the Knife*. More on this in *Into the Woods*.
17. Interview with author, May 2013.
18. Kevin Brownlow, *The Parade's Gone By* (Alfred A. Knopf, 1968).
19. Elinor Glyn, *The Elinor Glyn System of Writing* (The Authors' Press, 1922).
20. H. H. Van Loan, *'How I Did It'* (Whittingham Press, 1922).
21. Glyn, *System of Writing*. The full quote is:

> But Keep Your Hero Clean. He may err – but his mistake should be the result of carelessness, thoughtlessness, mischievousness, or recklessness but never the result of direct intent. That's all there is to it. Establish a premise and then rush for the final scene. Don't waste any time en route. Be sure that it contains action, action, and them more action. Mix a few thrills with it. Bring a tear to the eyes of your audience. The next instant, chase away the tear with a smile. If you do that then you've got a story.

> To be fair, that's not bad advice.

22. David Mamet, *Three Uses of the Knife: On the Nature and Purpose of Drama* (Columbia University Press, 1998).
23. An average worldwide gross of $680 million per film. (See: https://www.the-numbers.com/movies/production-company/Pixar.) To date Pixar have won twenty-three Academy Awards (including eleven for best picture), ten Golden Globes and eleven Grammys. It's simply unprecedented.
24. The phrase 'dark inversions' was coined, as far as I can tell, by Christopher Booker in his maddening *Seven Basic Plots*. The book is full of great material, but comes to fairly deranged conclusions.

25. Tony Jordan, Peter Moffat, Russell T. Davies and Tony Grounds have all at various times railed against structural orthodoxy.

26. 'Play fucking loud!' shouted Bob Dylan to his band (The Band) at the Manchester Free Trade Hall in 1966, when the traditionalists (largely Manchester's student community) railed against him for going electric. His battle cry was catalysed by one legendary heckle from the audience: *'Judas!'* 'I don't believe you,' he retorted, 'you're a liar!' before crashing into 'Like a Rolling Stone'. At the risk of showing my age, if you haven't heard it, you should. It's on the albums *No Direction Home* and *The Bootleg Series vol 4: Live 1966,* and you can see it here: https://www.youtube.com/watch?v=znrlL-DGoynU. For people over fifty this is a semi-religious moment – the smiting of the old guard. I have often wondered if most us would have been with the beatniks, scratching our beards and telling ourselves he'd sold out by playing 'commercial shit'. Not me though, obviously . . .

27. In fact, the Skladanowsky brothers' films had preceded them by a month, but narrative wound its way around the Lumière brothers and history settled on the idea that cinema began on this date. Such is the power of story.

28. 'Revealed: the results of the 2022 Sight and Sound Greatest Films of All Time poll', BFI News, 1 December 2022, https://www.bfi.org.uk/news/revealed-results-2022-sight-sound-greatest-films-all-time-poll.

29. This is not to denigrate *Jeanne Dielman*, which is a fascinating exercise in minimalism, and particularly the genre we have come to know as 'slow story', which also contains such luminous works as *Once upon a Time in Anatolia, Satantango, Werckmeister Harmonies, Beau Travail* and *An Elephant Sitting Still. Jeanne Dielman* tells the story of a housewife trapped in a routine of cooking, cleaning and housekeeping for her student son, and prostitution. She cooks an identical meal to mark each day of the week, and entertains male clients in the same manner. Built on single static takes over three and a half hours, the film constructs a modernist symphony of repetition (there are shades of Philip Glass here) as we get a sense of the profound importance to Jeanne of her routine, and then slowly of the neuroses that underlie it too. The drama in the story comes from the slow accumulation of, and then deviation from, routine.

 In many ways the film is very traditional. It's built round a classic three-act structure, over three days, with two big subversions of expectation. The first is the revelation of her deeply incongruous job, the second a hideous act of violence. This latter moment is a classic example of *peripeteia* or *anagnorisis* when, with a shocking twist, the true meaning of the movie becomes clear. 'Oh no!' we shout, then, very quickly, 'But of course!' The film also has a fantastically important central midpoint,

Akerman's equivalent of E. M. Forster's Marabar Caves. Exactly halfway through the film, something happens in her bedroom that destabilizes Jeanne's routine and leads to her eventual breakdown. There's a crisis point, too: one of total inertia, when, for the first time in the film, she is bereft of purpose, and it's this that leads to her final violent act.

A hallmark of slow cinema, the passing of time is emphasized, and narrative events are reduced to an absolute minimum. One of the reasons the film was slow to catch on (it wasn't even released in the US until eight years after its first release in 1983, and you couldn't buy a DVD of it until 2009) is that it demands an audience's absolute attention. You must recalibrate the way you watch film to seek out the smallest of nuances. If you do that, it becomes a masterclass not just in feminist cinema, but in the portrayal of neurosis, truly a life of quiet desperation. The greatest film of all time? It's undeniably powerful, but its joyless misery teeters on nihilism, and its ending walks too close to melodrama.

30. This and preference falsification are massive obstacles to creating any generically sensible 'best of' list. Such lists, just like award shows, are far more about the power of narrative than any work's intrinsic worth. I bow to no one in my love for Michelle Yeoh, but the idea that her performance in *Everyone Everywhere All at Once* was better than Cate Blanchett's in *Tár*, and that the former is a better film, is frankly absurd. Its campaign just had a better story. That's how you win awards: not with the film but the tale you tell around it.

31. A good friend of mine said to me that the critics who voted for *Jeanne Dielman* were directly responsible for Trump's second electoral victory. It's a little bit of an overstatement, but I know exactly what she means. Intellectuals are capable of the finest stupidity, and sometimes it takes the 'poorly educated', as Trump would call them, to point out they have no clothes.

32. Josh Milton, 'Russell T Davies "literally refused" to write this "unbelievably crass" *It's a Sin* scene', *Pink News*, 3 March 2021.

33. Russell T. Davies with Benjamin Cook, *Doctor Who: The Writer's Tale* (BBC Books, 2008).

CHAPTER 2

1. It's worth noting that a core object of the High Renaissance (borrowed from the period's classical influences) was to move toward a world without darkness and mystery, and that the vanishing point itself was a device to shine light on the dark space of the medieval, mystical and unknowable – the

'woods', in other words. So the structure of the painting carries that deeper thematic meaning too.

2. Rob Delaney, *A Heart That Works* (Coronet, 2023).

3. Horace, *Ars Poetica* (Loeb Classical Library, OUP, 1999, https://www.loeb-classics.com/view/horace-ars_poetica/1926/pb_LCL194.467.xml#:~:text =Whatever%20you%20thus%20show%20me%2C%20I%20discredit%20 and%20abhor.&text=Let%20no%20play%20be%20either,fourth%20 actor%20essay%20to%20speak).

4. I created this paradigm by combining the work of Gustav Freytag and Thomas Baldwin's *Shakespeare's Five-Act Structure*.

5. Except for the very end, where Macbeth is clearly punished for his sins. A personal position, certainly, but I think *Breaking Bad* would have been more powerful if it hadn't fallen for the idea of trying to redeem its hero at the end.

6. Every moment of change in *Moonlight* involves water, a symbol of both baptism and transformation.

7. Far more on the nose, though equally ambitious, is Dennis Potter's revolutionary *The Singing Detective* (1986). Philip Marlowe is admitted to hospital with psoriatic arthropathy, a terrible skin disease. Over six hour-long episodes he finally accepts that the cause is psychosomatic. The midpoint? A flashback to the defining episode of his childhood, when he witnessed his mother having sex with another man in the heart – of course – of the forest.

8. In *Thelma & Louise*, Thelma (Geena Davis), who has begun the story as a gaslit girl dominated by an abusive partner, experiments with the idea of letting her hair down, literally and figuratively. Exactly halfway through the film she does just that by having sex with J. D. (Brad Pitt). Thelma has discovered something profound. Her sexuality, yes, but her autonomy too. She will not be gaslit again. She takes charge, and the women rob a store – she's experimenting with change.

9. Post by Coleen Rooney on her Facebook, Twitter (now X) and public Instagram accounts, 9 October 2019.

10. Quoted in Burkhard Bilger, 'What George Miller Has Learned in Forty-Five Years of Making "Mad Max" Movies', *New Yorker*, 19 May 2024, https://www.newyorker.com/culture/the-new-yorker-interview/ what-george-miller-has-learned-in-forty-five-years-of-making-mad-max-movies.

11. First published in Britain as *Freytag's Technique of the Drama: An Exposition of Dramatic Composition and Art*, translated and edited by Elias J. MacEwan

(Scott, Foresman and Company, 1894). Text available at https://archive.
org/details/freytagstechniquoofreyuoft.

12. Freytag's five stages map exactly onto Baldwin's observations on the
structure of Terence.

13. E. M. Forster, *A Room with a View* (Edward Arnold, 1908).

14. The midpoint of the film is where Lucy learns that George, from whom
she fled in Florence, is coming to live in the village, just as she has accepted
the invitation to marry Cecil, his opposite.

15. The parallel is underlined by the way the second scene forces Lucy to
recall the one before. As soon as Cecil kisses her, she remembers the
surname of George, whom she is still refusing to acknowledge lives in
her heart. 'Emerson the name was, not Harris,' she declaims, announcing
to the reader – if not to either herself (she is in denial) or Cecil (he's just
ignorant) – where her passion really lies.

16. All of this is from a conversation with Tony in 1994: the first lesson in story
structure I ever had.

17. Two other contemporary examples: Alfonso Cuarón's *Gravity* opens with
a shot of the earth taken from deep space and it ends with a shot of Dr
Ryan Stone standing on the earth staring up at the heavens. Bong Joon-
Ho's *Parasite* begins and ends with the same downward-tracking shot
from the window of the Kim family's semi-basement flat to reveal the
youngest son Ki-woo. The first is during daytime, and the boy is looking
at his phone, the last is at night, with the boy studying a musical score.

18. *Classical Rhetoric for the Modern Student* (OUP, 1999) defines chiasmus as 'a
reversal of grammatical structures in successive phrases or clauses – but
no repetition of words'. Technically 'Fair is Foul and foul is fair' is *anti-
metabole*, as is Kennedy's 'Ask not . . .' Chiasmus avoids direct repetition, as
in 'She has all my love; my heart belongs to her.' But this is where things
can get a bit too pedantic; chiasmus is normally used as a shorthand for
both.

19. Take a two-part story like the hugely successful French saga *Jean de Florette*
and *Manon des Sources*. Claude Berri's 1986 films (and Marcel Pagnol's
original novels) tell the story of two greedy French men who try to drive
an incoming farmer off his new land by blocking his water supply. In the
first film they block the well to stop the farmer getting water and he dies,
but his daughter Manon discovers the dastardly plan. In the second film
she takes revenge by blocking the well to stop the village getting water.
The culprits die. Manon lives happy ever after, the land now hers. It's a
classic chiasmus.

20. The chiastic structure of *Aliens* can be broken down as follows:

ACT ONE

A. Ripley and Jones are in hypersleep.

 B. Ripley learns her daughter is dead.

 C. Ripley is stripped of her rank.

 D. Gorman guarantees Ripley's safety on a rescue mission. She agrees to go.

 ACT TWO

 E. The *Sulaco* heads to alien planet to rescue survivors and kill aliens.

 F. Ripley discovers Newt, the only surviving colonist.

 G. stuck in complete darkness, the marines have no chance against the aliens.

 H. Ripley rescues Marines.

 ACT THREE

 I. The survivors discuss whether to continue the fight or retreat.

Midpoint
I. Dropship gets destroyed, stranding them on alien planet.

 I. The survivors discuss whether to continue to fight or retreat.

 ACT FOUR

 H. Ripley builds barricades to protect Marines.

 G. Hicks gives Ripley a tracking device to help protect her against aliens.

 F. Ripley confronts Carter Burke about his role in getting the colonists killed.

 E. A dropship leaves the *Sulaco* to rescue them before they are killed by aliens.

 ACT FIVE

 D. Gorman sacrifices himself to save Ripley.

 C. Ripley takes charge.

 B. Ripley destroys alien queen's eggs.

A. Ripley and Newt go into hypersleep.

21.	For far more detailed analysis of chiasmus in *Aliens*, *Terminator 2*, and many more films, dejareviewer.com/ offers fantastically intricate breakdowns of numerous different films.

22.	For much of the information on *Star Wars* and ring structure, I am enormously indebted to Mike Klimo and his essay 'Ring Theory: The Hidden Artistry of the *Star Wars* Prequels'. You can read far more about it here: https://www.starwarsringtheory.com. His website led me to many of the quoted interviews too. In addition, Mike rightly credits Anne Lancashire, Professor of Cinema Studies and Drama at the University of Toronto, for some of the original insights in her 2000 essay '*The Phantom Menace*: Repetition, Variation, Integration'.

23.	Though the table design is my own, I've used the act descriptions provided by Mike Klimo as they're unimprovable: https://www.starwarsringtheory.com.

24.	The midpoints of the six films further illustrate the striking nature of the chiasmus:

FILM	MIDPOINT
A. *Phantom Menace*	Podbike race – Anakin leaves his mother
B. *Attack of the Clones*	Obi-Wan travels 'into the woods' to meet Jango Fett
C. *Revenge of the Sith*	A great disturbance in the force when Anakin turns to the dark side
C. *A New Hope*	A great disturbance in the force – as Luke learns the ways of the Jedi
B. *The Empire Strikes Back*	Luke travels 'into the woods' to meet Yoda
A. *Return of the Jedi*	Speeder bike race – Luke leaves his friends

25. Surah al-Baqarah is the longest chapter of the Qur'an. Raymond K. Farrin, author of 'Surat al-Baqara: A Structural Analysis' (*The Muslim World*, vol. 100, no. 1, 19 January 2010, pp.17–32), observed 'the marvellous justness of [its] design':

> It is precisely and tightly arranged, as we have seen, according to the principles of ring composition; even the section lengths fit perfectly in the overall scheme. Moreover, the precise structure serves as a guide, pointing to key themes in the sura. These occur, according to the logic of the pattern, at the centers of individual rings and, particularly, at the center of the whole sura. At the center of the sura, again, one finds instructions to face Mecca – this being a test of faith; identification of the Muslims as a new, middle community; and the message that all people, regardless of their *qibla* or spiritual orientation, should race to do good and God will bring them together.

Its 286 verses, Farrin observed, can be divided into nine main sections based on subject or theme:

1. Faith vs unbelief (1–20)
2. Allah's creation and knowledge (21–39)
3. Deliverance of Law to Children of Israel (40–103)
4. Abraham was tested (104–141)
5. Ka'ba is the new *qibla* (142–152)
6. Muslims will be tested (153–177)
7. Deliverance of Law to Muslims (178–253)
8. Allah's creation and knowledge (254–284)
9. Faith vs unbelief (285–286)

Rearranging this demonstrates the ring composition:

A: Faith vs unbelief (1–20)

 B: Allah's creation and knowledge (21–39)

 C: Deliverance of Law to Children of Israel (40–103)

 D: Abraham was tested (104–141)

 E: Ka'ba is the new qibla (142–152)

 D': Muslims will be tested (153–177)

 C': Deliverance of Law to Muslims (178–253)

 B': Allah's creation and knowledge (254–284)

A': Faith vs unbelief (285–286)

All of the above is Farrin's work.

26. John Granger is the self-styled 'Hogwarts Professor' of hogwartsprofessor. com ('a site for serious readers'). The site contains a lot of different articles, collected in book form in *Harry Potter as Ring Composition and Ring Cycle: The Magical Structure and Transcendent Meaning of the Hogwarts Saga* (Unlocking Press, 2010).

27. Mary Douglas, *Thinking in Circles: An Essay on Ring Composition* (Terry Lecture Series, Yale University Press, 2007).

28. Gordon J. Wenham, 'The Coherence of the Flood Narrative', *Vetus Testamentum*, Vol. 28, Fasc. 3, July 1978, pp. 336–348. Wenham's work, which also pinpointed the deeper time structure, built on that of F. I. Andersen in *The Sentence in Biblical Hebrew* (The Hague, 1974).

29. If ring structure began as a rhetorical device, it soon began to infect written narratives. Observe the shape of Milton's epic poem *Paradise Lost*, as noted by Leland Ryken in Kelly M. Mapic and Randall C. Gleason, eds., *The Devoted Life: An Invitation to the Puritan Classics* (InterVarsity Press, 2004):

A: Satan sins (Books 1–3)
B: Paradise is entered (Book 4)
C: War (destruction) erupts in heaven (Books 5–6)
C´: The creation of the world (Books 7–8)
B´: Paradise is lost (Book 9)
A´: Mankind sins (Books 10–12)

30. Douglas, *Thinking in Circles*.

31. Ibid.

32. I used these examples in *Into the Woods*, though without mentioning chiasmus. At that stage I wasn't aware how deep this went.

33. Orpheus and Eurydice is one of the most popular of all the Greek myths, and Buster Keaton's *The General* is arguably *the* enduring classic of silent cinema; both use an identical structure. When Eurydice dies from a snakebite, her lovesick partner follows her into the Underworld, using his magic lyre to enchant Hades into giving her back. On the second half of the journey, the return, he must escort her without looking back, but of course he can't, and she dies. That's the tragic version of the story; Keaton's is the heroic one. When his beloved locomotive is stolen by Union forces in the American Civil War, Keaton must pursue it deep into enemy territory, steal it back and return it home pursued by a furious enemy.

34. Douglas, *Thinking in Circles*.

35. You see this shape – or its shadow – in every narrative work, though it's
not always so pronounced. I am grateful to playwright David Edgar for
the following example:

Virgil Hilts (Steve McQueen) is not interested in being part of an
escape team. A symbol of American isolationism, he prefers to spend his
time at Stalag Luft III embarking on ever more fanciful escape attempts,
aided by his best friend (and direct physical and mental opposite) RAF
Flying Officer Ives. How Hilts becomes a key member of the escape team
is central to the story of *The Great Escape*, and pivotal to the story is the
film's midpoint.

'X' (Richard Attenborough), the head of the prisoners' escape commit-
tee, has asked Hilts if he might break out of the camp, do some reconnais-
sance, then allow himself to be recaptured. Hilts thinks 'X' is mad. Then
one of the three allied tunnels is discovered by the Germans, and in the
confusion Ives sees a clear run over the fence and into the forest beyond.
Ives is a desperate man, his judgement is off and he's shot by the guards,
his body left to hang limply from the barbed-wire fence. Disgusted, Hilts
seeks out 'X' and asks him what information he will need.

It's a classic turning point, and a classic midpoint too. The protagonist
is delivered a truth, something that up until now they've denied them-
selves, and this truth will change everything for ever. The truth in this case
is *collective action* – that Hilts is part of something bigger than himself (the
argument that President Roosevelt had been making for many years) – and
the second half of the story is how he comes to terms with that.

With a flawed character, the truth is normally the opposite of
everything they've ever believed in. The greater their terror of that
moment, the more powerful the story.

36. This quote is actually a paraphrase of Campbell from *Reflections on the
Art of Living: A Joseph Campbell Companion*, edited by Diane K. Osbon
(HarperCollins, 1991). The actual text, said to be a verbatim transcription,
is longer:

> It is by going down into the abyss
> that we recover the treasures of life.
>
> Where you stumble,
> there lies your treasure.
>
> The very cave you are afraid to enter
> turns out to be the source of

what you are looking for.
The damned thing in the cave
that was so dreaded
has become the center.

You find the jewel,
and it draws you off.
In loving the spiritual,
you cannot despise the earthly.

37. Quoted in J. W. Rinzler, *The Making of 'Star Wars: Revenge of the Sith'* (Del Rey Books, 2005).
38. Those in any doubt should watch *Light & Magic*, Lawrence Kasdan's documentary on the history of Lucas's company Industrial Light & Magic. It's a fascinating insight into how the pursuit of perfection is a thinly veiled mask for the desire to remove all human interaction. Lucas is responsible for so much of the modern movie industry that's great (on screen and off), but his removal of human imperfection is a sad debit, doing almost equal amounts of damage.
39. Douglas cites Sterne's time at Oxford, where he would have been exposed to study of biblical literature, in particular 'Bishop Lowth's famous lectures on biblical poetry'. She concludes that 'He could quite conceivably have copied the chiastic model for his book' (*Thinking in Circles*).
40. Scott Chernoff, 'The Plot Thickens', interview after release of *Attack of the Clones*, '*Star Wars' Insider*, July/August 2002.

CHAPTER 3

1. You can watch the full speech here: https://www.youtube.com/watch?v=qXBswFfh6AY.
2. Ronald Reagan, 'A Time for Choosing'. Full transcript here: https://www.reaganlibrary.gov/reagans/ronald-reagan/time-choosing-speech-october-27-1964.
3. For a fuller understanding of the impact of 'A Time for Choosing' see Rick Perlstein, *Before the Storm: Barry Goldwater and the Unmaking of the American Consensus* (Hill & Wang 2001), Perlstein writes:

It was clear within five seconds that this was like no other Goldwater-Miller TV show before. Those had lost nothing in effect when they were simulcast on radio. Not so this. As Reagan began to speak, the camera

dolly swooped dramatically overhead, slowly fixing on the man with the sturdy torso and the gleaming hair at the dais, eyes locked on you like some smiling, gentler version of the prophet Jeremiah. It was hard not to pay attention [. . .] The stories went by faster than thought, like a seduction [. . .] images danced with words [. . .] The language had the sweep of poetry [. . .] It was, David Broder and Steve Hess would write, 'the most successful national political debut since William Jennings Bryan electrified the 1896 Democratic Convention with the "Cross Of Gold" speech.' [. . .] In Goldwater circles a cult was quickly forming. The checks, those grubby paper bags stuffed with cash, the envelopes full of children's spare change – they came, and came, and came after October 27 Reagan speech. More money, even, than could be counted.

4. Rick Perlstein, *The Invisible Bridge: The Fall of Nixon and the Rise of Reagan* (Simon & Schuster, 2014).

5. This remark was made in an on-stage interview with me at the British Screenwriters' Festival. Fellowes was guiding an audience through the first episode of the show.

6. Maybe I would say this, as I helped make it. I took over the commission as one of the executive producers just as it was going into production, when I became MD of Company Pictures.

7. Look at Disney's *Pinocchio*. To make the journey from puppet to boy, Pinocchio must embark on a Homeric epic, learning the lessons of decency, kindness, bravery and sincerity by rejecting lewdness, idleness, gambling and anything that seems remotely middle class. Though it was released before his presidency, it's a hymn to Eisenhower's America – and the war delayed its impact. It only made its money back when it resonated with its time.

8. Jon Cruddas, Labour MP for Dagenham, put this very succinctly when analysing labour's pitiful post-Blair election record:

> We failed to re-establish the essential character of the Labour party. We developed a dice-and-slice strategy that balkanized the electorate. Labour only wins when it has a unifying, compelling, national popular story to tell. It has only really won in 1945 ['a country fit for heroes'], in 1964 [on the scientific and technological challenges of the 1960s] and in 1997 [on economic and social modernization, a compelling vision of national renewal].

(Quoted in Toby Helm, 'Jon Cruddas: this could be the greatest crisis the Labour party has ever faced', *Guardian*, 16 May 2015, https://www.theguardian.com/politics/2015/may/16/labour-great-crisis-ever.)

9. The poster was designed by the in-house Conservative team. Widely visible online, it immediately attracted flack for actually being a picture of a German road taken six years before. Why this should be important is debatable, but said a lot about the level of political argument in that period. See: https://www.independent.co.uk/news/uk/politics/tories-use-picture-of-german-road-in-road-to-recovery-election-poster-9956206.html

10. Like Reagan and Thatcher before him, Tony Blair embodied the aspiration of the time by understanding and shamelessly exaggerating the fears and anxieties of that same time. Just as Godzilla embodied Japanese trauma post-Hiroshima and Nagasaki, so every successful story somehow encapsulates the conscious or subconscious fears of its consumers. It's no accident that *Jaws*, arriving post-Watergate, post-Vietnam, post-oil shock, suggested that a dangerous predator lurked underneath an all-American idyll.

11. Quoted in Jeffrey Toobin, 'The Absolutist', *New Yorker*, 23 June 2014 https://www.newyorker.com/magazine/2014/06/30/the-absolutist-2.

12. Most elections are lost by fighting on unwinnable territory. When Labour leader Ed Miliband produced a mug bearing the slogan 'Controls on Immigration' at the party conference in 2016, he immediately attracted outrage from much of his own party, who saw it as deeply racist. It would have been impossible to outrun the Conservative Party by moving to the right. To do so you must pick another battlefield, one where you know you can win. By 2024 that battlefield had become clear: the Tories had made such a mess of their immigration policy that all Labour needed to do was offer order, calm and due process. Control the process, show it can be fair. The trick with then reducing it to a slogan is to allow the audience to infer most of the key elements, figuring out what you can omit to keep words to a minimum. The Labour Party, however, once in power, has to date failed to do any of this.

13. Two years before Britain's Brexit referendum, journalist Phil Collins gave a lecture to a group of professional speechwriters. A veteran of the task himself (for many years he'd worked for Tony Blair), he pointed out that 'Let's Stay the Same' isn't much of a message, and that consequently those who wished to stay in the EU were at an enormous disadvantage. Change is essential to any good narrative. The promise of transformation has a power it's hard to compete with, for that transformation encapsulates two of the most powerful emotions of all: hope and desire. 'Make America Great Again' added to that a sense of righteousness, of paradise lost. Collins's worst nightmare was realized when the anti-EU campaign released their own slogan. 'Let's Take Back Control' pushed it further, out-Trumping Trump.

14. William L. Shirer, *Hitler, The Nightmare Years (1930–1940)* (Little, Brown & Co., 1984).

15. Paul Fusco's photos of Kennedy's train journey are an extraordinary snapshot of an America united in grief. Even more moving now, given our polarized times: https://www.newyorker.com/culture/photo-booth/robert-f-kennedys-funeral-train-fifty-years-later.

16. Quoted in interview with S. Prasannarajan, 'Modi must provide an intellectual alternative', *Open* magazine, 26 November 2014, https://openthemagazine.com/features/india/modi-must-provide-an-intellectual-alternative/?%40Openthemag.

17. Take just one country: France. Here Charlot (Tramp), as Chaplin was called, was a god. The critic Louis Delluc, writing in 1921, described him as more famous than 'Joan of Arc, Louis XIV and Clemenceau', keeping company only with 'Jesus or Napoleon'. And that's just one country. This fame was repeated all around the word. Even before his first major movie, *The Kid*, it's estimated his short films were being watched by 12 million people every day. At that point he was already earning $1.8 million dollars a month (in modern terms) – an amount that would be dwarfed by his later earnings.

18. It remains an absolute tragedy that the only officially available version is the re-release Chaplin sanctioned in the sound era, to which he added an entirely extraneous voice-over. The film historian Kevin Brownlow, to whom our industry owes an incalculable debt, managed to reassemble most of the original (Chaplin had simply thrown it away). If you get a chance, watch that, it's vastly superior. It's very funny, very moving and the ambition, even to a modern audience, is striking. As I write there is news of a new silent version, sanctioned by the Chaplin estate – though unconfirmed at time of going to press.

19. David Thomson on *City Lights*, in *Have You Seen . . .? A Personal Introduction to 1,000 Films* (Allen Lane, 2008).

20. In big British hits like *The Moorside*, *The Salisbury Poisonings* or *Appropriate Adult* the choice of protagonists is instructive. The main agents in the events of each programme are, respectively, KAren Matthews, who kidnapped her own daughter; the FSB, who attempted to murder Russian defectors; and the serial killers Fred and Rosemary West. The protagonists of these adaptations are not as obvious, but each one is perfect: Shannon's betrayed best friend; a director of public health; and a witness to the killer's interrogation. All middle-aged women, none especially remarkable, yet somehow blessed with a special power.

21. Quoted in Mark Olsen, 'Fist in the Face', *Sight and Sound*, November 2000.

22. Jonathan Rosenbaum, film review in *Chicago Reader*, 13 June 2019.

23. As late as 2023, McQuarrie still did occasional screenwriting Q&As on Twitter (now X). This quote is just one of the numerous pearls of wisdom his threads have produced. The depth of knowledge and its articulation are extraordinary. They're wise, funny and overflowing with love for the medium.

24. Spielberg to Tom Cruise at Oscars party, 13 February 2023. (See *Hollywood Reporter*, 14 February 2023, https://www.hollywoodreporter.com/movies/movie-news/steven-spielberg-tom-cruise-top-gun-maverick-1235325800/.)

25. Of course, you can make a drama as good as Jack Thorne's *Best Interests*, in which the heroine fights to stop the withdrawal of medical treatment from her daughter, brain damaged by a rare form of muscular dystrophy, but only if you understand that the audience will be limited.

26. FX took ten *hours* to tell the Monica Lewinsky story in *Impeachment: American Crime Story*. The first five hours were seen through the eyes of Linda Tripp, one of the most hated people in America. Played brilliantly by Sarah Paulson in a fat suit, she was a great character, but from the first five minutes her monstrosity killed the show dead. You didn't want to be within a million miles of her. To make matters worse they made Monica, with whom it should have been impossible not to empathize, a sap, when in real life she seems anything but. Halfway through, the show switched perspectives, though far too late to save it. Should Elizabeth Holmes be the protagonist of *The Dropout*? Should serial killers lead *The Landscapers*? The answer depends on how it's done and who your audience is, but when ITV decided to tell the story of one of Britain's worst serial killers, Dennis Nilsen, his name may have been the title (*Des*) and David Tennant, who played him, the big starry part, but he wasn't the protagonist. We met him through the eyes of his investigating officer, and it was immediately more compelling.

27. Conversation with author, 2025.

28. You can watch the trailer here: https://www.youtube.com/watch?v=pE7PWSa6oC4.

29. The power of Scorsese's *Taxi Driver* comes from our totally identifying with Travis Bickle: we *do* want what he wants, even though he is clearly a psychopath. In *Killers*, the empathy is more uncomfortable, which is what makes watching it a cold and disquieting experience. So you can do it – of course you can – but you need to work incredibly hard to keep your audience on side. DiCaprio is able (just) to make it work, since his character is as much a victim (of his uncle) as a perpetrator. Spielberg's *Munich* is another fascinating example; it's not a comfortable watch.

30. Personal taste obviously, but it contained questionable performances from its male players, had a passive female lead, and was at least an hour too long. You can believe Scorsese is capable of genius and still admit that *Killers* is a terrible piece of film-making.

31. *Squid Game* became Netflix's most-watched series (surpassing *Bridgerton*) and the most-watched programme in ninety-four countries, attracting more than 142 million member households and 1.65 billion viewing hours in its first four weeks. (Wikipedia, 'List of most-watched Netflix original programming', https://en.wikipedia.org/wiki/List_of_most-watched_Netflix_original_programming.)

32. *Script Apart* podcast, 17 January 2023.

33. Voted on via Ship of Fools website poll, so perhaps not the most rigorously conducted contest. But it is a great joke.

34. The initial programme was nowhere near as polarized as its later proponents became. As Nicholas Lemann writes: 'Reading Recovery itself draws upon both phonics and whole-language theory, but in America it has served as a transmission device for whole-language. Reading Recovery specifically, and whole-language reading instruction generally, spread like wildfire through the education world during the 1980s.' ('The Reading Wars', *The Atlantic*, November 1997, https://www.theatlantic.com/magazine/archive/1997/11/the-reading-wars/376990/.)

35. Figures from National Literacy Review report 2022–23, https://www.thenationalliteracyinstitute.com/post/literacy-statistics-2022-2023. 'Illiteracy has become such a serious problem in our country that 130 million adults are now unable to read a simple story to their children.'

36. 'We're in the midst of a huge war,' one California state legislator told journalist Nicholas Lemann, 'This is worse than abortion.' ('The Reading Wars'). And that was back in 1997, long before Bush got involved and the spiral, which amplified massively as he became more and more unpopular, began. Such is the power of the story shape.

37. Roger Eatwell, 'Community Cohesion and Cumulative Extremism in Contemporary Britain', *Political Quartelry*, 77, April 2006, pp. 204–216, https://researchportal.bath.ac.uk/en/publications/community-cohesion-and-cumulative-extremism-in-contemporary-brita.

38. Anne Applebaum, https://www.anneapplebaum.com/2020/10/30/the-radicalization-is-mutual/

39. I should know – I've made them. The (thankfully) long-forgotten affair on *EastEnders* between Kat, Alfie and Little Mo in 2003 was a great example of a story where, though it lasted a year, none of the characters had anything to do but continually change their minds.

40. Katrin Redfern and Richard Whatmore, 'History tells us that ideological "purity spirals" rarely end well', *The Conversation*, 1 July 2020. The essay, whose authors are historians at the University of St Andrews, is full of other notable examples, which I have paraphrased liberally, though the observation on parallels with story structure is my own.

41. From China to Cambodia, from Syria to England after its civil war, such spirals are universal, and they don't just play out in the royal palaces of the world. You can find them in the church halls where Militant convened, in almost any social justice debate, in the forums of Young Adult fiction, in the school playgrounds and villages of England – and notably in knitting circles too. Reporting on BBC Radio 4, Gavin Hayes told the story of Nathan Taylor, who ran an online knitting circle and, in effort to promote diversity, created the hashtag #Diversknitty. Within months, Taylor went from a champion of intersectionality to a pariah. None of his critics could be anti-racist enough. The online pile-on was so extreme that it led Taylor to a nervous breakdown. As Hayes reported, 'even here, he was accused of malingering, his suicidal hospitalization described online as a "white centring" event.'

42. I remember, during my brief flirtation with the radical left in the 1980s, the fervour with which my comrades shouted 'Traitor!' Anyone who has followed British politics will know it's a catechism of the left, with every leader a target of the charge, from Ramsay MacDonald to Keir Starmer, via Harold Wilson and in particular Tony Blair. In almost all cases, at some level, it signals both a retreat from empirical reality and from a basic understanding of how multi-party democracies work.

43. There are two further lessons we can derive from purity spirals. Firstly, they rely on what Timur Kuran termed 'preference falsification' – lying about what you believe publicly to make yourself look better. In screen-writing terms, a character develops a façade, and characters who develop a façade, rather than shedding one, are tragic – they imagine themselves as heroes, even as they are swallowed by their masks. Like Walter White in *Breaking Bad*, like Macbeth, like Michael Corleone in *The Godfather*, they don't realize they're in a tragedy. As James Baldwin wrote in 1961, 'Nobody is more dangerous than he who imagines himself pure in heart, for his purity, by definition, is unassailable.'

Provable reality is left far behind as the protagonists reach escape velocity from objective truth and float off into an ether of projection and falsification like smoke drifting away from a fire. Such is the power of an intoxicating story. Identity politics seems to be both a classic illustration of preference falsification and an implicit surrender in the face of real-world problems. ('We can't control that but we can control *this*.') Preference

falsification led to the collapse of the Soviet Union, and the collapse of the Soviet Union was directly related to the disaster at Chernobyl. When everyone is lying, no one notices the raging nuclear fire burning ferociously within.

This is key. The opposition is crushed, but the perpetrator too. As Kuran himself noted, public preference falsification inevitably distorts private belief. Private belief is, in fact, the fuel the protagonists set alight to keep the preference falsification burning. They 'triumph' when there is nothing of their insides left to burn. That's a great definition of modern tragedy, in which the triumph is no victory at all. As they stand on their smouldering pyres, these 'heroes' stare out like Ozymandias on the ruins they bestride. Beneath them, Marat lies dead in his bathtub and Michael Corleone sits alone in the forest, the leaves blowing quietly around his feet. The Twitter warrior stands replete, totally self-deceived, atop their empire of dirt.

44. David Hume, 'Of Superstition and Enthusiasm', in *Essays Moral, Political, and Literary* (1742–1754), Essay XII https://web.english.upenn. edu/~mgamer/Etexts/hume.superstition.html. Hume's actual phrase was 'leave the air more calm and serene than before'; I have cited it as in the Redfern and Whatmore edition.

45. Purity spirals are graphic illustrations of the power of antagonism, but there are more nuanced ways of looking at the role of the antagonist too. Joe Biden didn't beat Donald Trump in 2020 because he was more charismatic, he won because he *wasn't* Donald Trump. Spending most of the election period in his basement, when he did surface it was to be seen driving a classic American car or to reminisce nostalgically about his years commuting on an Amtrak train – anything that made him seem as all-American as possible. It was a smart strategy: if people long to kill the monster enough, they'll pledge allegiance to the only hero available. A perfect antagonist (if you can hate the devil enough) can save an otherwise flailing story.

'When they are ordered to carry a message across enemy lines to call off a scheduled attack, two young men have six hours to save 1,600 men.' That's the logline of Sam Mendes' film *1917*, which in 2019 became a critical and commercial juggernaut. It grossed $384.9 million worldwide, and Wikipedia even has a separate page for the awards it received. Can you name the central character? It's hard. Those who follow cinema may well remember the actor's name, but what about the person he is playing? How would you describe him? Could you pin him down in a word, a sentence? Could you define him as a make of car? Or in any way that creates an emotional response? The lack of definition is telling.

What makes *1917* work is partly it's technical mastery (the illusion of

one-shot), but mostly it's the astonishing power of the antagonist. How could you not root for these boys against *that*? How could you not be stirred to the point of distraction by the sheer suicidal nature of their mission?

The Adventures of Tintin is an unorthodox but apposite parallel. Hergé's Tintin has no discernible personality whatsoever – he's a blank sheet of paper, a vague outline of the young boys who were its original target audience. This didn't matter, however, because he was surrounded by a carousel of colourful grotesques. If the monster is big enough, then staying in the basement is enough, too. Indeed, there's a powerful argument for not colouring in heroes at all: any detail makes them less like *us*. Let's counter that argument, though. Imagine *1917* with a living, three-dimensional character instead of a blank slate designed to motivate the camera moves. Transplant Martin Sheen from *Apocalypse Now* or Christopher Walken from *The Deer Hunter* into that film. Imagine a character wrapped in internal conflict who *changed*.

If the most powerful stories are orgiastic, they must on some level be tapping into something deep and dark. We may not pay to watch gladiators in the Colosseum anymore, but the primal desire to do so has never gone away. Darkness, conflict, warfare, excess, ecstasy, violence will always win over a sensible-looking man driving an American car.

If a great antagonist can save a film or a campaign, the lack of one can destroy it.

'Is that all we desire from a movie, though—that it should agree with us, and vice versa?' mourned *New Yorker* movie critic Anthony Lane ('Steven Spielberg's Ode to Journalism in "The Post"', *New Yorker*, 8 December 2017, https://www.newyorker.com/magazine/2017/12/18/steven-spielbergs-ode-to-journalism-in-the-post). He was reviewing Steven Spielberg's *The Post*, the story of how the *Washington Post* released the top secret Pentagon Papers that spelled out the true cost of America's war in Vietnam. His point is equally applicable to a raft of post-millennial movies, including *Denial* (taking a Holocaust denier to jail) and *She Said* (the true story of bringing Harvey Weinstein to justice for his multiple sex crimes).

It will sound antithetical to argue this after saying that we must 'give a shit' about what our protagonist wants. But while that's true, we must add something else. The antagonist must be a credible threat; it must kick back. *She Said*, in the winter of 2022, was hyped as the movie of the coming winter, the one all other Oscar contenders would have to be beat, but it died at the box office, taking all award hopes with it. How could that happen? It was ridiculously topical; it was a zeitgeist conversation – a

hashtag – how could it not work after its clear antecedent *Spotlight* did so well? Two things account for this, I think, and both can be laid at the door of *craft*.

The first was that all the disturbing offences were reported. For reasons of taste, and perhaps rightly, everything was off screen. The language of cinema is mimetic. The language of this film was diegetic – we were being *told*. The second was that the characters themselves, or the protagonists, at least, were *always* right. The film was Pinocchio to Pinocchio – puppet to puppet. They never disbelieved, they never struggled, they never asked any difficult questions of themselves at all. They had nothing to *learn*. If you were being kind, you might acknowledge that we agreed with them, but in a rather passionless way (where was the internal struggle?). If you were being harsh, they were MAGA caricatures of smugness: well-paid, powerful people in lovely jobs who were always right. That is harsh, but for a film to work, the antagonist needs to be a clear and present danger – it needs to threaten to kill you unless you kill it. Yes, we should be desperate to defeat it, but that alone doesn't stimulate an emotional response. What does do that is fear: a terrible beast slouching imperturbably towards you. Fear that forces you to change.

Compare *She Said* to *The Assistant*. Released in 2019, it told the same story from the point of view of an entry-level assistant (Jane) working for a company a lot like Miramax and a terrifying boss not unlike Harvey Weinstein. In both movies the monster remains unseen. In *She Said* he's represented by lawyers and victims who are scared to talk, but in *The Assistant* his absence is used in a completely different way. He's invisible, but *everywhere*. Every single thing Jane does could incur the monster's wrath. Everyone is terrified, so terrified the fear remains unspoken. It's just *there* – he is the air.

That's a completely different kind of antagonist. It turns the movie from a docu-drama into *A Quiet Place*: one sound and you're dead. *She Said* and *The Assistant* are polar opposites – one is anaemic and self-satisfied, the other pulsing with fear and dread. Ecstasy and violence again. You love Jane with all your heart, you are desperate for her to vanquish the foe with a biblical vengeance, but the fear comes from the fact that the monster is all around her (and thus you), and has already left an army of dead and injured in his wake.

'Is that all we ask for in a film, that it agrees with us?' Well, yes, but only after a long battle, where that argument is combat-tested to the point of destruction. Don't kick a dead dog. That's not a story. Kick a dog and wound it, that's how the perfect story begins. It's what makes the heart start pumping. It's life.

46. Richard Hofstadter, *Anti-intellectualism in American Life* (Alfred A. Knopf, 1963). The book won the 1964 Pulitzer Prize for General Nonfiction.

47. When Pele died, most commentators declared him 'one of the greatest footballers in the world', mindful – no doubt wary of slighting Maradona or Messi – of declaring him 'the greatest'. It's a noble sentiment but it refuses to understand that Pele was from a different time. Watch his matches from the 1970s if you can. He is so far ahead of everyone on the pitch he seems to be from a different planet. That's what the script and execution of *Citizen Kane* feel like. If it seems less remarkable now, it's only because everyone copied it and caught up.

48. Seventy years later Guy Ritchie borrowed this idea for a ridiculously expensive Nike advert, 'Take It to the Next Level': https://www.youtube.com/watch?v=lZA-57h64kE.

49. In 1941 Welles issued a fascinating press release, attempting to plead that Kane wasn't based on William Randolph Hearst. The whole thing is worth reading. About Rosebud, he says this:

> The device of the picture calls for a newspaperman (who didn't know Kane) to interview people who knew him very well. None had ever heard of 'Rosebud.' Actually, as it turns out, 'Rosebud' is the trade name of a cheap little sled on which Kane was playing on the day he was taken away from his home and his mother. In his subconscious it represented the simplicity, the comfort, above all the lack of responsibility in his home, and also it stood for his mother's love which Kane never lost.
>
> In his waking hours, Kane had certainly forgotten the sled and the name which was painted on it. Casebooks of psychiatrists are full of these stories. It was important for me in the picture to tell the audience as effectively as possible what this really meant. Clearly it would be undramatic and disappointing if an arbitrary character in the story popped up with the information. The best solution was the sled itself. Now, how could this sled still exist since it was built in 1880? It was necessary that my character be a collector – the kind of man who never throws anything away. I wished to use as a symbol – at the conclusion of the picture – a great expanse of objects – thousands and thousands of things – one of which is 'Rosebud.' This field of inanimate theatrical properties I wished to represent the very dust heap of a man's life.

('Press statement issued by Orson Welles regarding his forthcoming motion picture entitled, *Citizen Kane*, which will be released by RKO-Radio Pictures', 15 January 1941.)

50. Annoyingly the episode was never made – one of the key actors was ill.

51. Francis Schaeffer (who is billed as Franky Schaeffer V in the credits of the original film) later reflected on his father's rightward trajectory:

> So how did Dad move from this guy to this guy? It's because of the abortion issue. It's because of *Roe v. Wade*. Had it not been for that, he would be remembered as a somewhat obscure, slightly-to-the-left, interesting cultural anomaly, a guru who had this following, who loved art and music and Jesus, and that would have been the end of it.

(Interview with Frank Schaeffer, *God in America*, PBS, 23 October 2009, https://www.pbs.org/godinamerica/interviews/frank-schaeffer.html.)

52. Ibid.

53. Ibid. Schaeffer continues: 'Their whole reaction was: "What do you mean? That's a Catholic deal. Why would we take a stand on that when we believe in contraception and all these other things? Isn't that part and parcel of the same deal?"'

54. The path from home movie to totem was, in hindsight, absurdly simple:

> We would go to some place, like [to] Jerry Falwell, and we would talk about abortion, that babies are killed, and they're dismembered, and it's a horrible procedure, and how come we have this, and God must hate this. Part of that convinced people. But what really convinced them was to see how riled up ordinary rank-and-file Americans of all persuasions got, and they looked at that and they said, OK, we have an issue here that will work'

(Ibid.)

55. Ibid.

56. As Schaeffer reflected:

> No matter what we said about abortion itself, the real issue was not abortion. The real issue was winning the cultural war by finding a place you could draw a line in the sand against what was the new left [. . .]
>
> I think the reason why the pro-life movement took off and became huge actually had nothing to do with abortion [. . .] A lot of people were just waiting to draw the line somewhere against this rising tide of secularism they felt encroaching on their space. They wanted to fight back. No one had showed them how, because you had to have an issue around which to coalesce, and abortion was a handy issue.

(Ibid.)

'Handy' is an understatement. Abortion had become a symbol that encapsulated fear of change. To believers it epitomized the savagery of progressive thought.

> There's actually very little in Scripture about abortion. There's not a biblically based argument against abortion in the sense of a text
> I think the real argument is that on the level of an ideal family, it's the same argument about premarital sex and all these other things. It's that here is the biblical ideal: one man, one woman, your children and so forth. This is the tradition; this is what everybody's always done. And in that context, abortion is wrong morally because of the connotation of kind of a casual approach toward sexuality.

> (Ibid.)

Schaeffer was to regret his actions in later life. He watched helplessly as the purity spiral he had engendered escalated: 'The whole mentality shifted. It was no longer about the issues. It was about access to power. It was about maintaining an enemies list that keeps you green and fertile and a happening cause. And that's where it all changed . . .' Frank was to become an arch-enemy of the American right. He and his father were genuine, middle-of-the-road Christians, a marriage of old America and new. was a gifted speaker; the son had mastered a new technology. They came together to create a story so insanely powerful that it could bring the country to civil war, but in the process destroy them too. Frank stole fire from the Gods and out of that forged a perfect story. The Gods didn't forget and came to collect – fulfilling the promise of an older Greek tale.

57. Andy Griffith and Don Knotts talking on the *Today Show*, NBC, 4 March 1996.
58. Norman Mailer, *The Presidential Papers* (Penguin, 1964).
59. Sinclair Lewis, *It Can't Happen Here* (Jonathan Cape, 1935).
60. Jonathan Freedland, 'Welcome to the Age of Trump', *Guardian*, 19 May 2016, https://www.theguardian.com/us-news/2016/may/19/welcome-to-the-age-of-trump. Freedland continues:

> For his followers, Trump's willingness to trample on the pieties of civic discourse is a sign of his bona fides, even a statement of intent. If he's prepared to say *that* about Carly Fiorina's face, maybe he'll be prepared to come down hard on an American company about to relocate a manufacturing plant from the US to Mexico. After all, he's clearly not fettered by the restraints that hold back the rest of those politicians.

> The idea of the maverick is a powerful myth, and not one only used

by conservatives. Many years before a similar story could be found on the political left.

On 14 February 1884, Theodore Roosevelt made a simple entry in his diary. Below a large black cross, he wrote, 'The light has gone out of my life.' His mother and his wife had both died that day, in the same house at the same time. Roosevelt sought solace by escaping to the wilderness, abandoning politics to become a rancher in North Dakota. The life hardened him, and he healed through a process of denial (he would rarely mention his beloved wife again, nor used his daughter's name) and reinvention. When his cattle were wiped out in the savage winter of 1886, he took it as a signal to return. His colleagues were sniffy, and thought they could hijack his ambitions by giving him the cul-de-sac job of Vice President, but then President McKinley was assassinated by an anarchist, and the top job was his. Roosevelt was no outsider; he was the scion of a dynasty, but in seeking to heal his emotional pain he had given himself a different origin myth. Just like Trump, he could now present himself as the outsider, the maverick. Unlike Trump, he knew how to govern, and if you only count his creation of the great national parks and sweeping anti-trust laws, he really did destroy the old order and replace it with something new.

61. Aldous Huxley, *Crome Yellow* (Chatto & Windus, 1921).

62. René Girard, *I See Satan Fall Like Lightning* (Orbis Books, 2001).

63. We hanker for definition, and those most like us threaten us most of all. Most successful stories, if not built on revenge, are built on 'This is me.' (Every superhero story ever written, for example.) Any threat to identity, if realized well, provokes huge outpourings of emotion.

64. The documentary *Best of Enemies* pinpointed a moment where this sentiment, tapped into by both sides, became a tipping point in our own political discourse. A struggling network, ABC, decided to stage a series of debates between William Buckley and Gore Vidal, alpha spokesmen for right and left, to fill airtime cheaply during the political conventions of 1968. The two despised each other so profoundly that the debates erupted into violence, and thus consequently the public consciousness. As Buckley called Vidal a 'goddamn queer' and Vidal parried with 'crypto-Nazi', the tree of ratings, watered by the blood of its victims, grew exponentially. ABC topped the ratings and punditry morphed into the promise of violence. Morally, this may be distasteful, but distaste doesn't negate the fact. That Buckley and Vidal were absolute opposites – 'matter and antimatter' someone said – helped enormously.

65. Richard Hofstadter, 'The Paranoid Style in American Politics'. The essay was first delivered as a lecture in 1963, then printed in *Harper's* magazine

in 1964 and then published in book form: *The Paranoid Style in American Politics, and Other Essays* (Alfred A. Knopf, 1965).

66. Back in 1964, Hofstadter predicted what might happen if America wasn't careful. He feared that the paranoid strain might well be 'a persistent psychic phenomenon' and that there were certain circumstances where these would become particularly inflamed.

> Perhaps the central situation conducive to the diffusion of the paranoid tendency is a confrontation of opposed interests which are (or are felt to be) totally irreconcilable, and thus by nature not susceptible to the normal political processes of bargain and compromise.

He may not have realized this, but Hofstadter was outlining the very process in which stories evolve. Protagonist and antagonist derive their power from opposition. Every event invites the observer to define the two key criteria, and then story structure demands those two elements become increasingly polarized. In a story, of course, there is resolution. One hopes there is in life too. Hofstadter warns:

> The situation becomes worse when the representatives of a particular social interest – perhaps because of the very unrealistic and unrealizable nature of its demands – are shut out of the political process. Having no access to political bargaining or the making of decisions, they find their original conception that the world of power is sinister and malicious fully confirmed.

(Hofstadter, *The Paranoid Style in American Politics*)

That's what a large number of people felt, that they were shut out of the story. At that point discontent escalates into rage and a particularly quixotic spell is cast. The crowd don't demand leaders, they demand gurus. Offence starts to pickle into cult. The forces of antagonism must increase. Story structure demands it.

There is a moment of great importance here, where the parasocial relationship starts to become more intense, moving from something healthy to something more religious. It's a subject Sinclair Lewis was clearly excited by. In the film of his novel *Elmer Gantry*, Burt Lancaster brings to life a fake evangelical preacher, a character who, in his shamelessness and brilliance, more than resembles Trump. The line between story, cult and religion is a direct one, as I hope this book makes clear.

67. In early 2024 the ITV drama *Mr Bates vs The Post Office* dramatized the story of many of the sub-postmasters who, victims of a faulty IT system, were falsely accused, tried and jailed for theft of public funds. It became a

major talking point in Britain, leading to both changes in the law and exoneration for the accused. The waves of anger the programme unleashed came from that very same sense of ecstasy and violence against the perpetrators, in particular the Post Office CEO at the time, Paula Vennells. It's easy to think of this rage as a base emotion refined palates should avoid (and, rationally, perhaps we should just let due diligence do its work). However, it is central to all of the most powerful stories.

CHAPTER 4

1. From 'The Scaffolding of Rhetoric', 1897. Full speech here: https://winstonchurchill.hillsdale.edu/the-scaffolding-of-rhetoric/.

2. Multiple sources: V-Dem Institute Democracy Report 2023; Tony Blair Institute for Global Change Global Populism Database; International IDEA Global State of Democracy Report 2023. As of 2024, some estimate as many as 2–2.5 billion.

3. See: https://www.theguardian.com/world/ng-interactive/2019/mar/06/revealed-the-rise-and-rise-of-populist-rhetoric.

4. 'Guo Yunfei, President of the Data Engineering College of the PLA's Strategic Help Forces, argued in 2020 that of the bodily, data, and cognitive domains, it's the cognitive area that would be the final area of army confrontation between main powers.' (Colonel Koichiro Takagi, 'The Way forward for China's Cognitive Warfare: Classes from the Battle in Ukraine', *Special Forces News*, undated, https://www.specialforcesnews.com/the-way-forward-for-chinas-cognitive-warfare-classes-from-the-battle-in-ukraine/. Original source (in Mandarin): http://www.81.cn/xue-xi/2020-06/02/content_9826822.htm.)

5. This problem is far bigger than we give it credit for. A document leak from 2025 gave a startling glimpse into the activities of Russia's Social Design Agency (SDA), their unit that specializes in psychological warfare. The Swedish government's Psychological Defence Agency (PDA) shows how one small country is fighting back, but their study is chilling. As Edward Lucas wrote in *The Times*, 'China's digital surveillance state is known for its big brother controls of Chinese citizens. But it is turning outwards to scrutinise and manipulate behaviour in foreign countries. Similarly the Kremlin, with its cynical spin doctors, rent-a-mobs and endemic fakery, is using on foreigners tricks it fine-tuned on Russians.' Quoting the Sweden's PDA, he continues, 'The aim is to create populations "divided, fearful, and malleable to cognitive and informational manipulation" [. . .]' 'When we believe that nothing is

true, nothing is private, nothing is trustworthy and nothing matters,' Lucas concludes, 'we become pushovers for our foes. Beyond the land, sea and air domains, mind warfare looms.' There are many tactics at play, but social media is the most easy to manipulate. It has opened the gates of the West to any malignant actor. How gleefully we wave at the big wooden horse as we pull it within our gates. (Edward Lucas, 'The West is Taking the Fight to Russia Online', *The Times*, 18 January 2025, https://www.thetimes.com/comment/columnists/article/the-west-is-taking-the-fight-to-russia-online-p7f5blx5z.)

6. Quoted in Jeffrey Goldberg, 'The Obama Doctrine', *The Atlantic*, April 2016, https://www.theatlantic.com/magazine/archive/2016/04/the-obama-doctrine/471525/#3.

7. Tucker Carlson, @TuckerCarlson, Twitter, 14 March 2023, https://twitter.com/TuckerCarlson/status/1635446265692532738.

8. Both quotes from the 'Why Men Seek Danger' episode of the podcast *Honestly with Bari Weiss*, 16 March 2023.

9. I am grateful to John Collee for this insight.

10. 'Initially, *Scarface* was neither a blockbuster nor critical success,' writes Morgan Jerkins in an article on the appeal of Italian American protagonists to Black audiences:

> Since then, however, the story of Tony Montana has reached an almost-mythical status – one that Boyd [Dr. Todd Boyd, professor of cinema and media studies in the University of Southern California School of Cinematic Arts] attributes to Black people, particularly rappers: 'The film really put up when it was put out on VHS and it appealed to many rappers, particularly from the West Coast. The whole gangster element of hip-hop, which is linking the streets to the culture, a film like *Scarface* is very much a part of that. The film's a cautionary tale . . . but I also thought one of the reasons many Black people like *Scarface* is because it's biblical.'

> (Morgan Jerkins, 'The Outsiders', *Vanity Fair*, 25 September 2023, https://www.vanityfair.com/hollywood/2023/09/italian-american-film-black-audiences.)

11. Tom Peck, 'TV Review', *The Times*, 18 October 2024.

12. From the late eighteenth century, the United States had largely followed a policy of political isolation. Roosevelt had long wanted to stand up to the emerging Nazi threat (he pioneered the Lend-Lease scheme that bailed out his future allies in 1941), but he knew he couldn't convert American opinion. On 7 December 1941, all of that changed.

If Roosevelt is still held up as a great president (even Reagan, while dismantling almost all of Roosevelt's work, admired him enormously) then part of the reason is that he was a president who was continually gifted a transcendent cause. Elected on the back of the catastrophic Wall Street Crash, his New Deal, in the words of Raymond Moley, 'saved capitalism in eight days'. If it was faltering again by 1939 then the growing menace of war gave Roosevelt purpose again.

13. Special mention should be made here of Taylor Sheridan, who in 2024 was running no less than eight different shows, all descended from the huge success of *Yellowstone*, all massive hits and all catering for a middle-American (and not just Republican) audience that had substantially been left behind. If you leave such a gaping hole in your programming, you are creating an enormous opportunity. Sheridan and Paramount Plus saw this in the US; in Britain we're still waiting for someone to realize just how much of our traditional audience has been left behind.

14. The speech was written by then junior staffer Peggy Noonan, in her own words 'a little schmagoogie in an office in the Old Executive Office Building'. The last two lines are a quote from the poem 'High Flight' by John Gillespie Magee, a nineteen-year-old World War II pilot, who wrote it shortly before he died. This is the full speech:

> Ladies and gentlemen, I'd planned to speak to you tonight to report on the state of the Union, but the events of earlier today have led me to change those plans. Today is a day for mourning and remembering.

> Nancy and I are pained to the core by the tragedy of the shuttle *Challenger*. We know we share this pain with all of the people of our country. This is truly a national loss.

> Nineteen years ago, almost to the day, we lost three astronauts in a terrible accident on the ground. But we've never lost an astronaut in flight; we've never had a tragedy like this. And perhaps we've forgotten the courage it took for the crew of the shuttle; but they, the *Challenger* Seven, were aware of the dangers, but overcame them and did their jobs brilliantly. We mourn seven heroes: Michael Smith, Dick Scobee, Judith Resnik, Ronald McNair, Ellison Onizuka, Gregory Jarvis and Christa McAuliffe. We mourn their loss as a nation together.

> For the families of the seven, we cannot bear, as you do, the full impact of this tragedy. But we feel the loss, and we're thinking about you so very much. Your loved ones were daring and brave, and they had that

special grace, that special spirit that says, 'Give me a challenge and I'll meet it with joy.' They had a hunger to explore the universe and discover its truths. They wished to serve, and they did. They served all of us.

We've grown used to wonders in this century. It's hard to dazzle us. But for twenty-five years the United States space program has been doing just that. We've grown used to the idea of space, and perhaps we forget that we've only just begun. We're still pioneers. They, the members of the *Challenger* crew, were pioneers.

And I want to say something to the schoolchildren of America who were watching the live coverage of the shuttle's take-off. I know it is hard to understand, but sometimes painful things like this happen. It's all part of the process of exploration and discovery. It's all part of taking a chance and expanding man's horizons. The future doesn't belong to the fainthearted; it belongs to the brave. The *Challenger* crew was pulling us into the future, and we'll continue to follow them.

I've always had great faith in and respect for our space program, and what happened today does nothing to diminish it. We don't hide our space program. We don't keep secrets and cover things up. We do it all up front and in public. That's the way freedom is, and we wouldn't change it for a minute.

We'll continue our quest in space. There will be more shuttle flights and more shuttle crews and, yes, more volunteers, more civilians, more teachers in space. Nothing ends here; our hopes and our journeys continue.

I want to add that I wish I could talk to every man and woman who works for NASA or who worked on this mission and tell them: 'Your dedication and professionalism have moved and impressed us for decades. And we know of your anguish. We share it.'

There's a coincidence today. On this day 390 years ago, the great explorer Sir Francis Drake died aboard ship off the coast of Panama. In his lifetime the great frontiers were the oceans, and an historian later said, 'He lived by the sea, died on it, and was buried in it.' Well, today we can say of the *Challenger* crew: Their dedication was, like Drake's, complete.

The crew of the space shuttle *Challenger* honored us by the manner in which they lived their lives. We will never forget them, nor the last

time we saw them, this morning, as they prepared for their journey and waved goodbye and 'slipped the surly bonds of earth' to 'touch the face of God'.

('Address to the Nation on the Explosion of the Space Shuttle *Challenger* January 28, 1986.' Ronald Reagan Presidential Library. https://www.reaganlibrary.gov/archives/speech/address-nation-explosion-space-shuttle-challenger (accessed 24 June 2025).)

15. A recording of the speech is available here: https://www.youtube.com/watch?v=Qa7icmqgsow.

16. Allen Carr, *Packing IT in the Easy Way* (Penguin, 2005).

17. It doesn't have to be this overt, this genre-based or even feature a character at all. In the third season of *The Crown*, Episode 9 ('Imbroglio') begins with a shot of fluffy clouds which slowly part to reveal the white cliffs of Dover. We hear radio chatter, and as the camera slowly tracks back it reveals two pilots talking to ground control. We are on a plane flying towards England. The camera continues its journey away from the cockpit and into the rear of the plane, creating mystery and uncertainty. *Where is it going? What are we supposed to be looking at?* Then we see it: the edge of the Royal Standard. As the camera quietly finishes its long retreat, the mystery is finally revealed. The flag is draped over the coffin of Edward VIII. The monarch who abdicated is returning to England for the last time. It's strangely moving and a classic subversion – only not, this time, for the characters, but for the viewer alone. You start with something blithe and pastoral and slowly twist it.

18. For example, *Star Wars: A New Hope* is a three-act film, and the first act also has three acts within it: Luke receives the distress call from Princess Leia, goes and asks Obi-Wan Kenobi what to do about it and returns to find his step-parents have been murdered by Darth Vader.

19. David Gross, Twitter (post now private), https://twitter.com/davidgrosstv/status/1582490013601697793?s=58&t=8Z2jToj3h-cK4onu7JAmFQ.

20. Shane Black, 'Scriptwriters Network Newsletter (June 1992)' quoted by William Martel in David Trottier, *The Screenwriter's Bible,* 3rd edition (Silman-James Press, 1998).

21. Based on the novel by Walter Tevis, *The Queen's Gambit* is about Beth Harmon's central battle to embrace or reject isolation. Each scene swings one way, then the other, with the stakes getting bigger and bigger as dramatic tension increases.

22. Chris McQuarrie, @chrismcquarrie, Twitter, 15 April 2023.

23. Quoted in *The Witch Trials of J. K. Rowling* podcast, Episode 2 (Free Press,

February–March 2023, produced by Andy Mills, Matthew Boll and Megan Phelps-Roper).

24. Frank Cottrell-Boyce, 'When we asked the Queen to tea with Paddington, something magic happened', *Guardian*, 11 September 2022, https://www.theguardian.com/commentisfree/2022/sep/11/when-we-asked-queen-to-tea-with-paddington-something-magic-happened-most-lovely-goodbye.

25. Much of this work is drawn from an invigorating conversation with Professor Sophie Scott (CBE), Director of the Institute of Cognitive Neuroscience at UCL.

26. King was actually paraphrasing part of a sermon delivered by the abolitionist minister Theodore Parker in 1853: 'I do not pretend to understand the moral universe. The arc is a long one. My eye reaches but little ways. I cannot calculate the curve and complete the figure by experience of sight. I can divine it by conscience. And from what I see I am sure it bends toward justice.' The phrase gained common currency through its continual use by President Obama.

27. 'Now, here comes the science bit – concentrate!' is the line Jennifer Aniston delivered in a memorable shampoo advert that a whole generation will remember. No one actually concentrated, but the fact that it was there somehow validated her claim that she was 'worth it'. It gave her argument the failsafe backing of logic and reason.

28. If you are a demagogue, then, you can argue that suppression of wages, rising crime, dwindling community cohesion and increases in unwanted pregnancies are a result of immigration. It has no more validity than the 'arc of moral justice' but it appeals to a very basic pseudo-rationality: if there are only so many jobs, and there are a ton of people willing to work cheaper than us, in the famous words of the fictional bigot Alf Garnett, 'It stands to reason, dunnit?' even though rational analysis doesn't back this up at all. Alf was once the biggest character on British television; Archie Bunker was the American version. In an illustration of kairos, it's very hard to imagine either existing now.

29. The argument in *Jurassic Park* is embedded in two characters. Alan Grant (Sam Neill) is completely distrusting of technology and the future, a point underscored by his dislike of children. John Hammond (Richard Attenborough) is the opposite: he loves children, and the future. 'Spare no expense!' is everything. When the dinosaurs break out, the two are split up and both beliefs are tested. Grant has to look after Hammond's grand children, while Hammond has to deal with the fact that the dinosaurs he has brought back to life are destroying everything he has just built. Who is right? The film hedges its bets. Hammond realizes that the cost of progress is too high,

while Grant accepts that technology can be a good thing. All things, the
film tells us, are fine in moderation.

30. The BBC's bid was helped hugely by one monstrous error made by ITV
(then led by David Liddiment): moving their long-scheduled *News at Ten*.
For years, the BBC had broadcast their own news at 9 p.m., running their
dramas afterwards at 9:25, while ITV had a clear hour from 9 p.m. for
dramas. This gave ITV a huge advantage, as drama always beats news.
However, when ITV decided to move their news to 10.30, the BBC saw
an open goal and quickly moved their news to 10 p.m., giving themselves
a 9 p.m. start for dramas. That decision by the BBC's Director General
Greg Dyke really altered the entire drama landscape, bringing forty years
of ITV monopoly on popular drama to an end.

31. Helen Lewis, 'The Bluestocking vol 162', Substack, 6 November 2020,
https://helenlewis.substack.com/p/the-bluestocking-vol-162. Earlier in
the newsletter, Lewis observes: 'The uncomfortable undertone of *Life on
Mars* was always "they're awful, but you like them". The 70s coppers are
unashamedly sexist – "you look whiter than a ginger bird's arse", telling
the lone WPC to strip, etc. etc. – and we are supposed to feel nostalgic for
the time when you didn't need a warrant to kick down a rapist's door.'

32. Announced by Jim Lee, chief creative officer and publisher of DC, at a
virtual event for fans in October 2021.

33. Harold Lloyd was once the biggest star in the world. In 1924 he embodied
everything America believed in – be humble, be resourceful, you will
succeed and get the girl. A hundred years later, however charming his
films may seem, that dream is dead.

34. For those too young to remember, *M*A*S*H* told the story of American
army surgeons in Korea. Really, though, it was about the victory of
American courage in Vietnam. It was huge, not just in America but around
the world. It ran for 256 episodes over eleven seasons, and the final episode,
'Goodbye, Farewell and Amen', became the highest-rated television
episode in US history with an extraordinary 125 million viewers. A testament
to the lessons pioneered by Chaplin: timing, comedy and emotion.

35. Robert Towne, the legendary screenwriter of *Chinatown*, also did a silent
pass on *The Godfather*, writing the scene with Don Corleone and Michael
in the garden two-thirds of the way through the film. Commenting on
one of the reasons the film struck such a chord, he said that, at the time:

> [. . .] when we felt families were disintegrating, and our national family,
> led by the family in the White House, was full of backstabbing, here
> was this role model of a family who stuck together, who'd die for one

another. The real appeal of the movie was showing family ties in a setting of power. It was really kind of reactionary in that sense – a perverse expression of a desirable and lost cultural tradition, filling people with longing for a family like that, a father who not only knew what was best but, if a guy was giving you a hard time, could have someone kill him.

(Quoted in Michael Sragow, 'Godfatherhood', *New Yorker*, 16 March 1997, https://www.newyorker.com/magazine/1997/03/24/godfather-hood?ref=quillette.com)

36. *Mr Bates vs The Post Office* offers a similar encapsulation. Ethos: a lovingly dogged central character who is wronged and sets about doing right. Pathos: the central characters suffer a terrible injustice at the hands of an unfeeling bureaucracy. And logos? That the prosecution feels fundamentally outrageous and wrong. As for kairos: the timing was perfect. At the beginning of January, the population was largely off work, with no other big news stories to steal attention. (Also, as the executive producer Patrick Spence acknowledged, it tapped into a wider and growing anger about how far Britain had fallen over the previous thirteen years, and how corrupt it had become). Finally, telos: the point could not have been clearer – justice. The drama also simplified the villains and never really (perhaps for legal reasons) went into any motive other than that the baddies were bad.

37. *Rhetorica ad Herennium*, where the principles first appeared, was traditionally credited to Cicero, but more recent studies suggest that he was not the author, who remains unknown.

38. Full text may be found here: 'Remarks by the First Lady at the Democratic National Convention, July 25, 2016', https://obamawhitehouse.archives.gov/the-press-office/2016/07/25/remarks-first-lady-democratic-national-convention.

39. Philip Collins, former *Times* columnist and speech writer for Tony Blair, wrote a useful guide to speechwriting, *The Art of Speeches and Presentations* (Wiley and Sons, 2012). Every speech is an argument, he points out, as is every drama. Can you reduce it to a line? A paragraph? Can you argue against it? If not, it's no good. Structurally he suggests using Cicero's five canons of persuasion:

1. Introduction – Set your goal, decide your tense and tone of voice and get to the point
2. Narration – A statement of the most pertinent facts
3. Proof – The corroboration and illustration of the superiority of your point

4. Refutation – destruction of the opposing point of view
5. Conclusion – Restate your case and lead to an emotional pay-off

Collins also reminds us of Churchill's own template for writing speeches, which has as much application to screenwriting as it does to rhetoric:

1. Strong Beginning
2. One tight theme
3. Simple Language
4. Word Pictures – think of 'Iron Curtain'
5. Emotional Ending

Such are the parallels with screenwriting, Collins's book could easily double as a very handy guidebook to the art.

40. The speech by Martin Luther King that marked the centre-point of the march on Washington for jobs and freedom in August 1963 needs no introduction. It is rhetorical fireworks, and its perfect combination of not just ethos, pathos and logos but kairos and telos too, has ensured its place in history. Less well noticed is its underlying structure:

A: The Greatest Demonstration for Freedom
 B: The Emancipation Proclamation
 C: An Exile in His Own Land
 D: Honoring This Sacred Obligation
 E: Stand on the Warm Threshold which leads to the Palace of Justice
 F: Our Struggle on the High Plane of Dignity and Discipline
 F': Justice Rolls Down like Waters and Righteousness like a Mighty Stream
 E': Veterans of Creative Suffering; Unearned Suffering is Redemptive
 C': Let Us not Wallow in the Valley of Despair
 D': I Have a Dream
 B': We Will Be Free One Day
A': Let Freedom Ring

Sections C and D don't quite balance, but even so the chiasmus is remarkable given that King extemporized much of the speech on the day.

41. Caitlin Moran, 'I'm Kicking Butts', The Times, 1 April 2017, https://www.thetimes.com/life-style/article/caitlin-moran-im-kicking-butts-lq25dhtxo.
This is the full column:

I started smoking because I had to. I literally did. I was the youngest person at an adult-education centre – 16, and home-educated for the past 5 years. Everyone else was a grown-up – in their thirties, forties and fifties – all attracted to this part-time course on film and media because a) it was a pretty cool thing to do, and b) you got a free bus and rail pass for the entire West Midlands, and that was a pretty cool thing to do, too. To get free buses and trains to Dudley and Bilston. To *Birmingham*.

On the first day, we were given our induction – toilets, place to hang coats and a guide to the drinks machine, which vended coffee that tasted of tea, tea that tasted of coffee, and something that was supposed to be soup but turned out to be a paper cup with a clump of savoury matter at the bottom. This never actually turned into soup, no matter how much you stirred it with one of the three battered teaspoons left on the side.

They showed us the camera, the edit suite, the lights. 'There are two kinds of lights,' our teacher – a tiny, kick-ass woman – told us. 'These are called "blondes" and these are called "redheads". That's because all lighting men are sexist.'

'Right *on*,' I mouthed, because I'd recently read *The Female Eunuch*.

'And now, you've got a ten-minute break,' she said. And everyone got themselves a cup of not-tea, not-coffee or not-soup, and went outside for a fag.

And because I did not smoke, I stayed inside, next to the drinks machine, and heard them all outside, introducing themselves to each other, chatting and borrowing lighters and cigarette papers, while I sat there thinking, 'OK, I just have to start smoking, then. That is clearly part of being a grown-up.'

At the end of the day, when everyone went home, I walked across the road to the newsagent, bought a packet of ten Silk Cut – because the Manic Street Preachers had explained that they smoked Silk Cut because, 'That's the working-class woman's cigarette' – sat under a tree and taught myself to smoke. It was *disgusting*. It tasted of pubs and dirty carpets and *brown*.

'People smoke . . . *brown*,' I thought, as I finally worked out how to make the lighter synchronize with the cigarette and produce a small,

orange glow. 'This is *horrible*. No wonder children aren't supposed to smoke. This is a *terrible* thing.' Nevertheless, I persisted.

The next day, at breaktime, everyone went out for a fag, and I joined them.

'Gah, I've been *dying* for this all day,' I said, as I carefully lit up and exhaled, along with everyone else, and started chatting. And I was part of the smoking gang! It worked.

And that was how I learnt how to be around people, and talk, and for people not to notice that I was a virgin child in a large hat, who had never been anywhere or done anything. By smoking. That was my . . . *thing*.

The course ended, but I carried on smoking because, by that point, I was working as a journalist: down to London three times a week to review gigs and interview bands, even though I was still an awkward child in a hat. And to a lonely child, cigarettes felt *magic*. A packet of cigarettes was like a combination of a shield and a sword. It both protected you from awkwardness – because someone smoking a cigarette isn't *lonely*; they're just smoking a ciggie – and cut you free from bad situations: 'Just going to pop outside for a fag.' They were useful. They really were.

This week, I turn 42. My lungs feel like two socks of wet ash; I have to shower the bad smells off me before my kids come home from school. As is often the way with weaponry, my sword and shield feel hopelessly outdated: I can't use them in the modern world. You can't use them at gigs, or in pubs, or in other people's houses any more. They are not useful at *all*. I'm still fighting my teenage awkwardness, but alone, now – on rainy patios and in doorways – so that makes no sense any more. I'm stuck in a moment in 1992. *I'm* the grown-ups I'm trying to impress.

And, when my 16-year-old catches me huffing on one, in my shed, at the bottom of the garden, I'm struck with the terrible fear: 'What if she picks up these old weapons – like a child finding a rusty grenade on a bomb site – thinking, like I did, that this is just part of being an adult? Some awful thing you must learn?'

So, tomorrow, I'm finally giving up smoking. I'm finally going to *allow* myself to be stuck in awkward social situations, and to feel lonely, from time to time. Because, at 16, you *would* rather die than have 5 bad minutes. But, at 42, you think, 'Five bad minutes . . . that is better than no minutes at all.'

CHAPTER 5

1. Siegel and Shuster very quickly realized their mistake and spent most of their lives challenging the decision. By the 1940s they agreed to drop their claim in exchange for $94,000, but in the 1970s Siegel launched a fresh campaign to be properly remunerated, saying:

 > The publishers of Superman comic books, National Periodical Publications, Inc., killed my days, murdered my nights, choked my happiness, strangled my career. I consider National's executives economic murderers, money-mad monsters. If they, and the executives of Warner Communications which owns National, had consciences, they would right the wrongs they inflicted on Joe Shuster and me.

 DC Comics gave each of them a $20,000-per-year annuity, later hiked to $30,000. The film franchise alone has netted over $2.5 billion.

2. When *The Ten Commandments* was first released in 1956, it was accompanied by an introductory film. Elmer Bernstein's score soared across the auditorium, while the title 'Overture' was proudly projected on a red velvet curtain. The music faded as director Cecil B. DeMille parted the curtains and walked to a microphone to address his cinema audience directly:

 > The theme of this picture is whether men are to be ruled by God's law or whether they are to be ruled by a dictator [. . .] Are men the property of the state, or are they free souls under God? This same battle continues throughout the world today.

 The parallel he was drawing with the battle against communism would have been inescapable.

3. During his first election campaign Barack Obama argued that the 'Joshua Generation' had to pick up the baton the 'Moses Generation' had passed on. 'The previous generation, the Moses generation, pointed the way. They took us 90 percent of the way there. We still got that 10 percent in order to cross over to the other side.' (Selma, Alabama, March 2007). As Obama wrote in his bestselling memoir, 'Like many American kids of my generation, I'd had the story of Exodus etched in my brain.' The book's title? *A Promised Land*.

4. Nelson Mandela's *Long Walk to Freedom* is another clear echo.

5. Theodor Herzl, one of the founding fathers of Israel, claimed he had been chosen as a modern Moses to lead the persecuted Jews of Europe back to Palestine; he had been visited, he said, with this knowledge in a dream. The Holocaust and its aftermath are a literal retelling of the founding myth.

6. The shockingly racist notion that any given Western population will be overcome by non-natives. Until May 2023, Tucker Carlson regularly entertained this idea on Fox News.

7. Jerry Siegel, 'A Curse on the Superman Movie', press release, 1975. The full quote reads:

> What led me into conceiving Superman in the early thirties? Listening to President Roosevelt's 'fireside chats' . . . being unemployed and worried during the depression and knowing hopelessness and fear. Hearing and reading of the oppression and slaughter of helpless, oppressed Jews in Nazi Germany . . . seeing movies depicting the horrors of privation suffered by the downtrodden . . . reading of gallant, crusading heroes in the pulps, and seeing equally crusading heroes on the screen in feature films and movie serials (often pitted against malevolent, grasping, ruthless madmen). I had the great urge to help . . . help the despairing masses, somehow.

8. Roy Schwartz, 'Men of Steel: Superman vs Übermensch', *Philosophy Now*, 2022, https://philosophynow.org/issues/148/Men_of_Steel_Superman_vs_Ubermensch. Much of the information here, for which I'm extremely grateful, comes from Roy Schwartz's *Is Superman Circumcised? The Complete Jewish History of the World's Greatest Hero* (McFarland, 2021).

9. Quoted in *'I'm Not a Monster': The Shamima Begum Story* podcast (BBC, 2023).

10. *Good Morning Britain*, ITV, 15 September 2021.

11. Sharmeena Begum had gone to Syria as a fifteen-year-old following the death of her much-loved mother, after which her father had quickly remarried.

12. Text message from Sharmeena Begum to Josh Baker, quoted in *I'm Not a Monster*, Series 2, Episode 10.

13. That need for a narrative is more pressing, of course, when the absence of one is deeply felt. When a hole becomes a vacuum, something truly terrible can occur. William Faulkner's *Light in August* tells the story of Joe Christmas. He's an orphan of mixed race, adopted by a religious fundamentalist who attempts to force that belief system upon him. Christmas kills his foster-father and goes on the run, living under a series of different racial identities. Joe's tragedy, Faulkner tells us, is that he's a man who does not know who he is. That he's shot and castrated at the end tells us a good deal about Faulkner's view of the psychic trauma such a lack of identity can bring. That need to *be* is fundamental to our mental and our

political health. At the same time, it offers us astonishing insights into where stories come from and what a story can do.

14. Normal estimates range between 40 and 80 million. When you count the number of deaths across the world linked to followers of the ideology, it is unimaginable in scale. Sources include: Frank Dikötter, *Mao's Great Famine* (Walker & Company, 2010), which cites 45 million dead during the Great Leap Forward (1958–1962); R. J. Rummel, a democide researcher, who estimates that 'Soviet governments were responsible for the death of 61.9 million of their own people from 1917 to 1987.' *The Black Book of Communism* by Stéphane Courtois et al. (Harvard University Press, 1999), a comprehensive historical account, estimates between 40 and 80 million. These are just the deaths in China, the main causes being the Great Leap Forward famine, Cultural Revolution violence, political purges, forced labour and the execution of perceived class enemies. Outside of China there were roughly an additional 2 million, including approximately 1. 5–2 million deaths in Cambodia (around 25 per cent of the population) caused by the Khmer Rouge; around 17,000 people killed during the Maoist insurgency in Nepal between 1996 and 2006; 6,000–7,000 deaths connected to the Naxalite movement in India since 1996; and approximately 70,000 linked to the Shining Path in Peru between 1980 and 2000. Sources include Ben Kiernan, *The Pol Pot Regime*, (Yale University Press, 1996); 'Truth and Reconciliation Commission of Peru' (2003 report); 'UN Nepal Conflict Report' (2012); South Asia Terrorism Portal.

15. Edgar Snow, *Red Star Over China* (Victor Gollancz, 1937).

16. Julia Lovell, *Maoism: A Global History* (The Bodley Head, 2019).

17. Ibid.

18. Snow, *Red Star Over China*. The rhetoric here is not dissimilar from that of St Paul in Philippians 4:12. Perhaps the borrowing is conscious.

19. Sun Shuyun, *The Long March: The True History of Communist China's Founding Myth* (Penguin Random House, 2008).

20. Ed Jocelyn and Andrew McEwen, *The Long March* (Constable, 2006).

21. Snow, *Red Star Over China*.

22. F. Scott Fitzgerald, 'The Crack-Up', *Esquire*, February 1936. The same point applies to writers – story is, to a great extent, the art of sculpting paradox. To do that you have to see and acknowledge it first.

23. Churchill had a particular problem with India and its people. 'I hate Indians,' he reportedly said. 'They are a beastly people with a beastly religion.' Gandhi was 'a thoroughly evil force' who 'ought to be lain, bound hand and foot, at the gates of Delhi and then trampled by an enormous elephant'.

However, he is also on record saying 'Upwards of two and a half million Indians volunteered to serve in the forces, and by 1942 an Indian Army of one million was in being, and volunteers were coming in at the monthly rate of fifty thousand [. . .] the response of the Indian peoples, no less than the conduct of their soldiers, makes a glorious final page in the story of our Indian Empire.' from *The Hinge of Fate: the Second World War*, Cassell & Co., 1951) It may not pass muster to modern eyes, but there is enough biographical information to make him a much more complex character than either side in the culture wars would like to admit. Empire was at the heart of his identity, and his enemies tended to be those that challenged that.

24. Did Woody Allen sexually abuse his daughter? Was Meghan Markle driven from the royal family by racism? The terrible truth is that we cannot know, because we were neither present while those events were occurring, nor inside the heads of each of the participants or accusers at the time. Almost all news stories get colonized by the tribes of good and bad fighting over what they perceive to be right and wrong.

25. In the 1964 US election, Richard Viguerie quietly revolutionized his country's politics, and thus subsequently the world's. Viguerie employed a gang of workers to illicitly copy many thousands of addresses of people who'd donated more than $50 to the Barry Goldwater campaign. He set about writing to each and every one of them on a regular basis, intending to terrify them about an enemy at the door. As historian Rick Perlstein put it, 'he ended up mastering [. . .] a rhetorical style which is very familiar to viewers of Fox News, in which the apocalypse is right around the corner, and his innovation was to intimate that you could help stop it with a, y'know, $5, $10, $50 donation.' (Rick Perlstein, *Reaganland: America's Right Turn*, Simon & Schuster, 2020.) Viguerie's insight made the donor an active agent in the campaign. It allowed them to insert themselves directly into the battle against godless communism. If you donated you became a warrior against the infidel. It also made him extremely rich.

26. John Collee argues that 'the difference between an origin story and propaganda is simply whether you present your belief as a contest or a self-evident truth. Drama is much more persuasive because it mimics how we form our own beliefs – by wrestling with paradox to arrive at a new way of seeing the world.'

27. The quote appears in Sinclair's account of the 1934 gubernatorial election campaign in California, *I, Candidate for Governor: And How I Got Licked* (Farrar & Rinehart, 1935).

28. A belief system, by its very nature, cannot be true. Its definition is predicated on allowing only existing knowledge, and it is thus closed to

anything that threatens its well-being. The whole purpose of one is to deny epistemological reasoning – to provide you with a world devoid of marshes and deserts, valleys and mountain peaks. All landscape is familiar, which makes you, to the exclusion of non-believers, its master.

29. 'When intelligent people affiliate themselves to ideology, their intellect ceases to guard against wishful thinking, and instead begins to fortify it, causing them to inadvertently mastermind their own delusion, and to very cleverly become stupid.' ('Gurwinder', 'When Smart People Believe Stupid Things', Substack, February 2023, https://gurwinder.substack.com/p/why-smart-people-hold-stupid-beliefs#:~:text=When%20intelligent%20people%20affiliate%20themselves,to%20very%20cleverly%20become%20stupid.) As the process the journalist Gurwinder Bhogal describes starts to take hold – as we move from passive to active, as we distort and exaggerate, as we shape and order a chaotic whiteboard or chalkboard into a perfect grid, as we paint our enemy every darker and make our goal a promised land – then, tribally, we are close to finding the perfect story.

 Collective effervescence plays a fundamental part. If your words can reach a whole group of people and inspire them to a collective action then you're probably doing something very right, even as in real life you're probably doing something quite wrong. All this suggests something else about the nature of stories and their power – something that becomes all too clear when people refuse to ever question their ideological beliefs. For that involves *faith*, and once faith is involved, we have moved quietly into the territory staked out by religion.

 If reading a story is a relatively passive activity and ideology an active one, religious belief goes further. If ideological goals tend to be tangible, religious ones are transcendent; if ideology is belief according to *apparent* logic, religion is belief contrary to empirical thinking. That's what faith *is*. Against all the common-sense information your brain is telling you, you must choose the opposite. You are Luke Skywalker. You must choose the Force.

30. Festinger gave an example of a religious group who had predicted a divine catastrophe, a terrible flood, on a certain date. When the flood failed to arrive, those members of the tribe who were alone started to doubt their belief, while those who experienced the moment together doubled down – it strengthened their feelings. Tribal allegiance is a far more powerful agent than we credit, and when that allegiance invites you to deny objective reality – to have faith – its power is squared. Belief against all rationality, along with the invisibility of the narrative forces working upon you – these are the superpowers that bewitch us all. And that's what gives us Donald Trump.

31. The Samaritans continually warn that one should avoid 'single cause'

narratives when discussing suicide, since taking one's own life is almost always a decision reached when cumulative factors coalesce. This can be true of almost any traumatic event. A very good example of the single-cause fallacy is the rise of the 'trauma plot', the tendency to ascribe current dysfunction to a single traumatic incident in the past (Ray Charles and Johnny Cash, for example, both watch siblings die in *Ray* and *Walk the Line* respectively). For more, see the very good essay by Parul Sehgal in the *New Yorker* here: https://www.newyorker.com/magazine/2022/01/03/the-case-against-the-trauma-plot.

32. Andrew O'Hagan, 'The Tower', *London Review of Books*, 7 June 2018, https://www.lrb.co.uk/the-paper/v40/n11/andrew-o-hagan/the-tower.

33. L. Ron Hubbard, *Scientology 8-8008* (1st edition 1952). Originally typed and duplicated, the third edition was typeset and published by Foundry Press in 1956.

34. C. S. Lewis's remarkable essay 'The Inner Ring' (https://search.app/gwnx8fWMzLNWDut66) outlined how Scientology works six years before it was founded. It explains, by inference, the driving force of story structure, *and* it's beautifully written.

35. Robert Tressell, *The Ragged Trousered Philanthropists* (Grant Richards Ltd, 1914). The 1914 publication was an abridged one, with the full version not being published until 1955.

36. From Durkheim's *The Elementary Forms of Religious Life* (Alcan, Paris, 1912). Quoted in Tara Isabella Burton, *Strange Rites: New Religions for a Godless World* (PublicAffairs, 2020).

37. Burton, *Strange Rites*, paraphrasing Peter L. Berger, *The Sacred Canopy: Elements of a Sociological Theory of Religion* (Doubleday & Co., 1967) and Clifford Geertz *The Interpretation of Cultures* (Basic Books, 1973).

38. Margaret Atwood, 'Am I a Bad Feminist?', *Globe and Mail*, 13 January 2018.

39. *The God That Failed* (Harper & Brothers, 1949) was a collection of six essays by disillusioned ex-communists: Koestler, Louis Fischer, André Gide, Ignazio Silone, Stephen Spender and Richard Wright. It was edited by Labour Party MP Richard Crossman.

40. Yuval Noah Harari, *Sapiens: A Brief History of Humankind* (Random House, 2014, first published in Hebrew, 2011).

CHAPTER 6

1. You see something similar in *Mad Men*. Don Draper is the ultimate example of a reaction formation (itself the process in which the psyche creates its opposite), for he's not really Don Draper at all:

DON DRAPER

APPEARANCE

Rich, sophisticated playboy
In charge of everything he surveys
A man who has everything

REALITY

Dirt poor 'white trash'
A lost soul
A man who is nothing

Frustratingly this internal conflict is all played out by the end of the first season, then discarded as Draper effectively becomes two dimensional. It's a good way of prolonging the series (and making everyone a lot of money) but there was a much more interesting – and shorter – story to be told.

2. *Aliens* (1986) written and directed by James Cameron. Story by James Cameron, Walter Hill and David Giler.

3. *Moonlight* (2016) written and directed by Barry Jenkins. Story by Tarell Alvin McCraney.

4. *Serial* premiered on 3 October 2014, an offshoot of *This American Life*. It was produced by Sarah Koenig, Julie Snyder, Dana Chivvis and Emily Condon.

5. There's an interesting parallel here with the introduction of Quint (Robert Shaw) in *Jaws*.

6. If you do this with the other side, you get a direct inverse – each element an opposite:

1. WHOSE STORY IS IT?	Petrov's side
2. WHAT DO THEY NEED?	To say they are in terrible danger
3. WHAT IS THE INCITING INCIDENT?	Reactor explodes
4. WHAT DOES/DO THE CHARACTER/S WANT?	To insist on the truth
5. WHAT OBSTACLES ARE IN THEIR WAY?	Zharkov's side
6. WHAT'S AT STAKE?	Their lives and the future of the country
7. WHY SHOULD WE CARE?	They see through the myth

8. WHAT DO THEY LEARN?	The falsehood is more comfortable than truth
9. HOW AND WHY?	The power of a good story
10. HOW DOES IT END?	The town will be sealed off; the country will lie.

7. Journalist Nick Cohen described a seminar at London's Institute of Contemporary Arts where Amis addressed an audience of middle-class intelligentsia on this subject: ' "Would all those in the hall who think they are morally superior to the Taliban please raise your hands," he asked. Only a third did.' In a later interview with Cohen, Amis added:

> If you're ideological you've got two people living with you the cheerleader and the commissar, the frowning commissar. The cheerleader kisses you and the commissar pats on you on the back for doing what's necessary to uphold the party line. To be ideological means to fear individuality. You must see safety in numbers, in the herd, so your vanity is always protected. The ideologue can't live by himself; he needs the validation of the like-minded.

> (Quoted in Nick Cohen, 'When Martin Amis Took on the Left', Substack, 22 May 2023, https://nickcohen.substack.com/p/when-martin-amis-took-on-the-left?utm_source=post-email-title&publication_id=721720&post_id=123130751&isFreemail=false&utm_medium=email.)

8. The copied work was 'The Dialogue in Hell Between Machiavelli and Montesquieu', a satire on the widely despised Napoleon III.
9. Adolf Hitler, *Mein Kampf*, translated by Ralph Manheim (Mariner Books, 1999).
10. I am enormously grateful to David Aaronovitch and his book *Voodoo Histories* (Jonathan Cape, 2009) for introducing me to much of this information. It's an invaluable guide.
11. Robert Reinhold, 'The Longest Trial – A Post-Mortem', *The New York Times*, 24 January 1990.
12. Virginia McMartin, the daycare's founder, was arrested on charges of child molestation which were later dismissed. Her daughter Peggy was indicted and held in custody for two years. She was eventually acquitted. The case devastated the McMartin family financially, professionally and personally, with Ray, Peggy's son, spending five years in prison despite also ultimately being acquitted of all charges. Ten years before she died Peggy said, 'I've gone through hell, and now we've lost everything.'

The original accuser, Judy Johnson, was diagnosed with acute paranoid schizophrenia and died in 1986 from complications of chronic alcoholism before the preliminary hearing concluded. Years later, in 2005, one of the alleged child victims, Kyle Zirpolo, admitted he had lied about the abuse, saying 'I remember thinking to myself, "I'm not going to get out of here unless I tell them what they want to hear."'

13. Mostly historically, fortunately. Endorsers include Colonel Ghaddafi of Libya, President Arif of Iraq and King Faisal of Saudi Arabia. The impact of the forgery has been devastating.

14. 'Today it is Palestine, tomorrow it will be one country or another. The Zionist plan is limitless. After Palestine, the Zionists aspire to expand from the Nile to the Euphrates. When they will have digested the region they overtook, they will aspire to further expansion, and so on. Their plan is embodied in the "Protocols of the Elders of Zion", and their present conduct is the best proof of what we are saying.' (From 'The Covenant of the Islamic Resistance Movement', 1988, https://avalon.law.yale.edu/20th_century/hamas.asp.) Hamas itself issued a revised charter in 2017 that removed some (though not all) of the most explicitly antisemitic rhetoric).

15. Christopher Hitchens, *Hitch 22: A Memoir* (Atlantic Books, 2010).

16. Quoted in interview with *New York World*, February 1921.

17. Nikhil Sonnad, *Quartz*, 29 June 2017, https://qz.com/1010684/all-the-wellness-products-american-love-to-buy-are-sold-on-both-infowars-and-goop.

18. See: https://www.businessinsider.com/what-is-a-vaginal-egg-goop-lawsuit-2018-9?r=US&IR=T.

19. Bill Wilson, *Alcoholics Anonymous Comes of Age* (Harper & Brothers, 1957). Wilson founded AA with Bob Smith in 1937. They met as fellow alcoholics and members of the Christian revivalist Oxford Group.

20. Arthur L. Greil and David R. Rudy, 'Conversion to the World View Of Alcoholics Anonymous: A Refinement Of Conversion Theory', *Qualitative Sociology* Vol. 6, No. 1, 1983. I first came across the quotation in 'Is Alcoholics Anonymous a Religious Organization?: Meditations On Marginality', *Sociology of Religion* Vol. 50, 1988. I am grateful to Greil and Rudy for leading me to the other quotes on AA mentioned here.

CHAPTER 7

1. John McPhee, 'Structure: Beyond the Picnic-Table Crisis', *The New Yorker*, 6 January 2013, https://www.newyorker.com/magazine/2013/01/14/structure.

2. The final piece, 'The Pine Barrens', was about the vast forest of pine trees, cedars and oaks in New Jersey. It was later published in book form with the same title. https://www.newyorker.com/magazine/1967/11/25/the-pine-barrens.

3. Simran Hans, 'Less Storytelling Please: Why Documentaries Will Benefit from Getting Real', *Observer*, 7 June 2021, https://amp.theguardian.com/film/2021/jun/07/less-storytelling-please-why-documentaries-will-benefit-from-getting-real.

4. We might also add anything by Nick Broomfield – or any film where the presenter is effectively the detective investigating a case.

5. Hans, 'Less Storytelling Please'.

6. Brett Story, 'How Does It End? Story and the Property Form', *World Records Journal*, undated, https://worldrecordsjournal.org/how-does-it-end-story-and-the-property-form/.

7. Interview with Morgen by Nicholas Barber, *Screen International*, 25 November 2022.

8. Quoted in Olivia Atkins, 'Brett Morgen on Bowie', Creative Boom, 20 February 2023, https://www.creativeboom.com/features/brett-morgen-on-bowie/.

9. It is possible to criticize Morgen's film. It's sanctioned by Bowie's estate, so there's no reference either to his first wife or to the chilling Nazi salutes on Victoria Station in 1978. But it's equally possible to argue that's not the point. 'I wanted to explore if there was a way to do a non-biographical experience that would ultimately bring us to a truth,' Morgen said – and the film, both as a celebration of an icon and a hymn to taking the road less travelled, has been the most successful of his career.

10. Quoted in James Morrtram, 'Inside "Moonage Daydream": The David Bowie Doc That Nearly Killed Its Director', *New Musical Express*, 15 September 2022, https://www.nme.com/features/film-interviews/moonage-daydream-david-bowie-brett-morgen-interview-3310215.

11. In this case, is he Diego (the nice guy) or Maradona (the monster)?

12. McPhee, 'Structure: Beyond the Picnic-Table Crisis'.

13. A few more from a packed script: 'I'm pleased to report that the situation in Chernobyl is stable'; 'In a just world I'd be shot for my lies but not for this – not for the truth'; 'You think asking the right question will get you the truth?'; 'When the truth offends we lie and lie until we can no longer remember it is even there – but it is there'; 'These men work in the dark, they see everything.'

14. *The West Wing* is another good example. One notable episode is 'Someone's Going To Emergency, *Somebody's Going to Jail*' (Season 2, Episode 16). The

theme is communication, and every single exchange is written to illustrate
how impossible that can be.

15. Simon Lancaster, 'In Need of a Perfect Conference Speech? Here's
The Recipe', *Guardian*, 5 October 2015, https://www.theguardian.
com/commentisfree/2015/oct/05/perfect-conference-speech-david-
cameron-leaders.

16. You often see this structure on a very basic level in films with two protag-
onists. In *American Graffiti* one character learns the value of home while
the other learns the value of leaving it. In *Thelma & Louise* one learns
confidence, one humility. But the more you pursue this idea into political
or ethical waters, the more powerful the drama becomes. However loath
we are to admit it, most thinking is tribal and looks something like this
internet meme:

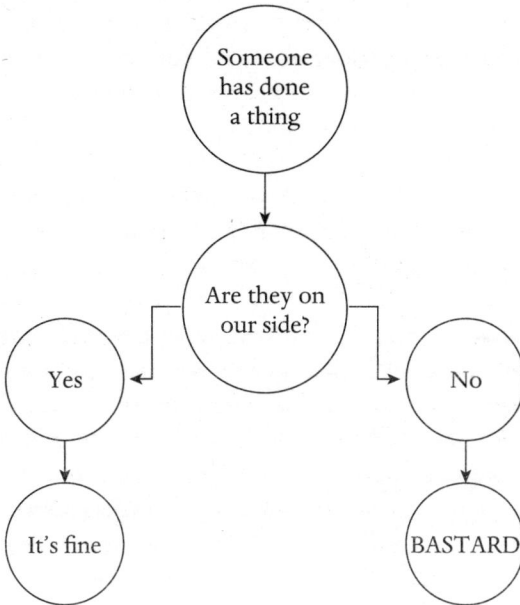

The ability to argue both sides of the tribe is fundamental to great
drama. If you're going to write a story advocating a woman's right to
choose, you cannot realize its full potential without asking, 'What might
be the worst impact of that choice?' If you're not asking what the worst
possible consequence is of your argument, you will never do your story
justice. If you want to write a great narrative, then you need to attack
your beliefs with the force of the best prosecutor on the planet.

17. Critics are very sniffy about *Crash*, particularly since the murder of George Floyd. Many have never forgiven it for beating *Brokeback Mountain* for the Best Film Oscar, nor for the message (everyone is capable of racism) they didn't want to hear. Some decried its plot coincidences too, not realizing that what they were watching was not verisimilitude but *fable*. Whatever you think of the content, however, structurally it's a masterclass in multiprotagonism.

18. Equally importantly, it's incredibly useful as a structural tool. Once you've created your A story, or spine, you can instantly produce other stories and plots to surround it. Theme and counter-argument are incredibly useful in the generating of story. In a sense, they are algorithms, they're AI, they remove the terror of the blank page, replacing it with parameters for sketching out story.

19. Speaking in *78/52: Hitchcock's Shower Scene* (2017) by Alexandre O. Phillipe.

20. Ibid. Scorsese freely admits copying the shower scene for the big fight sequence in *Raging Bull*. In 2023, director/writer J. A. Bayona cited it as the inspiration for his extraordinary plane-crash sequence in *Society of the Snow*.

21. McPhee, 'Structure: Beyond the Picnic-Table Crisis'.

22. Vincent Canby, 'Film Fete: "Andrei Rublev" From Russia Is Shown The Cast', *The New York Times*, 10 October 1972, https://www.nytimes.com/1973/10/10/archives/film-fete-andrei-rublev-from-russia-is-shown-the-cast.html.

23. Steve Rose, 'Andrei Rublev: The Best Arthouse Film of All Time', *Guardian*, 20 October 2010, https://www.theguardian.com/film/2010/oct/20/andrei-rublev-tarkovsky-arthouse.

24. Anthony Lane, 'The Current Cinema', *New Yorker*, 3 September 2018, https://www.newyorker.com/magazine/2018/09/03/mcenroe-in-the-realm-of-perfection-and-the-tennis-star-as-existential-hero.

25. John McPhee, 'A Roomful of Hovings Rorimer', *New Yorker*, 12 May 1967, https://www.newyorker.com/magazine/1967/05/20/a-roomful-of-hovings-rorimer.

26. If you're unhappy with this analogy, then replace dub with cubism. Indeed, dub was 'as big a break from classic recorded music as Picasso's invention of cubism was from representational painting,' according to reggae author Joe Muggs. The urge to deconstruct traditional form is alive and vital in any art form, but Picasso could only do it well because of his understanding of traditional line drawing, drilled into him by the atelier system. He wanted to represent the feelings in his head, and so sought a form to do so.

27. David Thomson, *Have You Seen . . .? A Personal Introduction to 1,000 Films* (Allen Lane, 2008).

28. Adam Curtis has specialized for years in making remarkable documentaries, most of them held together by his guiding narrative voice. Arguably his greatest work, however, is his twelve-part history of the collapse of communism and the rise of Putin, composed entirely of archive material with a few linking subtitles. It's also his least watched. Why? There is no voice-over, no obvious protagonist to hold your hand – so you have to work much harder to follow it. The protagonist has become *you*. This may be an indictment of capitalism, but it's also a sign that, given the choice, most people will gravitate to a single, emotional voice, a process that ends with the power and reach of Joe Rogan. There are few, if any, podcasts that eschew conventional form.

29. Kevin Maher, 'Nickel Boys review – a shatteringly powerful movie about abuse', *The Times*, 1 January 2025, https://www.thetimes.com/culture/film/article/nickel-boys-review-movie-57vsq8827. 'Very occasionally a movie appears that understands the potential of cinema so deeply that it changes the medium for everyone,' says Maher. It is, I think, a powerful film, but it screams, 'Look at me!' Audiences didn't – they largely stayed away from it. The medium remained stubbornly unchanged.

30. Many of us wanted to shout at those critics who didn't acknowledge that this point of view is the central – and very funny – conceit of Jesse Armstrong and Sam Bain's *Peep Show*. However, for the geeks among us, it is more than that: it's *Lady in the Lake*, *Dark Passage*, *Enter the Void* and *Hardcore Henry*. So, not really revolutionary at all. You would think if it really gave you a transcendent experience it might catch on. It doesn't, which is why we see 99.9 per cent of all movies from an angle other than inside our protagonists' heads.

31. Story, 'How Does It End?'.

32. Some of these diagrams can be found in McPhee, 'Structure: Beyond the Picnic-Table Crisis'.

CHAPTER 8

1. Hartmut Koenitz, Dennis Jansen, Brian de Lint, Andrea Di Pastena & Amanda Moss, 'The Myth of "Universal" Narrative Models: Expanding the Design Space of Narrative Structures for Interactive Digital Narratives', in *Interactive Storytelling. ICIDS 2018. Lecture Notes in Computer Science*, Springer, 2018, https://www.researchgate.net/publication/329064597_The_Myth_of_%27Universal%27_Narrative_Models.

2. Ibid.
3. Ibid. They are talking about application in gaming obviously, so to give the full quote for context: 'What is needed instead, is a radical shift in the way designers and academics think of what interactive digital [game] narrative could and should be, which entails first and foremost doing away with "classical [Western] notions of narrative" [. . .] and dethroning the Hero's Journey as the standard narrative structure for IDN.'
4. Ibid.
5. 'The significance of plot without conflict', Still Eating Oranges: A multimedia arts collective founded in 2011, Tumblr, 15 June 2012, https://stilleatingoranges.tumblr.com/post/25153960313/the-significance-of-plot-without-conflict.
6. The suffix -ku indicates a phrase or a line of verse (strictly the five- or seven-mora verse of waka or hai-ku).
7. As Dr Irena Hayter, Associate Professor of Japanese Studies at the University of Leeds wrote in an email exchange with me:

> It is primarily about rhetoric, and not storytelling – that seems to be a crucial and strategic misunderstanding by [. . .] western scholars of the form): they see what they want to see (. . . a familiar Western reflex which overlooks the complexities of Japanese/Chinese/non-Western cultural production, in order to set up grand binary oppositions and abstractions which are more critiques of Western representational conventions or colonialism, rather than reality: we see this with Japonisme and Impressionism, with Chinese opera and Bertol Brecht, with Roland Barthes and the Japanese bunraku puppet theatre, with film scholar Noel Burch and Japanese cinema, etc.. etc..). Because it sees ahistorical totalities and uses grand generalizations, to me and other scholars this is a form of Orientalism.

She continues:

> In Japanese sources, Kishōtenketsu refers to the structure of Chinese-style poetry (as opposed to the Japanese waka and haiku which work on the 5-7-5 principle [. . .] writing Chinese-style poetry was popular [amongst] the warrior elite in premodern Japan and scholars such as San'yō Rai). From there, it's extended to refer to learning to write well in general, to rhetoric. Maynard (1997: 159) regards it as 'model organisational structure for expository (and other) writing'; she doesn't mention narrative. Exposition is about explaining, illuminating, etc.. it's not storytelling.

8. Translation by Dr Irena Hayter. The original Japanese:

> *Ōsaka Motomachi itoya no musume*
> *Ane wa jūroku, imōto wa jūgo*
> *Shokoku daimyō wa yumiya de korosu*
> *Itoya no musume wa me de korosu*

9. Game Maker's Code Kit, 'Super Mario 3D World's 4 Step Level Design', YouTube, https://www.youtube.com/watch?v=dBmIkEvEBtA&t=31s.

10. This had long been a criticism of the groundbreaking work of Studio Ghibli, that it was beautiful but could never really translate. Conflict-free narrative was just too different for a Western audience, who prize definite, goal-oriented triumph over philosophical enquiry. There would always be a niche market for intellectuals, but it could never really catch on. I think there's a bit of a leap in such assessments. While they may be true of mainstream genre narrative (Hollywood, Disney, the crime novel), they certainly don't describe how things work in modernist novels or in arthouse cinema.

11. *Spirited Away* has a 97 per cent rating on Rotten Tomatoes, with audience score 1 per cent behind: https://www.rottentomatoes.com/m/spirited_away.

12. *My Neighbour Totoro* tells the story of two little girls who move with their father to the countryside. Their mother is ill in hospital, and while waiting for news the youngest girl Mei discovers a creature in the woods. This creature may turn out to be benevolent, but in structural terms its presence is no different from any classic Western fairy tale. The 'monster in the woods' trope is as old as civilization itself; it's there in *Beowulf*, in the *Epic Of Gilgamesh*, in *Harry Potter*, in *Rashomon* too. In every Western tale it's a real monster or a proxy for the thing the protagonist most fears – a liminal zone where the hero finds whatever is missing from themselves. That zone can be a desert in *Lawrence of Arabia*, the ocean in *Crimson Tide*, the snow and ice of *The Gold Rush* or the Island in *Porgy and Bess*.

 Legend tells us that medieval map makers marked up the undiscovered world with the words *hic sunt dracones*: 'Here be dragons'. One of the first modern atlases, made by Ortelius in 1570, *Theatrum Orbis Terrarum*, showed the monsters literally.

 Every story in Western literature involves a journey into the woods, into *terra incognito*. *My Neighbour Totoro* does exactly the same thing. How different is it after all?

13. *Spirited Away* is a more complex and darker proposition. Chihiro is ten and she's travelling, reluctantly, with her parents to a new home. She's surly and monosyllabic. Her father stops the car in front of a tunnel, and they enter to find themselves in a long-abandoned amusement park. While her parents eat at a magically replete stall, Chihiro meets a young boy, Haku, who warns her to leave. She returns to find her parents have turned into pigs. Stuck in the park, she is forced to ask for work in the bathhouse. She's given a mentor: a witch who tries to frighten her off. Other workers dislike her but she persists, slowly finding magic in the world, tasting beautiful food, warming to Haku and then helping to wash the giant 'sink spirit', a sloth-like monster, removing a bicycle handle that has become embedded in his side. Haku is injured, and she goes to help him. No-Face is introduced: another kind of monster who swallows everything. Chihiro pacifies him, before confronting Yubaba the witch, who threatens to murder her parents. She passes a final test and is returned to the real world, her parents remembering nothing.

On one level the story is incredibly complicated and beautiful (and I have paraphrased it massively). But on another it's relatively simple. It's both *Alice in Wonderland* and *Kiki's Delivery Service*. Chihiro is a self-obsessed ten-year-old. She falls down a rabbit hole and, no longer sitting in the back seat being driven everywhere, must learn to fend for herself. She works reluctantly, then fights for another job – and then, exactly halfway through, she bathes the sink spirit when no one else will. She nearly gets consumed by his mud, nearly loses herself, but she holds. 'It's a bath house for the spirits – it's where they come to replenish themselves,' Haku tells her. It's a bathhouse for Chihiro as much as anyone else, and by removing the pain in the monster's side, she has temporarily overcome her first-act flaw. It's the midpoint. Now, her newfound selflessness with be tested to destruction, and if she can keep hold of it despite the worst consequences, the threatened murder of her parents, she will emerge reborn. Washed, if you like. Just like Kiki or any Pixar protagonist, she is now selfless, mature and ready to face the world as a grown up. As Irena Hayter wrote to me:

> There have been attempts to describe [these films] as East Asian and other-oriented, as opposed to the 'Western individualism' of Disney / Hollywood. But 'western' growing up models also include coming to terms with the reality principle, with others, reining in the infantile ego [. . .] It's interesting that in *Spirited Away*, the witch is not killed (Yubaba and Zeniba are beautifully Jungian, the two sides of the good mother and the punishing mother . . .).

14. Nils Ödlund offers an alternative version of this on the blog *Mythic Scribes*: https://mythicscribes.com/plot/kishotenketsu/.

15. The *Jane Eyre* insight is not my own. I am very grateful to this site, one of the few that talks, briefly and well, some common sense on the subject: https://everwalker.wordpress.com/2017/11/03/kishotenketsu-japanese-4-act-structure/.

16. This translation of the poem is drawn from here: https://www.tofugu.com/japanese/japanese-argument-structure/.

17. Sometimes that conflict is overt, as in the examples above, and sometimes it's internal. It doesn't have to be Wonder Woman discovering she's Wonder Woman or Superman revealing himself to the world – just look at *The Quiet Girl* or *Aftersun*.

18. This was also tradition in silent cinema, and was Charlie Chaplin's practice throughout his career. He would keep crews, actors and sets on standby for weeks, filming endless different versions that he made up on set. He was, luckily, so phenomenally rich that he could afford the enormous expense. Kevin Brownlow and David Gill's 1983 documentary *Unknown Chaplin* provides a fascinating exploration of his method. It's like watchting – indeed *is* – a live re-enactment of what goes on in the human brain as it struggles to write. That its subject is Chaplin's greatest film, *City Lights*, makes it all the more extraordinary.

19. From Tom Mes, Transcript of December 2001 press conference with Miyazaki, 7 January 2002, http://www.midnighteye.com/interviews/hayao-miyazaki/. Earlier in the interview, Miyazaki says:

> I don't have the story finished and ready when we start work on a film. I usually don't have the time. So the story develops when I start drawing storyboards. The production starts very soon thereafter, while the storyboards are still developing. We never know where the story will go but we just keeping working on the film as it develops. It's a dangerous way to make an animation film and I would like it to be different, but unfortunately, that's the way I work and everyone else is kind of forced to subject themselves to it.

20. Interview with author, March 2023. Dr Hayter has degrees in Japanese studies and cultural studies from the Universities of Sofia and Kyoto, and a PhD in modern Japanese literature from SOAS, University of London. Her published works include *Tenkō: Cultures of Political Conversion in Trans-war Japan*, edited by Mark Williams, Irena Hayter and George T. Sipos.

21. Interview with author, March 2023. Dr Hayter continues: 'It's projecting your fantasies onto the other, rather than seeing the other.' She sees similar reductiveness amongst previous scholars of Kishōtenketsu: 'It also has to be mentioned that neither the study group at Utrecht, nor Fernandes, who uncritically takes a claim from Upton, nor Upton, who misreads Maynard (equating rhetoric with storytelling), read Japanese or have access to Japanese sources.'

22.

<div align="center">

The Farmer that Became a Doctor

By Robert Robleto

</div>

Introduction

Many people here believe that I am a doctor that became a farmer. But that's not so. I am a farmer that became a doctor. The origin of this is that my father and my grandfather live right over there. Right over there where that house is. My father was born there. They are people from here. Originals. They were country folk. My father didn't know how to read or write. It was hard for him to even write his name. All of his life he worked the land. But he didn't want me to be a farmer. He never taught me anything about farming. Nothing, absolutely nothing. Because he wanted me to be a doctor.

I am a farmer that became a doctor.

I started my clinic here. Things went well, more or less. My father never said 'this calf is yours' because he never wanted me to be a farmer. He always wanted me to be a doctor. So I opened my clinic and it went well thank God. Because everything I now have is thanks to my clinic. Then, someone was selling this little farm and they said 'Let's go and see it.' And I said, 'Why do you want to see it? Why do we want a farm?'

Climax

It's abandoned. There's nothing there. But with much insistence I bought it.

Journey

There was a lady – I was her doctor and had visited her in her house many times. And one day she said to her son Santiago 'Look, Santiago, give a calf for the doctor. Look for a good one,' and so they gave me a calf, a Holstein. And that was my first cow. My first cow was given to me by a patient.

Then that calf grew, and I got more cows; I cleaned up and arranged the abandoned farm.

I always dedicate myself to my clinic, but the truth is my passion is the farm, my animals.

Close

It's quite a story. I'm someone who was born here in the country but my father didn't want me to be a farmer.

He wanted me to be a doctor. And thank God I became a doctor, but now I have returned to my roots and I also dedicate myself to my farm.

I am a farmer that became a doctor.

23. 'Go Down Moses' was the first spiritual to be transcribed on sheet music, and became widely known because of this, around 1862.
24. See: https://www.youtube.com/watch?v=FuKgH3p7Hx0.
25. See: https://en.wikipedia.org/wiki/List_of_story_structures#Indigenous_peoples_of_North_America_and_Latin_America.
26. A blog post on narrative structure expands somewhat: Robleto 'was conceptualized by Cheryl Diermyer during a 2010 trip from the southern tip of San Juan Del Sur to the northern parts of Santa Lucia. Diermyer noticed a shared narrative structure when Nicaraguan community members told stories about their lives and culture. The structure is named after Robert Robleto, a cattle farmer and doctor of medicine in Nicaragua.' https://typoistd.wordpress.com/wp-content/uploads/2011/07/wk1_narrative_structures.pdf.

 It's just plausible, but who is Cheryl Diermyer? She an Associate Director of innovative Teaching and Engagement at the University Of California Riverside. There are no official papers, and no other examples of the Robleto form. I also spoke to two professors of Latin American literature – neither had any knowledge of it. That doesn't mean it doesn't exist, nor that it isn't good or doesn't work, but it's not a different kind of story structure. Indeed, it's hard to conclude it actually exists at all.

27. Diagram from Koenitz et al. 'The Myth of "Universal" Narrative Models.'
28. Koenitz et al., 'The Myth of "Universal" Narrative Models'.
29. Harari, *Sapiens*.
30. It's estimated that the Anglican community numbers 80 million, with roots in more than 160 countries worldwide. It grew out of seventeenth-century colonialism, first in the US, Australia, Canada, New Zealand and South Africa, and then across Latin America, Asia and Africa. While worship has diminished massively in the UK, it's a far more potent force elsewhere.
31. See: https://www.stabroeknews.com/2009/08/16/sunday/arts-on-sunday/the-african-story-telling-tradition-in-the-caribbean/. The form

itself is not that dissimilar to the Anansi (Ananse) tales of Ghanaian origin. Further information can be found in Appendix IV.

32. 'Griots form an endogamous caste, meaning that most of them only marry fellow griots. They pass the tradition of storytelling along the familial line. Each aristocratic family of griots accompanied a higher-ranked family of warrior kings or emperors. In traditional culture, no griot can be without a king and no king can be without a griot. However, the king can loan his griot to another king.' ('Storytelling Traditions Across the World: West Africa', All Good Tales website, 15 October 2018, https://allgoodtales.com/storytelling-traditions-across-world-west-africa/.)

33. See: Dima Sharif, 'Al Hakawati: The Storyteller Tradition', blog post, 26 July 2013, https://www.dimasharif.com/al-hakawati-the-storyteller/.

34. Robleto isn't a new structure. *Karagöz* (listed on Wikipedia as non-Western narrative) is a type of Turkish Shadow puppet play that follows a very traditional shape. *Ta'ziyyah*, another victim of Wikipedia, is an Arabic Passion play. All of these – Robleto, Kishōtenketsu, Hakawati, Griot narrative, Crick Crack, Bengali Widow's Narrative – are just stylistic or performative adaptations of the same primary shape. Studying them doesn't tell you anything about resistance to colonial hegemony; it reminds you instead that every tribe has a story at its centre, and that a story's function is to pump oxygenated blood around the tribe. If the story is off, or the telling is bad, or no one can agree what the story should be, then that's a tribe with problems. But what the study shows more than anything is that, even though there may be unique cultural signifiers, even though there may be unique ritualistic elements, it's not difference that is revealed – it is a common root.

35. Kim Yoon-Mi, 'World Wide Story Structures', blog post, 1 February 2021, https://www.kimyoonmiauthor.com/post/641948278831874048/worldwide-story-structures.

36. 'Kishōtenketsu: Japanese 4-Act Structure', blog post, 1 November 2017, https://everwalker.wordpress.com/2017/11/03/kishotenketsu-japanese-4-act-structure/.
 The post references a previous article on Japanese horror structure: https://www.tofugu.com/japan/japanese-horror-structure/.

37. Ursula K. Le Guin, *Steering the Craft: A Twenty-First Century Guide to Sailing the Sea of Story* (Mariner Books, 2015). She continues: 'Change is the universal aspect of all these sources of story. Story is something moving, something happening, something or somebody changing.'

38. https://writingtheother.com/non-linear-story-structures-2023/

39. 'Beyond The Hero's Journey. Non-Western Story Structures', WriteHive, 2022, https://www.youtube.com/watch?v=ovOUowbWJrA. For an hour and a half the presenters discuss non-Western structure. Finally, when asked to name any examples they admire, they are lost for words. Eventually they come up with a few – either classic Western forms with narrative tweaks (such as second-person narrative) or novels like *Station Eleven* by Emily St John Mandel and *The Raven Tower* by Ann Leckie, both of which have clearly discernible classic narrative forms. The more positive observation from the video is the joy they all take from having a common enemy. It's not nasty; on the contrary, it's incredibly good-hearted, and they all come across really well.

40. Steve Seager, 'Beyond the Hero's Journey', Medium, April 2015, https://medium.com/@steveseager/beyond-the-hero-s-journey-four-innovative-narrative-models-for-digital-story-design-f7458983bc16.

41. Koenitz et al., 'The Myth of "Universal" Narrative Models'.

42. Space precludes a detailed examination, but a couple of smaller examples may suffice. Vogler aligns the midpoint with the ordeal, and then describes the ordeal thus: 'ET dies before our eyes but is reborn through alien magic and a boy's love.' But this is not of course the midpoint at all, but a very clear crisis point happening at the end of the (traditional) second act, two-thirds of the way through the film. *ET* has its own separate midpoint, the moment when Eliot agrees to help his alien friend phone home. It's here that he is presented with the 'truth' of the film: the lesson that if you love someone you have to let them be free. In his analysis of *The Wizard Of Oz*, Vogler makes a similiar mistake, stating that the supreme ordeal is the battle in the Wicked Witch's castle, where the witch is killed and Dorothy is liberated. However, the supreme ordeal – or midpoint to use our terminology – is clearly bang in the centre of the film, when our four heroes meet the Wizard for the first time. Both suggest Vogler doesn't quite understand the concept of the supreme ordeal, mistaking it for the crisis point.

43. Another example of this egregious misunderstanding can be found here, in a long article in *Aeon* magazine. It's full of category errors (most stories don't have the same plot, they have the same underlying structure) and it makes the very modern mistake of calling up sexism, racism and imperialism as bogeymen (all apparently products of the hero's journey), making it inviting to agree with. Look at the structure of the article. It's in three acts, framing a very clear hero's journey by the journalist: Eliane Glaser, 'Our Narrative Prison', *Aeon*, 13 May 2025, https://aeon.co/essays/why-does-every-film-and-tv-series-seem-to-have-the-same-plot.

44. In fact, very few of them actually bother presenting any evidence that disagrees with their thesis.

45. Space precludes a detailed critique of McKee's *Story*, but a look at his definition of inciting incidents is telling. While not new (it was first articulated in 1808 by Schlegel and taken up by Freytag sixty years later, before being christened by Thomas Baldwin in 1945), McKee's definition gave the concept a vigour and importance previous commentators had failed to recognize. 'The Inciting Incident radically upsets the balance of forces in the protagonist's life,' McKee tells us, before fusing this with a larger definition of story:

> For better or worse, an event throws a character's life out of balance, arousing in him the conscious or unconscious desire for that which he feels will restore balance, launching him on a quest for his object of desire against forces of antagonism [. . .] He may or may not achieve it.

While McKee is right in terms of description, his examples unfortunately are often wrong. In some films – *On the Waterfront*, *Kramer vs Kramer* and *Sullivan's Travels*, for instance – he claims it happens within the first two minutes of the story, while in others – *Casablanca*, *Rocky* or *Taxi Driver* – he suggests it is later, up to thirty minutes in. Then, just to cover all the options, in some cases he puts it around the ten-minute mark, perhaps most famously when he cites the moment everything changes in *Ordinary People*, when Beth (Mary Tyler Moore) throws her son's French toast down the waste disposal.

All of these, I think, are profoundly wrong, but they hand us the opportunity to finally define what an inciting incident really is.

McKee is right in his most basic definition, one we discussed in Chapter 10 on theme. An inciting incident is the 'major dramatic question', but it is a question structured in a very specific way. The best way to understand how it works is to look through the prism of fractal structure. Every story has three acts (see earlier note on *Star Wars* on p. 398 (Note 18)), but every act also has three mini-acts. If every story has a setup, a midpoint and a crisis, then likewise every act will contain them too. Therefore every first act contains a very familiar pattern – the one we've previously we've only observed in complete story form:

1. (mini) Inciting incident
2. (mini) Midpoint
3. (mini) Crisis

Take a look at the first act of *Finding Nemo*:

(mini) Inciting incident: Marlin's family are eaten by Barracuda. He vows to protect Nemo, his son.

(mini) Midpoint: Marlin harangues Nemo, believing he has swum out beyond the reef with his friends. Nemo hasn't, and is furious with his dad.

(mini) Crisis: As if to prove himself, Nemo swims out himself and is captured by divers. Marlin's life is turned upside down.

The more you look, the more you see a universal shape emerge. From *Some Like It Hot*:

(mini) Inciting incident: Jerry and Joe need a job but are not desperate enough to dress up as girls.

(mini) Midpoint: They witness the St Valentine's Day Massacre.

(mini) Crisis: Newspaper headlines ('feared bloody aftermath') drive them to join the girls' band and flee to Miami.

From *Moonlight*:

(mini) Inciting incident: Chiron is rescued from crack house by Juan, a drug dealer.

(mini) Midpoint: Chiron returns to his mother, who punishes him for running off.

(mini) Crisis: Juan, who is secretly selling her drugs, tells Chiron, 'You can be whoever you want to be.'

There is a clear pattern here. In every first act your protagonist will:

1. Do or become involved in something fairly familiar, then something will happen that will call them to action.
2. They will make a decision on how to react to this and pursue a course of action. Something unexpected will happen . . .
3. which will precipitate a crisis which in turn will force them to make a decision, propelling them into a whole new universe.

In simple terms, then, an inciting incident is just the crisis point of the first act. It coincides with the Roadmap Of Change's *Awareness* – it's where the story problem is injected into the protagonist's veins.

CHAPTER 9

1. The claim that the inciting incident must be on page 12 appears in Blake Snyder's *Save the Cat! The Last Book on Screenwriting You'll Ever Need* (Michael Weise Productions, 2005): 'put it where it belongs: page 12'.

2. A few examples: https://duckduckgo.com/?q=screenwriting+diagrams& t=osx&ia=images&iax=images; https://www.google.co.uk/search?sca_ esv=7485c90aae8489da&q=screenwriting+diagrams&udm=2&fbs= AIIjpHxU7SXXniUZfeShr2fp4giZ1Y6MJ25_tmWITc7uy4KIeoJT KjrFjVxydQWqI2NcOha3OIYqG67F0QIhAOFN_ob1yXos5K_Q09Tq- ocVPzex8YVosMX4HbDUrR7LivhWnk2ZcNYXURQRTKuLwUDZcys HJuCMqO9OSYKbqSCXIu76gK_dgCrHoSNPncudhM- HcrokkgKzMIPALhyUyJEZNqw1AbhMMA&sa=X&ved=2ahUKE wjM1uGDpvaNAxWcWoEAHab4KKsQtKgLegQIGRAB&biw= 1405&bih=886&dpr=2.

 And three personal favourites: https://uk.pinterest.com/pin/ story-structure-diagram--475129829408066402/; https://www.reddit. com/r/Screenwriting/comments/cbisie/meta_there_is_no_formula_a_ diagram_of_structure/; https://ingridsnotes.wordpress.com/wp-content/ uploads/2013/05/final-revision_traditional-mountain-structure-handout_8- 5x14.jpg.

3. Stuart Voytilla's *Myth and the Movies* (Michael Wiese Productions, 1999) is the most egregious example – possibly the worst screenwriting book ever written, amid crowded competition. Christopher Vogler's interpretations at the back of *The Writer's Journey* aren't much better; his breakdown of *The Wizard of Oz* is riddled with enough errors to make you doubt the soundness of *any* of the book (see earlier note 43, p. 425 for further detail), including his comprehension of Campbell.

4. It is perhaps ironic that this over-analysed film is about abandoning analysis and relying on intuition . . .

5. N. I. Yefimov, 'Formalizm V Russkom Literaturovedenii', quoted in Victor Erlich, 'Russian Formalism: In Perspective', *Journal of Aesthetics and Art Criticism*, Vol. 13, No. 2, December 1954, pp. 215–225, https://www.jstor. org/stable/425914.

6. The thirty-one stages, paraphrased from *Morphology of the Folk Tale*, are as follows. The parallels with the hero's journey should be readily apparent.

 1. **ABSENTATION**: A member of the hero's community or family leaves the security of the home environment.

 2. **INTERDICTION**: An interdiction is addressed to the hero ('don't go there', 'don't do this').

3. **VIOLATION OF INTERDICTION**: The prior rule is violated. The villain enters the story via this event.
4. **RECONNAISSANCE**: The villain makes an attempt at reconnaissance.
5. **DELIVERY**: The villain gains information about the victim.
6. **TRICKERY**: The villain attempts to deceive the victim to take possession of them or their belongings.
7. **COMPLICITY**: The victim is fooled and unwittingly helps the villain.
8. **VILLAINY** or **LACK**: The villain causes harm or injury to a member of a family, or a lack is identified.
9. **MEDIATION**: The misfortune or lack is made known; the hero is dispatched.
10. **BEGINNING COUNTERACTION**: The hero decides on counteraction.
11. **DEPARTURE**: The hero leaves home.
12. **FIRST FUNCTION OF THE DONOR**: The hero is tested, interrogated or attacked, preparing the way for receiving a magical agent or helper.
13. **HERO'S REACTION**: The hero reacts to the actions of the future donor.
14. **RECEIPT OF A MAGICAL AGENT**: The hero acquires the use of a magical agent.
15. **GUIDANCE**: The hero is transferred, delivered or led to the whereabouts of an object of the search.
16. **STRUGGLE**: The hero and the villain join in direct combat.
17. **BRANDING**: The hero is branded or marked – perhaps a scar or an item like a ring or scarf.
18. **VICTORY**: The villain is defeated by the hero.
19. **LIQUIDATION**: The initial misfortune or lack is resolved.
20. **RETURN**: The hero returns.
21. **PURSUIT**: The hero is pursued.
22. **RESCUE**: The hero is rescued from pursuit.
23. **UNRECOGNIZED ARRIVAL**: The hero arrives unrecognized or unacknowledged.
24. **UNFOUNDED CLAIMS**: A false hero presents unfounded claims.
25. **DIFFICULT TASK**: A difficult task is proposed to the hero – a riddle, test or similar.
26. **SOLUTION**: The task is resolved.

27. **RECOGNITION**: The hero is recognized.

28. **EXPOSURE**: The false hero and/or villain is exposed.

29. **TRANSFIGURATION**: The hero is given a new appearance.

30. **PUNISHMENT**: The villain is punished.

31. **WEDDING**: The hero marries and is rewarded – often becoming ruler of the land.

 It's intriguing that Propp's book was published four years after Stalin came to power, a time when anything that might encourage independent thought, including the study of folk tales, was being brought under the centralized control of the Party.

7. Vladimir Propp, *Morphology of the Folk Tale*, (University of Texas Press, 1968, first published in Russian as *Морфология сказки* (*Morfologiia skazki*), 1928).

8. Joseph Campbell, *The Hero with a Thousand Faces* (Bollingen Foundation/ Pantheon Press, 1949).

9. Tzvetan Todorov, 'The 2 Principles of Narrative', *Diacritics* vol. 1, no. 1, Autumn 1971, pp.37–44, https://www.jstor.org/stable/464558?origin=crossref.

10. Ibid.

11. Ibid.

12. Ibid.

13. The full trailer, from which all these quotations are drawn, can be viewed here: https://www.youtube.com/watch?v=cKTOj7HnLbo.

14. Statement from Allen and Soon-Yi Previn, released to the *Hollywood Reporter*, https://www.hollywoodreporter.com/movies/movie-news/woody-allen-soon-yi-previn-respond-to-allen-v-farrow-filmmakers-these-documentarians-had-no-interest-in-the-truth-4136128/.

15. The famous quote (and rhetorical rule) is, 'Tell 'em what you're going to tell 'em. Then tell 'em. Then tell 'em what you told 'em. https://quoteinvestigator.com/2017/08/15/tell-em

16. From *The Shawshank Redemption* by Frank Darabont (1994). Adapted from the novella *Rita Hayworth and The Shawshank Redemption* by Stephen King.

17. 'Multiple agencies investigated them at the time and found that, whatever Dylan Farrow may have been led to believe, absolutely no abuse had ever taken place.' https://www.theguardian.com/film/2021/feb/22/woody-allen-denies-claims-hbo-allen-v-farrow-documentary

18. Documentaries perhaps offer us the clearest way of seeing this. In Asif Kapadia's *Amy* the immensely vulnerable girl who just wants to sing jazz becomes, halfway through, the biggest rock star in the world, and because

of that reconnects with her heroin dealer, after which it's all downhill. It's very hard to find a biopic or documentary where the midpoint isn't the apex of the star's career (as in *Ray* or *Walk the Line*, *Rocket Man* or *Bohemian Rhapsody*) before decay sets in, with tragic or happy consequences, depending on the source material of the film. James Mangold's Bob Dylan biopic *A Complete Unknown* is a welcome exception.

Sometimes argument for/against is incredibly overt. The first half of Alex Gibney's documentary *We Steal Secrets* tells us Julian Assange is an incredible freedom fighter working on our behalf; the second half is, 'Uh, hang on a second, maybe he's both entirely untrustworthy, slightly mad and a rapist.' Gibney does something identical with *The Armstrong Lie*. His film about the multiple Tour de France winner Lance Armstrong is clearly bisected: 'Here's this amazing cyclist,' followed by, 'You have no idea how great a cheat this man is.' It's often this overt in documentary form, but the same pattern suffuses every archetypal narrative: premise; argument for; midpoint; argument against; conclusion.

19. Three examples of misidentifying the midpoint of the film can be found at: https://savethecat.com/beat-sheets/the-star-wars-beat-sheet-part-two, https://www.helpingwritersbecomeauthors.com/movie-storystructure/star-wars-a-new-hope/#:~:text=Midpoint%3A%20After%20emerging%20from%20lightspeed,hiding%20in%20Han%27s%20smuggling%20compartments and https://philipp.truebiger.com/three-act-structure/.

20. Quoted in Travis Langley, 'The Kübler-Ross Model and Five Stages of "Groundhog Day"', *Psychology Today*, 31 January 2020, https://www.psychologytoday.com/gb/blog/beyond-heroes-and-villains/202001/the-k-bler-ross-model-and-five-stages-groundhog-day.

21. S. I. Rosenbaum, 'When Every Day Is "Groundhog Day"', *New York* magazine (*Vulture*), 3 April 2017, https://www.vulture.com/2017/03/danny-rubin-groundhog-day-musical.html.

22. In 1983, James Prochaska and Carlo DiClemente introduced their Transtheoretical Stages of Change model for social workers to conceptualize, understand and help treat those suffering from smoking addiction. Over the years it has grown to encompass treatment for drug use, physical activity, healthy eating and variations of sexual behaviour, alongside the prevention of domestic violence, HIV transmission and child abuse. It's become a universal model for understanding and dealing with change.

Note the five stages: precontemplation, contemplation, preparation,

action and then either maintenance, termination or relapse. It matches not just the Kübler-Ross paradigm but our own Roadmap of Change as well.

23. You will see something very similar in any learning cycle. Kolb's learning cycle from 1984 – how we make sense of the world, basically – reflects exactly the same pattern: https://www.simplypsychology.org/learning-kolb.html.

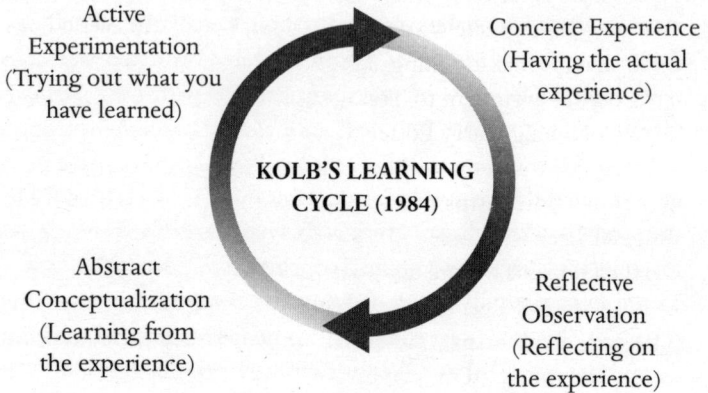

Active
Experimentation
(Trying out what you
have learned)

Concrete Experience
(Having the actual
experience)

**KOLB'S LEARNING
CYCLE (1984)**

Abstract
Conceptualization
(Learning from
the experience)

Reflective
Observation
(Reflecting on
the experience)

24. This is one of the many moments Robert McKee, who centres so much of his tuition around *Casablanca*, gets wrong. He claims the midpoint is the scene where Rick apologizes to Ilsa for refusing to listen to her when he was drunk the night before, but that doesn't actually change anything. The midpoint actually occurs when Ilsa comes to the café in the early hours of the morning (the dark cave), straight after the flashback that everything changes for Rick, when he is forced to ask, 'Who am I, and what have I become?' It is here Rick finds himself being ripped apart by the equal and opposite powers of old knowledge and new.

25. Delaney, *A Heart That Works*.

CHAPTER 10

1. John Donne, 'Holy Sonnets: Death, be not Proud' (1633).
2. 'A Profession Struggling to Sustain Itself', Society of Authors, 6 December 2022, https://societyofauthors.org/2022/12/06/a-profession-struggling-to-sustain-itself/.
3. These figures are approximate but take into account $394 million theatrical box office earnings; substantial book sales revenue (more than 120 million

copies); home video, TV and streaming revenues (around $800 million for first two films); as well as video games, merchandise and licensing. Mario Puzo, author of the original novel, sold the adaptation rights to his work in 1969 for $50,000.

4. Bilger, 'What George Miller Has Learned in Forty-Five Years of Making "Mad Max" Movies'.

5. W. B. Yeats, 'The Circus Animals' Desertion'.

6. Nick Cave, 'Chat GPT Making Things Faster and Easier', *The Red Hand Files* newsletter, Issue #248, August 2023, https://www.theredhandfiles.com/chatgpt-making-things-faster-and-easier/.

7. The counter-argument to 'Following Harry Potter will not give you a hit' is '*Not* following Harry Potter won't give you a hit either.'

8. Quoted in interview with Ian Parker, 'Mugglemarch', *New Yorker*, 24 September 2012, https://www.newyorker.com/magazine/2012/10/01/mugglemarch.

9. Calvin Conzelus Moore and John B. Williamson, 'The Universal Fear of Death Cultural Response', in *Handbook of Death & Dying*, SAGE Publications, 2003, https://www.sagepub.com/sites/default/files/upm-assets/5233_book_item_5233.pdf.

 Philip Larkin put it much more simply in 'Aubade' (1977):

 > No trick dispels.
 > Religion used to try,
 > That vast moth-eaten musical brocade
 > Created to pretend we never die

10. Moore and Williamson, 'The Universal Fear of Death'.

11. That's modern man, but in pre-history – in a world with no science, where the universe appeared to exert inexplicable power – what would humans do? The only agent of causation known to primitive man was human agency. Surely, they must have surmised, the laws of the universe must be governed by human-like agents: the sun was placed in a chariot and every day Helios would drive that chariot across the sky.

12. From a press conference Rowling gave at the start of her Open Book Tour to launch *The Deathly Hallows*, October 2007, https://www.christian-post.com/news/harry-potter-author-reveals-books-christian-allegory-her-struggling-faith.html.

13. Quoted in Max Wyman, ' "You can lead a fool to a book but you can't make them think": Author has frank words for the religious right', *Vancouver Sun*, 26 October 2000.

14. 'Kid,' says Han Solo at the midpoint of *Star Wars*, 'I've flown from one side of this galaxy to the other. I've seen a lot of strange stuff, but I've never seen anything to make me believe there's one all-powerful Force controlling everything.' Han Solo will end up muttering 'May the Force be with you' to Luke before too long. His journey will be one of belief too.

15. David and Goliath is just one of many biblical parallels in the movies. (See: https://medium.com/@conradflynn/what-star-wars-stole-from-the-bible-d47ee60aebe3.) Submission to the Force is a very Islamic concept. The Jewish festival of Hanukkah, which takes place over eight days each December, commemorates the miraculous victory, 2,000 years ago, of Israelite rebels over the brutal Seleucid Empire.

16. Opening inscription from second and third draft scripts of what became *Star Wars: A New Hope* by George Lucas.

17. Lucas himself said:

> I see *Star Wars* as taking all of the issues that religion represents and trying to distil them down into a more modern and more easily accessible construct that people can grab onto to accept the fact that there is a greater mystery out there. When I was 10 years old, I asked my mother – I said, 'Well, if there's only one God, why are there so many religions?' And over the years – I've been pondering that question ever since. And it would seem to me that the conclusion that I've come to is that all the religions are true, they just see a different part of the elephant.

(Interview with Bill Moyers, 'The Mythology of *Star Wars*', PBS, 1999, https://www.imdb.com/title/tt0458432/).

Harry Potter is not dissimilar. 'Personally,' Rowling has said of her religious faith, 'I think you can see that in the books. Of course, Hogwarts is a multifaith school.' (Quoted in Karen Lindell, *Ventura County Star*, 2007.) From a profile of her in *Time* magazine: 'The values in the books, she observes, are by no means exclusively Christian, and she is wary of appearing to promote one faith over another rather than inviting people to explore and struggle with the hard questions.' (Nancy Gibbs, 'Person of the Year 2007: Runners Up', *Time*, 19 December 2007.)

18. Quoted in *The Witch Trials of J. K. Rowling*.

19. 'What does Harry Potter mean to you?', Quora thread, https://www.quora.com/What-does-Harry-Potter-mean-to-you#:~:text=Harry%20Potter%20gave%20me%20an,Related%20questions%20(More%20answers%20below).

20. Particularly for first-generation fans, I think.

21. Hardly different from the quarrelling gods of Olympus. DC characters are mostly gods, while Marvel's are humans who have assumed god-like form.

22. *Raiders of the Lost Ark* is of course a biblical quest, too.

23. A particularly Old Testament religion, one shared with the Clint Eastwood of *Pale Rider* and *High Plains Drifter*.

24. Arlie Russell Hochschild, *Strangers in Their Own Land: Anger and Mourning on the American Right* (The New Press, 2016). The full passage reads:

 You are patiently standing in a long line leading up a hill, as in a pilgrimage. You are situated in the middle of this line, along with others who are also white, older, Christian, and predominantly male, some with college degrees, some not.

 Just over the brow of the hill is the American Dream, the goal of everyone waiting in line. Many in the back of the line are people of color – poor, young and old, mainly without college degrees. It's scary to look back; there are so many behind you, and in principle you wish them well. Still, you've waited a long time, worked hard, and the line is barely moving. You deserve to move forward a little faster. You're patient but weary. You focus ahead, especially on those at the very top of the hill [. . .] You've suffered long hours, layoffs, and exposure to dangerous chemicals at work, and received reduced pensions. You have shown moral character through trial by fire, and the American Dream of prosperity and security is a reward for all of this, showing who you have been and are – a badge of honor.

 [. . .] Look! You see people *cutting in line ahead of you*! You're following the rules. They aren't. As they cut in, it feels like you are being moved back. How can they just do that? [. . .] Through affirmative action plans, pushed by the federal government, they are being given preference for places in colleges and universities, apprenticeships, jobs, welfare payments, and free lunches [. . .] women, immigrants, refugees, public sector workers – where will it end?

 This story has had increasing salience in the years since Hochschild first articulated it, leaching from the deep south of America into much of the western world.

25. The term 'vibe shift' was coined by marketing consultant Sean Monahan in 2021. 'One day everyone was wearing Red Wing boots and partying in warehouses in Williamsburg decorated with twinkling fairy lights. VIBE SHIFT! Everyone started wearing Nike Frees and sweating it out in the

club.' (Quoted in Allison P. Davis, 'A Vibe Shift Is Coming. Will any of us survive it?' *New York* magazine (*The Cut*), February 2022.)

26. The Satanic panic, Recovered Memory Syndrome and the Salem witch trials all have very similar architecture. Such behaviour has traditionally been geographically localized, though modern social media has broken down many of the geographical barriers. Nonetheless, it is still quite common to see suicide clusters spreading through schools, communities and occasionally nations, for example after a celebrity death. This is known by many as the Werther Effect, after Goethe's 1774 novel *The Sorrows of Young Werther*, whose publication gave rise to the first recognized example of a narrative infection. Such infections are the main reason fictional suicides on television are so closely regulated. As the Samaritans explain:

> Young people are more susceptible to suicide contagion. When covering the death of a young person, do not give undue prominence to the story or repeat the use of photographs, including galleries. Don't use emotive, romanticised language or images – a sensitive, factual approach is much safer. Coverage that reflects the wider issues around suicide, including that it is preventable, can help reduce the risk of suicidal behaviour. Include clear and direct references to resources and support organisations.

(The Samaritans, '10 top tips for reporting suicide', https://www.samaritans.org/about-samaritans/media-guidelines/10-top-tips-reporting-suicide/.)

When Angie Watts took an overdose in the British soap *EastEnders* in 1986 it led to a sharp rise in copycat incidents. It isn't just broadcasting – suicides often occur in clusters for the same reason: a heightened sense of emotion, of romance, of 'They'll miss me when I'm gone.' The act offers the most dire version of being a hero in one's own story. When others see the 'hero' feted after death, they become bewitched by its tragic allure and thus follow suit. Such social contagions are narrative contagions – a particularly grisly example of the power of story.

27. Durkheim said totems were the recipients of a 'collective force' which came from the community that surrounded them. 'This sacred object receives the collective force and is thereby infused with the power of the community. It is in this way that a society gains a tangible idea, or representation, of itself.' Tribes desire totems; totems define the tribe. (https://iep.utm.edu/emile-durkheim/)

28. Ian Leslie, 'Maybe Your Opinion Is Just a Feeling About a Story', *The Ruffian* Substack, 7 December 2024, https://www.ian-leslie.com/p/

maybe-your-opinion-is-just-a-feeling?utm_source=substack&utm_medi-um=email.

29. Maria Konnikova, *The Confidence Game: The Psychology of the Con and Why We Fall for It Every Time* (Canongate Books, 2016).

30. See: https://en.wikipedia.org/wiki/A_Rape_on_Campus. Boss of *Rolling Stone* Jann Wenner would later say:

> You get beyond the factual errors that sank that story, and it was really about the issue of rape and how it affects women on campus, their lack of rights. Other than this one key fact that the rape described actually was a fabrication of this woman, the rest of the story was bulletproof.

Such a sentence should probably disqualify its writer from ever practising as a journalist.

31. Ben Bradlee, *A Good Life: Newspapering and Other Adventures* (Simon & Schuster, 1996). The original story, 'Jimmy's World' by Janet Cooke, won a Pulitzer before its provenance was uncovered. You can read it here: https://www.washingtonpost.com/archive/politics/1980/09/28/jimmys-world/605f237a-7330-4a69-8433-b6da4c519120/.

The journalist David Aaronovitch makes a related point about Stalin's show trials:

> Most modern theories have been conceived as a kind of historical revolt against the official version of events, but for authoritarian regimes in transitional periods the idea of conspiracy becomes convenient for the authorities themselves, as well as offering a painless explanation for massive failure. In Stalinist Russia the revelation that a dedicated band of plotters had been at work sabotaging the first socialist state's otherwise inexorable march towards nirvana was – if anything – a relief. Because, if it were true, then the great problems of state socialism could be solved by rooting out the plotters.

(David Aaronovitch, *Voodoo Histories*, Jonathan Cape, 2009)

For Stalin, for any other totalitarian regime, plotters are 'too good not to be true'.

32. George Monbiot, @GeorgeMonbiot, Twitter, 13 February 2023, https://x.com/GeorgeMonbiot/status/1625202093463068673.

33. For the ultimate example of left-wing conspiracy thinking, try Asif Kapadia's *2073*, which seems to suggest that everyone except enlightened

film-makers is right-wing, responsible for all the world's ills and guilty as sin. All while condemning outrage and polarization, of course.

34. Konnikova, *The Confidence Game*.

35. Ibid. Konnikova continues:

> Sometimes they actually read about personal news – local papers are treasure mines for what is happening to whom, and Facebook's ubiquity makes even those look obsolete. A friend of mine – call her Alexis – found herself the victim of an attempted scam after a series of Facebook posts made it clear that she was going through a breakup. (She had inadvertently befriended the con artist, an all too common occurrence.) Other times, they simply read people. A dejected walk is easy to spot if you're looking for it.

36. Ibid.

37. Ibid. Konnikova writes:

> Cons thrive in times of transition and fast change, when new things are happening and old ways of looking at the world no longer suffice. [. . .] That's why they flourished during the gold rush and spread with manic fury in the days of westward expansion. That's why they thrive during revolutions, wars, and political upheavals. Transition is the confidence game's great ally, because transition breeds uncertainty. There's nothing a con artist likes better than exploiting the sense of unease we feel when it appears that the world as we know it is about to change. We may cling cautiously to the past, but we also find ourselves open to things that are new and not quite expected. Who's to say this new way of doing business isn't the wave of the future?

38. In a story cited by Konnikova, Jim McCormick and Gary Bolton were jailed for 'inventing' and selling the perfect bomb detector. (See: https://www.bbc.com/news/uk-england-23768203.) Want to lose weight? Here's a wonder weight-loss drug that's twice as cheap as Ozempic and doesn't make you sick.

39. Konnikova quotes William James, the 'father of modern psychology', in his essay 'Brute and Human Intellect': 'To say that all human thinking is essentially of two kinds – reasoning on the one hand, and narrative, descriptive, contemplative thinking on the other – is to say only what every reader's experience will corroborate.' https://archive.org/details/jstor-25666088.

40. 'Young people arrested on suspicion of terrorism related offences in the UK continues to rise', Counter Terrorism Policing press release,

2023, https://www.counterterrorism.police.uk/young-people-arrested-on-suspicion-of-terrorism-related-offences-in-the-uk-continues-to-rise/.

41. When the police briefly imprisoned a group of protestors at King Charles III's coronation in 2023, they gifted republican campaigners a powerful story. British pressure group Republic, led by their Chief Executive Graham Smith, played their martyrdom to the hilt. Donations to the group rose by £50,000 over the following weekend, and their profile increased exponentially. For Smith it felt like vindication of his long-held beliefs:

> It's very simple: Instead of a coronation, we want an election. Instead of Charles, we want choice. The coronation is a pointless vanity parade that's costing a quarter of a billion pounds for Charles to parade along and have a hat put on his head when we're in the middle of a cost-of-living crisis – so it really isn't acceptable.

(Quoted in *Time* magazine, 4 May 2023, https://time.com/6277048/republic-graham-smith-interview-coronation-king-charles-iii/.)

Monarchies are a rational absurdity and, as Smith has pointed out many times, an affront to democracy. In a world where the Queen's second son was good friends with a convicted paedophile and had to settle a sex-abuse lawsuit out of court; where her grandson could accuse his own family of racism; and where her first-born once wished to be reincarnated as a tampon, it would be hard not to agree with his observation that the British royal family are 'tax-funded Kardashians'.

Faced with that reality, you can almost physically feel the lure of republicanism that drove the founding fathers to America. 'Where [. . .] is the King of America?' asked Thomas Paine in *Common Sense*. 'I'll tell you Friend [. . .] that in America THE LAW IS KING. For as in absolute governments the King is law, so in free countries the law ought to be King; and there ought to be no other.' Paine believed, and America was built on, the logical assumption that monarchies are absurd. One look at the catalogue of deranged sex pests, fantasists, paedophiles and infantilized narcissists who believed themselves to be God's representative on earth should convince anyone there can be no justification for their existence. Except, of course, *one* – the understanding that the illogical is fundamental to the survival of any tribe.

A monarch is not a person, they are a symbol: the embodiment of a nation in human form. So, while it's easy to look at the holder of the title and find fault, they are, in essence, not really a person at all; they are the living incarnation of a tribal story. Why might that be important? In a profoundly polarized world, do you want your nation's identity to repose in a

figure with huge power, voted for by less than half your population, or do you want it stored in something that feels eternal, timeless, that answers the need for the mystical in people, but has no actual political power? Would you prefer Tony Blair or Margaret Thatcher to have been president, a figurehead of the nation's values? Or might you see that a figure that didn't really exist, a projection of the people they governed, might actually be a wiser course?

Research suggests that, compared to republics and dictatorships, constitutional monarchies actually produce higher standards of living and far greater political stability. Indeed, according to think tank The Constitution Unit, 'In the most recent Democracy Index compiled by the Economist Intelligence Unit, six out of the top ten democracies – and nine of the top 15 – in the world were monarchies. They include six European monarchies: Norway, Sweden, Denmark, the Netherlands, Luxembourg and the UK.' (See: https://constitution-unit.com/2020/09/30/the-role-of-monarchy-in-modern-democracy/.) When grotesque disparities of wealth tend to produce unhappier countries, it feels counterintuitive to see anything worthwhile about monarchical rule, but constitutional monarchs prohibit politicians from staying in power, they prevent political overreach, they have a long-term focus because they tend to be dynastical and, because they're constitutional not absolute, there is little incentive to overthrow them. All of these are overtly logical reasons to keep monarchy, and there are good arguments against all of them, but it's in the mystical or narrative realm that the case for them tends to have the most force.

42. Seventy per cent of the American population were affiliated with a synagogue, church or mosque in 1999, 50 per cent in 2018 and 47 per cent in 2020 – a seemingly one-way trajectory, perhaps marked best by the increasing fervour of the evangelical base and its ever-growing affiliation with Trump and the American right. Like any individual, aggression tends to manifest itself when it senses a threat. If the dams are breached and the rivers of religion run dry – what happens then?

43. Nick Cave, 'Why the fuck are you going to the King's coronation?' *The Red Hand Files* newsletter Issue #235, May 2023, https://www.theredhandfiles.com/why-are-you-going-to-kings-coronation.

44. Ask yourself why India, Ghana, Tanzania, Zambia, Jamaica, Trinidad and Tobago, and Singapore, when newly independent – each with fiery nationalist leaders – chose to join the Commonwealth. Even Kenya, home to unique British savagery, took the Queen as its head. Was that lazy, self-hating nostalgia or an understanding that allegiance to a common story gave a far greater prospect of domestic stability than accepting financial incentives for loyalty from darker forces elsewhere? And while King and

Country were the driving narrative behind the brutal establishment of Britain's bloody empire, ask yourself did the existence of that Commonwealth allow Britain to divest itself from those interests with far less bloodshed than France or Belgium? That, actually, a story that all of them signed up to might have been an aid? Be sure of your answer, and before you become a cheerleader to a republic, cast a glance at how Thomas Paine's dream has turned out. Ask yourself if your completely logical and good intentions are a handmaiden to something much darker instead.

What many anti-monarchists misunderstand is that the King isn't a person, he's a symbol of the state. Charles may well be a buffoon, but the king is technically different. As the *Commentaries, or Reports of Edmund Plowden* put it in the sixteenth century:

> The King has in him two Bodies, *viz.*, a Body natural, and a Body politic. His Body natural (if it be considered in itself) is a Body mortal, subject to all Infirmities that come by Nature or Accident, to the Imbecility of Infancy or old Age [. . .] But his Body politic is a Body that cannot be seen or handled, consisting of Policy and Government, and constituted for the Direction of the People, and the management of the public-weal, and this Body is utterly void of Infancy, and old Age, and other natural Defects and Imbecilities, which the Body natural is subject to, and for this Cause, what the King does in his Body politic, cannot be invalidated or frustrated by any Disability in his natural Body.

45. The Ukraine Famine of 1932–33, known as the Holodomor, was a direct result of Stalin's forced collectivization. *Holod* is the Ukrainian word for 'hunger', and *mor* 'extermination' or 'genocide'. Estimates of death range between 3 and 7 million.

46. There's a wonderful description of this in Han Suyin's *A Many-Splendored Thing*, her novel about a love affair with a Western man in Hong Kong, set just as the communists were sweeping across China, and everyone knew a new world was coming:

> Religious emotion; Faith in Man. Like all new-roused faiths, intolerant and fanatical. Come to clothe the poor, feed the hungry, do justice to the downtrodden. With its zealots, its saints, its soldiers. Rousing the lovely things in the soul of man: ardor, craving for purity, single-mindedness and self-abnegation. But also over-reaching itself, working itself up into frenzies of hatred for those that did not conform; denouncing and suspecting heretics everywhere, imposing terror in the name of justice and forgetting mercy; on and on, driven purification by death, public

execution, and Holy War; nothing that other revolutions and other religions had not done, on a bigger or smaller scale; inescapable the pattern it would follow. For man would always strive to conquer the world, to establish the will of man in the name of his God. With banners and shouting, legions and crosses, eagles and suns, with slogans and with blood. Feet in the dust, head among the stars. Old gods with new, wet paint upon their faces.

The book is remarkable for its insight into how these belief systems work, all the more ironic in that Han Suyin later became an apologist for Mao's Cultural Revolution. The novel is well worth reading however: a love story set just as communism was usurping colonialism proves an extremely fertile seam.

A statue is just a lump of metal or stone. If you ascribe to it qualities of good or bad you are illustrating your susceptibility to religious faith. We all must find something that lashes us to our planet. We must believe in something, or the nausea will envelop us in the end. Even seeming enemies of religion find faith somewhere. The liberals who decried religion as a feudal anomaly, their belief was vested in progress. The great atheist Richard Dawkins worships science, Steven Pinker reason. John Gray, author of *Seven Types of Atheism,* called this 'the belief in improvement that is the unthinking faith of people who think they have no religion'.

47. Helen Lewis's BBC Podcast *The New Gurus* is a fascinating insight into the quest for modern enlightenment. https://www.bbc.co.uk/sounds/brand/m001g9sq.

48. 'Shattered by diminishing faith in the ideals of single nations and their tribal faiths. Social Justice at its most strident fills the gap for those of us who despair of our countries, and nothing betrays its religious underpinning more than its policing of art. The high priests don't want art, with all its nuance and subjectivity and ambiguity,' Helen Lewis wrote in an email exchange with me. 'They want scripture.'

49. You can find yourself productivity gurus, race gurus, yoga gurus, seduction gurus; you can place your faith in LSD or Bitcoin; in Tucker Carlson, in David Icke, in Piers Corbyn or Russell Brand – the endless cycle of shamans who will tell you that theirs is the only true way.

50. 'Remarks by President Biden on the Continued Battle for the Soul of the Nation', 1 September 2022. The idea of an American civil religion is a long-standing one, given greater purchase by the sociologist Robert Bellah in his 1967 article 'Civil Religion in America'. For Bellah, the Declaration

of Independence and the Bill of Rights can be seen as sacred texts, with the shared holidays, culture, rituals and values framing a religion in all but name. Think of the opprobrium that greets any desecration of the flag, or the outcry when NFL footballer Colin Kaepernick 'took the knee' during the playing of the national anthem. For many, it wasn't a political protest but an act of blasphemy. Sinéad O' Connor, too, gravely damaged her career in America by refusing to allow the anthem to be played before her concert. It's hard to imagine a similar fuss in the UK.

51. In *Strange Rites*, Tara Isabella Burton writes:

> Among the hundreds of thousands of *Star Trek* fans worldwide, you often find, according to sociologist Michael Jindra, a culturally resonant, coherent, and consistent theological strain: the 'mythical resonance of a future universe-wide utopia.' *Star Trek*'s creator, Gene Roddenberry, spoke frequently in interviews about the utopian vision of technological progress and human potential that underscored *Star Trek*'s plotlines and grounded its moral systems. Another of the show's writer-directors reflected on how the show had 'evolved into a sort of secular parallel to the Catholic Mass. The words of the Mass remain constant, but heaven knows, the music keeps changing.'

I am extremely grateful to Burton's book. It's both deeply knowledgeable and refreshingly unpretentious on the different ways we seek faith.

52. Ibid. 'While the number of people who say they consider themselves Jedi is relatively small – about 250,000 worldwide – it's worth noting that this still makes Jediism among the most practiced "alternative" religions in the world, beating out longer-standing traditions like Wicca and Scientology.'

These sagas of schools and space are the Bibles of our day. But there's one other religion that's significant – one that threatens to topple the very foundations civilization is built on. True or not, it became accepted by both observers and participants that Richard Nixon lost the US election to John F. Kennedy because of television. Any natural advantage when they debated live was destroyed by Kennedy's film-star charisma and by Nixon, sweating under the lights in a rumpled shirt, unable to hide his sinister-looking five o'clock shadow. By 1968, however, Nixon had learned. He would remount the horse, master the medium and destroy his rival Hubert Humphrey. 'We can't win the election of 1968 with the techniques of 1952,' said Raymond K. Price, a key Nixon adviser. 'We're not only in a television age, but in a television-conditioned age.' Price's musings were to redefine US politics – all politics, in fact – forever. (Quoted in Joe McGinniss, *The Selling of the President*, Trident Press, 1969.)

'The natural human use of reason is to support prejudice, to arrive at opinions,' Price reflected. Newspapers and magazines were good for discursive reasoning, but television wasn't. It was a medium of *emotion*.

> We have to be very clear on this point: that the response is to the image, not to the man [. . .] Voters are basically lazy [. . .] Reason requires a high degree of discipline, of concentration; impression is easier. Reason pushes the viewer back, it assaults him, it demands that he agree or disagree; impression can envelop him, invite him in, without making an intellectual demand [. . .] When we argue with him, we [. . .] seek to engage his intellect [. . .] The emotions are more easily roused, closer to the surface, more malleable.

(Ibid.)

One phrase jumps out from Price's deliberations: 'It can only be effective if we can get the people to make the emotional leap, or what theologians call the "leap of faith".' (Ibid.) Politics had stumbled upon the portal to religion.

Without a royal family to symbolize the nation, with a flag that no longer unites but divides by meaning completely different things to different groups, by removing any real sense of a uniting civil religion, the religious impulse is instead channelled by many Americans into politics. As identity becomes inextricably linked to political affiliation, the true power of narrative asserts itself, with worrying implications.

That power was to be tapped like never before, first by Bill Clinton, then Barack Obama and then by Donald Trump, who thanks to television became the embodiment of an unholy trinity: a living test tube where God, politics and the big con meet and mix to find an explosive new form.

53. Quoted in Michael Marinacci, 'The Patten Ministry' blog post, 1 January 2015, http://califias.blogspot.com/2015/01/the-patten-ministry-patten-university.html.

54. Konnikova, *The Confidence Game*.

55. Patten died aged forty-five from a heart attack, triggered in part by a morphine addiction. Bebe was unphased, became a national evangelist and received three separate resolutions from the California State Senate for her achievements in religion and education. The Patten University exists to this day.

56. We *must* fill Pascal's vacuum, and how better than with something manifestly untrue, something perfectly engineered to fill the bespoke shape of your wound, something identical to Konnikova's con? Faith trumps all.

57. Konnikova, *The Confidence Game*.

58. Burton, *Strange Rites*.
59. Religion and narrative are inextricably linked. As Burton says:

> What a wellness junkie who spends days on an expensive juice cleanse
> to purify her body of toxins shares in common with an 'incel' or white
> supremacist domestic terrorist perpetrating a mass shooting is a sense that
> their personal decision-making is rooted in a grand narrative about why
> the world is the way it is – and who (or what) is to blame.

It's not only that, it's the underlying structure. Scientology, AA, *Harry
Potter*, the beliefs of Shamima Begum, *Superman*, Reagan, Hamas. Every
successful story has a god and a devil, with priests as outriders, guarding
the protagonist inside. Find the right god and devil for the people you wish
to bewitch, and you have found the pathway to gold at your rainbow's end.

60. Dominic Dromgoole, *Astonish Me! First Nights That Changed the World*
(Profile Books, 2022). '[The arts]' said David Mamet, '[are] created to
arbitrate the functions of the conscious and the unconscious mind. In
great art – The Bible, Shakespeare, Bach – the balance is long-lasting. It is
not that great art reveals a great truth, but that it stills a conflict.'
61. Prince Harry echoes this exactly at the midpoint of *Spare*. He must
hold onto this encounter, this unreal moment when the line between me
and the external world grew blurry or disappeared outright. Everything,
for one half second, was one. Everything made sense. Try to remember,
I thought. How it felt to be that close to the truth. The real truth.
62. The Sanskrit word *guru* means 'dispeller of darkness', and gurus dispelled
that darkness by telling stories about how the heavens worked. The myths
they told were, as Joseph Campbell has said, designed 'to harmonize. The
mind can ramble off in strange ways, and want things that the body does not
want. And the myths and rites were means to put the mind in accord with
the body, and the way of life in accord with the way that nature dictates.'
(From interview with Bill Moyers, 'The Power Of Myth' Episode 3,
'The First Storytellers', https://billmoyers.com/content/ep-3-joseph-
campbell-and-the-power-of-myth-the-first-storytellers-audio/.)
63. Taken from *Tolkien in Oxford*, a BBC television interview with John Izzard,
transmitted on 30 March 1968. The full quote (edited for clarity) is:

> If you really come down to any large story that interests people, that
> can hold their attention for a considerable time [. . .] they're always
> about one thing, aren't they? Death. The inevitability of death [. . .]
> There was a quotation from Simone de Beauvoir that I read in the
> paper the other day [. . .] 'There is no such thing as a natural death.

Nothing that happens to man is ever natural, since his presence calls the whole world into question. All men must die: but for every man his death is an accident, and even if he knows it and consents to it, it is an unjustifiable violation.' You may agree with the words or not, but those are the keyspring of *The Lord of the Rings*.

More on the (very moving) programme here: https://www.bbc.co.uk/archive/release--jrr-tolkien/znd36v4.

We have talked about how the best stories place us in a virtual reality, almost as real as life. But the perfect story *is* the one each of us is trapped in now. Our belief systems, our world views, are prescribed by a series of invisible narratives, wrapping us tightly, protecting us from the external fears we have convinced ourselves are there.

APPENDIX IV

1. Hayao Miyazaki, quoted in interview with Roger Ebert, 2002, https://www.rogerebert.com/reviews/great-movie-spirited-away-2002.
2. One typical tale is 'Anansi and the Yam Hills' by Michael Auld:

 There was an old woman '5' who as a child was relentlessly teased for her name. When she was older she cast a spell: 'From this day on, anyone who says "5" will disappear,' Anansi the spider, our trickster hero, decides to exploit this by planting five Yams on a road, and asking passers-by to tell him how many Yams he has. When the gullible count them, they disappear, leaving any goods they're carrying free for Anansi to collect. One day Mrs Guinea Fowl comes along and counted the Yams for Anansi '1-2-3-4 and the one I'm standing on.' Frustrated he asked her three times to answer his question. Finally, she asked him what she is supposed to say. Anansi counts the numbers and disappears forever.

 (Michael Auld, https://www.anansistories.com/, 2007)
3. Al Creighton, 'The African story-telling tradition in the Caribbean', *Stabroek News*, 16 August 2009, https://www.stabroeknews.com/2009/08/16/sunday/arts-on-sunday/the-african-story-telling-tradition-in-the-caribbean/.
4. Florence Baer identified 140 stories with African origins, twenty-seven with European origins and five with Native American origins. (Florence E. Baer, *Sources and Analogues of the Uncle Remus Tales*, Folklore Fellows Communications, 1980.)

Index

Page references in *italics* indicate images.

Abbott, H. Porter: *The Cambridge Introduction to Narrative* 15
Adolescence (Netflix series) 105, 128
Afanasyev, Alexander 291
African oral storytelling 263, 264–5, 348–9, 351, 353
Aftersun (film) 125, 345
Agony and the Ecstasy, The (film) 235
Akerman, Chantal 27, 371n
Alcoholics Anonymous xv, 204–7, 272, 333n
Aliens (film) 24, 54, 67, 187–8, 374–5n
Allen v. Farrow (documentary) 293–7
American Civil Religion 329, 442n
American Graffiti (film) 221, 231, 234, 415n
American War of Independence (1775–83) 156
Amis, Martin 197, 412n
Amy (documentary) 132, 134, 212, 218, 430n
An Cailín Ciúin (*The Quiet Girl*) (film) 136
Anansi (Ananse) Tales 263, 349, 351, 424n, 446n
'And Now Win the Peace' (slogan) 81
Andrei Rublev (film) 234–8, 239, 242, 288

Andy Griffith Show, The (TV show) 111, 112–13
antagonist xvii, 35, 151, 156, 163, 170, 218, 250, 261, 262, 264, 426n
defined 15–16, 170, 319
designing 98
empowerment and 45
five-act structure and 40, 337
Get Back and 14
goals and 108–9
Harry Potter and 310, 311
hero and 199
Kübler-Ross paradigm and 302, 303
politics and 77, 83, 85, 88, 96–106, 108, 109, 111–13, 128, 324
protagonist, antagonist and goal, uniting 111–13
purity spirals and 386–8n, 393n
religion and 199, 204, 206, 218
self-definition and 101
ten key questions of story and 183, 184, 186
three act structure and 15, 16
antisemitism 79, 152, 158, 200, 202, 309
antithesis 16, 148, 223, 237, 296
Apocalypse Now (film) 236
Applebaum, Anne 102

Apprentice, The (TV series) 9, 10
Arabic narrative traditions 351–2
Arbuckle, Fatty 131
argument
 argument for, argument against
 297–300, 431*n*
 Clinton and 122, 123
 counter-storylining and 230
 crisis point and 305
 defined as 'an emergency of self-
 definition' 106
 logos/plausibility of 139–41, 146
 resolution of 223–4
 scientific method and 306
Ariadne (mythical figure) 241, 244,
 263
Aristotle 267
 Poetics 246
 rhetorical appeals 121–45, 152
 The School of Athens xii, xiii, 37–8
Army of Shadows (film) 142
arthouse films 27–8, 84, 96*n*, 188,
 212, 233–44. *See also individual film
 name*
artificial intelligence (AI) 283, 313
associative editing 213
Attlee, Clement 82
Atwood, Margaret 177–8, 351*n*
 The Blind Assassin 352
 The Handmaid's Tale 178, 352
Augustine of Canterbury 328
Avatar (film) 128, 183

BAFTA 4, 78, 215, 242
Baker, Josh 160–61
Baldwin, Thomas 39, 385*n*, 426*n*
Banco de Credito del Peru, Lima,
 attack on (1992) 163
Bannon, Steve 106
Bass, Saul 232

Batman (film) 159
Battlestar Galactica (film) 94, 346
BBC 3, 4, 11, 30, 47, 77, 79, 86, 128*n*,
 142, 145, 160, 253, 334, 345
Bear, The (TV series) 128, 228
Beatles, The 12–14, 26, 128; *Let It Be*
 12–13
Begum, Shamima 160–62, 167, 180,
 199, 328, 406*n*
Bengali widow's narrative 247, 261–3
Beowulf (Anon.) 23, 183, 263, 419*n*
Berger, Peter L. 174–5
'Beyond Hero's Journey:
 non-Western Story Structure'
 (video essay, YouTube) 270
Bible 47, 59, 110, 155, 207, 208–9, 236,
 310, 313, 316, 330, 388*n*, 391*n*, 395*n*,
 443*n*. *See also individual book of
 name*
Biden, Joe 330, 386*n*, 442*n*
Bildungsroman (journey from
 childhood to adulthood) 254
binary systems 77, 84, 97, 168, 181,
 183, 185, 196, 198, 202, 203, 307, 311,
 418*n*
black-and-white thinking 136–7
Black Mirror (TV series) 263
Black, Shane 135, 138
Blair, Tony 82, 116, 183, 381*n*, 385*n*,
 439*n*
Blyton, Enid 349
Bradlee, Ben 326, 437*n*
Bradley, Garrett 213
Br'er Rabbit stories 349
Breaking Bad (TV series) 41, 43, 45,
 97, 111, 127, 304, 372*n*, 385*n*
Brexit xii, 84, 85, 100, 115–16, 156, 281*n*
Bridgerton (TV series) 127, 144, 384*n*
Brownlow, Kevin 20, 382*n*, 421*n*
Burnett, Mark 9

Burton, Tara Isabella: *Strange Rites: New Religions for a Godless World* 174, 330, 332, 442–3*n*
Bush, George W. 100–101, 269

Cameron, David 82
Cameron, James 54, 67, 128, 132, 187, 340, 411*n*
Campbell, Joseph: *The Hero with a Thousand Faces* xvi, 19, 56–7, 64, 246, 270–72, 283, 288, 290, 293, 378*n*, 445*n*
Capote, Truman: *In Cold Blood* 136
Captain America (film) 159
Caribbean story structure 264, 349
Carr, Allen 131–5
Carr, Maxine 95
Casablanca (film) 304, 305, 305*n*, 426*n*, 432*n*
cave, inmost/dark 64, 253, 271, 274, 282, 284, 286, 300, 379*n*, 432*n*
Cave, Nick 313, 329, 440*n*
Celebrity Apprentice (TV series) 9
Cernovich, Mike 115
Challenger, Space Shuttle 129, 130, 143, 145–6, 148, 298, 320, 396*n*, 397–8*n*
Channel 4 9, 30
Channel 5 95
chaos 8, 10, 11, 12, 16, 34, 44, 51, 171, 185, 216, 217, 326, 327
Chaplin, Charlie 89–90, 131, 173, 382*n*, 400*n*, 421*n*
ChatGPT 313
Chatterton, Thomas 18, 18*n*
Chekhov, Anton 168
Chernobyl (TV series) 11, 128, 141, 144, 170, 189–95, 196, 198, 224–6, 365*n*, 385*n*, 414*n*
Cherokee 349

chiasmus 47–58, 118, 148, 151*n*, 161, 225, 275, 293, 310
 Harry Potter series and 342–3
 ring structure and 61, 68
 Roadmap of Change and 340–43
 series chiasmus 55–8
 Terminator 2 and 340–41
Child, Lee: *Jack Reacher* 96, 114, 116, 119, 177, 319
chimpanzees, collective action and xvii–xviii
China 59, 122, 394*n*, 407*n*, 441*n*
 epic narrative 345–6
 episodic narrative 263
 Four Great Classical Novels 346
 frame narrative and 247, 268
 Kishōtenketsu and 248, 249, 255–6, 268
 Mao/Cultural Revolution/Edgar Snow 104, 112, 121, 163–7, 178–9
 Wuxia narrative 346–8
Churchill, Winston 81, 120, 121, 152–3, 168, 402*n*, 407–8*n*
Cicero, Marcus Tullius 145–6, 401–2*n*
Cinderella effect 199
Citizen Kane (film) 43, 107–8, 111, 389*n*
City Lights (film) 27, 90, 421*n*
Claudel, Philippe 221
Clay, Marie 101
Clinton, Bill 444*n*; 'A Place Called Hope' 121–2, 145
Clinton, Hillary 83–4, 84*n*, 106, 147
CNN 145
Coel, Michaela 42, 227
Cognitive Revolution 179
cognitive warfare 121
collective action xvii–xviii, 378*n*, 409*n*
collective effervescence 176–7, 409*n*
Collee, John 85, 95, 368–9*n*, 408*n*

composition
 aim of 144
 power of 38
 ring composition *see* ring
 composition
conclusion 146–7, 170, 230, 240–41,
 244, 248, 250–52, 254–6, 275, 298,
 402n
confidence artists/games 324–8,
 330–32, 351, 437–8n, 444n
confirmation 146, 147, 148
conflict 15, 319–20
 conflict-free narrative structure
 25, 247–8, 253–5, 257, 259, 344, 347,
 418n, 419n
 conflict narrative 266–70
 integral to all narrative 15–17, 63,
 141, 319, 344
 ten key questions of story and
 183–5
Conservative Party 82–3, 381n
conspiracy theories xvi, 199–204,
 269, 276, 283, 326, 437n
constitutional monarchies 309,
 439–40n
contrast 38, 47, 147, 248
Corbyn, Jeremy 77, 79, 112, 128,
 169
Cottrell Boyce, Frank 137
counter-storylining 228, 229–30
counterterrorism 328, 438n
Covid-19 pandemic (2020–21) 93, 128,
 323
Crash (film) 231, 416n
creation stories/myths 12, 58, 313,
 348, 353–5, 376n
Creighton, Al 264
Crick Crack 264, 349, 424n
Crimea, Russian annexation of (2014)
 122, 123

crisis point 32, 42, 45, 186, 221, 237,
 253, 295, 299, 305, 330, 340, 371n,
 425n, 427–8n
Cromwell, Oliver 156
Crouching Tiger, Hidden Dragon (film)
 347–8
Crown, The (film) 127, 145, 228,
 398n
Cruz, Ted 84
cults xi, 93, 104, 172, 197–208, 329, 332,
 380n, 393n
cultural colonialism 266
cumulative extremism 101–3
Cusk, Rachel 106; *Outline* 242

Dad's Army (TV series) 128, 184
Dahmer (TV series) 107
Daily Mail 115–16
Daily Telegraph 115
Davies, Russell T. 28–9, 30, 32, 33, 36,
 68, 185, 307
Dawson, Les 134
Dearborn Independent, The 200
death, fear of xviii, 166, 307, 309, 310,
 312, 314–17, 320, 324, 330, 334
Del Toro, Guillermo 232
Delaney, Rob: *A Heart That Works* 39,
 41–2, 45
demagogues 86, 201, 207
Democratic Party, US 74, 109, 123,
 129, 146, 147, 152, 380
DeSantis, Ron 123
desire, object of 186–7, 323–4
devotion, inspiring 318–19
Dexter (TV series) 95
Diego Maradona (documentary)
 219
Diermyer, Cheryl 260, 423n
difficulty, admiration of 27
discovery 26–7, 130, 397n

disruption 16, 33, 51, 115, 243, 270
 equilibrium 290–94, 298–300, 304,
 307–8
 recognition of 291, 292–4, 299, 300,
 307
dissonance xiii, 16, 24, 97, 98, 101, 134,
 168–71, 175, 197, 209–77, 310
 arthouse film and 234–44
 counter-storylining 228, 229–30
 frame narrative 262–77
 hero's journey, non-Western
 narrative and 245–77
 host-seeking emotion 232–4
 Moonage Daydream 216–19
 multiprotagonism 230–34
 non-archetypal and non-Western
 narrative 211–16
 theme 219–29
documentary 7–8, 15, 43, 116, 132,
 212–19, 293–5, 297, 312, 379n, 389n,
 392n, 417n, 421n, 430–31n. See also
 individual documentary name
Donaldson, Julia: The Gruffalo 34, 54
Douglas, Professor Mary: Thinking
 in Circles: An Essay on Ring
 Composition 59–63, 67
Downey Jr, Robert 126, 128
Downfall (film) 126
Downton Abbey (TV series) 78–9
#DrainTheSwamp (slogan) 83
Dromgoole, Dominic 333, 445n
drug dealing, storytelling as 131–8
dub music 238–42, 416n
Durkheim, Émile 174, 176–7, 323,
 436n

EastEnders (TV series) 47–50, 108,
 133, 136, 138, 384n, 436n
Eatwell, Roger 101–2
ego defence mechanism 159, 162

8½ (film) 240
Eisner, Will 158
Eliot, T. S. xiii, 215
Elizabeth II, Queen 137–8, 228, 329
Elvis (film) 131
emotional damage 86–7
empathy 21, 22, 44, 73, 88, 94, 95, 98,
 113, 123–7, 148, 151, 186, 231, 233, 312,
 325, 383n
empowerment 24, 26, 45, 178, 276,
 326, 349
Empty Your Cup (Buddhist story) 348
enemies 56, 77, 80, 90, 104, 111, 119,
 197, 249, 271, 274, 284–5, 391n, 392n,
 407n, 408n, 442n
Engelmann, Siegfried 'Zig': The Pet
 Goat 100–101
English Civil War (1642–51) 105–6,
 385n
Enthusiasm: Symphony of the Donbas
 (film) 173–4
equilibrium 290–94, 298–300, 304,
 307–8
ER (TV series) 111, 233–4, 242, 307
Ethelbert of Kent, King 328
ethos 122–9, 145, 151, 401n, 402n
Euripides: Orpheus and Eurydice 62
events (fabula), and (syuzhet). division
 between 320–21
Exodus, book of 155–7, 166, 167, 178,
 323, 450n
exordium 146, 147, 148

Face in the Crowd, A (film) 113
Fall (film) 63–4
family 111–12, 125, 142, 143, 147, 178,
 200, 222, 315, 316, 321, 330, 391n,
 401n
fascism 66, 114–15, 118, 326
Fast and Furious (film) 345

fear 75, 83, 101, 104, 130, 152, 158, 163,
 178, 255, 265, 266, 267
 cave you fear to enter 63–9
 conspiracy theories and 200–204
 death, fear of xviii, 166, 307, 309,
 310, 312, 314–17, 320, 324, 330, 334
 goal and 111
 grid of opposites and 207, 208
 purity spirals and 105
 Roadmap of Change and 265–7,
 276
 stories to quell our biggest fears
 354
 theme and 222, 224
Fellowes, Julian 78
Festinger, Leon: A Theory of Cognitive
 Dissonance 169, 409n
fiction
 definition of xiv, 77
 lessons from school of 1–69,
 279–334
Field, Syd: Screenplay xi, 3, 4–5, 7,
 19–20, 35, 267, 276, 293, 312, 334
Finding Nemo (film) 21, 26, 222–4,
 226, 427
Fiorelli, Giuseppe 14
Fitzgerald, F. Scott 168, 407n
five act structure xv, 30–36, 38–42,
 42n, 45–6, 65, 68, 267, 291, 302
 Moonlight and 335–9
Flaherty, Robert 8, 34
Fleabag (TV series) 114, 117, 127, 136,
 138, 177, 184
Fleming, Ian: From Russia with Love
 62
Floyd, George 105, 416n
For All Mankind (TV series) 135
Ford, Henry 202
Forster, E. M. 68; A Room with a View
 46–7, 64

48 Hours (film) 143
Fox News 145, 406n, 408n
fractal structure 33, 41, 42, 56, 57, 133,
 163, 190n, 195, 238, 250, 295, 307,
 311, 346, 426n
frame narrative 247, 262–77, 350n, 351n
framing 37, 84, 252, 426n, 442n
Frank, Scott 136
Freedland, Jonathan 115, 391–2n
French Revolution (1789) 103–5
French Structuralists 288
Freud, Sigmund 99, 102, 107, 232, 276
Freytag, Gustav: Die Technik des
 Dramas/Freytag's Pyramid 45,
 246, 267, 288, 294, 295, 297, 373n,
 426n
Friends (TV series) 9, 142, 145
Fyre (documentary) 43

Game of Thrones (TV series) 125, 127,
 143, 185, 207, 233, 346, 350
Geertz, Clifford 174
General, The (film) 27–8, 62, 377n
general elections, UK
 (1945) 81
 (1997) 82
 (2010) 82
 (2015) 82–3
Genesis, book of 12, 58, 59
Get Back (documentary) 12–14, 26
'Get Brexit Done' (slogan) 84, 85
Gettysburg address (1863) 140, 144,
 149, 151
Ghostbusters (film) 257, 258
Gill, A. A. 78
Gilligan, Vince 97
Gilot, Françoise 333
Girard, René: I See Satan Fall Like
 Lightning 116–17
Girl Shy (film) 136

Glyn, Elinor: *The Elinor Glyn System of Writing* 20, 369n
'Go Down Moses' (spiritual) 156, 260
goals xviii, 13, 14, 16, 38, 61, 176, 177, 234, 259, 264, 269, 304, 311, 320, 333, 346, 401n
 EP ('End Phenomenon') 171–2
 holy trinity of protagonist, antagonist and 106–19
 politics and 74, 77, 81, 82, 83, 85, 86, 87, 105–19
 ten key questions of story and 186, 196, 198, 199, 204
 transcendent 125, 151, 165
God 12, 68, 96, 99, 157, 157n, 171, 173, 179, 181, 198, 203, 205–7, 272, 313, 315–17, 321, 328, 329
 story/fiction as 330–34
Godfather, The (film) 40, 51–2, 183, 296, 305, 310, 385n, 400–401n
Godfather Part II, The (film) 147–8
Goebbels, Joseph 158–9, 332
Gold Rush, The (film) 89–90, 131
Goldwater, Barry 73–5, 115, 148, 379–80n, 408n
golem 158–9
Gone Girl (film) 256, 257, 258
Granger, John 59, 377n
Greil, Arthur 207
grief, Kubler-Ross Cycle of xv, 272, 301, 302, 304, 307, 355
griot 264–5, 348, 351, 353, 424n
Gross, David 134
Groundhog Day (film) 301, 302
Gunn, James 159

Haggis, Paul 231
Hakawati 265, 351
Hale County This Morning, This Evening (documentary) 213

Halevi, Yossi Klein 201
Hallmark 312
Hamas 201
Hans, Simran 212–14, 241, 242
Happy Valley (TV series) 90–92, 96, 111, 114, 117, 118, 119, 127, 128
Harari, Yuval Noah: *Sapiens: A Brief History of Humankind* xvii, 179, 196, 264
Harris, Joel Chandler: Uncle Remus stories 349
Harris, Kamala 152
Harrison, George 14
Harry Potter (book and film series) 61, 96, 119, 125, 127, 174, 207, 254, 270
 chiasmus and 342–3
 five act structure 65–8
 Harry Potter and The Deathly Hallows 66, 315, 342
 Harry Potter and The Goblet of Fire 65–6
 Harry Potter and the Philosopher's Stone 309
 hormonal stimulation and 136–8
 power of/religion and 309–20
 ring structure and 58–9, 65–8
Hayashida, Koichi 250–51, 255
Hayter, Dr Irena 257–8, 268, 354, 418n, 419n, 420n, 421–2n
HBO 9, 170, 189, 293–4, 295
Heaney, Seamus 142
Heimat (TV series) 23, 77–8
Herrmann, Bernard 54, 232
hero 16, 20, 24, 36, 44, 51, 75, 76, 80–81, 85, 96, 180, 183, 199, 202, 208, 235, 299, 309, 319, 323, 342, 369n, 372n, 380n, 385n

hero's journey xvi, xviii, 62, 96–7,
100, 158, 206, 215, 300, 418n, 426n,
428–30n
Andrei Rublev and 238
Moonage Daydream 218
non-Western narrative and 212–13,
246–8, 253, 262–3, 269, 270–77,
343–8
origins of xvi, 56–7, 290 *see also*
Campbell, Joseph
Red Star 167
Roadmap of Change and 284–5,
355
Star Wars series 56–7, 282–8
Hillsborough (TV series) 144
Hitchens, Christopher 201–2
Hitler, Adolf xvii, 15, 81, 86, 114, 117,
126, 332; *Mein Kampf* 200
Hochschild, Arlie Russell: *Strangers
in Their Own Land: Anger and
Mourning on the American Right*
321–3, 435n
Hoffer, Eric: *The True Believer* 87,
118, 320
Hofstadter, Richard 106, 117, 393n;
'The Paranoid Style in American
Politics' 113–14
Homer
The Iliad 61, 63
The Odyssey 85
'Homes fit for Heroes' (slogan)
81, 85
Horace 39
host-seeking emotion 233
Hoving, Thomas 237–8
Hubbard, L. Ron 171, 172n, 207
Hugo (film) 27
Hume, David 105–6, 333
Huntley, Ian 95
Hurwitz, Sarah 146

Huxley, Aldous 116
hypothesis 305–6, 306, 311, 356
I May Destroy You (TV series) 42–3,
114, 127, 136, 177, 221, 226
I've Loved You So Long (*Il y a longtemps
que je t'aime*) (film) 220–22, 230
Identity Transformation
Organization (ITO) 207
ideology 138, 165, 167, 168–71, 172, 177,
197, 198, 203, 204, 407n, 409n
immigration 100, 140, 152, 157, 158,
200, 322, 323, 381n, 399n, 435n
In Daughters of the Dust (film) 240–41
inciting incident xvi, 151, 282, 292,
305, 311, 325
classic rhetoric and 148
Crash 231
Finding Nemo 222–4, 226, 226n
French Revolution and 104–5
Freytag's Pyramid and 294, 295
Get Back 14
I May Destroy You 42
I've Loved You So Long 230
It's a Sin 32–3
Kishōtenketsu and 253, 259–60
McKee's definition 267, 276, 426–7n
Moonage Daydream 218
Roadmap of Change and 340
scientific method and 306
Star Wars and 299
ten key questions of story and
186–90, 195, 411n
India 17, 88–9, 96, 100, 120, 165, 183,
247, 407–8n
Indian epic narrative 263, 350
indigenous storytelling 260, 352–3
individual stories 159–63
innermost cave 64, 300
Inside Out (film) 21, 22, 26

inversion 22, 47, 54, 97, 196, 201, 293, 320, 369–70n
IRA 79, 102
Iron Man (film series) 36, 126, 127, 128, 135
Islamic State (IS) 160
It's a Sin (TV series) 28–35, 185

Jack Reacher (film, TV and book series) 96, 114, 116, 119, 177, 319
Jackson, Peter 13, 14
Jaffa, Rick 97
James May: The Reassembler (TV series) 11
Japan 123, 124, 249, 251, 256, 265, 418n, 421n
 Ma (間) 263, 345
 Zen stories 346–8
Javid, Sajid 160
Jaws (film) 52–3, 75–6, 82–3, 84, 100, 232, 361n, 411n
Jeanne Dielman, 23 Quai du Commerce, 1080 Bruxelles (film) 27–8, 240, 370n, 371n
Jediism 330, 443n
Jenkins, Barry 42, 188, 335, 411n
jeopardy 10, 44, 45, 186, 250, 352
Jocelyn, Ed 167
Johnson, Kirsten 213
JoJo Rabbit (film) 54
Joker (film) 51, 126–7
Joon Ho, Bong 251, 262
Jordan, Tony 47–50, 68
journey and its return 62
joy, importance of xiv, 25, 26, 27, 28, 30, 173, 177, 397n, 425n
Joyce, James 215, 216; A Portrait of The Artist as a Young Man 12
Junger, Sebastian 124–5
Jurassic Park (film) 141

kairos 141–4, 143n, 145, 151, 159, 349, 399n, 401n, 402n
Kane, Bob 159
Kapadia, Asif 132, 219, 430n, 437n
Kazan, Elia 106–7, 113, 333
Keaton, Buster 27, 28, 62, 180, 377n
Keegan, Claire 136
Kennedy, John F. 59, 60, 121, 145, 170, 202, 373n, 382n, 443n
Kennedy, Robert 88
Kid, The (film) 131, 382n
Kiki's Delivery Service (film) 252, 253, 420n
kill the witch 122
Killers of the Flower Moon (film) 95–6
Killing Eve (TV series) 114, 117, 125–7
King, Martin Luther 139, 156, 402n
Kino-Eye (documentary) 7–8, 173
Kipling, Rudyard: Just So Stories 349
Kirby, Jack 159, 293
Kishōtenketsu xiii, 212, 247–60, 268, 270, 345, 418n, 422n
koans (公案) (Japanese Zen stories) 348
Koenitz, Professor Hartmut 246–7
Koestler, Arthur
 Darkness at Noon 178
 The God That Failed 178, 204, 205, 207, 329
Konnikova, Maria 326–7, 351; The Confidence Game 324, 331–2
Kübler-Ross, Elisabeth: On Death and Dying xv, 301–3, 355, 431n
Kuomintang party 164, 166
Kurtzberg, Jacob 159

La Ronde structure 262
Labour Party 79–83, 112, 173, 380n, 381n
Lake Charles 321

Lancaster, Simon 146, 227, 393n; *Speechwriting: The Expert Guide* 146

Lane, Anthony 235

language, flexible 179

laughter 28, 130, 134–5, 176

Lawrence of Arabia (film) 162, 419n

Le Carré, John 142 Le Guin, Ursula 268–9

learning x, 16, 34–5, 40, 55, 64, 101, 121, 221–4, 237

 Kolb's learning cycle 431–2n

 learning lessons, character 21–3, 42–3, 45, 148, 174–5, 228, 251–4, 264, 283–6, 295, 298, 303–8, 311, 316, 327, 340, 346, 375n, 388n, 404n, 415n

 stories as units of learning 21–3, 303–8

 ten key questions of story and 186–90, 195–6, 411–12n

Lee, Ang 347–8

Legend of the Condor Heroes, The (film and television series) 347

Leslie, Ian 324

'Let's Take Back Control' (slogan) 84, 85, 381n

Lewis, Helen 143

Lewis, Sinclair: *It Can't Happen Here* 114–15

Licked Hand, The (story) 249–50

Lien, Henry 269–70

Life on Mars (TV series) 142–3, 368n

Lincoln, Abraham 140, 144, 208

Lindsay-Hogg, Michael 12, 13

Lloyd, Harold 135–6, 136n, 400n

Loew, Rabbi Judah 158

logos (apparent logic of the argument) 122, 139–41, 141n, 145, 151, 401n, 402n

London's Burning (TV series) 93–4

Long March 166–7

Lovell, Julia: *Maoism: A Global History* 165–6

Lubbock, Percy 266–9

Lucas, George 58, 64–5, 67–9, 230, 271, 283, 287, 317, 318, 379n, 394n, 395n, 434n

Luhrmann, Baz 131

Lumière brothers 24–5

Luther (TV series) 114

Lynch, David xiii, 240

*M*A*S*H* (TV series) 111, 143, 400

Ma, Japanese (間) 263, 345

Mad Max (film series) 45, 312

magical realism 17

Magnificent Ambersons, The (film) 54

Mahābhārata, The 185, 262, 263, 346, 350

Mailer, Norman 114

#MakeAmericaGreatAgain (slogan) 83–4

Mamet, David: *Three Uses of the Knife* 20–21

'Man on a Bridge' (religious joke) 98–9, 117

Man with a Movie Camera (documentary) 8, 173

Mankiewicz, Herman 107

Mao Tse Tung 104, 120–21, 164–7, 170, 178, 199, 263, 310, 407n, 441–2n

Māori creation narrative 263, 353–4

marks 6, 324–8

Marvel 36n, 126, 159, 344, 434n

Master and Commander (film) 85

Matsuyama, Utako 268

Maxine (film) 95

Mazin, Craig 170–71, 195

McAuliffe, Christa 130

McCain, John 95
McCartney, Paul 14, 368n
McEwen, Andrew 167
McGovern, Jimmy 3, 144, 351n
McKee, Robert: Story 4, 5, 19, 276,
 293, 426n, 432n
McMartin family 200, 412n
McPhee, John 211
McQuarrie, Chris 92, 93, 136, 382–3n
Méliès, Georges 25, 27, 28, 332
Melville, Jean-Pierre 142
Mencken, H. L. 281
Meshes of the Afternoon (film) 27, 241
metaphor 63, 64, 68, 118, 147, 237, 255,
 263, 272, 275, 277, 284, 286–7, 293,
 303, 331, 353
midpoint xvi, 14, 58n, 151, 151n, 157,
 172, 206, 220, 244, 283
 A Room with a View 47, 64
 Allen v. Farrow 294, 295, 297
 Andrei Rublev 237
 argument for; argument against
 and 298
 Casablanca and 432
 cave you fear to enter and 64
 Colleen Rooney and 44–5
 defined 26
 Finding Nemo 224, 427
 French Revolution 104
 Get Back 14, 26
 Harry Potter 65–6, 66n, 343
 I May Destroy You 42–3
 It's a Sin 32–3
 Kiki's Delivery Service 233
 Kishōtenketsu and 233, 257
 McKee and 276, 293, 432
 middle, meaning is in the 17, 30, 62,
 296, 296n, 299
 Moonage Daydream 218
 Moonlight 42
Psycho 232, 233
 recognition of the disruption and
 291, 292–4, 299, 300, 307
 Roadmap of Change and 273, 274,
 285, 286–7
 rule of opposites and 183
 Star Wars 64–5, 68, 300, 317–18
 stories as chains of cause and effect
 lassoed around truth located at
 147–8
 Terminator and 55, 340
 The Godfather 296
 The Godfather Part II 147–8
Midsomer Murders (TV series) 35
Miliband, Ed 82, 83, 95, 381n
Mill, John Stuart 299
Miller, Arthur 112; Death of a
 Salesman 333
Miller, George 45, 312, 312n, 328
mirroring 47, 51–4, 58, 66, 172, 184,
 232, 307, 332, 343–4
Mission Impossible (film) 93, 136
Miyamoto, Shigeru 250
Miyazaki, Hayao 255, 257, 345, 421n
Modern Times (film) 131
Modi, Narendra 77, 88–90, 92, 96
Moffat, Peter 77–8
Monbiot, George 326
Monkey (Saiyūki) (TV series)
 345–6
monomyth 247, 271, 290
Moonage Daydream (film) 215–19, 239,
 242
Moonlight (film) 42, 42n, 43, 45, 64,
 188–9, 293, 305, 335–9, 372n,
 427n
Moore, Calvin.: 'The Universal
 Fear of Death and The Cultural
 Response' 314–15
Moore, Ron 346

Moran, Caitlin 149–51
Moresco, Bobby 231
Morgen, Brett 215–18, 414n
Moses (biblical character) 24, 97, 104, 156, 156n, 157, 165, 260, 405–6n
Mr Bates vs The Post Office (ITV drama) 119, 177, 394n, 401n
Mulholland Dr. (film) 240–41
Mullan, John 19
multiprotagonism 29, 190, 195, 212, 228, 230–34, 238, 242, 273, 275, 416n
Munich (film) 265, 383n
My Neighbour Totoro (film) 252, 257, 263, 330, 419n
'Myth Of "Universal" Narrative Models, The' 246, 423n
mythology 5, 12, 14, 17, 56–7, 79, 83, 89, 140, 143, 155, 157–8, 166–7, 179, 218, 271–2, 290, 313, 323, 348, 353, 377n, 392n, 411n

Naishtat, Benjamin 226, 227
Nanook of the North (film) 8
'narcissism of petty differences' 99–100
narratemes 289
narrative structure
 audiences crave 9
 conflict and 15 *see also* conflict
 frame narrative 262–77, 351–52n
 Get Back, introduction of narrative into 13
 narrative cinema born 24–6
 narrative theory of equilibrium 290–92
 non-Western narrative *see* non-Western narrative
 political narrative *see* politics
 religious *see* religion

'rules' of 6
 self and life, arises from collision between 16
 universal narrative models, myth of 246
narratology (academic study of story) xiii, xvi, 276, 288, 290, 293, 320–21
NASA 130, 397n
nation stories 163–7
nationalism 99–100, 156, 164, 165, 168, 201, 268, 326, 440n
Native American stories 263, 265, 352–3, 446n
Navalny (film) 215, 242
NBC 8, 9, 233
Nedivi, Ben 135
need, want and xvi, 68, 183–91, 195–6, 201, 202, 208, 305, 327–31, 334, 355, 411n
negging 161
New Labour 82
newspaper columns 15, 103, 116, 149–51
Newton, Isaac 185
Nicaragua 120, 247, 258, 423n
Nickel Boys (film) 243, 417n
Nietzsche, Friedrich 117, 216
9/11 124, 142, 145, 201
Nintendo 250, 258
Nixon, Richard 76, 106, 443n
No Bears (film) 276
No Child Left Behind programme 100–101
non-Western and non-archetypal narrative xv–xvi, 211–19, 245–77, 344–54, 418n, 425n
 African oral storytelling 263, 264–5, 348–9, 351, 353
 Arabic narrative traditions 351–2

Bengali widow's narrative 247, 261–3
Chinese epic narrative 345–6
Chinese Wuxia narratives 346–8
frame narrative 247, 262–77, 350n, 351n
Indian epic narrative 263, 350
indigenous storytelling 260, 352–3
Japanese Ma (間) 263, 345
Japanese Zen stories 346–8
Kishōtenketsu xiii, 212, 247–60, 268, 270, 345, 418n, 422n
Polynesian storytelling 353–4
Robleto structure 247, 258–60, 349, 422–4n
Noonan, Peggy 129, 396n
Northern Ireland 102
Not Far from Buddhahood (Japanese Zen story) 348

O'Brien, James 116
Obscure Object of Desire, That (film) 240
O'Hagan, Andrew 170–71
Obama, Barack 95, 123, 405n, 444n
Obama, Michelle 146–7, 148, 304
Office, The (TV series) 8, 9, 127
old knowledge vs. new knowledge 28, 68, 208, 304–5, 312, 355, 432n
Olympic Games (2012) 137
One Thousand and One Nights 262–3, 350n, 351n
opposites 21–2, 37–8, 46–7, 54, 64–5, 68, 85, 101, 104, 134, 296, 307, 311, 332, 373n, 410n, 411n
grid of 181, 182–5, 189, 196, 198, 207, 213
rule of 182–5
oral traditions 39, 60, 247, 258–9, 263, 265

African oral storytelling 263, 264–5, 348–9, 351, 353
indigenous storytelling 260, 352–3
oratory 73, 120, 145, 147n
order 8, 10, 12, 16, 34, 44, 45, 60, 68, 116, 185, 196–7, 216, 257, 288, 292, 293, 330
Orientalism 258, 418n
Orwell, George: 1984 136, 196, 197
othering 178, 354

Panahi, Jafar 276
Parasite (film) 251–2, 257, 262, 373n
partition 146, 147
Pascal, Blaise: Pensées 331, 444n
pathos (ability to incite emotion) 122, 129–39, 145, 151, 314, 401n, 402n
Patten Academy for Religious Education 331
Patten, Bebe 331
Patten, Carl Thomas 331
Pearl Harbor, attack on (1941) 123–4, 320
peripeteia (reversal) 133, 138, 370–71n
Perlstein, Rick
 Before the Storm 106, 379–80n
 Reaganland 75–6, 408n
Phantom Menace (film) 56, 57, 58, 64, 317, 375n
Philips, Emo 99
Phillips, Todd 51
phonics 101
Picasso, Pablo 313, 333, 416n
Pinocchio (film) 97, 104, 380n, 388n
Pixar 21, 22, 121, 222, 223, 305n, 369n, 420n
Plater, Alan 3, 4, 6, 7, 17, 18, 23, 35, 312, 334
Plath, Sylvia: The Bell Jar 136
Plato xii, xiii, 37, 139

political narrative 73–119, 152
 antagonist and 96–106
 'deep story' and 321–4
 goal and 106–111
 political slogan 81–5
 protagonist and 86–96
 pulling together protagonist,
 antagonist and goal 111–19
Polynesian storytelling 353–4
popular art 20, 28
popular storyteller 265
populism 77, 113, 120, 132, 207, 329
post hoc, ergo propter hoc (after,
 therefore because of) 170
Prague School 288
Preston, Billy 14, 26
Propp, Vladimir: *Morphology of the
 Folk Tale* 288–91, 430n
protagonist xvii, 11, 13, 17, 21–2,
 29–30, 33, 35, 77, 86–96, 106
 Citizen Kane 107
 defined 15, 16
 ethos and 123, 125, 127, 128
 five act structure and 40–42
 learning and *see* learning
 midpoint and 42, 151, 151n
 multiprotagonism 29, 190, 195,
 212, 228, 230–34, 238, 242, 273, 275,
 416n
 politics and 77, 81, 83, 85, 86–96, 100
 rule of opposites and 183–4
 story formation and 170
 ten questions of story and 186–91,
 195–6
Protocols of The Elders of Zion, The
 199–201
Psycho (film) 232–3, 260
pulse code modulation 182
purity spiral 103–6, 110, 206, 272,
 384–5n, 386n, 391n

purpose 227, 230, 263, 265–6, 269, 311,
 317, 329, 320, 327, 354, 371n
 politics and 75, 80, 83, 121, 124–5,
 144–5, 396n
 religion and 156, 162, 167, 168, 172,
 174, 180, 205, 208

Queen's Gambit, The (TV series) 136,
 398n
questions of story, ten key 182–98
 Aliens 187–8
 Chernobyl 189–98
 Moonlight 188–9
 opposites and 182–5
 Serial 188–9
 ten questions 185–7

racism 95, 105, 152, 168, 266, 322, 324,
 354, 381n, 385n, 406n, 408n, 416n,
 426n, 439n
Ramis, Harold 301, 303
Raphael 66, 68; *The School of Athens
 (Scuola di Atene)* ix, xii–xiv,
 37–8, 50
rationality
 appearance of 139–40
 denial of 175
Raven, The (Native American story)
 353
reaction formation 159, 161, 176, 180,
 201–202, 349, 410–11n
Reading First initiative 100–101
Reading Recovery 101, 384n
Reagan, Ronald xiii, 53, 119, 127, 128,
 139, 381n, 396n
 'A Time for Choosing' 73–8, 80, 84,
 145, 148, 379–80n
 Challenger speech 129, 130, 143–4,
 145, 148–9, 298, 320, 396–8n
 Reagan Democrat 110, 129

reality television 9–10
Reckoning, The (TV series) 145
Red Sparrow (film) 333–4
Redfern, Katrin 103, 384*n*
Reeves, Alec Harley 182
refutation 146, 147, 148, 402*n*
religion xi, xii, xiii, xv, xvii, 12, 37, 58,
 60–61, 68, 87, 88, 96, 98, 104, 109,
 111, 153–208, 218, 260, 314, 393*n*,
 406*n*, 409*n*, 433*n*, 434*n*, 441–4*n*
 cults and 198–208
 definition of 174–81
 ideology and 168–70
 individual stories and 159–63
 nation stories and 163–7
 Scientology xv, 171–2, 174, 180, 181,
 198–9, 206, 207, 208, 250, 272, 330,
 333, 443*n*
 ten key questions of story and
 182–98
 The Ragged Trousered Philanthropists
 and 172–4
 true power of stories and 309–34
Repair Shop (TV series) 11, 86, 96,
 119
repetition 10, 64, 67, 82, 135, 228, 250,
 258–9, 260, 311, 312*n*, 370*n*, 373*n*
Republican Party 73, 75, 95, 106, 109,
 110–11, 113, 123, 128, 145, 269, 281,
 396*n*
resolution 14, 17, 24, 26, 34, 98, 133,
 213, 215, 244, 260, 268, 273, 291,
 295, 306, 340, 346, 393*n*, 444*n*
revenge 42, 43, 65, 85, 107, 116, 117,
 118, 126, 131, 163, 177, 187, 199, 296,
 347, 392*n*
reversals 53, 133–6, 138, 221, 250, 310
Rey, Ferando 240
Rhapsodes 265
rhetoric xiii, xv, 53, 60, 73–5, 77,
 120–52, 227, 249, 257, 272, 281–2,
 297, 377*n*, 402*n*
 Aristotle's rhetorical appeals 121–45
 Cicero's structural framework of
 145–52
Riefenstahl, Leni: *Triumph of the
 Will* 15
righteous destruction 177
ring structure 58–69, 148, 232, 375*n*,
 377*n*
Rise of the Planet of the Apes (film) 97
Rivals (TV series) 127
Roadmap of Change 54*n*, 272–5, 299,
 301, 302, 345, 431*n*
 hero's journey and 274–5
 Star Wars and 284–6
 Terminator 2 and 340–41
Robleto 247, 258–60, 349, 422–4*n*
Robocop (film) 54, 91, 116
Rogan, Joe 116, 243
Rojo (film) 226–7
Rolling Stone 326, 436–7*n*
Rooney, Colleen 43–5
Roosevelt, Franklin Delano xiii,
 76, 123–5, 127–9, 320, 378*n*, 392*n*,
 395–6*n*, 406*n*
Rosenthal, Jack 93–4
Ross, RaMell 213, 243
Rowling, J. K. 58–9, 66, 67, 136–7,
 269, 309–10, 314, 315, 316, 318, 343,
 369*n*, 434*n*
Royal Court Theatre, London 3
Rubin, Danny 301, 303
Rudy, David 207
Rushdie, Salman 369*n*; *Midnight's
 Children* 17, 18, 33
Russian Formalists 288

Salem witch trials 112, 435*n*
Sansho the Bailiff (film) 263–4

satanic panics, US (1980s) 200
Sartre, Jean Paul: *La Nausée* 11, 315
Savile, Jimmy 145
Savonarola 155–6
Scarface (film) 97, 104, 126, 304, 395n
Schaeffer, Francis 109–11, 390–91, 390n
Schwartz, Roy 159
scientific method 306–7, 355, 356
Scientology xv, 171–2, 174, 180, 181, 198–9, 206, 207, 208, 250, 272, 330, 333, 443n
Scorsese, Martin 27, 232–3, 363–4n, 416n
screenwriting, study of
 as 'art of turning psychology into behaviour' 106–7
 'gurus' xi, xvi, 4–5, 19–20, 293
Seaward, Tracey 137
Serial (podcast) 188–9
sex trafficking 161
Shakespeare, William 23, 38, 39, 45, 138, 185, 267
 Hamlet 147, 148
 Macbeth 22, 40, 41, 43, 183, 199, 262, 304, 372n, 385n
Shameless (TV series) 9, 368n
Shawshank Redemption, The (film) 296
Sherlock Jr (film) 180
Shi Nai'an: *Water Margin* (novel) 346
Shining Path 163–4, 166, 407n
Ship of Fools 98
Shirer, William L. 86, 114–15; *Hitler: The Nightmare Years* 117
Shuster, Joe 155, 157, 158, 405n
Siegel, Jerry 155, 157, 158, 159, 405n, 406n
Sight and Sound magazine 27, 243
Silver, Amanda 97

Silverman, Ben 8–9
Slow Horses (TV series) 143
Smoke, The (TV series) 94–5
Snow, Edgar: *Red Star Over China* 163–8, 170, 178–9
Snyder, Blake: *Save the Cat* 19, 253
soap opera 9–10
social contagion xv, 323, 436n
socialism 79, 167, 172–4, 193, 205, 437n
Social Network, The (film) 126, 183, 298
Soon-Yi 294, 294n
Sorkin, Aaron 108, 231
Soul (film) 21
sound-waves 182
Space Shuttle *Challenger* 129, 130, 143, 145–6, 148, 298, 320, 396n, 397–8n
Spielberg, Steven 93, 128, 265
Spirited Away (film) 252, 253, 255, 257, 258, 263, 420n
Spooks (TV series) 142
Squid Game (TV series) 96, 114, 117, 118, 127, 136, 143, 145, 384n
Stalvey, Jennifer 332
Star Wars (film series) 61, 68–9, 127, 165, 167, 174–5, 207
 cave you fear to enter and 64–5, 300
 hero's journey and 270, 271, 283–7, 293, 299–300
 midpoint 293, 299–300, 433n
 religion and 317–19, 320, 330, 434n
 ring structure and 55–8, 61, 375n
 rule of opposites and 183
 three-act structure and 398n
 See also individual film name
Sterne, Lawrence: *Tristram Shandy* 61, 67, 379n
Steve Jobs (film) 108
Stevens, George 208

Storr, Will: *The Science of Storytelling*
 133–4
story
 child's well-being and xvi
 counter-storylining 228–30
 creation 12, 58, 59
 deep story 322, 323, 324, 326, 328
 definition of xi, xiv–xv, 106,
 281–308
 dissonance and *see* Dissonance
 drug dealing, storytelling as 131–8
 fiction and *see* fiction
 individual stories 159–63
 narratology, the academic study of
 story *see* narratology
 nation stories 163–7
 non-Western and non-archetypal
 narrative xv–xvi, 211–19, 245–77,
 343–54, 418n, 425n
 perfect story xvi–xvii, 7, 36, 50, 83,
 106, 110, 118, 121, 161, 174, 206, 308,
 309–34
 politics and *see* Politics
 power of xi, xvii, 309–34
 religion and *see* Religion
 structure *see* structure *and*
 individual type of structure name
 ten key questions of 182–208
Story, Brett 213–15; *The Prison in*
 Twelve Landscapes 213, 214, 241–4
Strauss, Neil: *The Rules of the Game*
 161
#StrongerTogether 83–4
structure 7–36
 defined 7–8, 12, 14
 as the enemy 3, 4, 6, 7, 17, 18, 23,
 35, 334
 five act *see* five act structure
 midpoint *see* midpoint
 non-Western and non-archetypal

 see non–Western and
 non–archetypal narrative
 order and 7–8, 12
 ring structure *see* ring structure
 rhetoric *see* rhetoric
 three act *see* three act structure
Studio Ghibli 251–3, 255, 257, 345,
 419n
subject matter 15, 116, 170, 215, 222,
 231, 232, 236, 276, 290, 301
subversion of expectation 132–4, 138,
 248, 255–7
surfing, story and 312, 328
Sullivan, David 332
Sun Shuyun 167
Sun Yat-Sen 164
Super Mario 3D Land (video game)
 250
Superman (film and comic book
 series) 89, 143, 155, 157–9, 172,
 180, 201, 208, 309, 319, 328, 405n,
 406n
supreme ordeal 271, 274, 286–7, 356,
 425n
Swan-Geese, The (Russian folk tale)
 291, 295n
symmetry 8, 26, 33–4, 38, 50–51, 56,
 64, 67, 68, 172, 183, 185, 196, 206,
 244, 250, 257, 275, 282, 293, 307, 310
synthesis 16, 223, 237, 296

'Tar Baby' stories 349
Tarkovsky, Andrei xiii, 234–5, 240
Taseer, Aatish 89
Tea Party 113, 321, 324
telos 141–2, 144–5, 147, 151, 349, 401n,
 402n
Terence 23, 39
Terminator 2 (film) 54–5, 67, 132–4,
 136, 340–41, 375n

Thelma & Louise (film) 52, 125, 184, 293, 299*n*, 319, 372*n*, 415*n*

theme xvi, 59, 216–29, 231–2, 234, 237–9, 241, 243, 254, 261, 263, 344, 353, 376*n*, 402*n*, 414–15*n*, 416*n*, 426*n*

thesis, antithesis, synthesis 16, 148*n*, 223, 237, 296

third-act twist 258

This Evening and Cameraperson (documentary) 213

Thomson, David 90, 240

Thomson, George H.: *The Italian Romances* 47

three act structure xi, 3–7, 14–36, 58, 133, 184, 191, 223, 254, 262–3, 282, 307, 354, 370, 398*n*, 426*n*
defined 15–17
dissonance and 213–15, 240–44
five act structure and 38, 39, 41
It's a Sin 29, 33
Mamet on 20–21
Moonlight 335–9
Pixar and 21–2
Rushdie on/*Midnight's Children* 17–18
Truby on 4–6, 23–4, 35, 36, 244, 275

Time (documentary) 213

Todorov, Tzvetan: 'The 2 Principals of Narrative' 288, 290–93, 300, 304

Toland, Gregg 107

Tolkien, J. R. R. 334, 445–6*n*

Tolstoy, Leo: *Anna Karenina* 229, 230

Top Gun: Maverick (film) 93

totems 114, 176, 269, 323, 324, 390*n*, 436*n*

Toy Story (film series) 21, 26

Trading Places (film) 143

transcendence xvii, 85, 95, 118, 119, 137–8, 180, 312, 320, 417*n*
Andrei Rublev and 234, 236, 237
definition of 207, 227
promise of 156, 162, 165

transcendent cause 123–5, 127–8, 128*n*, 130, 132, 151, 165, 172, 174, 177, 396*n*, 409*n*

Transformers (film series) 104

Tranter, Jane 142

Tressell, Robert: *The Ragged Trousered Philanthropists* 173, 178, 205

tribal identity xvii, 57, 80, 97, 101–102, 111, 134, 141, 200, 308, 323, 324, 328, 408*n*, 409*n*, 415*n*, 424*n*, 439*n*, 442*n*
ideology and 169–71, 174, 176, 177, 179
non-Western narrative forms and 264, 265, 348, 351, 353
purity spirals and 105
transcendent cause and 123–5, 128, 128*n*, 156

troubadours or bards 265

Truby, John 4–6, 23–4, 35, 36, 244, 275

Trump, Donald xii, 9–10, 77, 101, 147, 169, 196, 198, 320, 326, 327, 349, 371*n*, 386*n*, 391–2*n*, 393*n*, 409*n*, 440*n*, 444*n*
appeal of 113–16, 152, 321
deep story and 324
empathy and 126–7
Goldwater and 113–14
Hillary Clinton as perfect foil for 106
popular storyteller par excellence 265

simple clear story, relentless
 pursuit of 152
slogans 83–4, 84n
truth
 five act structure and 40, 41
 midpoint and 42, 147–8, 147n
 religion/ideology and 170,
 179–80
 School of Athens and 38
 ten questions of story and 189–91,
 195, 197, 411–12n
 Truby and 5–6
Tubman, Harriet 156
21 Jump Street (TV series) 5

Ugetsu (film) 263–4
Ukraine 8, 122–3, 173n, 441n
Underground Railroad 156
University of Utrecht 246, 258, 260,
 263, 422n
US Presidential elections
 (1964) 73, 75, 408n
 (1968) 443n
 (1980) 128–9
 (1996) 121–2
 (2008) 405n
 (2016) 83, 321
 (2020) 115, 386n
 (2024) 152
Usual Suspects, The (film) 92

vaccine denial 323
Valentino, Rudolph 87–8, 96
Van Loan, H. H. 20
Vardy, Rebekah 43–5
Vertov, Dziga 8, 34, 173, 367n,
 389n
Vesuvius, Mount 14
vibe shifts 323
Vidor, King: *The Crowd* 51

Vietnam War (1955–75) 75, 76, 143,
 144, 387n, 400n
Village, The (TV series) 77–80
Vogler, Christopher: *The Writer's
 Journey* 5, 19, 271–2, 275, 425n, 428n
*Voyage dans la Lune (A Trip to the
 Moon)* (film) 25–30, 34, 35, 332, 355

Waller-Bridge, Phoebe 125–6
Waltons, The (TV series) 112, 143
Washington Post 110, 326
Way Of The Gun, The (film) 92
Welles, Orson 54, 107, 389n
wellness 203, 329
Western hegemony 266
Western structure 275, 344, 346,
 425n
West Wing, The (TV series) 111, 231,
 414–15n
What Happened To The Human Race?
 (film series) 109–10
Whatmore, Richard 103–4, 384n
When Harry Met Sally (film) 223
Whole Language Learning 101
Wife Swap (TV show) 9
Williams, John B.: 'The Universal
 Fear of Death and The Cultural
 Response' 314–15
Wilson, Bill 204–5
Wilson, Harold 82, 385n
Winehouse, Amy 132, 218
Wisher, William 132, 340
Wolpert, Matt 135
writers strike, US (2007) 8–10
Wu Cheng'en: *Journey to the West*
 263, 345–6
Wuxia narratives 346–8
Wyckoff, Gene 106

X-Factor, The (TV show) 9, 10

Yeats, W. B. 313
Yellowstone (TV series) 119, 144, 396*n*
Yonkoma manga (or 4 Koma) 255
Yoonmi, Kim 266–7
Yorke, John: *Into the Woods* xi–xii, xv, 20, 23*n*, 51, 57*n*, 61*n*, 62, 159*n*, 222, 246*n*, 271*n*, 272, 290*n*, 305*n*, 308, 313
Your Name (Kimi no Na wa) (film) 251

Zen stories 346–8
Zhang Yimou 268, 348